The
Romance
of
Modernism

~

The Romance of Modernism

paintings and sculpture
from the
Scott M. Black Collection

George T. M. Shackelford

MFA PUBLICATIONS
a division of the Museum of Fine Arts
Boston

MFA Publications
a division of the Museum of Fine Arts, Boston
465 Huntington Avenue
Boston, Massachusetts 02115
www.mfa-publications.org

This book was published in conjunction with the exhibition "The Romance of Modernism: Paintings and Sculpture from the Scott M. Black Collection," organized by the Museum of Fine Arts, Boston, from December 12, 2006, to May 6, 2007.

Generous support for this publication was provided by Scott M. Black.

For a complete listing of MFA Publications, please contact the publisher at the above address, or call 617 369 3438.

Cover: Paul Signac, *Antibes, The Pink Cloud,* 1916 (see p. 67)
Frontispiece: Georges Braque, *Pipe and Compote,* 1919 (see p. 84)

All illustrations in this book were photographed by Michael Gould and Greg Heins of the Imaging Studios, Museum of Fine Arts, Boston, except where otherwise noted.

Edited by Mark Polizzotti
Copyedited by Jodi Simpson
Designed and produced by Cynthia R. Randall
Printed by Sawyer Printers, Charlestown, MA

Available through
D.A.P. / Distributed Art Publishers
155 Sixth Avenue, 2nd floor
New York, New York 10013
Tel.: 212 627 1999 · Fax: 212 627 9484

FIRST EDITION
Printed on acid-free paper
Printed and bound in the United States of America

Contents

Director's Foreword

SCOTT BLACK HAS BEEN A FRIEND and supporter of the Museum of Fine Arts, Boston, since his childhood. He came to the Museum with his parents at an early age, forming his taste for great works of art. Now, as he nears his sixtieth birthday, he can be found in the Museum nearly every weekend, visiting his old friends in the galleries of European paintings and sculpture, and seeing examples generously lent from his own collection side by side with works that came into the Museum generations ago.

The Romance of Modernism: Paintings and Sculpture from the Scott M. Black Collection presents more than forty paintings and more than a dozen sculptures that Scott has collected over the past two decades. Spanning nearly a century—from the 1860s to the 1960s—the works of art in the Black Collection show the rise of modern art in the paintings of Impressionists such as Cézanne, Degas, Monet, and Renoir; its transformation at the hands of the Post-Impressionists—Toulouse-Lautrec and Signac, for example; and the explosion of creativity in the early years of the twentieth century, with works by Braque, Léger, Matisse, and Picasso, among others.

The exhibition has been curated by George T. M. Shackelford, Chair, Art of Europe, and Arthur K. Solomon curator of Modern Art, assisted by Sabrina Abron and by staff throughout the Museum.

Scott and Isabelle Black are true friends of the MFA. We are grateful to them for sharing these extraordinary paintings and sculptures with the Museum, and through us with the people of Boston and our visitors from across the world. I hope that everyone who sees *The Romance of Modernism* will come away with a sense of the deep love for art and the passion for discovery that have inspired Scott Black in the formation of this beautiful collection.

MALCOLM ROGERS
Ann and Graham Gund Director
Museum of Fine Arts, Boston

Preface

TEN YEARS AGO, WHEN I JOINED the curatorial staff of the Museum of Fine Arts, Boston, I met one of the most passionate collectors it has ever been my privilege to encounter: Scott Black. Scott is a dynamo—driven in his work, with a keen intelligence and a truly unusual memory, and above all an intense love for art. He is also a generous man, lending his collections to the Museum of Fine Arts, Boston, and to the Portland Museum of Art, as well as to international loan exhibitions.

With his wife, Isabelle, Scott has served as a devoted member of the Visiting Committee to the Art of Europe Department and is a supporter of our projects. In memory of our dear friend Robert J. Boardingham, who was Assistant Curator of European Paintings at the time of his death in 1997, Scott has funded an annual lecture on topics in modern European art, presented by some of the most distinguished scholars from museums and universities in this country and abroad. I would like to thank Scott and Isabelle for the opportunity to work on this collection, and to present in Boston, for the first time, a comprehensive survey of the great paintings and sculptures that they have brought together.

At the museum, my thanks go to Malcolm Rogers, Ann and Graham Gund Director, as well as Katherine Getchell, Deputy Director, Curatorial, for their enthusiastic support of the project. Sabrina Abron, Research Assistant, Art of Europe, helped me with all aspects of the exhibition; in our department, I am also grateful to Deanna M. Griffin, Brooks Rich, and Susie Wager for their help. Mark Polizzotti, Cynthia Randall, and Jodi Simpson of MFA Publications, and photographers Michael Gould and Greg Heins of the MFA Imaging Studios, have worked to produce this handsome catalogue. Many other MFA colleagues contributed to the success of the exhibition. I would like to thank Patrick McMahon, Keith Crippen, and Jennifer Liston Munson in Exhibitions and Design; Patricia Loiko, Head Registrar; conservation staff Irene Konefal, Annette Manick, Susanne Gansicke, and Andrew Haines; Dave Geldart and his staff for managing the installation; Benjamin Weiss for interpretation; Dawn Griffin, Kelly Gifford, and Jennifer Standley for publicizing the exhibition; and Kim French, Janet O'Donoghue, and Jennifer Weissman for their marketing expertise.

Our colleagues at the Portland Museum of Art have been extraordinarily generous with their time and advice. I would first like to thank Daniel O'Leary, Director, and former curator Carrie Haslett for their support. Ellie Vuilleumier, Registrar; Lauren Silverson, Associate Registrar; Stephanie Doben of Rights and Reproductions; and the museum's preparators, Stuart Hunter and Kris Kenow, and Exhibition Technician Greg Welch graciously welcomed us on several occasions. We are also grateful to David Norman and John Tancock of Sotheby's, New York, and to Guy Bennett of Christie's, New York, as well as to their colleagues Lucinda Ciano and Jessie Fertig. Many scholars have given me good advice as this catalogue was prepared; I would particularly like to thank Juliet Wilson-Bareau, Emily Braun, Isabelle Cahn, Susan Compton, Philip Conisbee, Robert L. Herbert, John House, William Jeffett, Dorothy Kosinski, Dominique Lobstein, Barbara Mathes, Alexandra Murphy, Joachim Pissarro, Theodore Reff, Anne Roquebert, Richard Thomson, Paul Hayes Tucker, Anne Umland, Jean-Pierre van Noppen, Sarah Whitfield, and Karen Wilkin.

GEORGE T. M. SHACKELFORD
Chair, Art of Europe,
and Arthur K. Solomon Curator of Modern Art

The Collector's Passion

A Conversation between Scott M. Black
and George T. M. Shackelford

*Scott, I would like to begin by asking you what
your earliest memories are about art. What are
the first things you think about when you think
about your life and art?*

I remember when my family was living
in Newton, just outside Boston, between
1950 and 1955. I must have been about
three years old. Over my mother's sofa in
the living room was a reproduction of
Renoir's *Madame Charpentier and Her
Children*—a wonderful painting. My mother
also had *The Lovers* by Picasso, a Monet
Japanese Bridge, and a ballerina by Degas.
Even though we certainly didn't have the
kind of money ever to aspire to own such
objects, I was familiar with them because we
had images of them throughout the house.
My mother loved French Impressionism
and early-twentieth-century painting.

I also remember visiting the Museum of
Fine Arts in Boston as a child. I was fascinat-
ed with the Evans Wing Hemicycle, which
contained the *Grain Stack*s by Monet and his
paintings of the cathedral at Rouen. I knew
those at an early age, and I've continued
to be particularly attracted to Monet.
Another painting at the MFA that I loved as
a child was Renoir's *Children on the Seashore,
Guernsey*. It was a beautiful painting, with
dazzling colors. It's a vertical, as you well
know, not a horizontal painting, which is
unusual for his landscapes.

Despite their economic circumstances,
my mom and dad went to Europe and
visited art museums. My mother's favorite
painter was Renoir; my father's was
Toulouse-Lautrec, whose work he saw at
the Jeu de Paume in Paris. I don't think
it's accidental that I bought a Toulouse-
Lautrec, the two women making the bed
(p. 53), in memory of my dad.

*So from the very beginning, you were oriented
toward French later-nineteenth-century painting.
But you're also interested in a lot of other things
nowadays.*

I enjoy going to Europe as often as I
can. The first time I went to Italy was in
1977, when I was about thirty. I traveled to
Rome, Florence, and Venice. I'd seen the
great Italian paintings in textbooks, but to
see firsthand the Raphael rooms at the
Vatican, or Michelangelo's *Last Judgment*
in the Sistine Chapel, or the paintings in
the Uffizi and the Pitti Palace… It was a
wonderful experience. I love great Italian
painting. Quite candidly, as good as Renoir,
Monet, Degas, and Picasso are, they're not
as good as Raphael or Leonardo or
Michelangelo.

*Perhaps it's the scarcity of Raphaels and
Leonardos that has led you toward your fascina-
tion with French nineteenth-century and early-
twentieth-century painting. Did you study art
history?*

I really didn't. I majored in mathemat-
ics and economics at Johns Hopkins and
never had time to take an art history
course, although Hopkins has a wonderful
art history department. My sister had the
benefit of taking two courses with Charles
Stuckey. But we were fortunate, because
at the end of the Hopkins campus is the
Baltimore Museum of Art, which has the
best collection of Matisse in the world, as
well as some wonderful paintings by other
artists in the Cone Collection. I frequented
the museum when I was an undergraduate.

After Harvard Business School, in the
early 1970s, I moved to New York and
joined the Museum of Modern Art. I still
remember that in the old days, in the old
MoMA, you would exit the elevator on the
third floor and square in front of you was
Picasso's *Guernica*, which has now gone back
to Spain—as Picasso wanted it to, after the
death of Franco. I was also hugely impressed
by paintings like the *Demoiselles d'Avignon*.

I wasn't a scholar. I had a good memory
for dates, and I knew what the paintings

looked like, but it's only in more recent
years, especially since my wife, Isabelle, has
been studying art history more formally, that
I've developed a deeper understanding of
art history, more of a theoretical foundation.
But I have always enjoyed going to view art.

*So it was in your late twenties that your passion
for art really took off?*

That's right. When I lived in New York,
I often attended exhibitions. I went to see
the exhibition at the Met of the late work of
van Gogh at Saint-Rémy and Auvers. I must
have gone to the Seurat exhibition at the
Met at least four or five times, and to the
"Fauve Landscape" show three or four times.
I saw "Mary Cassatt: Modern Woman" at the
MFA, but I also flew to Chicago to see it
there, just to experience how it looked in a
different venue. Not to mention many exhi-
bitions in Paris and London.

I have a rule for collecting: if a painting
doesn't look good enough to hang on the
walls of one of these museums, it would
be a mistake to buy it. If you have limited
resources with which to buy paintings, as
I do—I was not born rich and I still don't
have that type of wealth—you can't afford
to make many mistakes. It is really gratifying
when museums include my paintings in their
exhibitions, such as at the recent "Cézanne
in Provence" show at the National Gallery,
to which I lent *Trees in the Jas de Bouffan* (p.
21). Not many private collectors lent to that
exhibition. I also lent a very fine late Degas
portrait from the 1890s to "Degas: Beyond
Impressionism" at the National Gallery in
London and the Art Institute of Chicago. It
affords me a lot of personal satisfaction that
I've collected well enough that my paintings
are hung side by side with other great mas-
terpieces from around the world. It's a com-
bination of luck and study—because the fact
is, there are just not that many museum-
quality paintings on the market anymore.

You clearly have a real avocation and a love for this art that started before you decided that you might actually own a painting for yourself. Tell us a little bit about the beginnings of your life as a collector.

It was purely by accident. In 1984, I was dating a woman from San Francisco who is a collector, and she invited me to accompany her to an auction at Christie's. It was interesting, but I didn't really understand the process. Honestly, I was intimidated by it. I assumed that only the wealthiest people went to Christie's and Sotheby's.

Nevertheless, I went to the auction, and I discovered that the prices weren't necessarily astronomical. The following year, I returned to Sotheby's and bid on a Signac, *The Fort at Antibes*. I bid to the high end of the estimate but was unsuccessful, because the price went above the range. I admit that I wasn't all that knowledgeable about the process: I thought the estimate would be roughly the same as the selling price. Additionally, I didn't have as much money to buy paintings as I do now.

How did your collecting proceed from there?

In coming to understand the auction process, a collector has to have a clear sense of what the values are and what paintings are good. I am much more knowledgeable about it today, twenty-one years later, than I was in 1985 when I first started. The first painting I bought was Bonnard's *Portrait of Mademoiselle Renée Monchaty* (p. 87). It's not his greatest painting, I know, but it has an interesting story behind it, because Monchaty committed suicide before Bonnard married his long-time companion, Marthe. The second painting I purchased, in 1986, was a wonderful Monet: *Monte Carlo Seen from Roquebrune* (p. 26). Fortunately, because Monet is such a good painter, it is difficult to go wrong—unless you choose a really bad one.

That's a good way to look at it! Did you have to stretch to buy the Monet?

Let's put it this way: I paid about 75 percent of my net worth for that painting. Luckily, my company, Delphi, was doing well enough to support it. This acquisition shows that I was passionate—most people don't spend 75 percent of their net worth on a painting. But I was thirty-nine years old, and buying the Monet represented something special to me. Other people like fast automobiles, but to me, owning a great Monet at that stage of my life was a real accomplishment. It was a milestone.

Monet is probably my favorite painter of the nineteenth century. Don't get me wrong: I love Cézanne, Degas, and Renoir, but I *connect* with Monet as with no other artist. I think he was a brilliant landscape painter. I've always said that if I went broke and had to sell forty-two of the forty-three paintings I now own, the one I'd keep would be Monet's *Monte Carlo*. It's sentimental for me.

It's terrific that you started with such a great picture—you made one baby step with the Bonnard and then a really giant step with the Monet. It's something you can be very proud of. Since then, you've bought a lot of artists besides the Impressionists or even the Post-Impressionists. You've got a very strong interest in early-twentieth-century art, for instance, particularly Cubism and Surrealism. How did your taste or your interests evolve?

Initially my taste did gravitate toward Impressionist works. They're aesthetically pretty, and when they're well executed it's easy to understand them and connect with them emotionally. But when I look back on those early years of collecting, I wish I had been a bit broader in my outlook—especially since prices weren't quite so high as they are today.

I remember a Magritte painting at Christie's of men in bowler hats, for instance: if

only I had been attuned to Magritte back then! There was a Picasso of the 1932 period, a small one, related to the double image at the Norton Simon, and it went for a reasonable price at Sotheby's. If only I'd known more about Picasso at the time!

Originally, I was much more knowledgeable about the nineteenth-century painters. I enjoyed looking at twentieth-century art, but it wasn't something I wanted to own. My hope was to fill in the gaps with painters like Monet, Renoir, Degas, and Pissarro. But as I went to more auctions, I not only saw that twentieth-century art interested me, I also began to get a better understanding of it—Cubism, Surrealism, Fauvism. I've made some blunders, but at least they were errors of omission rather than commission.

There is another point worth mentioning. Right after I began collecting art in the late 1980s, the market took off with the arrival of Japanese buyers. Even though good Picassos became available, and maybe paintings by Juan Gris or Braque, the prices for these works were going through the roof because the Japanese were willing to bid so high. It made it more difficult to buy at the first tier of talent. After I bought the Monet, the third painting I acquired was by Théo van Rysselberghe. Given the change in the market, I was really attempting to buy the top of the second tier. Van Rysselberghe is not a particularly good painter overall, but I will argue that the work I own, *The Regatta* (p. 59), is one of his best.

It's certainly one of the great ones.

It was painted in 1892, during his best period. I also bought the Vuillard. I bid on Nabi-era Vuillards later, but they were selling for very high prices. Sure, an 1895 painting might be better than the one I own, from the 1920s, but mine (*The Two English Friends*, p. 89) is still a remarkable

painting. The same is true for my Léger from 1929: it's a wonderful painting, even if it can't entirely compete with his *Contrast of Forms* series of 1913 and 1914.

The real breakthrough occurred in the fall of 1990. The stock market had receded and the Japanese collectors were more or less out of the art market. As you know, the spring of 1990 was the peak until this year, both at Christie's and Sotheby's. And then lightning struck when I bought *Pagans and Degas's Father* (p. 35). I know I said that, sentimentally, I like Monet's *Monte Carlo* the best, but if you ask me to name the single best painting I own, it's undoubtedly the double portrait of Lorenzo Pagans and Degas's father. It's a monumental work. I think that, among the late portraits, it's one of Degas's best. It would hang admirably in this museum—as it has—or in the Musée d'Orsay.

I never expected to purchase this painting. I went to the preview with my mother and sister and told them at the time I doubted I would be successful. I knew it would be a real stretch for me to buy it. But I also knew it was a great painting, and I'd been warned that another far wealthier collector might be bidding against me. By some miracle, he didn't. And that's really when my collecting started in earnest.

I had bought the Chagall previously, and Magritte's *Tempest* (p. 107). But the Degas was the second major painting I acquired, after the Monet. And then the floodgates opened. The market declined sharply and I could start indulging my passion.

As an example, the beautiful Signac I bought in 1992 (*Antibes, The Pink Cloud*, p. 67) had previously been sold to a German collector in 1990, and had set a record for the artist at $2.2 million. I bought it eighteen months later for $600,000. The painting hadn't changed—the market had. The same thing happened with Dufy's *Boats at*

Martigues (p. 73), which had been in the "Fauve Landscape" show at the Met and elsewhere. It came back to auction and I was able to buy it. I was also able to buy my Fauve de Vlaminck (*Houses and Trees*, p. 71) in 1993, at the low estimate. I knew this painting well, because it had hung for years on extended loan from a private collection to the Metropolitan, side by side with their great Derain, the *Fishing Boats at Collioure*, given by the same family.

So you were in the right place at the right time?

Yes. It was a great opportunity. If you were prepared and you knew what was going on, you could buy terrific paintings. At the auction of the Klaus Perls collection at Sotheby's, I bought Léger's *Bunch of Grapes* (p. 96) and Braque's *Still Life with Pears, Lemons, and Almonds* (p. 85). Both were giveaways at those prices, but the amazing thing is that other people weren't opportunistic. The same thing occurs when people chase stocks in a bull market instead of buying when stocks are out of favor and are less expensive. I looked at the depressed art market and decided to buy. In the period after that "art bubble," I was one of the most consistent buyers at Christie's and Sotheby's.

That must have been a terrific time to expand not only numerically, but also in terms of span of interest. You'd moved out of Impressionism and Post-Impressionism and now were buying paintings by artists who really came into their own around the time of World War I, like Léger and Braque.

My collecting was quite eclectic. One night, in the early nineties, I bought both the Degas pastel of a ballerina (p. 37), which had been owned by René Degas, the artist's brother, and *The Heart Unveiled* by Magritte (p. 104). I remember Michael Findlay of Christie's telling me that I was one of the rare "crossover buyers."

That was a very good moment for you, then. But it didn't last all that long, unfortunately.

That is true—in recent years it's been more difficult, but there are still opportunities from time to time. For example, in the spring of 2005, I was able to buy Miró's *First Spark of Day III* (p. 116). It was in the first night of the Sotheby's auctions in May, and they had a number of works that didn't sell. The Miró was a late lot in the sale. I had seen this painting before the preview and liked it immediately. It had previously hung at the Fondation Maeght in Saint-Paul de Vence, and I was advised by an expert whom I trusted that it was a very fine work. The sale didn't do well for Sotheby's, but I was lucky. By the time the Miró showed up, much of the audience had disappeared, and I was able to buy it without too much difficulty.

Then, in the fall of 2005, I bought the late Pissarro, *The Louvre, Winter Sunlight, Morning* (p. 43). I wasn't quite sure how competitive it would be, but sometimes just showing up is half of life, as Woody Allen used to say. I bid on it up to my limit, and when the bid was against me, I placed one last bid at half the house's increment. It worked, and I was able to get this wonderful painting. So there are occasional inefficiencies in the market…

…that can work in the favor of a collector who's paying close attention?

Right. I also have a huge library of books at home, and when something appears at auction I read extensively and do my homework. I go to see similar examples at the MFA or the Met, for comparison's sake. And I seek advice from scholars and curators. I like to hear what you think about a work of art that I'm interested in; and I might seek out the opinion of a specialist on a certain artist—I would want to talk to Paul Hayes Tucker about a painting by Monet, who he's studied for years, and I

still miss talking to our friend Bob Boardingham, the MFA curator who was an expert on Cézanne. I know that I am not an expert. I know what a good painting looks like and whether it's of museum quality, but I also know that if you're spending seven figures on a painting, you want to get as much reliable advice as you can.

I think it's very important to seek knowledge, as you've done, in a variety of ways—not only by talking to individuals or reading books, but also through the travel you've done to see so many comparable paintings. I also know you like to travel to the places where the artists that you have collected worked. Tell us a little bit about the pleasure you take in going to see these sites.

Well, it's no secret that I like traveling in Italy and France. There's a certain area, for example, where the fort at Antibes was painted by Monet, Signac, and Cross. It's called Le Salis, and the view that the artists preferred is on a hairpin turn in the road (see Cross's *Antibes, Afternoon*, p. 64). The first time Isabelle and I went to visit, there was quite a bit of traffic. She tried to photograph me, and I was lucky not to get run over!

This past summer we went to Aix-en-Provence for the hundredth anniversary of the death of Cézanne. We visited his family's house there, the Jas de Bouffan. They had a list of all the paintings that were painted in the garden, and I was very pleased to see that mine was included. To this day, they don't know exactly where my picture was painted—the garden has changed a lot—but just to walk on the grounds, see the house and the *allée* of chestnut trees, the reflecting pool, was really exciting.

Another adventure was our drive to Les Lauves, where Cézanne had his last studio. We saw the Montagne Sainte Victoire from the location where he painted it. Then we drove through the mountain roads in Le Tholonet, high up to the base, to one of the vantage points Cézanne loved. Now, you can call this a little bit fanatical, but I enjoy doing it, because you see with your eye exactly what the painter saw with his. Of course, there are the street scenes in Paris, too. I've stood on the bridge looking down at the Seine, a similar vantage point to the one that Pissarro recorded in my 1901 oil, and I've gone to look at the Pont Saint-Michel from Matisse's perspective (see p. 69). I've also traveled to Normandy, to Trouville and Deauville, so I know what the beach looks like where Boudin painted (see *Beach Scene near Trouville*, p. 28).

A few years ago I took Isabelle to Vétheuil, to the church Monet painted in the 1870s. Our visit came right after I bought *The Seine at Lavacourt* (p. 22). We went down to the river and discovered the place it was painted in Vétheuil, looking across at Lavacourt. You could picture how Monet painted Vétheuil from Lavacourt, working from his boat studio looking at that angle. And you can see how the Seine widens out a little bit there. On the other hand, when we went to Argenteuil, where Monet lived in the early 1970s, it was unrecognizable.

Some of the neighborhoods where the Impressionists painted in the 1870s and '80s have changed dramatically in the intervening years, and you can't always recapture the spirit of the late nineteenth century there.

But Vétheuil was very much similar to what it looked like then. It's still pristine.

Do you ever pick a painting because you know you can get to go to the site eventually?

No, not really. But there is one painting I have, Monet's *Manneporte*, in Etretat (p. 25), that will surely inspire a trip someday.

You'd better take some rubber boots if you go to Etretat, because you may have to wade through some water to get to the spot where Monet was painting! Tell me, Scott, you have spoken of your family and of Isabelle. Have they had an influence on your collecting?

There are three women that have been influential in my collecting over time: my mother, my sister Barbara, and Isabelle.

My mother is gone now, but as I mentioned earlier it was she who sparked my initial interest. She loved going to the previews in New York. Her main purpose was going to see the paintings—looking at them was more important to her than the auction process. There were certain things I bought knowing that she liked them. One in particular was the Picasso *Head of a Jester* (p. 75). She had seen it during the preview, and after the sale I called her to tell her we had gotten it. She was so excited! She wanted the *Jester* in the worst way.

You said your sister was another important influence.

Barbara used to accompany me to many auctions, and sometimes she would encourage me to "go one more bid!" One more on the Delvaux, one more on the Dufy… And she was right. Barbara has good taste. She really loves Matisse. When I bought *The Pont Saint-Michel*, I knew it wasn't one of his typical paintings from the 1920s. It's a tough, proto-Fauve painting. In terms of provenance, however, it's one of the best paintings I own, because it was in the Stein Collection—you can see it in their dining room in certain photographs. Psychologically, I probably bought the Matisse more for my sister than for myself. I wish I'd bought one from the twenties, too, but those are very expensive.

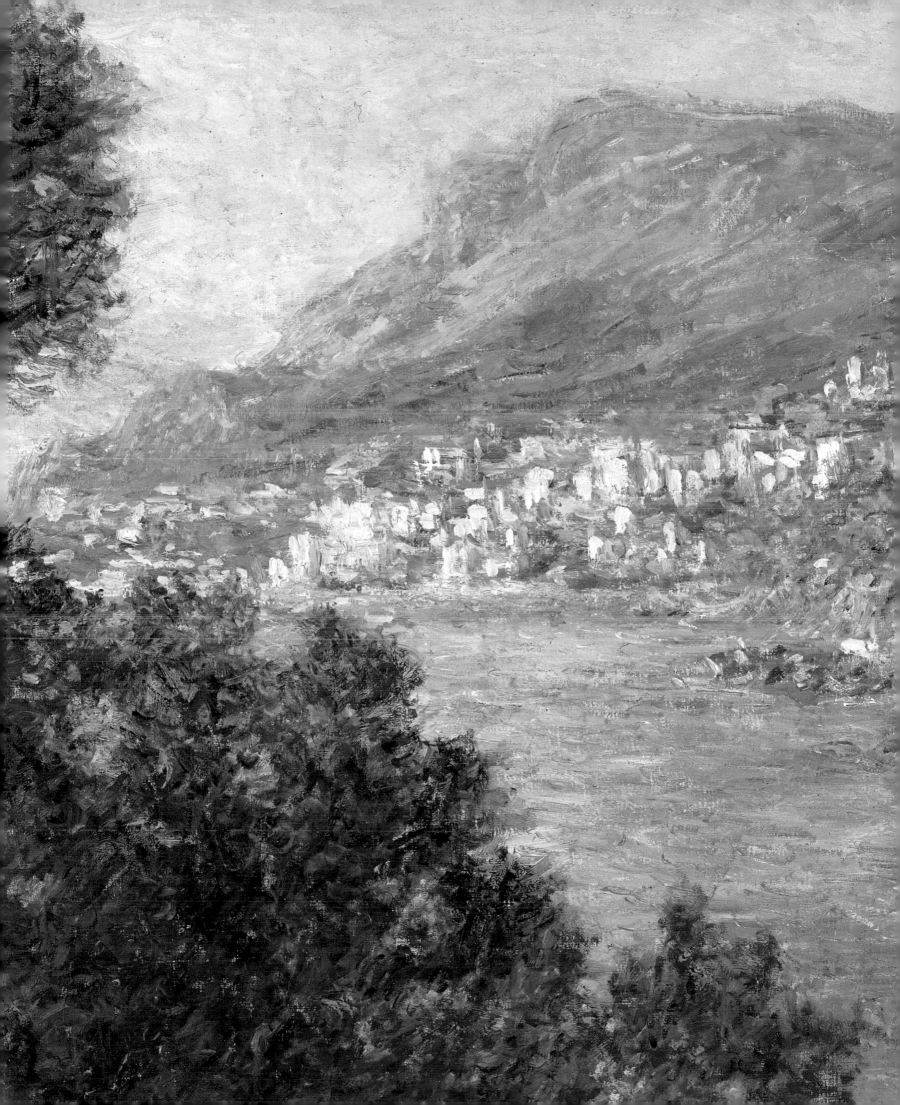

And your third muse is Isabelle?

One thing that is great about traveling with Isabelle is that she would rather visit paintings than shop for clothes. She loves art the way I do.

Izzy's more interested in the nineteenth century than the twentieth century. There are three Impressionist paintings that she's particularly liked over the last few years, and since I liked them too and thought they fit the collection, I pursued them. The first was Boudin's *Beach Scene*, which was from the collection of William Paley. She also loved *The Seine at Lavacourt*. And she really enjoyed the Pissarro view of the Louvre in winter. She says it reminds her of our trips to Paris. It's a very quiet painting, but it has a beautiful feeling of light; it's elegant.

But even with the twentieth-century paintings Isabelle has had an influence on me. We were once at Sotheby's and there was a Braque from 1908 (*The House*, p. 76). The next day, a very good small Chagall also went up for sale, an early painting in his Orphic Cubist style—called *Orpheus*, as a matter of fact. I was interested in the Chagall, but Isabelle felt the Braque was a better painting. And from a historical standpoint she was right, so I went for the Braque.

If you decided to change your collecting strategy altogether, which artists would you be interested in? Have you ever thought of buying an Old Master painting, for example?

I have. It wouldn't fit in the collection as it now stands, but if I were to start over, and given that the Impressionist and Modern market is so expensive, I would collect Italian Renaissance paintings—they're some of my favorite paintings at the MFA. And even though some Italian paintings depict scenes from the New Testament and I happen to be Jewish, I look at them as art, not as religious documents. To fully appreciate the work, it helps to understand the mean-

ing of the Flight into Egypt or the Deposition from the Cross. But from a strictly painterly standpoint, these paintings are fabulous.

Now, obviously, I can't afford to buy a Titian or a Mantegna, but there are many artists at the top of the second tier. Tintorettos are affordable, as are some of the Bassanos. I particularly like the High Renaissance in Venice and in Florence, the late 1400s into the 1500s. I receive the Old Master sales catalogues, and I enjoy studying them. Curiously enough, although my first passion would be Italian art, over the last few years I've become interested in French painting of the seventeenth century, like Philippe de Champaigne or Louis Le Nain or Charles Le Brun. I think many of those paintings are undervalued in the marketplace, because people don't gravitate to that area. On the other hand, I'm not a big fan of Fragonard and Boucher. I recognize their virtues as painters; they just don't agree with me visually.

Outside of the world of art, tell me about some of your other passions. I know you work as an investor and an advisor to people who are investing. Tell me a little bit about some of the non-art aspects of your life.

I'm a workaholic. People talk about type-A behavior; I have a type-A+ behavior. But it's never been just about making money. It's about excellence. Just as I like the idea of my paintings hanging side by side with the ones at the MFA, my objective has always been to work diligently for our clients and have Delphi be recognized as a leading investment firm.

The thing about Delphi is that it's been an engine to make enough money to afford things. I do a lot in philanthropy, mostly in education. The first major gift I gave was to my alma mater, Johns Hopkins, a chair in economics. I also became involved with the

Kennedy School of Government at Harvard, and eventually I donated a chair. It's not every kid who grew up in Newton who has the dean of the Kennedy School sitting in his chair!

That brings me to another topic that matters highly to me—national politics. I was fortunate in life. I didn't start out all that well financially, but the American dream still lives. If you work hard, you can get ahead. But there are many people who are less fortunate than we are, and many of them have three strikes against them before they start. And so I've always thought, you have to set the tone at the top. I worked in the poverty program during the Johnson Administration in summer jobs with Head Start and Upward Bound. I still think there is a place for public policy to try to change the equation.

Right across the street from the MFA, at Northeastern University, is the Center for the Study of Sport in Society—I helped found it over twenty years ago. Our first plan was to do outreach with athletes into the inner city, in places like Roxbury and Mattapan. We do drug outreach. We try to help these kids get an education. Because of federal funding cuts in the last couple of years, there was no money for a summer program, so I decided to underwrite one. This year it was in East Boston. We sent four hundred inner-city kids to camp for six weeks, with mentoring and real sports. This is very important to me. I'm an old Democrat from the era of Roosevelt, Truman, Kennedy, and Johnson.

Happily, your success in business has led to your ability to buy beautiful art, travel, enjoy life, and also make things better for other people, and that's a great combination. Is there anything you yearn to do that you haven't done? Any artist you haven't been able to explore?

There are three painters of the nineteenth century that are monumental, whose works I wish I could afford. The first is Manet. I have great respect for Manet. I think he was a wonderful painter—interesting character, too. To my regret, the Harris Whittemore collection came up too early in my collecting life. I bid on a painting, but I wasn't as well-to-do at the time, and I certainly didn't know the process as well as I do now. There was a painting of a Shakespearean actor standing in a shallow space, very Velazquez-like. It was affordable, but my eye didn't gravitate toward it then. And now, great Manets go for $10 million, $15 million, or even $20 million.

He's the godfather of Impressionism, and therefore one of the figures that would link to your collection very easily.

The other two are the great Post-Impressionists, of which you're the expert, Monsieur Gauguin and Monsieur van Gogh. Now, it's possible one could buy a pre-Pont-Aven Gauguin. For example, there was one a few years ago that came up at Christie's, a portrait of the artist, done in an attic. I bid on it very aggressively, but it went for double the high estimate—it's now at the Kimbell Art Museum in Fort Worth. I'd like to have a good Gauguin. Forget about the Tahitians—they're way off the charts. But something from the mid- to late 1880s would be great.

Then in the twentieth century, there are a couple of painters I'd love to pursue. A good Fauve canvas by André Derain comes to mind. Derain was so good. He was really the best in that short-lived movement. If you had to judge from only one or two paintings who was the quintessential Fauve painter, you could argue it was Derain. There was a view of the Thames that appeared early on in my collecting days. It was from 1906, when Ambroise Vollard sent

Derain to London to paint the same locations that Monet had painted for his 1904 show at Durand-Ruel. That painting has alternated between two Paris galleries for the past twenty years. It still hasn't sold and every year the price rises.

The other painter I've missed several times is Juan Gris. The closest I came to a really monumental one was 1992, at Christie's. They were selling a painting of a mandolin formerly in the collection of Douglas Cooper, the great Cubism scholar. It was a wonderful image—a quintessential Gris of the early teens, which is the ideal. I bid again and again, but ended up the underbidder. Ironically, that same week I bought both my Signac and my Delvaux (*The Greeting*, p. 108). The Delvaux is still one of my favorite paintings. But the Gris was wonderful. I've also pursued some great collages by Gris, but a great collector of Cubism has outbid me time and time again. I can't complain too much—his collection is spectacular.

So I feel those are the two holes in my twentieth-century collection—Derain and Gris. I had not had a Miró until several years ago, and I'm glad I now do. I'm not an expert on Miró; I haven't studied him academically the way I've studied Braque or Picasso or Léger, but I like his work enormously. I like the cutout-and-gouache painting I bought (*Composition*, p. 101). And more recently I bought *The First Spark of Day III*, a monumental painting, really big in scale. It's an exciting painting. It jumps off the wall, and I am delighted that I was able to add it to the collection.

Scott, it's clearly been an adventure over the last twenty years, one that I know continues to give you great pleasure.

It *is* about pleasure—visual and intellectual pleasure. I want to emphasize something: I have never bought art as an invest-

ment. I've never sold a painting. It really irks me is when I see articles in the *Wall Street Journal* about whether collecting is a good investment. In my view, if you buy art as an investment, you're not really a collector. You have to have a passion that makes you want to possess the work of art.

I look at the works I own, and they're like my family. Isabelle and I don't have children yet. Having these works of art is like having children. I connect with all of them. I bought them because I loved them. They're like members of the family, not investments.

And the other thing that has really inspired me is the pleasure I get in sharing these "family members" of mine. I take great pride when they hang next to important paintings from the MFA or other great institutions. I often receive loan requests from major museums for their exhibitions. It tells me that I am collecting works the world wants to see.

Something happened to me just a few months ago. Isabelle and I were at Renoir's house at Cagnes-sur-Mer. It had just been reopened, and there weren't too many people, unfortunately—maybe fewer than ten. And we opened a book in the gift shop, and there was my little *Head of a Woman*—a painting my mother urged me to buy. Several days later, we were at the Jas de Bouffan, Cézanne's family home, and in a book there we immediately found the painting *Trees in the Jas de Bouffan*. It gives us a lot of satisfaction. I'm not the richest person who ever collected, so it's a real feeling of satisfaction to go to Renoir's house and Cézanne's house and encounter my paintings in these books. I like to think it means that I bought correctly.

Pierre-Auguste Renoir

French, 1841–1919

PIERRE-AUGUSTE RENOIR was born in the city of Limoges, famous for its porcelain manufactories, but moved with his father and mother (a tailor and a dressmaker) to Paris in 1844. He was briefly apprenticed to learn the trade of decorating porcelains, but by the time he was in his late teens he had dedicated himself to becoming a painter. Near the end of 1861 he entered the studio of Charles Gleyre—where his friends Claude Monet, Alfred Sisley, and Frédéric Bazille were also to study—training with Gleyre for several months before winning entry to the Ecole des Beaux-Arts.

Renoir and Monet were to become particularly close in the later 1860s. Painting side by side at pleasure spots along the banks of the Seine, downriver from Paris, they forged the beginnings of the Impressionist landscape. Like Monet, Renoir greatly admired the work of Edouard Manet, above all the older artist's fluid and bold application of paint. By 1868, Renoir was able to incorporate elements of Manet's style, as well as that of Manet's rival Gustave Courbet, in his own work.

Woman in a Blouse of Chantilly Lace reveals Renoir's mastery of these influences. The broad touches of paint that describe the lace of the sitter's costume, the handle of a small cabinet sitting on a table behind her, and the cutwork cloth that lies on that table all suggest his admiration for Manet's work. By contrast, the softer modeling of the face and hands recall Courbet's sensual rendering of flesh in portraits and nudes. The sitter's eyes are depicted with great care and contain one of Renoir's signature touches: tiny brushstrokes are laid side by side to give depth to the lids and the orb, while her deep brown irises are accented with delicate dots of white, making her expression come alive.

The woman's pose—static, facing slightly to the left of the picture, her hands clasped in her lap—and her hint of a smile invite comparison with another work of art, Leonardo da Vinci's *Mona Lisa*. But in Renoir's work, Leonardo's dreamy, idealized landscape background is replaced by a confusing and cacophonous grouping of decorative planes—the cabinet, a box at right, the floral wallpaper—rendered with almost haphazard broad strokes. This "modernization" of a Renaissance portrait format is a stratagem that Manet, too, had employed at the beginning of the 1860s.

The painting is notable for Renoir's sophisticated use of monochrome, and particularly for the way in which he plays with shades of black. Like Manet, and before him Francisco Goya, Renoir in the 1860s used ranges of black with great skill, usually in depicting the clothing of his sitters, but occasionally in rendering the deepest shadows in a landscape or still life. In this portrait, the contrast of deep black against white or pink—in the woman's dress, the cutwork textile, the cabinet, or the wallpaper—is the element that brings movement and excitement to the sitter's repose. When, many years later, Renoir's dealer Vollard referred to black as a "non-color," Renoir replied:

Black a non-color? Where on earth did you get that? Why, black is the queen of colors. Wait. Look in that *Lives of the Painters*. Find Tintoretto. Here, give me the book! (He read.) "When Tintoretto was asked what his favorite color was, he replied: 'The most beautiful of all colors is black.'"…Once I tried to use a mixture of red and blue instead of black, but then I used cobalt-blue or ultramarine, only to come back in the end to ivory-black.[1]

The sitter for this portrait has not been identified. The critic François Daulte has proposed that she might be Camille, called Rapha, the mistress of Renoir's friend Edmond Maître, who is known to have posed for the painter on two other occasions. Daulte went so far as to identify the cabinet behind the sitter as an armoire that Renoir had painted in his friend's apartment; but since that decorative project is thought to have occurred in 1870, and this painting is dated to the year before, it seems unlikely to be the same object.[2] Renoir's sitter, in any case, seems altogether more matronly than the stylish Rapha of canvases from 1870 and 1871.[3] She may be an as yet untraced friend or client of Renoir; her name, it has been suggested, might be linked to the flower displayed at her breast: a daisy, or, in French, "Marguerite."[4]

Woman in a Blouse of Chantilly Lace
1869

Oil on canvas
81.3 x 65.4 cm (32 x 25¾ in.)

Camille Pissarro

French (born in the Danish West Indies)
1830–1903

CAMILLE PISSARRO, AMONG the oldest of the artists who were to be called the Impressionists, began his career as a landscape painter and later became known as a painter of peasant subjects. Although his oeuvre was fundamentally dominated by landscape and genre painting, from the beginning of his career to the end he made occasional sorties into the realms of still life and portraiture. The Black Collection includes two pastel portraits, created around the time of the early Impressionist exhibitions.

Both portraits were presumably completed in Pontoise, where Pissarro lived from 1872 until 1882. Pissarro, who preferred to reside in country towns around Paris rather than in the capital, had lived in Pontoise in the late 1860s, and he settled there again shortly after his return from England, following the Franco-Prussian war. Located about twenty-five miles to the northwest of Paris, on the banks of the river Oise, Pontoise had attracted artists of the previous generation—Corot and Daubigny in particular—and would become one of the centers of artistic innovation during Pissarro's tenure there. Pissarro's friend Paul Cézanne spent time in Pontoise or in neighboring towns throughout that period, painting in tandem with Pissarro on numerous occasions; after Pissarro's move to nearby Osny, he was often joined by Paul Gauguin, eighteen years his junior, eager to absorb the lessons that Pissarro had to teach him.

The *Portrait of Père Papeille, Pontoise* is thought to record the image of a local worthy. Scholars of Pissarro's art have not yet discovered the sitter's biography, but the artist's great-great-grandson, Joachim Pissarro, has astutely interpreted the portrait on the basis of the internal evidence it presents. He considers the portrait of M. Papeille "a notable deviation from Pissarro's practice of almost never executing portraits of anyone but close relatives…or close friends. This portrait," he writes, "is clearly that of an official, in a typically bourgeois interior, discreetly displaying a red ribbon, symbol of the Légion d'Honneur." Since Camille Pissarro was an avowed leftist, even an anarchist, it seems natural to conclude that Père Papeille was "on the fringes of Pissarro's world." Yet, as Joachim Pissarro notes, the portrait is imbued with an unmistakable if ironic sympathy for the sitter and a subtle quality of humor: it would "need little exaggeration to turn into caricature, and one cannot be too sure whether the sitter is serious or is about to burst into laughter."[1]

In 1871, Pissarro had married Julie Vellay, with whom he had been living for more than a decade, and with whom he fathered eight children. Julie's sister Félicie was the wife of Louis Estruc and they lived together in Paris with their daughter Eugénie, called "Nini," the contemporary of Pissarro's son Lucien—who would in his turn become a painter and his father's closest confidant in matters of art.[2] In the mid-1870s, Pissarro completed pastel portraits of Félicie and Louis Estruc, including the one shown here; he would depict their daughter Nini in another pastel, and in 1884 he painted a portrait of her in oils.

Presumably executed in the artist's home in Pontoise, the portrait of Louis Estruc shows the artist's brother-in-law in a conventional bust-length, three-quarters view—the standard pose, it should be noted, for many eighteenth-century pastellists. The sitter's face and his drooping mutton-chop whiskers are portrayed conventionally enough, and his placid expression gives no hint of the irascible drunkard he was to become. (In 1888, Pissarro reported to his son Lucien that Estruc, "as he couldn't stand on his own two feet, …had to be carried back home by force; he then directed his rage against the aunt and Nini, and things got so out of hand that they had to tie his hands and feet.")[3] The rest of the pastel, however, is riotously worked: bold strokes of black describe his suit coat; a mix of blue and white suggest a shirt and tie; and nervous passages of blue, gray, and brown make up the wall of the room, against the warm tone of the paper itself. Finally, Pissarro boldly inscribes his signature across a work of his own, which Joachim Pissarro has identified as a *Bouquet of Lilacs* from 1876,[4] hanging on the wall.

Upon Nini's death in 1931, all three pastel portraits of the Estrucs were bequeathed to Monsieur and Madame Emile Leboeuf, also residents of Pontoise. Together with the oil portrait of Nini, these portraits entered the art market between 1998 and 2002, leaving the private world of Pissarro's friends, family, and neighbors and finding their way into collections and museums in Europe and America.[5]

Portrait of Père Papeille, Pontoise
about 1874
Pastel on paper mounted on board
54 x 44.5 cm (21¼ x 17½ in.)

Portrait of Monsieur Louis Estruc
about 1876
Pastel on paper laid on canvas
46.4 x 38.4 cm (18¼ x 15 in.)

Paul Cézanne

French, 1839–1906

PAUL CÉZANNE WAS BORN in Aix-en-Provence, one of the capitals of southern France. His father, Louis-Auguste Cézanne, was originally a hatter, but by the time the painter was ten years old had established himself as a banker. Louis-Auguste prospered, and in 1859 (when Paul was twenty) he acquired the Jas de Bouffan, a mid-eighteenth-century manor house, or *bastide*, surrounded by some thirty-seven acres of land, on the western outskirts of the town. Cézanne would decorate the salon of the house with allegorical paintings around 1860–61, about the time that he first traveled to Paris to begin his serious study of art and his transformation into a great painter. Returning to Aix for part of almost every year, he would begin to paint in the garden and farm later in the decade.

Cézanne's collaboration with Camille Pissarro in 1873 in Auvers and Pontoise, to the north of Paris, was a turning point in his career. The two artists often painted together in the towns or in the countryside, and under Pissarro's influence Cézanne's palette brightened, his tones lightened, and he adopted a variant of the "light, fleet, vibratory touch of Impressionism."[1] This was not Monet's flickering comma stroke, but the kind of touch with which Pissarro would animate such a classically composed view as *Sunlight on the Road, Pontoise*, which he painted around 1874 (fig. 1).

It was possibly on his return to Aix in the summer of 1874 that Cézanne painted *Trees in the Jas de Bouffan*. It shows his adherence to a compositional formula that he had established in painting the landscape of the Auvers and Pontoise countryside. As John Rewald observed,

> Cézanne seemed to show throughout [the works of the mid-1870s] a predilection for horizontals in the foreground, sometimes combined with trees across which a view of the distance emerges. The panoramic views, of which he only painted one at Auvers…but of which he would eventually paint so many in the

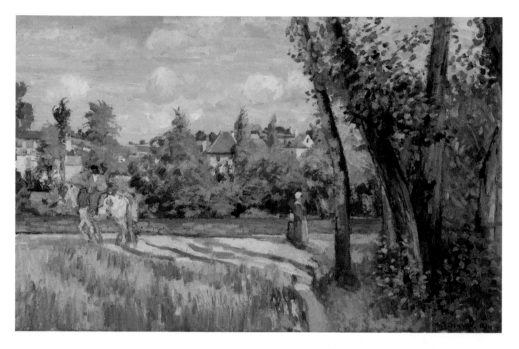

Fig. 1. Camille Pissarro, *Sunlight on the Road, Pontoise*, 1874, Museum of Fine Arts, Boston.

Fig. 2. Paul Cézanne, *Trees in the Jas de Bouffan, Springtime*, 1878–80, Private Collection.

countryside of Aix, did not yet preoccupy him. He preferred to them the tangle of vegetation, which he treated with lively and bold brushstrokes.[2]

Such brushstrokes employed here show Cézanne's evolution from the Impressionism he had espoused in 1873 to his mature painting style. The latter is marked by what has been called his "constructive stroke," in which single strokes of paint—each measuring a single brush-width—are placed side by side in a carefully calculated pattern that gives weight and form to the surface of the canvas.[3] The precise spot in the grounds of the Jas de Bouffan that Cézanne depicts is difficult to identify, but a watercolor that Rewald dates to the late 1870s seems to show the same configuration of trees in reverse (fig. 2). The pollarded tree with its deformed trunk and straight, soaring branches that appears at the right in the watercolor can be discerned at the left in *Trees in the Jas de Bouffan*, along with the rickety picket fence that divides foreground from background in both pictures.

Although conventionally dated 1875–77, *Trees in the Jas de Bouffan* might well date from the summer of 1874, when Cézanne first returned to Aix from his period of study with Pissarro. The painter spent all of 1875 in the north, but was again in Aix in the spring of 1876.[4] Whether it dates from 1874 or 1876, this canvas is surely among the first manifestations of Cézanne's mature painting method, and is one of the mileposts in our understanding of his complex stylistic evolution.

Trees in the Jas de Bouffan
about 1874

Oil on canvas
54.3 x 73.7 cm (21½ x 29 in.)

Claude Monet

French, 1840–1926

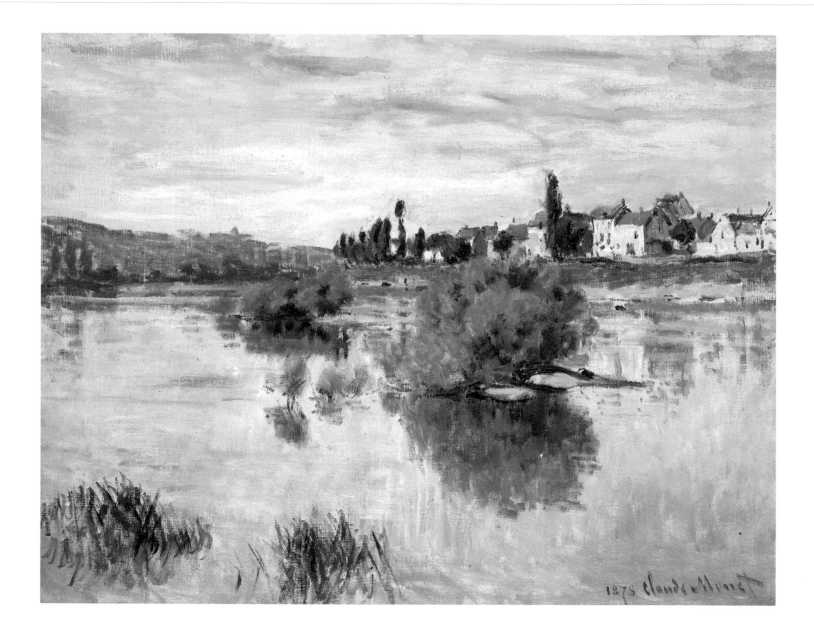

The Seine at Lavacourt
1878

Oil on canvas
56 x 73.7 cm (22 x 29 in.)

BORN IN THE CITY OF Le Havre, where the Seine opens out into the English Channel, Claude Monet never lived far from the banks of the river, which in many ways became the most cherished of his motifs. From his departure from Paris, where he had studied and painted in the 1860s, until the end of his life, Monet resided in small towns along the Seine. In late 1871 he settled in Argenteuil, a suburb some fifteen kilometers from the capital; seven years later, he moved with his own family and that of his friend and patron Ernest Hoschedé to the town of Vétheuil, further downstream from Argenteuil, across from the village of Lavacourt. About five years after that, following the death of Monet's wife Camille and Hoschedé's abandonment of his wife Alice, the household moved once more to Giverny, still closer to Monet's native Le Havre, where the painter would spend the rest of his life.

The five years of his residence in Vétheuil, from 1878 until 1883, became a turning point in his career, between the heyday of his experimentation in the early years of Impressionism and the ever-increasing maturity of his paintings in the later 1880s and 1890s. The late 1870s were also marked by divisiveness among the loosely grouped artists who had come to be known as Impressionists since their independent debut in 1874, with Monet as the head of one camp—the landscape painters, broadly speaking—and Degas leading the painters concerned with the figure and genre painting.

The Seine at Lavacourt may be among Monet's earliest views of Lavacourt from the Vétheuil bank. Looking upstream toward Paris, Monet showed the hills of the river's eastern bank at the left of the canvas, and the houses of Lavacourt as a series of geometric forms on the right-hand side.

Between the painter and the opposite bank lies an inauspicious central motif, two small islets, barely more than sandbars, capped by scruffy vegetation, perhaps willow trees, which cast their reflections in the placid surface of the river. The sky above is streaked with clouds, slashes of blue and white against the warm ground of the canvas; they, too, cast their reflections in the water below. As if to balance his signature at right, the artist adds two clumps of reeds that he paints, like the rest of the composition, quickly and surely in one thin layer of pigment. The painting seems unrehearsed, an attempt to render what the artist saw without affectation or drama, a pure record of sensation.

The painting, in fact, is an *impression*, a quickly executed study of a subject, made in the open air and painted with the fluency of touch and mastery of brush that Monet was known for by this date. Four years after he had exhibited his *Impression: Sunrise* to the consternation of most critics, Monet was here prepared to sign, date, and presumably sell a painting of extraordinary freshness and simplicity.[1] Sales of artworks were of particular concern to Monet in 1878 and 1879, when the expense of treating his dying wife and maintaining their family and the Hoschedés was great. In 1880, Monet decided to submit two paintings to the Salon, breaking ranks with the Impressionists, who had declared their intention of rejecting the official juried exhibition.

He chose the present canvas as the "sketch" from which he would work up a large-scale Salon painting.[2] As Camille Corot had done in the 1820s with his Italian views of the Ponte Augusto at Narni, Monet set about "perfecting" the plein-air *impression* to make a painting that would suit the tastes of a broader public and the Salon jury.[3] Measuring 100 by 150 centimeters— four times the size of the *impression*—the

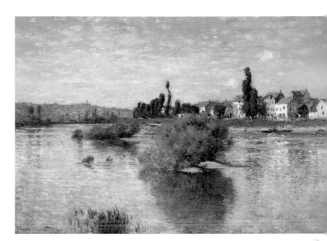

Fig. 3. Claude Monet, *The Seine at Lavacourt*, 1880, Dallas Museum of Art.

Salon painting (fig. 3) is notably more horizontal, and its surface is more consciously and thoroughly worked. Compositional details have been accentuated or suppressed for pictorial effect: at the center of the Salon canvas, for instance, the masses of willows have been reduced in size in relation to the bank behind them; above them, a tall poplar tree has been twisted slightly to achieve a more graceful curve; to its right, another clump of trees has been subtly enlarged to create a more picturesque mass. Similarly, Monet altered the patterns of reflection in the Salon painting, simplifying some reflections and elongating others in order to create a more placid, flowing effect. The artist himself regarded the Salon picture as "more bourgeois," and although it was accepted by the jury, it was hung on the uppermost row of paintings, where it received little notice. Monet exhibited once more with the Impressionists in 1882 but thereafter went out on his own, searching for new ways to make his art known to the public—and to collectors.[4]

Claude Monet

French, 1840–1926

SINCE THE 1860s, Monet had painted the coast of his native Normandy—from the beaches and terraces of Saint-Addresse, near Rouen, to the hotels of Trouville, where he and his wife Camille enjoyed the pleasures of the resort in 1870. Around 1880 he returned with new energy to the rugged cliffs of Dieppe, Varengeville, and Pourville, completing a series of canvases, many of which were shown at the Impressionist exhibition of 1882. At the beginning of 1883, he sought out one of the most peculiar and picturesque sites on the coast, the village of Etretat, which lies among spectacular rocky cliffs. Three great rock arches surround the town from east to west—the Porte d'Amont, the Porte d'Aval, and the largest, the Manneporte, the beach beside it accessible only by means of a tunnel, and then only at low tide.

On that beach, in 1883, Monet set up his easel to paint the present view of the Manneporte. One of some eight views of this rock formation painted in Monet's two visits to Etretat (he was there again in 1885), this has been thought to be among the earliest. It is conventionally dated to 1883, along with a smaller canvas now at the Metropolitan Museum of Art.[1] Its composition, however, in which Monet's point of view shifts to the right of the arch, not showing the left-hand vertical of the cliff itself, has more in common with signed and dated paintings from the 1885 campaign.[2] (One of these, perhaps the closest to the view shown here, is still more sketchily painted, and was given by Monet to his friend John Singer Sargent in 1887.)[3]

Monet never signed or dated the present canvas, and it remained in his studio until his death—perhaps because, in comparison with other canvases from the two campaigns, this view of the Manneporte is less dramatic. Here, the whole of the rock formation is in relatively dim light (as opposed to other versions, in which the rocks are lit from behind or sharply from above, creating distinctive contrasts of light and shadow). Because of this, the poetic effect of this canvas is more muted, relying on the beautifully observed contrast of the dim but massive gray rock, the churning green sea, and the delicately painted clouds beyond, struck by the afternoon sun with tones of pink, purple, and blue.

The Manneporte Seen from Below
1883

Oil on canvas
73 x 92 cm (29 x 36¼ in.)

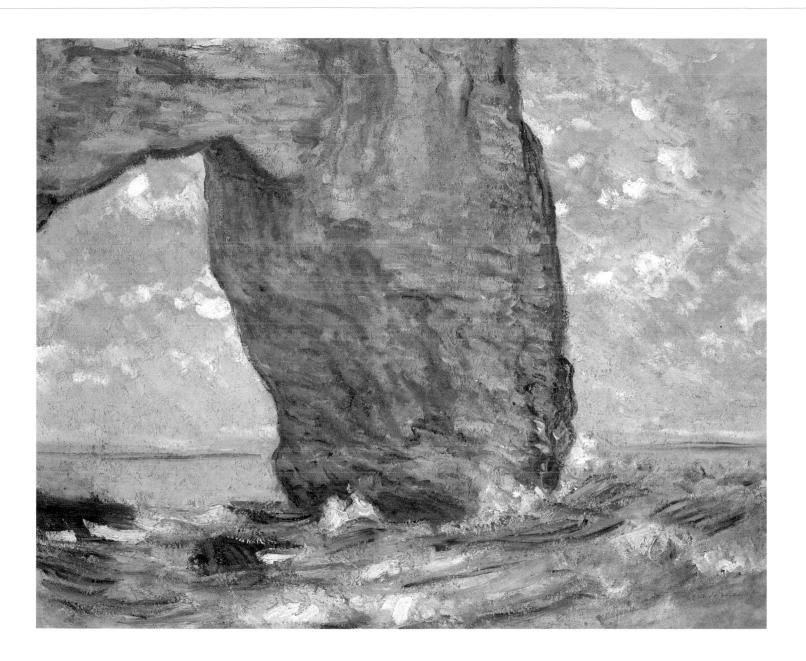

Claude Monet

French, 1840–1926

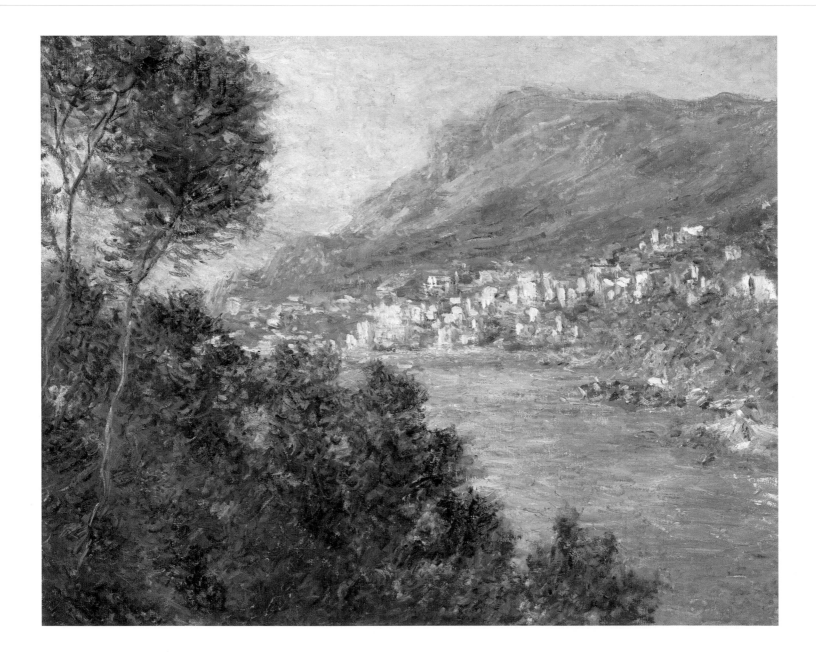

Monte Carlo Seen from Roquebrune
1884

Oil on canvas
66 x 81.3 cm (26 x 32 in.)

MONET AND RENOIR embarked on a trip to the Mediterranean coast of France and Italy in the last weeks of December 1883. Monet viewed the trip as an escape from Paris and from the pressures of his work there, but he was evidently inspired by what he saw in the south and returned to the Riviera the following month, staying until mid-April 1884. He was based chiefly in the Italian town of Bordighera, just twelve miles from Menton in France, but made a number of visits to Menton, and nearby Monte Carlo, before returning for a more extended stay on his way back to Giverny.

On April 6 he arrived at Menton, where he was to lodge for the next nine days, completing a group of vibrant canvases. He had written to his dealer, Paul Durand-Ruel, that it took "great courage on my part to stop at Menton; it is just that I feel I ought to bring back the souvenir of two or three pretty things I found there"— things that he presumably noted during his visit with Renoir or on previous expeditions from Bordighera. By the end of his first day at work on the French Riviera, Monet had four paintings under way.[1]

The present painting shows the city of Monte Carlo as seen across the Bay of Roquebrune from the town of the same name, looking out from the western edge of Cap Martin (this painting has also been called *Monte Carlo Seen from Cap Martin*). Monte Carlo is shown in bright sunlight, the rectangles of its white stone or stucco buildings beating a staccato rhythm against their own shadows, and against the green hills leading up to the mountain beyond called the "Dog's Head." The glare of the buildings, the mountain, and the sky is in contrast with the cool shadows in the foreground, where trees and grasses block the rays of the sun at left. As in his later paintings of France's Mediterranean coast, the artist's palette here consists of jewel-like tones: vibrant blues, deep greens and reds,

Fig. 4. Claude Monet, *Cap Martin, near Menton*, 1884, Museum of Fine Arts, Boston.

pale yellows and pinks are used in close juxtaposition to suggest the sparkling effect of the coast and its particular light.

The effects of light at different times of day played a role in Monet's compositional strategies in the group of canvases he painted while at Menton. Two more easel pictures focused on the Dog's Head as a central motif, the painter stepping away from the trees along the cape and down onto the road that led to Monte Carlo. Another pair of paintings, including *Cap Martin, near Menton* (fig. 4), looked back toward the Maritime Alps from the eastern side of the cape; yet a third pair concentrated on the cape's rocky coast. In each pair of paintings, Monet worked at different times of day to obtain very different effects of light and shadow, anticipating his practice at Antibes in 1888, at Rouen in the 1890s, and in London around 1900.[2]

Eugène Boudin

French, 1824–1898

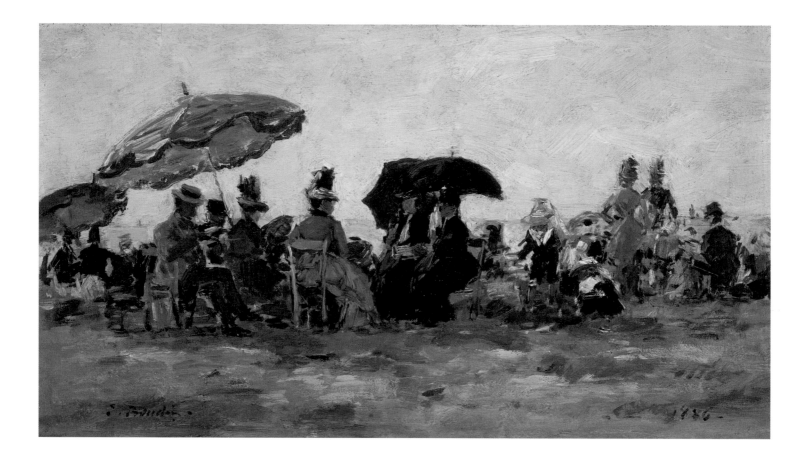

Beach Scene near Trouville
1886

Oil on panel
16 x 35.2 cm (6¼ x 14 in.)

LIKE HIS YOUNGER FRIEND Claude Monet, Eugène Boudin was born near the Normandy mouth of the Seine, in Honfleur. He met Monet in the 1850s and encouraged the budding artist to work directly from nature. Their collaboration and friendship, particularly in the early part of the following decade, was to have a profound effect on the development of Monet's art, and therefore on the development of Impressionist landscape painting.

Beginning in the 1850s, towns along the coast of Normandy—especially Deauville and Trouville, to the west of Honfleur and Le Havre—were developed as seaside resorts for Parisians. Hotels and gambling casinos were built, bathing beaches were set up, and the fashionable citizens of the capital flocked to the coast in the summer months. Boudin decided to turn his brush to this colorful crowd, and by 1863 or 1864 had produced a number of pictures of this type—several of which, executed on a large scale, he sent to the Salon.[1] But he also began to paint, for the Paris market, smaller paintings on similar themes, such as his 1865 *Fashionable Figures on the Beach* (fig. 5). He would continue to paint such themes well into the 1880s, in such examples as *Beach Scene near Trouville*. This freely rendered panel from 1886 depicts the next generation of holidaymakers—the children, perhaps, of the men and women Boudin had drawn and painted in the 1860s, in new costumes and with slightly differing customs. Notable at the center of the composition are two women dressed almost entirely in black and carrying large black parasols. The historian Juliet Wilson-Bareau has noted that they appear

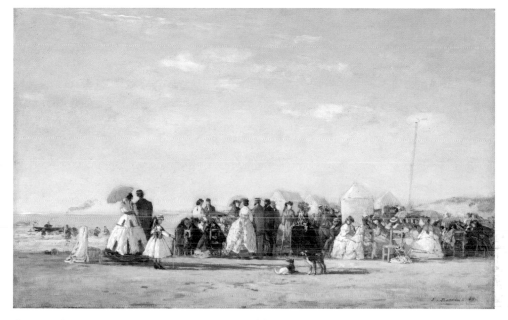

Fig. 5. Eugène Boudin, *Fashionable Figures on the Beach*, 1865, Museum of Fine Arts, Boston.

in Boudin's later beach scenes, and that they may be the governesses of the children at play around them. Here, they create a central intense black focal point, and, as Bareau notes, their inclusion "has much to do with the orchestration of composition, color and tone, and Boudin's juggling with his notebook sketches and watercolor studies when putting his pictures together."[2]

The popularity of these paintings is not surprising, given Boudin's gifts for transcribing social situations from the beach to his canvases and panels. By 1869, the critic Jules-Antoine Castagnary remarked that Boudin has not only "made a specialty of the Normandy coasts" but "has even invented a genre of seascapes that is wholly his own, and that consists of painting—along with the beach—the exotic *beau monde* that high society brings together in the summer

at our vacation spots."[3] Boudin himself, however, had already begun to complain of his subject in 1867, saying that the once delightful beach of Trouville seemed "merely a ghastly masquerade...[of a] band of gilded parasites who look so triumphant," admitting that he felt "a certain shame in painting their idle laziness."[4] And yet he continued to depict the beaches of Normandy well into the 1890s, perhaps because, as the critic Gustave Geffroy would write in 1883, there was nothing about them that was foreign to him. "Isn't this the supreme condition of such an art, when the artist displays a profound knowledge of the people and things for whom he wants to speak, the milieu he wants to surprise, and the life he wants to convey?"[5]

Pierre-Auguste Renoir

French, 1841–1919

PIERRE-AUGUSTE RENOIR, wrote the poet-critic Octave Mirbeau in December 1884, is

> the painter of women, alternatively gracious and moved, knowing and simple, and always elegant, with an exquisite visual sensibility, a touch as light as a kiss, a vision as penetrating as that of [nineteenth-century novelist] Stendhal. Not only does he give a marvelous sense of the physique, the delicate relief and dazzling tones of young complexions, he also gives a sense of the *form of the soul*, all woman's inward musicality and bewitching mystery. Contrary to the majority of modern painters, his figures are not frozen over by layers of paint; animated and vivacious, they sing out the whole range of bright tones, all the melodies of color, all the variations of light.

Fig. 6. Pierre-Auguste Renoir, *Boating Couple*, about 1881, Museum of Fine Arts, Boston.

"I do not understand," Mirbeau concluded, "why all women do not have their portraits painted by this exquisite artist, who is also an exquisite poet."[1]

In fact, throughout the 1870s, Renoir had been active as a portraitist, particularly of women, who may particularly have relished his delicate and flattering manner of painting flesh and hair. After his famous "crisis" of the mid-1880s—in which he rejected the shimmering effects of light he had so prized in the previous decade in favor of a new, altogether more sober and classical way of painting—he received fewer portrait commissions; but his abiding interest in the female face and form meant that he continued to paint and draw women to the end of his life.

The pastel *Bust of a Woman* is thought to date from around 1885—that is to say, at the juncture between Renoir's early Impressionist style and his new interest in linear compositions. Renoir used pastel often for portraits of friends and family and occasionally for casual studies of models that pleased him. For example, around 1880 or 1881 he produced a "double portrait," sometimes thought to represent himself and his companion Aline, in boating attire (fig. 6), perhaps as a prelude to his celebrated *Luncheon of the Boating Party*. In the present work, he seems to have been experimenting with different uses of the medium, employing fine strokes of the pastel laid side by side to describe the face, the complexion, and above all the hair of the sitter; bolder strokes make up the background and her costume. The effect of reflection in the model's hair is achieved by a subtle blending of hues, a mix of brown, black, and deep blue for the shadows, with white, a pale pink, and yellow defining the highlights of the woman's coiffure. These colors are all present in the

indefinite yellow-gold background, which seems at moments to merge with the woman's hair and cheek.

By 1887, when he painted the *Head of a Woman*, Renoir had rejected the flickering light effects of the early 1880s for a quieter, more controlled manner of painting. Feeling that he had "reached the end of Impressionism, and [had] reached the conclusion that [he] could neither paint nor draw," he turned to the art of the past—to Raphael and Ingres—for inspiration.[2] His dilemma, as one historian has written, was "to reconcile the direct study of nature with his desire to belong to an artistic tradition and combine the definition of form with the free play of colored brushwork."[3] Part of Renoir's new working method was to make many more preparatory studies, both drawn and painted, than ever before, studying a composition in greater detail through a variety of groupings of figures or poses, eventually working on a larger scale on paper to create cartoons for his canvases. His great labor of these years is the majestic *Bathers* of 1887, to which the *Head of a Woman* may be connected.

Very thinly painted on a white ground, this study of a young woman's head, neck, and naked shoulders might well depict one of the models who posed for *The Bathers*. The artist has concentrated on the coquettish position of the woman's head in relation to the column of her neck, on her deep blue eyes, and on the oval contour of her face, framed by her chestnut-colored hair. By contrast, her shoulders and chest are barely worked, giving the painting the freshness of a sketch, a quality that is reinforced by the freely brushed foliage in the background.

Bust of a Woman
about 1885
Pastel on paper
46 x 38 cm (18 x 15 in.)

Head of a Woman
about 1887
Oil on canvas
31 x 25.5 cm (12¼ x 10 in.)

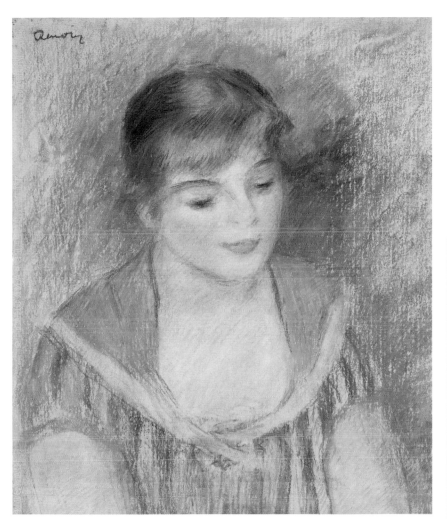

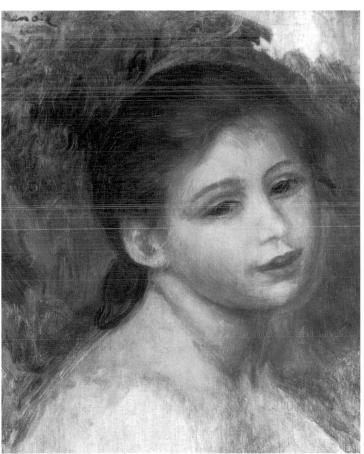

Edgar Degas

French, 1834–1917

EDGAR DEGAS WAS BORN in Paris, the son of Auguste De Gas, a well-to-do banker whose father had fled to Italy during the French Revolution, and his wife Celestine, who had come to France from New Orleans. (The artist's family generally used a pseudo-aristocratic spelling of their name—De Gas—which the artist abandoned in the 1860s.) Auguste De Gas was a cultivated man, an art collector, a lover of music and literature, and the young painter grew up in an atmosphere of learning that was to mark his future career.

In the mid-1860s, Degas met Edouard Manet, who shared his love of the Old Masters, old and modern music, and the sophisticated world of Parisian salons. One night in 1871, the mother of Manet's sister-in-law Berthe Morisot went to the Manets', where she found that "the heat was stifling, everybody was cooped up in the one drawing room, [and] the drinks were warm. But Pagans sang, Mme Edouard [Manet] played and Monsieur Degas was there."[1] The singer in question was Lorenzo Pagans, a tenor who specialized in songs from his native Spain. Pagans had apparently had a brief career at the Paris Opera, and now made his living singing in the drawing rooms of the capital, including in the home of Auguste De Gas.[2]

Degas painted Pagans with his father on three occasions. *Pagans and Degas's Father* is the last of the group, probably completed about 1895, in the painter's full maturity. It shows Pagans at right, sitting sideways on an upholstered chair and reading an open book—perhaps a bound musical score.

Auguste De Gas sits behind him. A fabric-covered table, strewn with books and papers, and a radically foreshortened piano occupy the left side of the composition. The paint is applied quickly, with sureness. Bright hues, mostly shades of red and orange, dominate the color scheme, playing against the black suits of the men. Most of the background wall, behind Auguste De Gas, is painted with the artist's fingers or thumb.

This work is a radical departure from the two paintings that preceded it. A first version, generally thought to be completed around 1871, was one of Degas's most cherished paintings: he kept it all his life, and it hung, as visitors to his apartment recalled, in his own bedroom. In this canvas, now at the Musée d'Orsay, Pagans sings out towards an audience beyond the picture plane, while behind him the retiring Auguste bends forward, his arms on his knees, listening with an abstracted expression to the voice of the tenor. It was the first portrait that Degas had ever painted of his father, who died in Naples in 1874 at the age of 67.

A second, much more freely worked version of the idea, now at the Museum of Fine Arts, Boston, is difficult to date; whether it was painted before Auguste's death or not, it was, in any event, based on the first canvas. This version (fig. 7) kept Auguste in the same position but shifted Pagans into a profile pose at left. Here, the two men—singer and listener—seem on a more equal footing.

We know that Degas continued to see Pagans as late as 1882, when he wrote to his sculptor friend Albert Bartholomé that he had a "Monday morning portrait sitting

with Pagans before he leaves for Spain."[3] It may have been at that sitting that Degas executed a somewhat tentative sketch of Pagans in the pose he occupies in the Black Collection canvas.[4] Pagans died in 1883.

Why is it that Degas, around 1895, decided to take up the theme of his lost father and vanished friend once more? Perhaps, as he passed his own sixtieth birthday, his father became an even greater presence for him; perhaps, gazing at the portrait that he kept in his bedroom, he decided to tackle the double portrait with new energy. His first attempt to revisit the pair was almost certainly a pastel based on the earlier drawing, in which Pagans looms large in mysterious light at the right of the composition, while Auguste De Gas appears only as a vague series of blurred or half-erased lines between Pagans's elbow and a piano at left (fig. 8). The present canvas is the last in this series of explorations. The figures have once again been brought into greater balance, while the elements of the table blocking the foreground and the piano pushing into the background at left are given greater prominence. The faces of both Pagans and Degas's father are more clearly articulated than in the pastel, and there is a greater range of colorful surfaces surrounding the two black-suited men. What began as an excursion into personal memory and an exploration of the artist's imagination was, in the end—as so often with Degas in the 1890s—the occasion for a celebration of the material joys of paint itself.

Fig. 8. Edgar Degas, *Sketch for "Pagans and Degas's Father,"* 1882, Philadelphia Museum of Art.

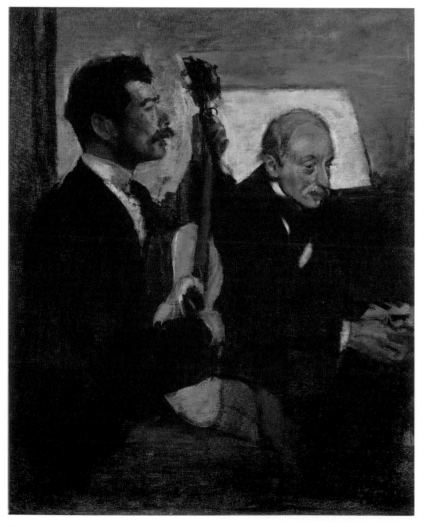

Fig. 7. Edgar Degas, *Degas's Father Listening to Lorenzo Pagans Playing the Guitar,* about 1872, Museum of Fine Arts, Boston.

Pagans and Degas's Father
about 1895

Oil on canvas
81.3 x 83.8 cm (32 x 33 in.)

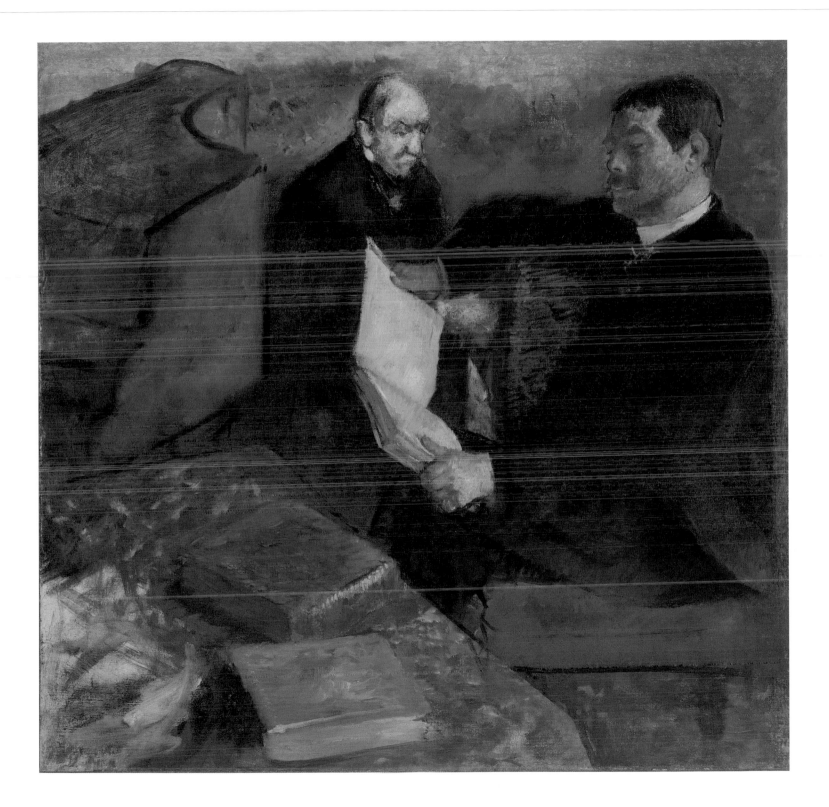

Edgar Degas

French, 1834–1917

AT THE END OF THE 1890s, Degas drew this image of a dancer seated on a bench in an extraordinary pose. With her right hand, she presses against her side or, perhaps, adjusts the waistband of her tutu. Her left foot is raised up onto the bench, her bent knee all but hidden under the froth of the tutu's fabric, and with her left hand she is rubbing her foot. Although seen in a private moment, she has paused in the midst of a public performance—her costume, imagined by the artist in tones of coral pink and rose, with scattered touches of white, is not for the classroom; and the backdrop she seems to lean against is literally that: a stage flat painted with landscape motifs, here blurred into clouds of green, blue, and lavender.

Degas first began painting dancers in the rehearsal rooms of the Paris Opera in 1871 and the motif became one of his most popular and most often repeated over the next four decades. In paintings, drawings, and pastels, he depicted dancers practicing under the supervision of a teacher; dancers stretching and exercising their muscles; and, finally, the weary dancers, worn down by their exertions, seated in poses that seem awkward or exaggerated but that almost invariably reflect the off-stage habits of the girls and young women who formed the *corps de ballet*.

As historians Jill De Vonyar and Richard Kendall have observed, "Physical exertion and its aftermath…became one of Degas's obsessive themes…The rigors of the dancers' exercises," they note, "formed a constant refrain in the Opéra literature, from [Nestor] Roqueplan's [1855] account of the 'hideous contortions…which weaken them, stifle them, drown them in sweat,'" to a report from the late 1880s, which said that "'some [dancers] groan or moan, others gasp or cough,'…and yet others 'can barely support themselves, overcome, crushed, almost dead.'"[1] The rigors of the

Fig. 9. Edgar Degas, *Dancers Resting*, 1881–85, Museum of Fine Arts, Boston.

dancers' training—which were the foundation of their apparently effortless stage performances—are reflected in many of Degas's works of the 1870s and 1880s, such as *Dancers Resting* of 1881–85 (fig. 9). This pastel shows two dancers in a pause between exercises or in a rehearsal; in addition to their white rehearsal tutus, they wear scarves or shawls to keep warm. One, at right, sits on a long bench and bends forward to massage her ankles, while the other, her feet carefully turned out to maintain flexibility, sits on a bass violin.

Degas, who had become a familiar of the Opera stage, its classrooms, and its personnel, could not have forgotten the realities of the dancers' existence, but by the 1890s he often preferred to obscure the tedium and hard work that the women

were forced to undergo. In the present pastel, he makes us first aware of color, juxtaposing the dancer's pale skin tones with the warm, vibrant pinks of her costume, then placing her form—a mixture of circles and angles—against a cool background of blues and greens. To separate the body from the ground, he added accents of black, sometimes describing a contour, in other cases setting in a shadow. With this same crayon, and with a soft cloth or a paper stump, he shaped the woman's face. In the smudges of pigment that suggest her nose, mouth, and half-closed eyes, he is able to tell us something about her state. In the midst of the enchantment of the performance, she is, once again, experiencing the exhaustion of the rehearsal.

Seated Dancer
1895–1900

Pastel on joined paper mounted on board
54 x 45 cm (21¼ x 17¾ in.)

Mary Cassatt

American (active in France), 1844–1926

Fig. 10. Mary Cassatt, *Ellen Mary in a White Coat*, about 1896, Museum of Fine Arts, Boston.

WITH HER NEAR-CONTEMPORARY Berthe Morisot, in the 1870s and 1880s Mary Cassatt introduced the domestic sphere of children, their mothers, and their nurses to the world of Impressionism, otherwise dominated by landscape and scenes of everyday life in the city or the country. Writing about the works that Cassatt had shown at the Impressionist exhibition of 1881, the novelist and critic Joris-Karl Huysmans—both a Naturalist and a decadent—extolled her images of children:

> For the first time, thanks to Mlle Cassatt, I have seen effigies of enchanting tots, calm and bourgeois scenes, painted with an utterly charming sort of delicate tenderness. Besides, it must be repeated, only woman is qualified to paint childhood. There is a feeling there that a man could not render; unless they are singularly sensitive and nervous, his fingers are too thick and ungainly not to leave clumsy and brutal marks.

He described Cassatt's paintings and pastels as "softly lustrous pearls"; "they are family life," he wrote, "painted with distinction, with love."[1]

From the 1890s onward, Cassatt was almost invariably recognized as the painter of childhood, so much so that the first biography of her, published by Achille Segard in 1913, was titled *Un peintre des enfants et des mères: Mary Cassatt.*[2] She had a strong preference for painting young children, such as her niece Ellen Mary Cassatt, painted in a fine matching coat and hat about 1896 (fig. 10). Occasionally she would agree to paint the older child of one of her siblings, or of her friend Louisine Havemeyer, but the majority of her models

seem to have been between the ages of three and six. As she wrote to Mrs. Havemeyer, "It is not worthwhile to waste one's time over little children under three who are spoiled and absolutely refuse to allow themselves to be amused and are very cross."[3]

None, perhaps, was portrayed more often than Simone, a little girl from the village of Mesnil-Théribus, near Cassatt's country house. Cassatt often dressed Simone in bonnets that seem not to be children's clothes—not, that is, the Sunday dress of a young girl such as her niece Ellen Mary. As one critic writes, these are "costumes that could not possibly accommodate childlike behavior…The impression is created of the child playacting in its mother's castoffs, acting out a role in an outsized world."[4] Here shown in a huge blue bonnet, the child sits calmly posed in an armchair against a formal architectural background.

Very freely worked, the pastel gives the impression of a sketch—an impression heightened by the fact that this particular work began as a counterproof, or printed copy, of another pastel. To that first pastel, a moistened sheet of paper was applied, and the two sheets were run through a printing press. The resulting "printed" image on the moistened paper was then reworked directly by Cassatt to strengthen contours and heighten areas that were less thoroughly transferred to the new sheet, such as, here, the strokes of white and blue on the sitter's dress and the yellow marks on the chair behind her.[5]

Simone in a Plumed Hat
about 1903

Pastel over counterproof on paper
61 x 50 cm (24 x 19¾ in.)

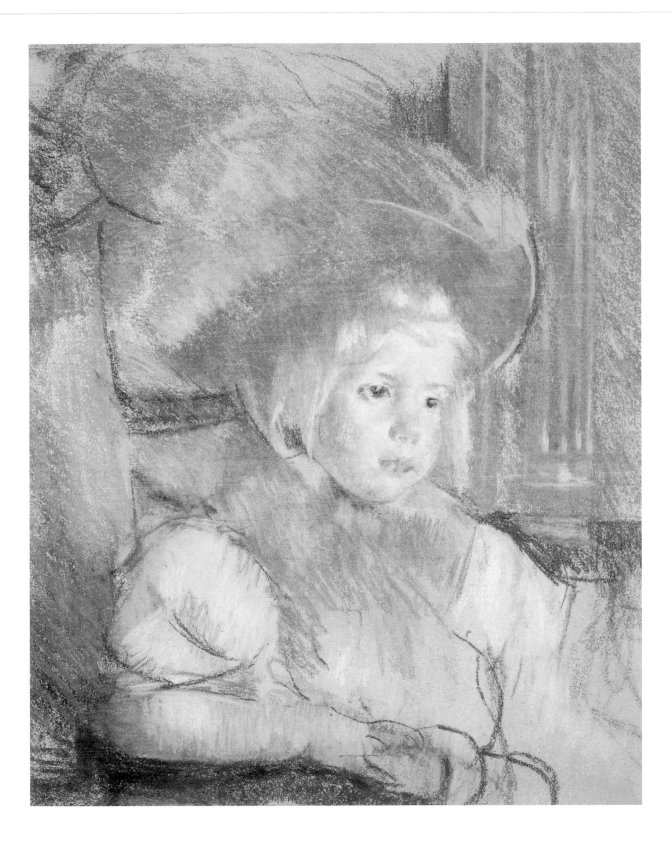

Camille Pissarro

French (born in the Danish West Indies)

1830–1903

Gardener Standing by a Haystack, Overcast Sky, Eragny
(also known as *Gray Weather, Morning with Figures, Eragny*)
1899

Oil on canvas
60 x 73 cm (23½ x 28¾ in.)

PISSARRO AND HIS family left Pontoise in 1882, after a decade living there, and for a year settled in nearby Osny. In 1884, they moved to the village of Eragny-sur-Epte, almost thirty miles to the northwest, on the Normandy border (Giverny, where Monet had settled in 1883, lies about twenty-five miles to the south and east of Eragny, where the Epte River meets the Seine). Pissarro was to live in Eragny, with occasional visits to Paris or to London, for the remainder of his life; there, as Joachim Pissarro has noted, he

> concentrated on this very confined area, on the visual material offered by the stretch of meadows lying in front of him, informed by poplars, gates, the river, and produced over two hundred paintings of these motifs. His representations of these fields and gardens constitute the most spectacularly intense pictorial effort to "cover" a particular given space in his career.[1]

The two decades of Pissarro's residence in Eragny also witnessed a series of changes in his style and in his allegiances. First there was the move from the center of the Impressionist movement toward an engagement with the Neo-Impressionism of Georges Seurat, almost thirty years his junior, whose pointillist style Pissarro adopted between about 1886 and 1890. Then, in the last decade of his life, Pissarro returned to a more classically Impressionist style, finding a newly invigorated range of brushstrokes and colors informed by his experiments with Neo-Impressionism but liberated from its stylistic constraints.

Painting the view from his window the year after his move to Eragny (fig. 11), Pissarro was concerned with balancing the landscape's colors under a sunny sky. Farm buildings are roofed with red-orange tiles only slightly darker than the plowed earth just beyond the fence that spans the foreground. These hues are countered by the

Fig. 11. Camille Pissarro, *View from the Artist's Window, Eragny*, 1885, Museum of Fine Arts, Boston.

greens, dark and light, that make up the pastures and the foliage of the trees that recede towards a distant blue-green horizon. The artist's intention is to transcribe or record, as he so often said, his "sensations" before the motif; they would be different sensations from those of Cézanne or Monet, and would be differently transcribed, but his use of short, staccato strokes of paint animate the picture's surface and convey something of the effect of shimmering light on a summer's day—at noon, since there are relatively few cast shadows.

Some fourteen years later, under overcast skies (*temps gris* in French, or "gray weather"), Pissarro turned to the fields surrounding his house to paint *Gardener Standing by a Haystack, Overcast Sky, Eragny*. Details

suggest that the painter is at work near the edges of his garden, where domestic space and agricultural space meet. Apple trees, their trunks pruned high into umbrella shapes, punctuate the borders of a field of rosy-yellow hay; small haystacks have already been formed at the lower left. Behind the young man in a bell-shaped straw hat and a blue-gray apron stretches a row of spiky flowers, perhaps foxgloves or delphiniums. A grassy lawn is shown at lower right. The muted hues and tones that are occasioned by the "gray weather" of the title seem perfectly suited to the deliberately peaceful mood of the painting. In this corner of the artist's world, life goes on without need of a narrative.

Camille Pissarro

French (born in the Danish West Indies)
1830–1903

TOWARD THE END OF HIS LIFE—that is, between 1893, when he first painted a group of street scenes around the Gare Saint-Lazare in Paris, and 1903, when he painted several views of the port of Le Havre—Pissarro embarked on a mission to complete a large number of paintings in series. In all, some three hundred works were executed, representing scenes in the Normandy cities of Rouen, Le Havre, and Dieppe, and above all in Paris. The Impressionist whose name is associated with the depiction of rural scenes turned again and again to decidedly urban subject matter in this last decade. The new series paintings were consciously ordered, in the manner of Monet's *Cathedrals* or *Mornings on the Seine*, taking up nearly identical points of view and contrasting effects of weather, season, and time of day.[1]

In Paris, Pissarro looked down from his hotel room on carriages and pedestrians in the rue Saint-Lazare, the boulevard Montmartre, the boulevard des Italiens, or the avenue de l'Opéra—all products of the remodeling of urban Paris under the Second Empire some forty years earlier. In 1898, he took an apartment on the rue de Rivoli, facing south onto the Tuileries Gardens, and depicted the park with its alleys and pools, as well as the monumental pavilions and façades of the Louvre to the east.

In the spring of 1900, after completing the Tuileries series, Pissarro moved to an apartment at the very tip of the Ile de la Cité—the westernmost of the two islands in the Seine that are the ancient heart of Paris. The apartment was located on the edge of the place Dauphine, with windows overlooking the square du Vert-Galant to the west and the Pont Neuf to the north. It was an ideal location from which to create a series of different perspectives, and he retained it until early 1903.[2]

It was there, probably in early 1901, that he painted *The Louvre, Winter Sunlight, Morning.* The view encompasses the façades and elevated roofs of the Louvre at the right. The sun, low in the sky to the south (that is, to the painter's left), shines warmly on the eastern end of the museum, the Cour Carrée. In the middle ground are the iron arches of the Pont des Arts, linking the Louvre with the Institut de France; in the foreground, the terrace of the square du Vert-Galant overlooks the northern branch of the Seine as it reunites with the southern branch, flowing downstream into the picture space. Pissarro includes a tugboat and some barges on the river, plying their way upstream, and, to give scale to the landscape, a handful of figures are suggested with just a few strokes of the painter's brush.

Suffused with the light of a winter morning, the composition is dominated by the contrasts of cool and warm hues—beige, pink, and yellow to describe the buildings and the reflected rays of the sun on the clouds above, versus cool blues and grays for the sky and the surface of the water. Through decades of painting such scenes (he had begun to paint winter themes by 1870), Pissarro had mastered the particular range of winter color and light.

Here, as in other winter scenes Pissarro painted, his elevated viewpoint gives him a sense of an omniscient observer. What he leaves out of *The Louvre, Winter Sunlight, Morning* is important. Had Pissarro shifted his point of view slightly to the left, he would have shown the statue of Henri IV, under whose reign the place Dauphine was constructed; the steps surrounding the raised bronze statue are visible at the left edge of the composition. Although he devoted a group of paintings to the statue and its surrounding square, here he chooses to let the Louvre stand for the France of kings. Equally telling—for Pissarro, the man of the people—is his omission of the crowd that would be seen in the street just out of view at the bottom of the canvas: the hustle and bustle of traffic linking the right and left banks across the Pont Neuf. The distinguishing characteristic of *The Louvre, Winter Sunlight, Morning* is its sense of calm and detachment. It is a pure celebration of the artist's sensations, as he confronts a new motif in the last years of his life and applies to it the classic methods of Impressionism.

The Louvre, Winter Sunlight, Morning
1901

Oil on canvas
74 x 92 cm (29 x 36¼ in.)

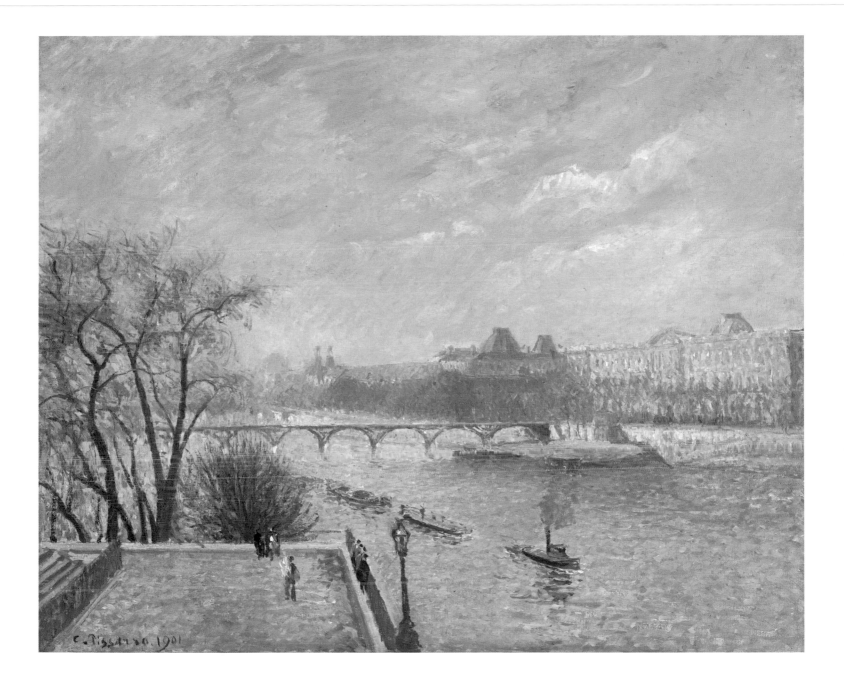

Auguste Rodin

French, 1840–1917

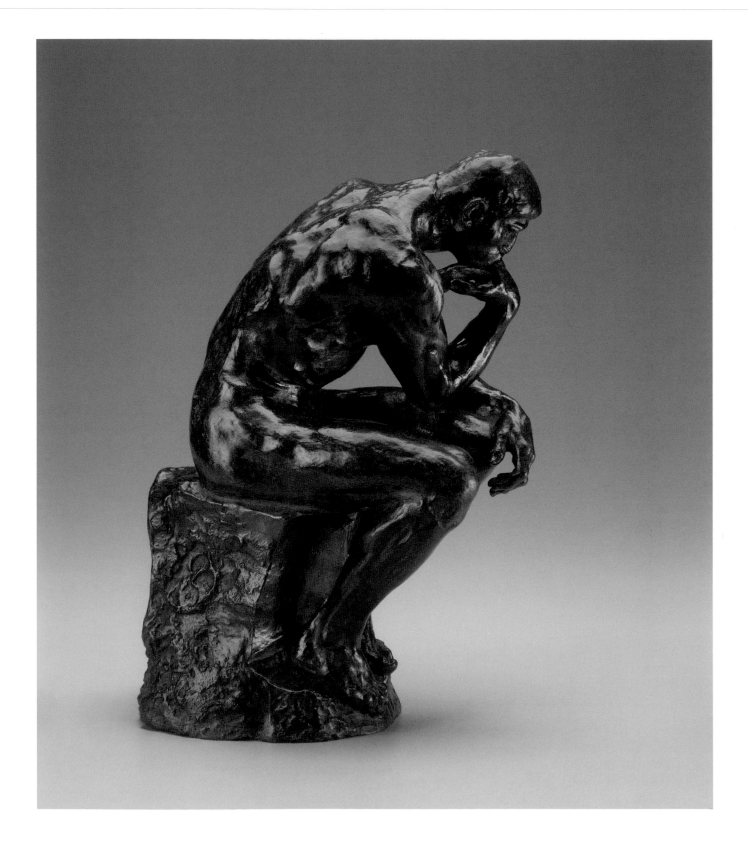

The Thinker

Modeled about 1880–81; this version cast later by Alexis Rudier

Bronze with dark brown and green patina
38 x 16.5 x 23.5 cm (15 x 6½ x 9¼ in.)

AUGUSTE RODIN, "the greatest sculptor France has ever known," in the words of his contemporary and friend Octave Mirbeau, had a difficult early career. He was born into a working-class family—his father was a clerk for the police—and despite excellent artistic training in his youth was repeatedly rejected for admission into the Ecole des Beaux-Arts. He eventually went to work for the older sculptor Ernest Carrier-Belleuse, with whom he collaborated throughout the 1860s. Only in the 1870s did Rodin begin gaining recognition, with an exhibition in Brussels and Paris of his first masterpiece, *The Age of Bronze*, an emotionally enigmatic but naturalistically modeled male nude. Critics were astonished by the figure's realism, and some even accused Rodin of casting the figure from life, not believing in his enormous powers of observation and modeling.

Three years later, Rodin was honored by the French State's purchase of a cast of *The Age of Bronze* and by a subsequent commission to execute a set of doors for a planned museum of decorative arts, to be erected on the banks of the Seine opposite the Louvre. (The site was eventually occupied by the Gare d'Orsay, the railway station now transformed into the Musée d'Orsay.) The elaboration of this portal was to occupy Rodin for the rest of his life. Most of the small-scale bronzes by him that we know today derive in some way from the figures that he planned to mount on the finished work.

Rodin's early ideas for the portal were influenced by the Florentine Renaissance sculptor Lorenzo Ghiberti's great *Gates of Paradise*, which he had seen on his trip to Italy in 1875–76. He imagined a monumental pair of bronze doors, flanked by large-scale statues and crowned by another allegorical figure. Rodin took his inspiration from Dante's epic *Inferno*; small-scale figures on the doors, on the pilasters to either side, and on the tympanum above were to allude to episodes in Dante's poem. Figures of Adam and Eve were to flank the main com-position, although these figures were eventually abandoned. At the center of the tympanum, Rodin planned to include a representation of Dante himself, seated like Christ in Judgment on the portal of a medieval cathedral. This figure, now commonly known as *The Thinker*, was in progress as early as 1880. Critics have often pointed to the implicit contradiction between its muscular, even brutish body—symbolic of the man of action, a soldier or worker—and the intense intellectual concentration suggested by its pose and expression. The portal came to be known as *The Gates of Hell* (fig. 12), in reference to the *Inferno* and in contradistinction to Ghiberti's *Gates of Paradise*.

As work progressed, the overall plastic conception of the portals grew more organic and flowing, incorporating an even larger number of figures that were to be placed against an undulating, swelling background, part landscape, part sea, part cloud. The artist's ideas for how these figures would be deployed were ever changing. By 1885, however, Rodin had reached a stage where Mirbeau could write that "all those who have been able to admire in the artist's studio the finished studies and those in course of execution agree in saying that this door will be the greatest work of the century. One must go back to Michelangelo to form an idea of an art so noble, so beautiful, so sublime."[1]

Despite such reactions, by the end of the decade it had become unclear whether the doors would ever be cast in bronze (in fact, the first bronze cast of the assembled composition occurred only after Rodin's death in 1917). At about this time, perhaps in response to the work's uncertain fate, the sculptor began to exhibit elements of the composition, what Mirbeau referred to as "finished studies," as independent works. *The Thinker*, for example, was first shown separately in 1888 as *The Poet*, its title modified the following year to *Thinker, Poet*.[2] It would become Rodin's most famous work, particularly after a large version in bronze was erected in front of the Panthéon in 1906. The composition was reproduced in smaller-scale bronzes (as in the example shown here), in casts of original scale, and in larger-than-life-sized versions.[3]

The *Eve* (p. 48) that began as one of the flanking statues for the portal was never finished. Rodin began modeling the figure about 1881 but abandoned the project when the pregnancy of the woman posing for him began to show. The sculpture from his hand, now known through casts, had a very rough, unfinished surface. Later, he allowed the original composition to be reproduced in marble several times and also to be reduced in scale; the transposition resulted in a more smoothly finished sculpture in stone or bronze, as in the example shown here.[4]

Another figure from *The Gates of Hell*, eventually integrated into the left side of the tympanum, is *Kneeling Fauness* (p. 48). Sometimes referred to by the sculptor as a "satyress," this was among the works Rodin chose in 1889 for his joint exhibition with Monet at the Galerie Georges Petit in Paris.[5] The *Fauness* is one of a number of small-scale sculptures of the female nude with which Rodin experimented at this time, which also include a figure of a bather known as *The Zoubaloff Bather* (p. 49), after the collector Jacques Zoubaloff, who once owned an original plaster of the composition.[6]

Rodin's working methods favored the multiplication of his ideas in many media. He began by modeling from the living figure in clay, but after the clay had hardened he soon had casts made from his original compositions, typically in plaster or, for greater flexibility, in fresh, malleable clay. These he could combine and recombine in seemingly endless permutations, twisting poses or adding and subtracting elements as his imagination saw fit. *The Prodigal Son* (p. 49), for example, is a variant of the lover in

Three details from Rodin's *The Gates of Hell*.

Fugit Amor (p. 50); both derive from the figure of one of the sons of Dante's Ugolino in another group devised for the *Gates of Hell*. Rodin's replication of motifs did not limit his creativity—rather, the opposite. In the end he was able to use the group *Fugit Amor* twice on the *Gates of Hell*, its repetition disguised by differences in orientation.[7]

Both of these compositions were recognized early on as works of genius with profound symbolic resonance and even religious fervor. The great German poet Rainer Maria Rilke, who as a young man acted as the sculptor's personal secretary, wrote of a marble version of *The Prodigal Son*: "This is not a son on his knees before the father. This gesture expresses the necessity of a God; within him who makes the gesture lie all those who have need of God." And the critic Arsène Alexandre wrote in 1900 of *Fugit Amor* that

the impression of Death, of an irreparable sin, is here fused with the first sensation of voluptuousness. Fixed one to the other, two beings fly swiftly in the air. The woman, disdainful, scornful, seems neither to see nor to feel the young man who, though ever weakening, clings to her. The two of them flee, in tandem, into nothingness.[8]

The multiplicity of meanings that Alexandre perceived in *Fugit Amor* is equally present in another Rodin composition, itself a fusion of two earlier ideas. In *Triumphant Youth* (p. 51), Rodin started with a reduced model of a figure of a dejected old woman that he had exhibited in 1890. This image appeared first on the lower part of the left pilaster for the *Gates of Hell* and was extracted by the artist and sculpted in the round; the figure has often been called *She Who Was the Helmet-Maker's Beautiful Wife*, in reference to a poem by the fifteenth-century balladeer François Villon. The woman appears in *Triumphant Youth* with her spine twisted to the viewer's right. A young girl, deriving from a sculpture called *Fatigue*, has been inverted and laid across her lap. As is often the case with Rodin, there are many possibilities for interpreting this sculpture's meaning: it has been called *Eternal Youth*, *Youth and Old Age*, *The Grandmother's Kiss*, and *Fate and the Convalescent*, the last in reference to a pair of scissors that the old woman has dropped, as if she were one of the Fates sparing the life of a young girl.[9]

Gifted with the ability to mold or draw the figure with the highest degree of naturalism, Rodin invariably removed all sense of the mundane from his subjects, instilling in them a sense of mystery and a multiplicity of references. When, for instance, he exhibited a plaster cast of the *Gates* at his one-man exhibition in 1900, he removed most of the figures from the doors, showing them simply as surging voids waiting to be filled with meaning in the shape of human forms.

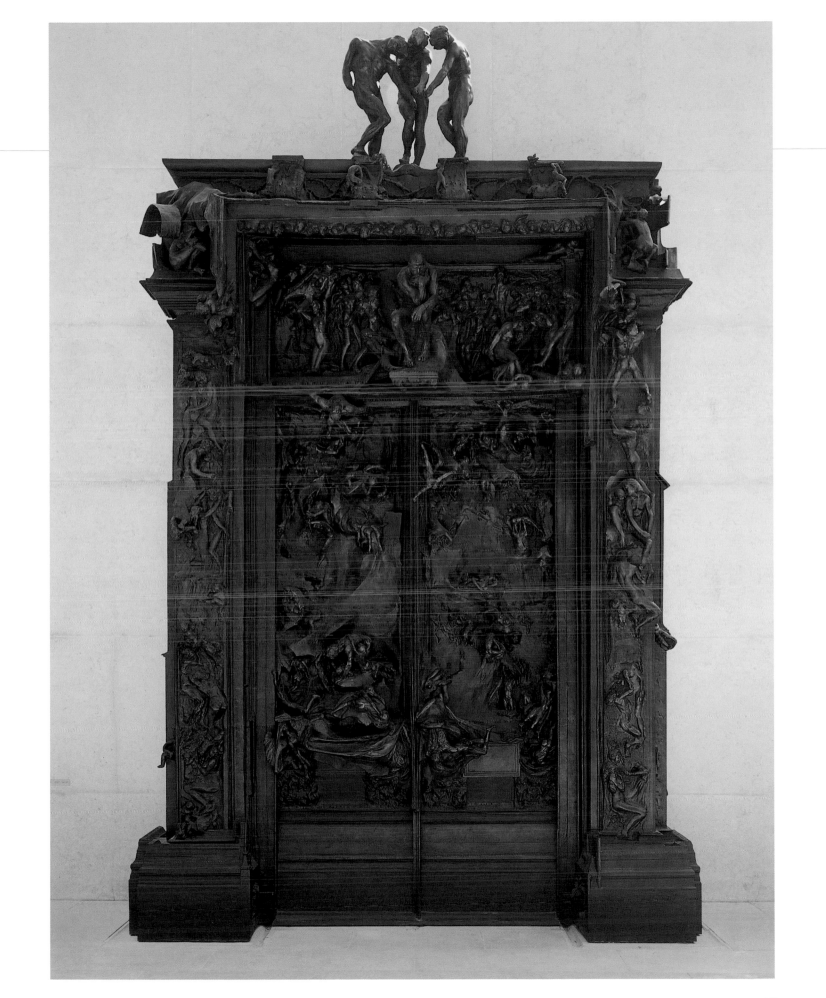

Eve
Modeled about 1881; this version cast
about 1920 by Alexis Rudier
Bronze
75 x 23 x 29.2 cm (29½ x 9 x 11½ in.)

Kneeling Fauness
Modeled about 1884; this version cast
later by Alexis Rudier
Bronze
52 x 20.3 x 28 cm (20½ x 8 x 11 in.)

Bather (known as *The Zoubaloff Bather*)
Modeled in 1888; this version cast before
1952 by Alexis Rudier
Bronze with dark brown patina
35.6 x 16.8 x 21.6 cm (14 x 6⅝ x 8½ in.)

The Prodigal Son
Modeled about 1886; this version cast
before 1952 by Alexis Rudier
Bronze with green and black patina
56 x 23 x 26 cm (22 x 9 x 10¼ in.)

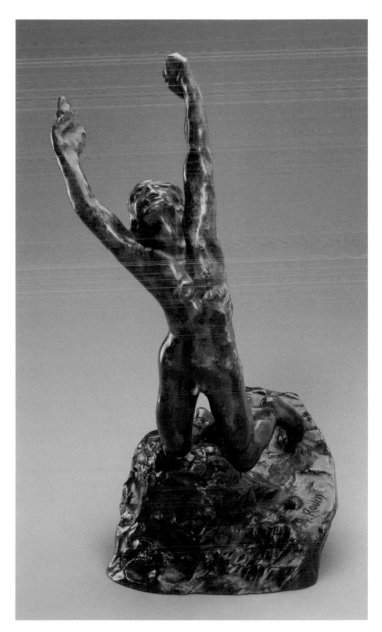

49

Fugit Amor
Modeled before 1887; this version cast
in 1964 by Georges Rudier

Bronze with dark brown and green patina
36.8 x 48.2 x 16.5 cm (14½ x 19 x 6½ in.)

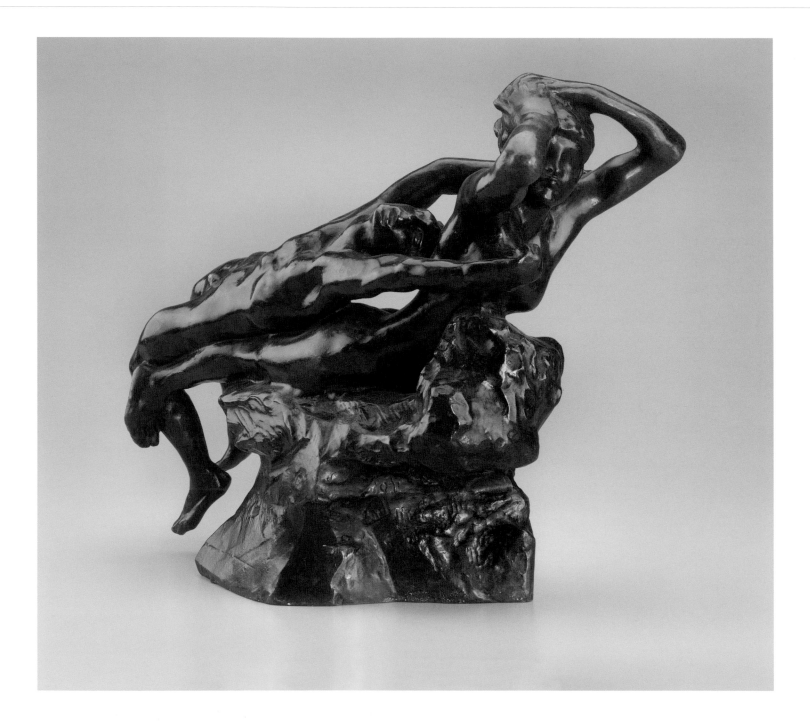

Triumphant Youth

Modeled about 1894; this version cast
after 1898 by Thiébaut et Frères

Bronze with dark brown and green patina
50.2 x 30.5 x 30.5 cm (19¾ x 12 x 12 in.)

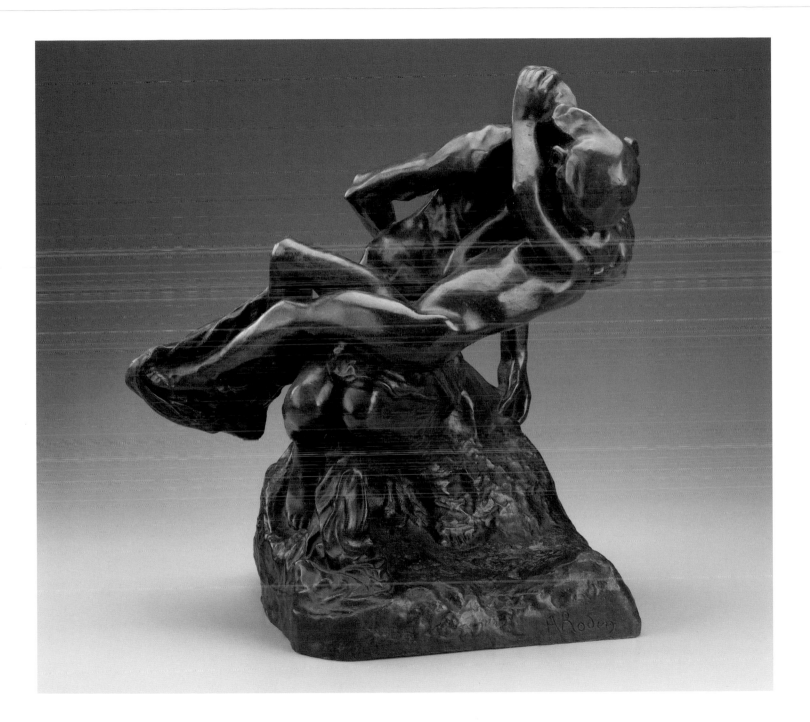

Henri de Toulouse-Lautrec

French, 1864–1901

BORN INTO AN ANCIENT aristocratic family from Albi, in southwest France, Henri de Toulouse-Lautrec was to become the great chronicler of the Parisian demi-monde in the last decades of the nine-teenth century. The future painter suffered two accidents as a child that stunted the growth of his legs and left him physically challenged throughout his adult life. He came to Paris to study art in 1882, entering the atelier of Fernand Cormon (along with Emile Bernard: see p. 54) in 1883. By 1885 he was working on his own in the Bohemi-an neighborhood of Montmartre, which he, more than any other artist, was to glorify in paintings, prints, and posters.

In the first half of the 1890s, Lautrec turned his attention to the *maisons closes* of Paris—the licensed brothels in which women worked under the guidance of a madam and under the strict regulation of the police and the health inspectors. He is known to have spent a considerable amount of time in brothels located on the rue des Moulins and the rue des Rosiers, houses that catered to a bourgeois class of cus-tomers—as distinct from the most luxurious of such institutions, located elsewhere.[1] Lautrec almost never depicted the interac-tion of the *filles soumises* with their clients but instead concentrated on the moments when they were together with each other: in waiting, static and expressionless, seated on sofas or banquettes in the brothel draw-ing rooms, or passing the time playing cards; attending to the business of their regulation, standing in line to be inspected for venereal disease; or alone, bathing or dressing.[2]

Fig. 13. Henri de Toulouse-Lautrec, *Woman in Bed, Profile*, 1896, Museum of Fine Arts, Boston.

As a consequence of his avoidance of male–female interaction in these paintings, the most passionate of Lautrec's images of prostitutes depict women together in les-bian relationships. Sometimes two women are shown sitting languidly on sofas, in close, intimate conversation. In other paint-ings, two women are shown in bed, their heads just peeking out from a jumble of bedclothes, as if the artist had just awak-ened them. Other paintings, still more explicit, show women kissing.[3] The locus of their intimacy is the shared bed, and that bed is the center of attention for the pro-tagonists in the painting shown here.

In *Two Women Making Their Bed*, one of the figures is represented in stark profile, standing upright and gingerly supporting the top sheet or coverlet of the bed to her left. Her companion leans over the bed, as if to straighten the coverlet, concentrating her attention on the business at hand. The bed itself is narrow, cheaply made of iron; it might once have been conceived as a wider model, since Lautrec seems to have changed his mind about the placement of the curving shape of its end at the extreme lower left. The room in which the bed stands is barely indicated: a dark trunk with brass latches and a circular form that might be either a mirror or the globe of a lamp give some sense of the location of a back wall, which like the floor at right is other-wise indicated only by blank cardboard. The overall flatness of the figures, contrast-ed with the sharp perspective with which the bed is rendered, may reflect the painter's admiration for Japanese prints—an admiration made obvious in his own lith-ographs, such as *Woman in Bed, Profile*, of 1896 (fig. 13).

The identity of neither model is known, though both bear some resemblance to a woman named Lucie Bellenger, known from an 1895–96 oil study by Lautrec.[4] But if their identities are vague, what a twenty-first-century audience would refer to as their "body language," seized upon by the painter-caricaturist, is clear. The figure at the right, with a stern brow and a boxer's nose, but also with the hint of a smile, stands frozen while she looks at the other woman, seemingly younger, whose attention is focused on the work of straightening the bedclothes. That they are intimates is cer-tain; whether they are lovers is not so obvi-ous. They might, in fact, be mother and daughter, like the models who may have posed for *Woman in Bed, Profile*, reported to be one Mademoiselle Pauline, called Popo—the mistress to Paul Guibert, a man in Lautrec's circle—and her mother, Madame Baron, who served her daughter as maid.[5]

Two Women Making Their Bed
1891

Oil on board
60 x 79.4 cm (23½ x 31¼ in.)

Emile Bernard

French, 1868–1941

Fig. 14. Paul Gauguin, *Landscape with Two Breton Women*, 1889, Museum of Fine Arts, Boston.

IN 1884, AT THE AGE of sixteen, the precocious Emile Bernard entered the studio of Fernand Cormon in Paris, where he was to meet and befriend the young painters Louis Anquetin and Henri de Toulouse-Lautrec. Less than two years later, he had left Cormon's atelier, and shortly thereafter met two older artists who were to become the giants of his generation: Paul Gauguin and Vincent van Gogh. Working closely with both, whether in Paris or in the Breton village of Pont-Aven, Bernard was to serve as a catalyst for artistic discovery. Vincent imagined that Bernard would join him and Gauguin in Arles, late in the decade, to establish a colony of independent artists there.

Rather than going to the south of France, Bernard remained in Brittany, mostly at Pont-Aven, where his own painting flourished. His "cloisonnist" style—so named

because the dark outlines painted around and between his figures and shapes resembled the patterns of cloisonné enamels—gradually abated in the years around 1890. In that year, in fact, Bernard was preparing an article on Cézanne for publication, and as he wrote about the older master, his own painting took on aspects of Cézanne's composition and facture, most notably Cézanne's closely spaced parallel brushstrokes.[1]

That Cézannesque brushwork is still visible in *Springtime*, painted in 1892. Through the middle ground and distance of the painting, Bernard places short rectangular strokes side by side, giving a sense of movement to the pink foliage of the trees of the Bois d'Amour (a glade beside the river Aven) and the grassy hill against which two women are placed. Gauguin, too, had admired Cézanne greatly—he owned several

examples of the artist's work—and likewise emulated this distinctive brushstroke in his 1889 *Landscape with Two Breton Women* (fig. 14). Both Bernard and Gauguin exploit in these paintings the motif of an exaggeratedly asymmetrical tree to give a curving central element to their compositions; both artists place two figures in physical proximity to each other but in psychological isolation; and, like Gauguin, Bernard uses the lower margin of the composition to cut one of his figures in two (in Bernard's case almost certainly a device derived from the Japanese prints he admired).

By 1892, Gauguin and Bernard had split definitively—Gauguin was in Tahiti for the first time—but, as was the case in the earliest years of their friendship, they often pursued similar paths and reached similar pictorial solutions. With reference to the composition of *Springtime*, however, it is worth posing the question of whether there may be other artists in Bernard's mind: is the woman at right who reaches up in to the branches an echo of the many such figures in Corot's bucolic paintings of the previous generation? Is the curving branch that frames a distant valley view a deliberate reference to Cézanne's pine trees that frame vistas of the Montagne Sainte-Victoire?[2]

The catalogue raisonné of Bernard's paintings lists this work as *Madeleine au bois d'amour* (*Madeleine in the Bois d'Amour*)—applying to it the title of Bernard's 1888 portrait of his sister stretched out on the ground beneath the trees in the *bois*—and assigns it the date of 1890.[3] It is, however, undoubtedly the painting that Bernard mentions in his inventory of canvases sold to the dealer Ambroise Vollard on May 22, 1901: there he rightly describes it as a size 30 canvas, horizontal; dates it to 1892; and gives it the title *Printemps*, or *Springtime*. His description of the composition is clear: "A woman is picking flowers, another has her head crowned with them. A very delicate landscape of flowering trees, and very freshly in leaf."[4]

Springtime
(also known as *Madeleine in the Bois d'Amour*)
1892

Oil on cardboard
74 x 100.2 cm (29 x 39½ in.)

The First Steps of Noële
1897

Oil on board
47 x 62.2 cm (18⅛ x 24½ in.)

"THE FIRST PERIOD OF my painting," wrote Maurice Denis late in his life, "is all about love, the feeling of wonder when confronted with the beauty of woman and child. Passionate intimacy. I only had meager gifts. What then? They were enough, the only thing that mattered was to express true feelings. Sérusier and Gauguin," he went on, "after the [Italian] Primitives, lent me their techniques, the simplicity of which was so in keeping with the feelings I was expressing in my joy."[1]

In this statement, Denis encapsulates the tendencies and motivation of his early works. A member of the Nabis (the group of followers of Paul Gauguin and Paul Sérusier, Symbolist champions of the previous generation), Denis was also inspired by the religious paintings of fourteenth- and fifteenth-century Italy, particularly the Tuscan masters. But above all, he stresses the personal side of his subject matter, his fascination with the beauty of woman—principally his wife, Marthe—and of children: his son, Jean-Paul, and his daughters, Noële and Bernadette.

Denis married Marthe Meurier in June 1893. Jean-Paul was born in October of the following year and was immediately the inspiration for several paintings of mother and child, manifestly inspired by images of the Virgin Mary with the infant Christ. Denis's deep religious faith was as important in the references made in these works as the religious art he so much admired. Jean-Paul lived only until February 1895. In April, the painter and his wife left for Italy to see the Renaissance masters in Tuscany and Umbria in situ for the first time.

Noële, the couple's first daughter, was born in June of the following year, inspiring another group of images of mother and child. Among these was a picture entitled *Mother and Child with an Apple* (fig. 15), in which Marthe holds the naked Noële in a tender embrace, while her sister Eva Meurier

appears at left, holding an apple toward the infant, as a donor might in a Renaissance Madonna and Child. The work was, in fact, inspired by a painting by Botticelli of the Virgin, Christ, and St. John at the Louvre.[2]

Painted in the same year, *The First Steps of Noële* is both an intimate record of family life and a reference to the art of the past and to religious subjects. "Little Nöele, now weaned, becomes less of a burden," Denis wrote in October to friends, with whom he was planning a trip to Fiesole, outside Florence. "We will certainly bring her along. She's walking, babbling, and is very naughty."[3] Little trace of that mischievousness is shown in this painting, where Noële looks out searchingly towards her father, the painter, as she walks between two women who observe her lovingly. It has been suggested that both women are meant to depict Marthe, but it is equally possible that one is Marthe's sister Eva. If this is the case, it would seem likely that Denis intended a subtle reference to the long pictorial tradition of scenes from the childhood of the Virgin Mary, placing his daughter—whose name makes reference to the nativity—in the central role.

The spatial construction of the picture is surprisingly complex. Denis presents the three figures against shifting planes of brown floor, pink wall, ocher and green doorstep, a strip of blue that might represent the floor of a corridor, a patch of blue wall beyond, and a view across a latticed balcony to a pasture where cows are grazing. Here, he rivals the perspectival ambiguities of his childhood friend Edouard Vuillard, whose intimate scenes of his own family life Denis must have admired. Like Vuillard, Denis loved to paint with very dry pigments. *The First Steps of Noële* has never been varnished; it preserves the superb matte finish that recalls the work of Vuillard but also the tender pastel tints of a fresco by Fra Angelico.

Fig. 15. Maurice Denis, *Mother and Child with an Apple*, 1897, Galerie Malingue, Paris.

Théodore van Rysselberghe

Belgian, 1862–1926

BORN IN THE BELGIAN city of Ghent, Théodore van Rysselberghe studied in the capital city of Brussels before voyaging to Morocco on a fellowship from his native city. So taken was he with the brilliant light of the southern Mediterranean that he traveled again to North Africa twice over the next several years just to experience it. In 1883 he helped found the vanguard Brussels group Les XX (Les Vingt, or "The Twenty"), joining in their exhibitions over the following decade and actively soliciting participation by artists from other countries—including Georges Seurat, Paul Signac, and Henri de Toulouse-Lautrec (see pp. 66 and 52).

After seeing Seurat's *A Sunday on La Grande Jatte* (1884–87) at the last Impressionist exhibition in 1886, van Rysselberghe became a convert to the technique commonly known as pointillism, which practitioners such as Seurat and Signac preferred to call divisionism (and which some critics referred to as neo-impressionism). He determined to adopt Seurat's method, in which color was divided into its component parts and applied in tiny dots, or points, so closely juxtaposed as to recreate—at least in theory—the visual sensation of reflected light. Having promoted such works by Signac as the *Port of Saint-Cast* (fig. 16) at the exhibitions of Les XX, van Rysselberghe became, with Henri Edmond Cross (see p. 64), one of the painter's closest colleagues in the years following Seurat's death in 1891.[1] He was also one of the most fervent apologists for the pointillist style, which gradually evolved away from a "scientific" approach to the depiction of visual sensations toward a more decorative and purely formal manner.

In March 1892, van Rysselberghe accompanied Signac on a sea voyage aboard his yacht *Olympia*. Signac had departed from the port of Concarneau, more than one hundred miles from Saint-Cast on the southern coast of Brittany. Picking up van Rysselberghe at Bordeaux, Signac sailed from the Atlantic to the Mediterranean via the Canal du Midi and entered the sea at the port of Sète (then spelled Cette)—where van Rysselberghe managed to record some decorative motifs. They continued north and east toward Marseille, and there Signac entered a boat race. It is generally thought that *The Regatta* commemorates this event.[2]

Without question, the painting commemorates van Rysselberghe's rediscovery of Mediterranean light. The strong rays of the afternoon sun, coming from behind the artist as he faces to the east, strike the sails of the racing boats and turn them into brilliant patches of white, floating like birds' wings against the blue of the sea. Composed of myriad tones of blue, intermixed with white, purple, green, and warmer dots of pink and orange, the mass of the sea is the complement of the craggy rocks at left, painted in opposing tones of orange and pink, intermittently dotted with blue shadow. The painting is artfully contrived: its artificially high horizon line, the decoratively rhythmic triangles of the sails, the undulating forms of the rocks at left—all suggest that van Rysselberghe was thinking of pattern and the harmonic balance of lines and colors before considering whether his painting would be an accurate record of his visual sensations.

Signac went on from Marseille to discover Saint-Tropez, where he would settle later that year. Although van Rysselberghe left Signac at Marseille to return to the north, he too repeatedly returned to the Mediterranean coast. In 1904, he joined Cross at Saint-Clair, between Saint-Tropez to the east and Toulon to the west; he visited that town between 1911 and 1920, and spent the last six years of his life there.[3]

Fig. 16. Paul Signac, *Port of Saint-Cast*, 1890, Museum of Fine Arts, Boston.

Maximilien Luce

French, 1858–1941

LUCE WAS THE SON of working-class parents, and lived for the first fourteen years of his life in the proletarian neighborhood of Montparnasse. It was there that he witnessed the bloody suppression of the Paris Commune in 1871, following the Franco-Prussian War, and as a young man was to become an ardent anarchist, like Paul Signac, whom he befriended in the late 1880s. His beliefs and activities landed him in prison in 1894—he was eventually acquitted of the charges against him—but his support for the political left never wavered. In the 1890s, he executed a series of paintings exploring the life and environment of miners and factory workers in the north of France and in Belgium, a series of moody, gritty images of industry and labor. And in 1905, thirty-four years after the conflict, he completed *A Paris Street in May 1871* as a memorial to the twenty thousand citizens of Paris who lost their lives in the bloody conflict of the Commune.[1]

Originally a wood engraver, Luce changed careers and became a painter, entering the Académie Suisse in Paris for his first lessons in 1876. After seeing *Bathing Place, Asnières* in 1884, he adopted Seurat's divisionist technique of painting with tiny strokes or dots of pigment. By 1887, Luce was exhibiting paintings marked by this application of paint at the Société des Artistes Indépendants, which had been founded a few years earlier. At this time, he became friendly not only with Signac (one of the society's founders) but also with another artist from the political left, Camille Pissarro, with whom he was to remain in contact for the rest of Pissarro's life.

Despite his strong political beliefs, Luce's oeuvre is not primarily concerned with social issues. Rather, his paintings most often depict landscapes, based on places that he had visited previously. The result of careful preparation, these compositions were first drawn or sketched in oils on site, then later refined through various renditions in the studio. Such is the case with his views of Camaret-sur-Mer, a fishing village in Brittany, which he visited in the summer of 1893 and continued to portray over the following two years. His painting of *Camaret, The Breakwater* is dated 1895 and records a view of the natural jetty that protects the port of Camaret from the sea. Painted in Luce's orthodox divisionist manner, the composition is marked by the strong diagonal of the jetty projecting from lower right to upper left, where it meets the horizontal of a distant, elevated shoreline.

Professor Jean-Pierre van Noppen has observed that this natural phenomenon, still in place today, is what gave its name to the town, since *Kameled* in Breton means "curved breakwater." As he writes,

> the beach in the foreground is known as the Corréjou beach, and is surmounted by a cliff protruding into the sea, known as the Pointe du Grand Gouin. Luce must have set up his easel there along the Sentier Côtier, a narrow path circling all of the Crozon peninsula, once used by customs' officers trying to catch smugglers. The tower at the end [of the breakwater] is known today as the Tour Vauban, since it was built by the famous French 17th-c. architect and military engineer who built fortifications all over Europe...as part of the fortifications protecting the military port of Brest. Appearances notwithstanding, the tower is not round but square (on the ground) and trapezoidal (in its elevation). Today it hosts a maritime museum.[2]

Professor van Noppen notes that Luce barely acknowledges a seventeenth-century chapel standing beside the Vauban Tower at the end of the breakwater. It is not clear whether physical distance, the atmosphere of the seaside locale, or the artist's politics led him to accord this building such a minor role.

By the end of the decade, Luce's paintings had become less meticulously divisionist in style; as Cross and Signac gradually adopted a "mosaic" technique in the years around 1900, Luce gradually moved toward an Impressionist manner that had much in common with the late works of Pissarro (see pp. 40–43). Throughout the 1880s and 1890s, Luce's preparatory sketches had preserved this more conventional technique—only his finished exhibition paintings were given the painstaking "dotted" finish he had so admired in Seurat's work. By 1899, when he painted *Eragny, The Banks of the Epte,* he was seeking a middle course between the rigorous divisionism of his youth and the broader manner of his twentieth-century production.

Eragny, The Banks of the Epte probably records the landscape in the vicinity of Pissarro's home in that village. From the late 1880s, Luce had visited Eragny from time to time (as he had visited Signac in Saint-Tropez), painting in Pissarro's gardens and orchard, and venturing farther afield to paint roads, pastures, stacks of grain, or apple trees in Eragny or Bazincourt, on either side of the river.[3] Several critics have noted that the painting is a kind of homage to the bathing scene by Seurat that had inspired Luce's conversion to divisionism. Instead of showing boys and men bathing in bright sunlight in the industrialized Seine downriver from Paris, however, Luce treats a country scene—bucolic if not arcadian—in the dying light of day. Realist in its subject, idealizing in the pleasing treatment of sky, earth, and water, the painting, as Luce's contemporary André Fontainas observed of the artist's work as a whole, "reveals qualities of rare and precise observation; it is genuine and sincere like the artist himself."[4]

Eragny, The Banks of the Epte
1899

Oil on canvas
81.3 x 116.2 cm (32 x 45¾ in.)

Henri Edmond Cross

French, 1856–1910

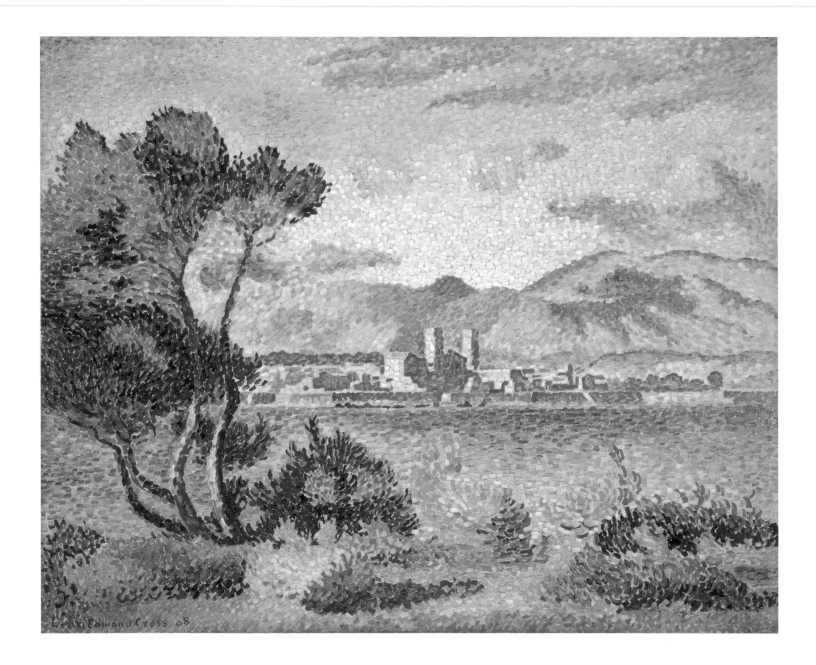

Antibes, Afternoon
1908

Oil on canvas
81 x 100 cm (32 x 39½ in.)

BENEATH A BRILLIANT blue sky, the color of aquamarines, the Baie des Anges lies calm in the afternoon light. In the background, the Maritime Alps rise up to meet the sky. In the foreground, pines seem to undulate in the breeze, their trunks deformed by the sea winds, while patches of vegetation, blue-green and yellow-orange, are scattered to the right. In the center of the composition lies the town of Antibes, with its distinctive fortifications and towers. There is little incident in this painting, little to note, apart from marking the traces of the painter as he transcribes the effect of seeing the distinctive light of his motif—treading a careful path between his elders, the Impressionists, and the young Fauves already biting at his heels.

Henri Edmond Cross (the son of an Englishwoman, he changed his name from Delacroix to Cross in order to avoid the shadow of the great Romantic painter) was born in Douai, near the city of Lille on the northern border of France. Like his friends Paul Signac and Théo van Rysselberghe (see pp. 66 and 58), he fell under the sway of Seurat's Neo-Impressionism in the 1880s. In the next decade, following Seurat's death, he was the first of his *confrères* to settle in the south of France, moving to Cabasson in 1891. In the next year, at the same time that Signac was discovering Saint-Tropez to the east, Cross moved from Cabasson to nearby Saint-Clair, a hamlet on the coast, where he would live for the rest of his life.

Over the course of the late 1890s, and above all in the years after 1900, Cross was to invent a particular method of applying paint that broke free from the classic dot of Neo-Impressionism and emerged as a short, square, staccato stroke, more or less dimensional, depending on the amount of paint on the artist's brush. Sometimes these strokes were placed closely together, giving the effect of colored tiles laid in a pictorial mosaic, each stroke following its own directional logic. Thus, in *Antibes, Afternoon*, the sky is composed of relatively small square strokes that float against each other with no particular sense of orienta-

Fig. 17. Claude Monet, *Antibes Seen from the Plateau Notre-Dame*, 1888, Museum of Fine Arts, Boston.

tion; the sea, by contrast, is composed of slightly larger and wider strokes that give a pronounced horizontal pattern to the middle ground, forming irregular lines that stretch from side to side on the canvas. Against these patterns, the mass of foliage swirls upwards, to right and left; the still larger brushstrokes here are more activated than the other areas of the composition.

In 1908, Cross visited Antibes in February, probably making watercolors and sketches, and returned to Saint-Clair to complete his series of views in April.[1] When considering these views of Antibes, it is important to remember that Monet had painted on the same site twenty years before, and had exhibited such works as *Antibes Seen from the Plateau Notre-Dame* (fig. 17) with the vanguard dealer Théo Van Gogh in 1888. Between times, Cross had expressed his ambivalence about Monet's art: "this fine painter often used to excite me," he wrote to Signac in 1895. "Lately, his work

seems colorless, or washed out."[2]

The coloristic brilliance of Monet's Antibes paintings is beyond dispute. The older artist's habit of blending paint on the brush or on the canvas, however, or of layering colors over each other, produced a complex interaction of hues quite removed from the effect that Cross sought by applying each pigment in a single stroke. By the time Cross undertook parallel subjects at Antibes, furthermore, he had experienced a new level of color intensity in the work of a new generation of artists. During the summer of 1904, Henri Matisse (see p. 68) had been staying with Signac at nearby Saint-Tropez. The three artists—Signac, Cross, and the younger Matisse—had worked in concert, Matisse absorbing and transforming the lessons of the older artists. In the fall of 1905, Matisse and a band of friends emerged as the Fauves at that year's Salon d'Automne, going beyond their elders in terms of brilliant color and expressive facture.

Paul Signac

French, 1863–1935

IN APRIL 1880, the sixteen-year-old Paul Signac attended the Impressionist exhibition, where he began to make sketches of works by Degas—and was promptly shown the door by Paul Gauguin. Two months later, he visited an exhibition of Monet (who had not shown with the Impressionists that year) and later cited this encounter with Monet's brilliant color and light effects as the turning point in his own decision to become a painter. Four years later, in 1884, he was to meet not only Monet—whose works he had more or less been aping—but also Georges Seurat, another young painter who was on the brink of inventing the method that Signac would come to champion: divisionism, or, as it is now generally known, pointillism.

Both Signac and Seurat were intensely interested in the physical properties of color and light, and in discovering ways in which light could be captured in the contrary medium of paint on canvas; in 1886, at the last of the Impressionist exhibitions, Seurat exhibited his landmark canvas *A Sunday on La Grande Jatte* and Signac a painting of milliners, which he had reworked with a pattern of dots in emulation of his friend's magnum opus. Through the 1880s, and after his move to Saint-Tropez in 1892, Signac remained faithful to the facture of Seurat's divisionism.[1]

Gradually, however—like van Rysselberghe and Cross—Signac adopted larger strokes, which, side by side, came to resemble the effect of mosaic tiles. As Françoise Cachin has written,

> Signac rejected the notion of Pointillism, developing a horror of the "dot" which he now found mechanical and inimical to brightness in a painting. He simplified the design and structure of his pictures, relying increasingly on the play of color across the canvas as both the architecture and the drama of his compositions…The purity of color in each stroke, the angle and patterning of the touches, the play of warm against cool colors, these became his painterly preoccupations.[2]

These preoccupations lie at the heart of *Antibes, The Pink Cloud*, one of the masterpieces of Signac's late career. The painting took Signac almost two years to complete. After the outbreak of the First World War in the summer of 1914, Signac had moved from Saint-Tropez to Antibes, arriving there in early October. Sometime thereafter, he painted one of his informal watercolor studies, the page divided into two segments (fig. 18). In the upper register, he painted a view of Antibes under a threatening gray cloud, annotating the image with color notes and commenting on the weather and the sky conditions. Below, an altogether more tranquil view appears, of a sailboat in a patch of calm water, beneath a gigantic pink cloud, rising above what appears to be a land mass just at the horizon. This casual watercolor was the inspiration for the painting that he described in a letter to Félix Fénéon, who had been the great supporter of the Neo-Impressionists in the 1880s. In early December he wrote to Fénéon, saying: "In the last fortnight I've begun a big cloud on a canvas that's too little; I'm going to transfer to a size 30 canvas—that format will allow me to modulate the 'cauliflower,'" a reference to the gigantic cumulus cloud that rose up from the horizon towards the top of the canvas.[3] Nearly two months later, he wrote from Saint-Tropez to another friend, describing his work on a "portrait of a cloud—of a very large cloud," certainly the size-30 canvas shown here.[4]

Signac referred to his painting as a "portrait of a cloud," and indeed the cloud is the protagonist in the picture, imbued with human characteristics. In a letter to Fénéon on December 19, he annotated a sketch of the painting so as to reveal the cloud's "personalities," referring to the vaporous form stretching out at upper left as Loie Fuller, the American dancer who had taken Paris by storm in the 1890s, and

Fig. 18. Paul Signac, *Antibes in Stormy Weather— The Pink Cloud*, about 1915, Arkansas Arts Center Foundation.

pointing out "some Michelangelesque figures" in the darkest underside of the cloud at right (these were more clearly suggested in his sketch than in the painting).[5]

Signac's witty reference to figures from Michelangelo must not be taken too lightly; he must have wanted to suggest a resemblance between his cloud and the clouds of the saved souls rising around the Redeemer in the *Last Judgment* from the Sistine Chapel. If this is so, then the *Pink Cloud* must be an image of hope and of joy in the midst of the tragedy of war, a tragedy that Signac felt deeply and that often left him unable to paint. Both the cloud and the French vessel it shelters at center must be seen as the antithesis of the "black squadron," as Signac called the German gunboats steaming into the composition at the right.

Antibes, The Pink Cloud
1916

Oil on canvas
71.1 x 91.4 cm (28 x 36 in.)

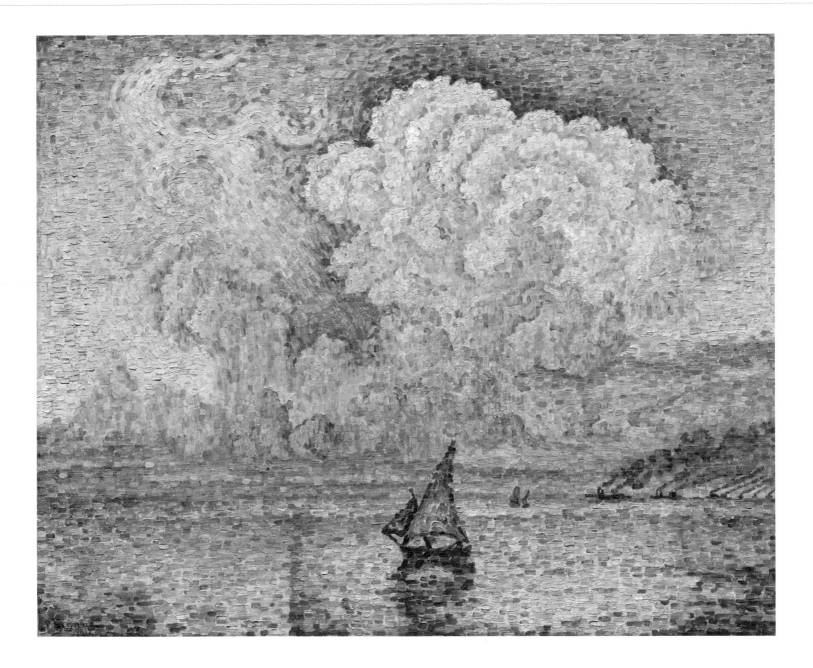

Henri Matisse

French, 1869–1954

UNLIKE MOST PAINTERS of his generation, who generally began their studies in youth, Matisse did not begin to paint until he reached the age of twenty-one, and began studying painting in earnest only in the next year. Like many students, he registered at the Académie Julian, where he was given instruction by the classicist Adolphe-William Bouguereau; later, he was invited by the eccentric painter Gustave Moreau to study with him at the Ecole des Beaux-Arts, where he was admitted formally in 1895. It was in Moreau's classes that Matisse encountered some of the painters who would become known as the Fauves after 1905.

Moreau encouraged his students to paint from nature, as well as to copy from the masters in the Louvre. Soon, however, Matisse's style began to reflect the advice of his friend Camille Pissarro (see pp. 18 and 40–43), nearly forty years his senior, whom he met in 1897. With Matisse's newfound enthusiasm for the lessons of Impressionism, his rapport with Moreau began to weaken.[1]

By 1900, when Matisse painted this view of the Pont Saint-Michel, he had absorbed the lessons Pissarro had to teach him and had moved forward. Certainly the practice of looking down onto the streets, rivers, and buildings of Paris from an apartment window echoes Pissarro's series of similar urban views, begun in the year he met Matisse and created in an apartment a few minutes' stroll from Matisse's own lodging on the quai Saint-Michel. But while Pissarro adhered to (or, more precisely, had returned to) a classical Impressionist style in such works as *The Louvre, Winter Sunlight, Morning* of 1901 (p. 43), here Matisse seems ready to announce a new direction in painting.

We can read the forms that Matisse depicts because the scene is familiar to Parisians and tourists alike. In the foreground lies the Seine, with barges and river boats either moored at the Ile de la Cité or plying this branch of the river; in the middle ground, the bridge connects the left bank with the island. A steady stream of pedestrians and vehicles flows across the bridge and down the quai at left. On the island, to right and center, government buildings—partly masked by a row of orange and red trees—enclose the spire of the Gothic Sainte-Chapelle. In the distance at left, along the path of the river, rise the rooftops of the Louvre, beneath a mint-green sky.

The Pont Saint-Michel follows the time-honored traditions of the freely painted landscape sketch, in which forms are sometimes suggested only by patches of color, and in which linear composition and perspective take a secondary role, giving greater prominence to effects of light and hue. But here, Matisse verges on violence in his excitement—for instance, in the inscribed horizontals that suggest the floors of the building in bright sunlight at right, or in the passage of the river at the left, where he has scraped through wet paint to reveal the white ground.

This work reminds us that the "wild beast" (*fauve*) in Matisse did not simply emerge in 1904–5 but was a logical evolution from his paintings of the 1890s and 1900. Here, strident contrasts of color, bold application of pigments, and challenging spatial constructions could already be characterized as Fauve. These qualities must have been appreciated by the American collectors Michael and Sarah Stein, among Matisse's most important early patrons, who were the original owners of this canvas.

The Pont Saint-Michel
1900

Oil on canvas
46.4 x 60 cm (18¼ x 22 in.)

Maurice de Vlaminck

French, 1876–1958

Fig. 19. Vincent van Gogh, *Houses at Auvers*, 1890, Museum of Fine Arts, Boston.

MAURICE DE VLAMINCK, the son of musicians—and himself a sometime performer and violin teacher, as well as a racing cyclist—spent his youth in the town of Le Vésinet, at the center of a great clockwise arc of the Seine several bends downstream from Paris. The sites along the riverbank in this area were dear to the Impressionists: to the east lies Chatou, where Renoir had painted scenes of boaters in the early 1880s; to the south is Bougival, well known at that time for its touristic entertainments, and Marly-le-Roi, where a great château and garden had once stood in the time of Louis XIV, and where Sisley and his Impressionist colleagues had painted in the 1870s. In 1892, Vlaminck moved with his parents to Chatou; ten years later, there was little left of the bustling tourist trade that had thrived a generation before.[1]

A chance meeting in 1900 with another resident of Chatou, André Derain, led to a collaboration between the two artists that launched them in the direction of a new sort of painting, emphasizing extremely bold brushwork and color. Sharing a studio on an island in the middle of the Seine, the two gradually became acquainted with a group of painters, including Henri Matisse, who were experimenting along similar lines. Derain introduced Matisse and Vlaminck in March 1901, on the occasion of an exhibition held at the Galerie Bernheim-Jeune— the first retrospective exhibition of Vincent van Gogh's work held in Paris since his death more than a decade earlier. Van Gogh's style was a revelation to Vlaminck; he was "seized by a violent desire to possess some van Gogh paintings," wrote one scholar. Though he would gladly have bought four paintings by Vincent—a seascape, two views of Auvers, and a depiction of crows above a field—for the sum of 400 francs, he could not raise the money.[2] (His finan-

cial success was not to come until several years later, after the *succès de scandale* of the Fauve exhibition in autumn 1905, and after the dealer Ambroise Vollard purchased the entire contents of his studio in spring 1906.[3])

Nonetheless, Vlaminck managed to assimilate van Gogh's manner, particularly the most violent brushwork of the lost painter's last works, such as his *Houses at Auvers* (fig. 19). Like *Houses at Auvers*, Vlaminck's *Houses and Trees* is based on compositions that Pissarro and Cézanne had executed in the 1870s, views of houses against hillsides, or seen from the tops of those hills. It probably represents Chatou, or else another nearby village along the Seine. In this work, Vlaminck takes van Gogh's visual language of quick, curving, parallel brushstrokes and distorted, brilliant color and exaggerates it, giving it a still more aggressive diction and a stronger accent. Laying in the outlines of his design (as van Gogh or Gauguin often did) in Prussian blue, Vlaminck proceeded to block in the forms of the houses in white, blue, and red. Slashes of blue and white suggest distant hills, a curve in the Seine, and the sky, while patches of green and orange-ocher indicate fields or earth in the middle distance. On top of this patchwork of colors, Vlaminck then proceeded to add an almost frenzied pattern of single strokes of red, describing twigs or grasses in the foreground and trees in the middle distance. But the effect of these curving, swirling, or staccato lines of paint is to energize the surface of the canvas, and to insist upon it. It reminds the viewer that *Houses and Trees* is not an Impressionist view of a river valley or even the furious product of an artist sensing that time was running short: it is, above all, a series of marks that reveal the artist's labor, the passage of his hand.

Raoul Dufy

French, 1877–1953

Fig. 20. Georges Braque, *Fishing Boats*, 1908–9, 1910, Museum of Fine Arts, Houston.

RAOUL DUFY, LIKE MONET before him, was born in the port city of Le Havre. The Normandy coast was to remain one of his preferred subjects, whether in his Fauvist beach and port scenes of 1905–6 or in his later images of fashionable entertainments at the resorts of Trouville or Deauville. Along with Othon Friesz and Georges Braque (see pp. 76 and 83), Dufy formed a triumvirate of "northern" Fauves, slightly apart from those artists who (particularly inspired by Matisse's 1904 visit to Signac in Saint-Tropez) saw the Mediterranean as the proper center of Fauvism.[1]

Still, Dufy had paid visits to the Mediterranean coast as early as 1903, visiting Marseille and nearby Martigues, known as the "Provençal Venice," a town of canals situated on the Etang de Berre, a lagoon that issues into the sea. There, presumably based on the view from a building near the canals or the port, he painted *Boats at Martigues*, one of several versions of this composition. The horizon line is pushed to the top of the canvas, and the foreground is made up of a mass of curves and straight lines that suggest fishing boats, some with masts and some with oars, clustering together in tones of blue, orange, green, and yellow. As Robert Boardingham has noted, "The bold spatial scheme of [this painting] reflects a sophisticated understanding of the work of Cézanne, particularly his later still lifes, several of which Dufy must have seen in the [large Cézanne] retrospective at the Salon d'Automne of 1907 a few weeks prior to his southern trip. In particular, the artist's ren-

dering of a group of boats against a tilted plane recalls Cézanne's depictions of fruit and pottery upon tabletops."[2] It should also be noted that Dufy's joyful use of the white ground of his canvas as a critical element in the composition, together with his freely drawn outlines surrounding isolated patches of color, may be a response to the surfaces of Cézanne's "unfinished" late canvases.

Boats at Martigues marks a critical juncture in Dufy's career, a high point of his Fauvist evolution and what might have been a turning point toward another way of working altogether. Boardingham recounts that Dufy joined Braque in L'Estaque, an old haunt of Cézanne's, in the summer of 1908. There, "abandoning the bright palette of fauvism, they painted landscapes in neutral hues of green, ocher, and black," approaching "the beginnings of a Cubist idiom" based on their reaction to Cézanne's works. Later that year and in early 1909, Braque would paint his breakthrough Cubist canvases, including *Fishing Boats* (fig. 20). It is ironic that Dufy—fundamentally a more conservative artist than Braque—should have experimented with a proto-Cubist conception of space in his *Boats at Martigues* series, a group of canvases completed more than a year before *Fishing Boats*. Perhaps it is the element of color—bold, bright, clear in Dufy's work, suggesting the summer light of the Mediterranean—that distracts the viewer from the artist's mastery of a chaotic pictorial space, a firm control that is both progressive and subversive.

Boats at Martigues
1907

Oil on canvas
65 x 81.3 cm (25½ x 31¾ in.)

Pablo Picasso

Spanish (worked in France), 1881–1973

PABLO PICASSO WAS BORN in Spain, but beginning in 1900, when he traveled to Paris to visit the Exposition Universelle, he spent increasing amounts of time in France. There, in 1901, he was given an exhibition at the gallery of the vanguard dealer Ambroise Vollard, showing sixty-four paintings that he had produced in a matter of weeks. Among the themes that preoccupied Picasso in his early Paris years was the world of the theatre and the carnival; dancers, acrobats, and harlequins were frequent subjects of his paintings at the time.

After a two-year return to Spain, Picasso again settled in Paris in 1904, moving into the former studio of a sculptor friend at 13 rue Ravignan. The ramshackle building was nicknamed the "Bateau Lavoir" because of its resemblance to a washing-boat moored on the banks of the Seine. Leaving behind the explicitly dismal imagery of his "blue period," the artist lightened his palette, introducing tones of pale blue, gray, beige, and pink—the apparent sweetness of which have given the works of 1904–5 the name "the rose period." The surfaces of these paintings were inflected with scumbled daubs of pigment that suggested reflected light, in counterpoint to the elegant contours that described his figures, which as before included a number of acrobats, jugglers, and street performers. By 1905 he was ready to exhibit a group of paintings and gouaches at a Paris gallery. His friend the poet and critic Guillaume Apollinaire commented in a review that "the harlequins live in their ragged finery while the painting gathers, heats up, or whitens its colors in order to tell of the strength and the duration of passions, while the lines outlining the costume curve, soar up, or are cut short."[1]

In the midst of these investigations of light, contour, and the world of performers, Picasso modeled the *Head of a Jester*. It is said that Picasso began the bust as a portrait of his friend the poet and art critic Max Jacob, considered the "court jester" of the Bateau

Fig. 21. Pablo Picasso, *Head of a Woman*, 1909, Museum of Fine Arts, Boston.

Lavoir, whom he had known since the time of his 1901 exhibition at Vollard's. Late one night, after a visit to the Médrano circus, the work began. As Roland Penrose described it:

> The clay at first took on the features of his friend—naturally, as it were—but when he resumed work the next day only the lower portion of the face retained a trace of the initial resemblance. He added a fool's cap, whereupon the head changed its personality.[2]

Though much of the resemblance to Max Jacob was lost in the evolution of the head, it remains a symbolic portrait of the creative performers in Picasso's circle—Jacob and Apollinaire, as well as the artist himself. In fact, Picasso was to explore the relationship between actors, musicians, and street performers in a range of images during 1904 and 1905, many of which seem to be vaguely disguised self-portraits.

The *Jester* was not Picasso's first sculptural work. He had modeled a *Mask of a Picador with a Broken Nose* (in homage to Rodin's *Man with a Broken Nose*) in Barcelona in

1903. Earlier in 1905 he had portrayed Alice Derain, the wife of the Fauve painter, in a small bust reminiscent of Rodin's life-size marble head-and-shoulders portraits of wealthy British and American women. *Head of a Jester*, however, is Picasso's most ambitious early sculpture, executed on a larger scale than his previous efforts, and revealing for the first time the painter's ability to translate a two-dimensional language into volume.

The bust was probably first sculpted in clay, or possibly in wax. Only later, over the course of many years, did Vollard, to whom Picasso had sold the original model, have it cast into a series of bronzes.[3] Its surface, marked by low convex daubs and shallow concavities, each reflecting light and creating shadow, gives a visual effect that is almost "Impressionist" in character, suggesting Picasso's awareness of the surface of bronzes, plasters, or waxes of Auguste Rodin and the Italian Medardo Rosso, who prized unfinished, unfocused surfaces in his own work.[4] There seems to be considerable interplay between his painted oeuvre and his relatively rare works in sculpture at this period; one historian has speculated that Vollard, who urged Renoir to take up sculpture, might have been Picasso's catalyst as well.[5]

In any event, we can notice a consistent logic to the relationships between the artist's two- and three-dimensional works. In 1906, his portraits of his lover Fernande Olivier and his old model Josep Fontdevila were created in tandem with pictorial equivalents in paintings or drawings. The invention of Cubism, with its exploration of multiple perspectives on the plane of the canvas, led Picasso to think once again in sculptural terms. When in 1909 he sculpted a portrait of Fernande (fig. 21), the interplay between his media was perfected. Here, Picasso once again mastered in three dimensions the achievements of his paintings, translating into a Cubist idiom the effects of fractured light, as he had earlier brought together the language of both paint and clay in his depiction of the jester.

Head of a Jester
Modeled 1905; this version cast later
by Valsuani

Bronze
40.6 x 36.8 x 19 cm (16 x 14½ x 7½ in.)

Georges Braque

French, 1882–1963

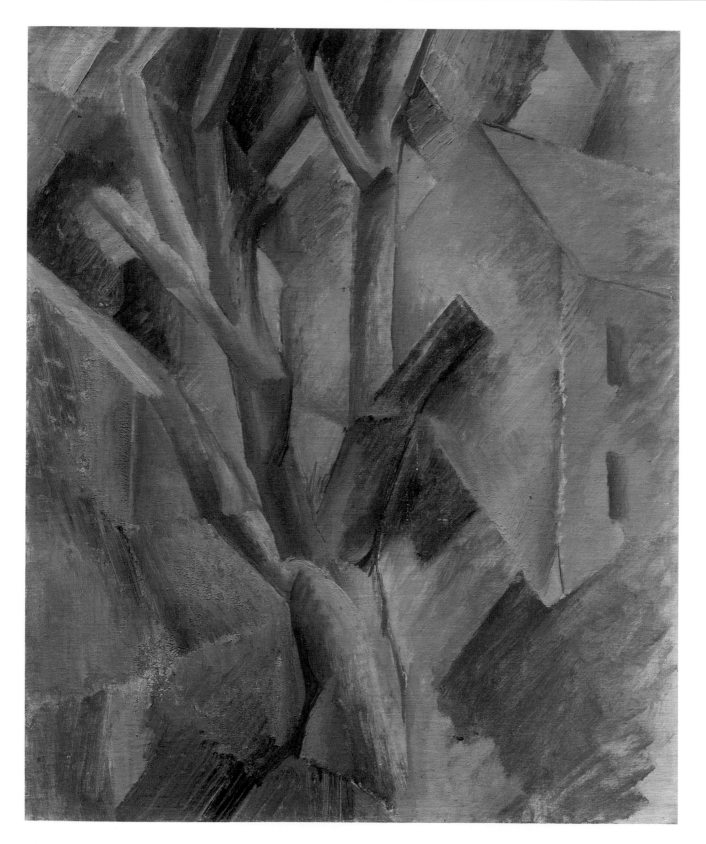

The House

(also known as *The House, La Roche-Guyon*)
1908

Oil on canvas
46 x 38.6cm (18⅛ x 15³⁄₁₆ in.)

GEORGES BRAQUE SPENT his youth in Le Havre, and at the art school there met Othon Friesz and Raoul Dufy (see p. 72). With them, he adopted the bright colors and striking brushwork that would shock the public and the critics—notably the critic Louis Vauxcelles, who in 1904 famously referred to these painters, along with Matisse and Derain, as *fauves*, or "wild beasts." It was not for his Fauvist canvases that Braque would be remembered, however. His first great contribution to the evolution of modern art was his role in the invention of Cubism.

One motivating influence in Braque's transformation of his style from the late Fauvism of 1906 to the nascent Cubism of 1907 and 1908 was his growing admiration for and understanding of the art of Cézanne (see p. 20). Works by Cézanne were available for Braque to study in Paris before the older painter's death in 1906, and the following year two major exhibitions of Cézanne's paintings took place in the capital: a show of his watercolors at the Galerie Bernheim Jeune in June, and a retrospective of more than fifty works, mostly paintings, that opened in October at the Salon d'Automne.[1] The latter exhibition, above all, impressed Braque profoundly.[2] His work in the autumn of 1907 began to include references to the late painter's compositional structures, treatment of space, and color palette, and even reflected Cézanne's choice of sites—above all L'Estaque, where he had often painted in the 1870s and 1880s.[3] Braque's admiration for Cézanne was shared by many artists in his circle, not only Matisse and Derain, but also Pablo Picasso (see pp. 74 and 98), with whom he became more closely connected at the end of 1907.

The House shows how much, by the next year, Braque had assimilated and transformed the models of Cézanne. The landscape has no visible horizon line, filling the surface of the canvas in a cascade of shifting planes. The tree at the center foreground is set against a landscape that seems to represent a hillside at left and the roof and walls of a house at right. The whole composition is rendered in tones of brown, gray, and deep green—a limited palette that both Picasso and Braque used until about 1909–10, when they virtually eliminated the green hue in favor of gray and brown alone. The tree itself is given volume through the shading of the limbs and trunk, which suggests tubular forms, but the background consists of geometric shapes that slip back and forth against each other. The interaction between them defies perspective and spatial recession, much like the "passages" that occur in Cézanne's paintings. Through the summer of 1908 and into the next year, Braque repeatedly avowed his admiration for his predecessor, an allegiance that he later called "more than an influence, it was an initiation. Cézanne was the first to have broken away from erudite, mechanized perspective."[4]

Exactly when and where this canvas was painted is still unknown. Its colors and composition have much in common with paintings of houses and trees that Braque executed in 1908, again at L'Estaque, but the work has also been associated with the town of La Roche-Guyon, nearer to Paris. It seems likely that this relatively small painting—about eighteen by fifteen inches—was the inspiration for a larger, more consciously "finished" work now in the collection of the Art Gallery of New South Wales, Sydney, which William Rubin believed was painted in Braque's studio in Paris in 1908–9 (fig. 22).[5] Emily Braun has pointed

Fig. 22. Georges Braque, *Landscape with Houses*, 1908–9, Art Gallery of New South Wales, Sydney.

out that, in his paintings of L'Estaque from 1908, Braque occasionally executed two versions of the same composition, and notes that while the Sydney version of this composition might date to the first months of 1909, the more saturated colors of the Black Collection painting seem closer to Braque's works of 1908.[6] If Braun and Rubin are correct, it would be appropriate to conclude that this painting and its larger pendant reflect a motif encountered at L'Estaque in Provence in 1908, rather than at La Roche-Guyon, where Braque first painted only in the summer of 1909.[7]

Fernand Léger

French, 1881–1955

THE WOUNDED MAN is a testament to Fernand Léger's experience in World War I. It was painted in the last months of 1917, when Léger had been hospitalized in Paris after falling sick while on leave. The painter had enlisted in the army at the outbreak of war three years earlier, and had served in the Argonne Forest and at the Battle of Verdun, working first as a sapper digging tunnels beneath enemy lines and then as a stretcher-bearer, carrying the wounded back from the trenches and manholes of the front. In the trenches, he had encountered men—workers turned soldiers—with whom he felt a particular kinship, since in spite of his education as an architectural draftsman and his career as a vanguard painter, he still thought of himself as the son of an agricultural worker.

In 1914, at the outbreak of war, Léger was deeply immersed in a pictorial experiment with what he called the "contrast of forms." His paintings of that year employ cylindrical and conical shapes, touched with red, blue, yellow, or green, and outlined in black, their roundness signified by stripes of white reflection; backgrounds often include stairs that unfold, accordion-like, at either side. This was the painter's personal, independent variation on the Cubist manner of Braque and Picasso, who since 1909 had worked so closely together that their individual styles had essentially merged into one. After entering the service, Léger had virtually no time to paint and very little in the way of artist's materials. He completed six paintings in 1915, four of them executed on scraps of wood or fragments of armaments crates, and only one painting is catalogued from 1916.[1]

During his convalescence in 1917 (he never returned to the front), Léger executed three paintings. One of these is a complicated "still life" in red, yellow, black, and white that serves as a signpost for the graphic simplification of his work of the 1920s (see p. 94). Another is The Card Game, measuring approximately four by six feet, which shows a group of soldiers, looking like metallic robots, playing cards around a table. A third is The Wounded Man, which alone in Léger's painted oeuvre directly addresses the mutilation that he encountered in his service at the front and in the Paris hospitals where he recuperated. He later recalled his period of service as "three years without touching a paintbrush," characterized by "contact with reality at its most violent, its most crude."[2]

In The Wounded Man, Léger forces the viewer to work hard to assemble the disparate elements of his composition into the image of a human being. Against a patterned background, punctuated at left by a series of stripes that suggest a staircase, are rounded white forms at the upper center of the composition—green about the "eyes" and surmounted by rectangular shapes—that can be interpreted as the wounded soldier's head. The assemblage of red and white tubes and cones at the right can be read as the figure's left shoulder, upper arm, forearm, wrist, and hand. A jumble of shapes at the lower left of the canvas, painted in tones of gray and blue, is not so easily interpreted but leaves the viewer with the impression that the man has suffered an amputation of his right arm.

Léger had undoubtedly encountered many men missing arms or legs in the course of his work as a stretcher-bearer and in his periods of hospitalization in 1917. But the experience of one man in particular seems especially important in this context. The vanguard poet Blaise Cendrars, a close friend of the artist and, like him, a common foot soldier, saw Léger often after the latter's return to Paris and during his recuperation.[3] Cendrars was author of the books La main coupée (The Severed Hand) and J'ai tué (I Have Killed), which Léger was to illustrate with five drawings in 1918. Cendrars had lost his right arm in action in Champagne in 1915.[4]

The Wounded Man
1917

Oil on canvas
61.6 x 46.7 cm (24¼ x 18½ in.)

Jacques Lipchitz

French (born in Lithuania), 1891–1973

JACQUES LIPCHITZ WAS BORN in the Lithuanian town of Druskieniki, the son of a prosperous building contractor. His mother overrode his father's objections to his son's interest in becoming an artist and arranged for him to travel to Paris at age eighteen. Studying first at the Ecole des Beaux-Arts and later at the independent Académie Julian, Lipchitz began to find his way in a vanguard milieu. By 1911, he had become part of a group of foreign-born artists who had come to Paris after the turn of the century, a group that included his friends Amedeo Modigliani, Pablo Picasso (see pp. 74 and 98), Juan Gris, and Marc Chagall (see p. 114), as well as the sculptors Constantin Brancusi (Lipchitz's neighbor on the rue du Montparnasse), Ossip Zadkine, and Alexander Archipenko.[1]

Of these friendships, the most important was with Juan Gris, with whom Lipchitz became particularly close in the last years of World War I; the two men shared a house in the country and studio space during the German bombardment of Paris in 1918. Their collaboration resulted in a kinship of aesthetics. Their working methods as painter and sculptor were linked, as Christopher Green explains it, by their "deductive" approach to the work of art. Gris, "instead of starting from figures or objects in the composition of his paintings…started from the arrangement of colored planes—abstract elements." Lipchitz claimed the same relationship: form came first, subject followed; his intention was to work visually and aesthetically with light-struck planes, gradually allowing a design to emerge from them, producing what another critic terms "pure sculpture."[2]

From a series of mounting, curving, vaguely triangular shapes, alternately convex and concave, Lipchitz arrived at the form of the *Bather*. This is one of several standing figures dating from the years 1915–20. The earliest of these figural sculptures have a pronounced architectural quality: limbs, torso, and head are barely recognizable. By 1916–17, the human body begins to emerge more clearly, recalling in three dimensions the pictorial experiments conducted by Braque and Picasso several years earlier. *Bather*, in fact—at least from its most frontal view—bears close comparison with Picasso's 1915 *Harlequin* (fig. 23) in its presentation of the body and head of the figure against a series of supporting, overlapping planes; and Lipchitz's treatment of the neck and the head, with a single round eye in the middle of the face, is unmistakably connected to the Picasso canvas.[3]

Lipchitz's working methods were in keeping with other artists of his epoch, and in fact reflected the practice of Auguste Rodin, an artist of a previous generation whom he admired greatly, though their works were visually and stylistically disparate. Opposing direct carving as the primary method of sculpting, Lipchitz argued that "modeling is the more appropriate technique for a sculptor." He thought that the laborious practice of carving impeded experimentation and momentary inspiration. "Ideas crop up with unimaginable speed, they are, so to speak, fickle; the artist must catch them and hold them as quickly as possible. The best technique for it is modeling."[4]

Once his clay model was completed, Lipchitz would engage a craftsman to create a plaster version of the sculpture. (The original plaster of *Bather* is now in the collection of the Musée National d'Art Moderne in Paris, where it is thought to date from 1917, rather than the generally held date of 1919.[5]) From the plaster, a specialist could be hired to produce a version in stone; the collector Dr. Albert Barnes

Fig. 23. Pablo Picasso, *Harlequin*, late 1915, The Museum of Modern Art, New York.

acquired a stone version of *Bather*, slightly larger than the plaster. An edition of bronzes could also be made over time based on the plaster model, of which the Black Collection *Bather* is an early example, cast in Paris in the 1920s. Other bronzes were cast after Lipchitz's immigration to the United States in 1940, and, as late as 1971, two years before his death, Lipchitz employed yet another stone carver to produce a marble version of the composition—at fifty-six inches, twice as tall as the original plaster and the bronzes cast from it.[6]

Bather
1919–20

Bronze with brown patina
71.8 x 28.3 cm (28¼ x 11 in.)

Georges Braque

French, 1882–1963

THE PREOCCUPATION WITH still life that emerged in Braque's paintings during his Fauve years, and that dominated his art between 1910 and 1914 (that is, the years of his great collaboration with Picasso), was also to characterize his production after his return from World War I. The painter had been gravely wounded in the head by a shell in May 1915 and spent two years in convalescence. By the time he returned to painting in mid-1917, he felt out of step with the evolution of Cubism that had taken place during his absence from the artistic fray.[1] By 1918–19, however, Braque had caught up with two artists who had worked through the war years—Picasso and Juan Gris, who, as Spaniards, were not called to fight—and had evolved his own version of a late Cubist style that governed his art for the next few years.

In such works as *Pipe and Compote*, Braque returned to an idea with which he had experimented before the war: simulating with paint and canvas the effects of a pasted paper collage. In 1912, both Braque and Picasso had begun to incorporate "found" elements in their oil paintings, including their painted versions of advertising typography, actual pasted papers, and passages of imitation wood graining. Braque, in the autumn of that year, was the first of the two to make drawings that incorporated pasted wood-grained wallpaper fragments, but Picasso quickly followed suit, introducing a still wider range of papers into his own cut-and-pasted compositions. Both artists' canvases of the next few months, though executed in paint on fabric, were inspired by and imitated their paper innovations, which had themselves risen from their early painted appropriations of "reality."[2]

"The limitation of means," Braque wrote in reference to his collages, "gives style, engenders the new form and incites to creation." He addressed the issue of trompe l'oeil in Cubist art, emphasizing the complex relationship between appearance and fact:

What fools the eye is due to an *anecdotal accident* which convinces us because the facts are simple. The pasted papers, imitation wood graining—and other similar elements—which I have employed in certain drawings also convince because the facts are simple, which accounts for their being mistaken for eye-fooling devices, although they are absolutely the opposite. They are incidentally simple facts, but *created by the mind*, and hence one of the vindications of a new portrayal in space.[3]

In making *Pipe and Compote*, Braque started with a commercially prepared canvas with a warm beige ground, which he covered completely in black paint mixed with grains of sand to give it an overall gritty surface texture. This black background served him in 1919 as the white sheet of paper had done in his first collages. Against it he laid down what seem to be cut-and-pasted sheets of paper but are, of course, simply shapes filled with paint. At top, at right, and at bottom, rectangles of green, gray, and white anchor the composition. At center, an irregular gray rhomboid appears to have been cut away to reveal the background—a void in the shape of the footed fruit dish, or compote, which then becomes the central element in the composition, its foreground role further defined by lines of paint that simulate white chalk. The compote rests on a tabletop of thicker ocher hue, an imitation in combed paint of the printed wallpapers that Braque had once employed. At left, scraps of green dotted with warm pink also mimic wallpaper. This pattern—whether inspired by a real paper or simply invented by the artist—must have appealed to Braque particularly, since he used more "scraps" from this imaginary stock of paper in other compositions of 1919.[4] Recalling his earlier works on paper, Braque then proceeded to draw over these "collaged" elements in thin oil paint, as he once had done in charcoal, shading the borders of the gray rectangle at left, creating an illusion of space and transparency,

and adding a small square of striated shadow at lower right.

To achieve such equilibrium of color, facture, and above all composition is no easy feat for the artist. The choice of still life—a subject arranged and invented by the painter—might arise from his desire to exert ultimate control over elements of composition, light, and space. *Pipe and Compote* is, after all, an intellectual puzzle arranged in the artist's mind, not a representation of an observed arrangement of objects on a tabletop. By the 1920s, however, Braque was to return to painting still lifes that, as his works of around 1906 had done, evoke the still-life stratagems of Cézanne, and convince us that they are painted from actual objects arranged by the painter for his study and inspiration.

Such a work is the 1927 *Still Life with Pears, Lemons, and Almonds*. As with *Pipe and Compote*, Braque uses a dark ground beneath the paint, which serves him both as deepest shadow and for the mid-tones. To achieve the range of grays that flow through the composition, for instance, the painter simply varies the opacity and hue of the lighter colors that he washes over the black, sandy ground, creating cool or warm tones as needed. The papered wall, parallel to the picture plane, that closes off the composition, the unruly white linen cloth on which Braque arranges a plate of pears, some lemons, a glass and a bottle of spirits, a black-handled knife, and some still-unripe almonds: all of these remind us of the still lifes of Cézanne's maturity. But in its coloristic restraint, and above all in its orchestration of deep blacks against bright whites, subtle grays, and muted greens, the painting seems to bear comparison with one of Cézanne's greatest still lifes of the 1860s, the *Still Life with Green Pot and Pewter Jug* (fig. 24). Although its surface effects are markedly more matte and restrained than the earlier work, Braque's 1927 *Still Life with Pears, Lemons, and Almonds* might have been painted with the same palette.

Oil and sand on canvas
35.5 x 64.8 cm (14 x 25½ in.)

Fig. 24. Paul Cézanne, *Still Life with Green Pot and Pewter Jug*, about 1869, Musée d'Orsay, Paris.

Still Life with Pears, Lemons, and Almonds
1927

Oil on canvas
50.5 x 61 cm (20 x 24 in.)

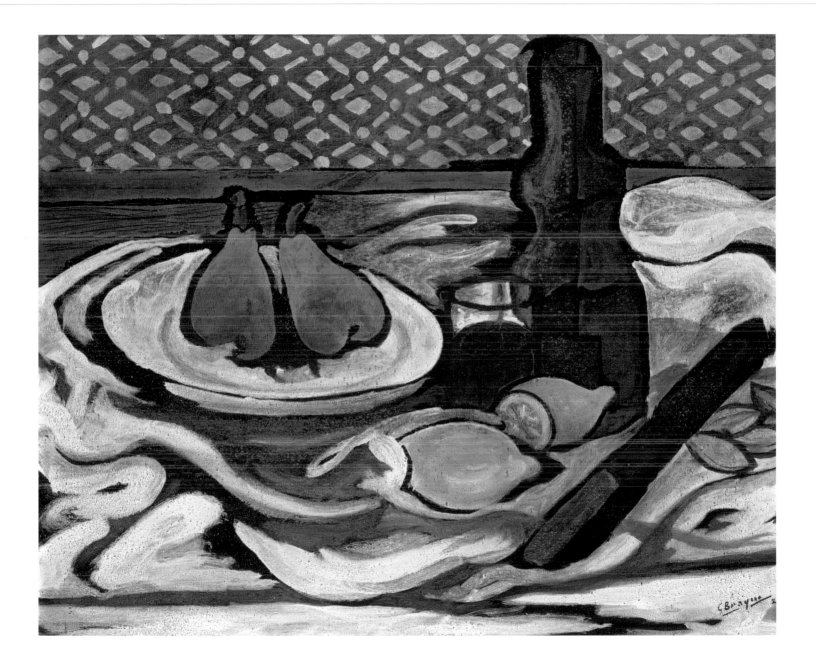

Pierre Bonnard

French, 1867–1947

THE YOUNG BLONDE woman with piercing blue eyes and an engaging smile depicted here is Renée Monchaty, whom Bonnard met around 1918. Her portrait is thinly painted in washes of oil color, permitting the white ground of the canvas to glow through the pigments and give greater luminosity to the image. It is an intimate, quickly executed portrait, a record of perhaps a single sitting, that suggests a friendly relationship between sitter and painter—and maybe, since Monchaty's eyes do not look into the artist's, the presence of another person in the room. That person might be Marthe de Méligny, Bonnard's companion since the 1890s who would become his wife in 1925.

The portrait is typical of the small, bust-length portraits that Bonnard painted throughout the 1920s, sometimes as records of friendship—this canvas is inscribed "to Renée," suggesting that the artist gave it to her—and sometimes as studio exercises. Casually finished, in distinction to his large-scale interiors, his nudes, or his landscapes, these informal portraits of friends or models must have served Bonnard much as his notebook drawings did, keeping his hand and eye busy in the intervals between working on his most ambitious canvases. They have a quality of immediacy and realism that distinguish them from the artist's more carefully controlled decorations or his haunting images of his wife bathing.

It is thought that this portrait was painted around 1920. By that date, scholars suspect, Pierre Bonnard and Renée Monchaty—who was known as "Chaty"—had become lovers.[1] It is known that they went to Rome together in 1921, and it has been suggested that they met Renée's parents there and that Bonnard sought their permission to marry Renée, who was some thirty years his junior.[2] In fact, they never did marry. Upon their return to Paris, Bonnard continued to live with Marthe, who suffered from a still-undetermined illness, perhaps tuberculosis, and who, as the years went by, had begun to exhibit pronounced anti-social behavior.[3] Monchaty continued to interact with the couple, writing to them in October 1924, for instance, to announce her return from a trip to Spain.

Later that year, Renée committed suicide. According to the artist's great-nephew, "Bonnard was deeply distressed." In spite of Marthe Bonnard's resentment of the younger woman and her husband's images of her, "he never parted with some of the works she [Monchaty] had inspired, and insisted on including them unobtrusively in his exhibition catalogues and in anything written on his painting."[4]

Portrait of Mademoiselle Renée Monchaty
about 1920

Oil on canvas
50.2 x 41.3 cm (19¾ x 16¼ in.)

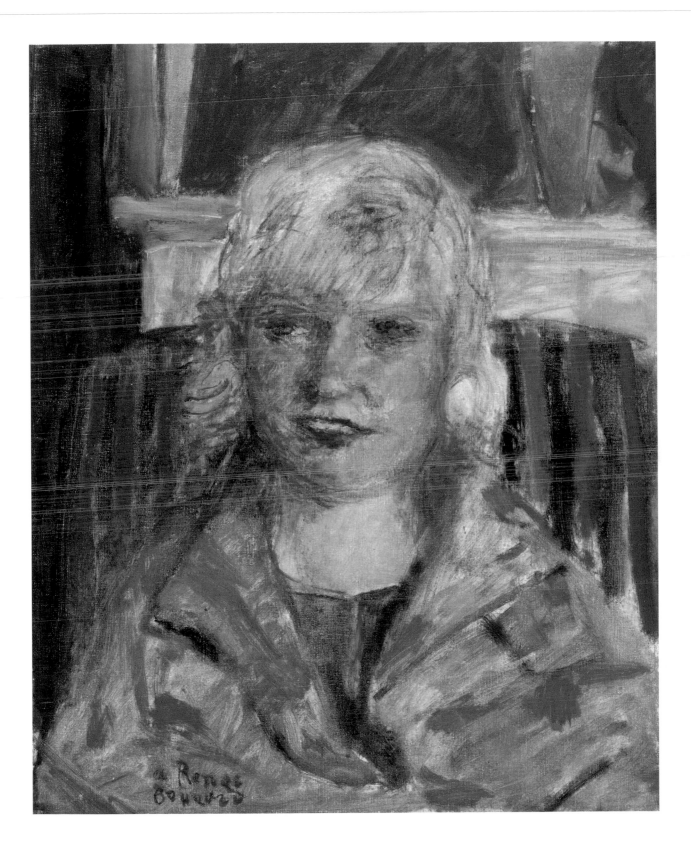

Edouard Vuillard

French, 1868–1940

EDOUARD VUILLARD was an early member of the Nabi group, along with Maurice Denis and Pierre Bonnard (see pp. 56 and 86). In the 1890s, he explored a radical art of remarkable stylistic diversity, moving from greatly simplified compositions inspired by the flatness of Japanese prints to spatially complex interiors peopled by his family or his "muses," each surface ornamented with a different pattern. After 1900, as the young Nabis reached maturity and sought divergent paths, Vuillard's art shifted toward a more traditional pictorial style, but his interest in the problems of representing space and his strong preference for a skewed approach to traditional subject matter would continue to mark his production.

The theme of the nude appears infrequently in Vuillard's art of the 1890s, but, as one critic has observed, nude models

Fig. 25. Edouard Vuillard, *Madame Vuillard Lighting the Stove*, 1924, Flint Institute of Arts, Michigan.

appear with some regularity in Vuillard's later work, perhaps as "a response to the increasing engagement with the nude that his fellow Nabi, Pierre Bonnard, had effectively announced" at the turn of the century. Vuillard's increasingly numerous images of nudes may reflect the importance of "a larger, ongoing enterprise: a visual investigation of 'the life of the studio.'"[1]

At first glance, this image of two women in an interior—one naked, seen standing from the back, the other clothed, on her knees to the right—could be construed as a simple depiction of such studio activity. Perhaps the posing session is coming to a close: the nude woman faces a mirror and arranges her hair, while her companion gazes towards the stove placed in the chimneypiece and holds an article of clothing as if preparing it for covering the other's nakedness. The scene is certainly the artist's studio, as comparison with another depiction of the room makes clear. In *Madame Vuillard Lighting the Stove* (fig. 25), the painter shows his aging mother on her knees in front of the fireplace, but the central character of the scene might actually be the gigantic plaster cast of the top half of the Venus de Milo that sits at the left edge of the mantel, sharing the space with a jumble of smaller statuettes, among them a small nude by Vuillard's friend and fellow Nabi Aristide Maillol (see p. 90). In *The Two English Friends*, the cast of Venus can be discerned as a kind of nimbus surrounding the torso of the model, as if connected to her in some way; her proper reflection can nonetheless be made out in the mirror, between the plaster cast and the bouquet of flowers.

Though shaped by the conventions of Vuillard's depictions of anonymous models

in his studio, the painting is not such a simple scene. Guy Cogeval has written that

> This strange picture, which appears almost unfinished, is particularly well-documented in the artist's Journal. The figures in question are a Mrs. Booth and a Mrs. Courtot, two English women Vuillard had met through Lucy Hessel [the wife of Vuillard's dealer and a particular friend of the painter]. One day in 1923, they offered to act out an Art Deco version of Sacred and Profane Love.

Vuillard referred in his journal entry for April 25, 1923, to this "most unusual proposal," and several weeks later expressed his concern with how the painting might turn out; he noted a drawing of Mrs. Courtot's naked back, which he compared to a conventional academic nude study, but felt himself "achieve a certain illusory sense of meticulousness that soon deteriorates and leaves me reeling, [with a] confused impression of old academic study that fills me with doubts."[2]

In *The Two English Friends*, Vuillard's uncertainty may account for the areas of reworking of the wall surface at the left (as if something once visible has been covered) and in the nervous contours, particularly visible in the model's calves and ankles. Then again, doubt and uncertainty are the hallmarks of Vuillard's art. Here, clothing an allegory of profane love (represented by Mrs. Courtot, nude, and her counterpart, the plaster cast of Venus) and sacred love (in the person of Mrs. Booth, kneeling beside her) with the conventions of a studio interior, he hides the subject from the viewer. This game of deliberately excluding his audience from the mystery of the scene lies at the heart of the painting's puzzling beauty.

The Two English Friends
(also known as *Nude in an Interior*)
1923

Oil on cardboard, laid down on paper
74.6 x 52 cm (29½ x 20½ in.)

Aristide Maillol

French, 1861–1944

ARISTIDE MAILLOL WAS born and raised in the Mediterranean town of Banyuls-sur-Mer, near the present-day border of France and Spain, and grew up speaking Catalan, from the neighboring Iberian province. He came to Paris at age twenty, and, after studying at the Ecole des Beaux-Arts, fell under the influence of Paul Gauguin. He joined the Nabis, along with Bonnard, Denis, and Vuillard (see pp. 86, 56, and 88), producing paintings, tapestries, and woodcut prints. In about 1900, he began to experiment with sculpture, which became the ruling passion of his life until his death in 1944.

By the end of his first decade as a sculptor, Maillol had emerged as a significant talent. He made not only small-scale figurines in plaster, terra cotta, and bronze, but also had ambitions to create life-size, even monumental, sculpture. His *Torso of Summer* (fig. 26), one of a series of seasons made in the years just before the First World War, shows the degree to which, in little more than a decade, Maillol had mastered the sophisticated depiction of the human body in repose. Subtly twisting her right hip toward the viewer, *Summer* appears a figure from the classical past—all the more so because the sculpture appears to be a fragment—and at the same time seems to be a living, moving, breathing body in the present. In 1910, Maillol thus hinted at a classical perfection but insisted on animating it with a tension that suggested modernity.

Twenty years later, in 1930, the sculptor set to work on a life-size figure, *Nymph*, based on "an athlete…a wonderful model." Maillol, it was said, "needed to do little more than copy her."[1] (Another source suggests that her name was Lucille.[2]) As Maillol proceeded, his sculpture took on a notable sense of balance and repose, more relaxed

and less overtly muscular than the *Torso of Summer*. Witnesses reported that he often began by sculpting the body from neck to thigh, then added legs, and next affixed a head to his composition. Last came the arms—and there, wrote Maillol's friend Pierre Camo, "the difficulty began":

> How to place them without doing harm to the harmonious contour of the whole, to its perfect wholeness? How to avoid the openings for light, the too-obvious angles, the ins and outs, all working against the concept of the thing—much more an art of repose than one of movement? This was his great challenge, which was even greater for standing figures, where there were so few pretexts for placing the arms parallel to the body, or for a movement that would bring them back to the breast. (Reclining, horizontal forms lent themselves toward parallelism, seated forms toward folding movements.) Thus, he found the Venus de Milo all the more admirable because she came to us armless. "They would add nothing to her beauty," he said to me. "They might even run the danger of ruining it."[3]

The armless *Nymph* shown here may reflect Maillol's preference for a standing sculpture that (as in the case of the *Torso of Summer*) concentrates the body's energy in its core. But the figure eventually received a pair of arms that fell toward her waist and then were raised up. By 1937, the sculptor had conceived a pair of nudes, nearly mirror images of each other, that faced his first, central *Nymph*, reaching their right and left hands out toward hers and forming a trio in the manner of classical or Renaissance representations of the three Graces. Maillol resisted this more conventional reference, however, insisting on calling his group of three nudes the *Nymphs of the Field*.[4]

Fig. 26. Aristide Maillol, *Torso of Summer*, about 1910–11, Museum of Fine Arts, Boston.

Nymph
1930

Bronze
155 x 40.6 x 24.1 cm (61 x 16 x 9½ in.)

Albert Marquet

French, 1875–1947

The Passersby
1933

Oil on canvas
46.2 x 55 cm (18¼ x 21½ in.)

ALBERT MARQUET, BORN in the port city of Bordeaux in southwest France, was (along with Henri Matisse) a student in Gustave Moreau's atelier at the Ecole des Beaux-Arts. Like a number of his classmates, Marquet began to paint in a bold, bright manner around 1904, and exhibited with his friends regularly; five of his canvases were shown in the notorious "salle des fauves" at the 1905 Salon d'Automne.[1] Although Marquet's paintings of 1904–10 are sometimes highly colored—his *Posters at Trouville* of 1906 (fig. 27) is a good example—he was consistently true to his optical experience. The bright colors of *Posters at Trouville* are there because the posters themselves were brilliantly colored, not because Marquet has exaggerated them, as his Fauve colleagues Matisse or André Derain would have done.

In the years between the two world wars, Marquet became a traveler, visiting Mediterranean ports in France, Spain, Italy, and North Africa; painting sites on the Atlantic, including La Rochelle, which he visited with Signac (see p. 66) in 1920; and journeying to harbors in the north—including Rotterdam, Scandinavian cities, and even the Soviet Union. In almost all of his views, whether of the Seine in Paris (he took over Matisse's apartment on the quai Saint-Michel in 1908; see p. 68) or farther afield, he adopted an elevated point of view, seeing the landscape or the port from a second- or third-story window, which afforded him a high horizon line and a large stretch of land or water in the foreground. He often chose to paint a scene in *contrejour* ("against the light") so as to heighten the dramatic effect of light emanating from the distance in his canvas, casting shadows into the foreground. He was equally adept at painting under gray skies, which infused his views with a placid tonality.

The Passersby is a remarkable composition in his oeuvre, showing figures placed very near to the artist, and slightly elevated,

Fig. 27. Albert Marquet, *Posters at Trouville*, 1906, National Gallery of Art, Washington, DC.

as if the seated painter were observing standing, moving people on the quai beside the beach. The scene is the seaside town of Les Sables d'Olonne, on the Atlantic coast between the Breton city of Nantes and the port of La Rochelle. Marquet had first painted in Les Sables in 1921, the year after he visited La Rochelle in Signac's company. He returned there for an extended stay in the summer of 1933.

Marquet's wife Marcelle described the circumstances that brought her and her husband to Les Sables d'Olonne that year:

> The summer of 1933 began without any precise plans. Marquet began to tire of the Mediterranean where there were too many people...Loading our car with all our usual extraordinary conglomeration of indispensable luggage we reached the Atlantic coast. [Marquet]...remembered Les Sables d'Olonne, the resources of which he knew [from his trip in 1921].

He would find boats there and bathers, too...Life there did not stop at the end of the season. It took us little more than an hour to find a suitable house in the center of activity. It had just a few steps between the door and the pavement leading straight to the beach, and was seething with children, men and women of all ages, dressed in bright colors. Red and white striped tents enlivened the scene on the sand.[2]

The overwhelming impression in *The Passersby* is of brilliant sunshine and heat. The central figure, a woman wearing a sleeveless blue dress, lifts her hand to shield her eyes from the glare. It may be that the flags displayed on the metal archway—a feature of the seaside promenade complete with its row of electric bulbs and tall, crooked streetlight—signify that the painting was executed around the time of the *fête nationale* of Bastille Day, July 14.

Fernand Léger

French, 1881–1955

DURING 1919 AND 1920, Léger explored a new way of painting, issuing from his Cubist works of the war period (see p. 78). Mechanical forms dominated his compositions, typically highly stylized and brightly colored, standing out against rhythmic, geometrical backgrounds that recall, in a radical new fashion, his early employment as an architectural draftsman. Around 1921, he became closely associated with the Purist movement, spearheaded by Amedée Ozenfant and Le Corbusier, and contributed paintings to decorate the Pavilion de l'Esprit Nouveau, the group's manifesto building at the Art Deco exhibition of 1925. While machinery and man-made objects continued to proliferate in his images, Léger—like so many of his contemporaries—had heeded the postwar "call to order," simplifying his pictorial strategies still further, and at the same time experimenting with pure abstraction.

Léger's art, like that of his de Stijl contemporary Piet Mondrian, was an art of extreme calculation. "I always begin by making very developed sketches," he said in 1924:

> I'm inspired by diagrams or mechanical elements, sometimes by advertising images, like the drawing of a siphon that I found in [the newspaper] Le Matin. But I also make still lifes and compositions in which the human element plays a role. When my drawing is finished, my painting is already three-quarters done. I always make canvases in series; at the moment I am working on about ten, all at the same time.[1]

In the mid-1920s, Léger's paintings generally incorporated industrial or domestic objects—ball bearings, hats, umbrellas, references to bits of architecture—pulled out of their normal context, excerpted, enlarged, and sometimes modified beyond recognition. The objects are usually framed by and anchored to rectilinear shapes that alternately push forward and recede, alluding to space but confounding an easy reading on the viewer's part. By the last years of the decade, however, the painter had begun to introduce a greater number of natural or seemingly organic objects and curving forms that were not determined by the imagination of the architect or industrial designer.

In The Bunch of Grapes, for instance, the central motif is depicted in black and white, each grape shaded mechanically and regularly. The oval shapes of the fruit are played against the oval of a human face to the left—a sculpted bust or perhaps a mannequin from a hat shop. To the left and right of the grapes, curving dashed lines in black and white recall grapevines, while at right a mechanical red shape, seen as if in low relief, connects to what appears to be a metallic handle or electrical wire. These oddly juxtaposed elements float in front of a pattern of curving biomorphic shapes, black and white, yellow, green, orange, and red, immediately reminiscent of the painted relief sculpture of Hans Arp.

Similarly, in Still Life from the following year, a number of amoeba-like shapes in red, black, white, and yellow are arranged against a blue background. In front of these forms, Léger places three "objects": a long red strip might be a straight-edge or a ruler; to its right, a child's toy, a top, is apparently both in front of the red strip and behind part of the black shape, its hidden contour expressed by a series of white dashes; still further to the right is a curious object composed of two linked squares, one blue and one white, on which are disposed triangles, rectangles, and circles, giving the appearance of a piece of machinery. Léger's careful execution in both paintings attests to his belief that "technique must be more and more precise, and execution must be perfect."[2]

What is most striking about these works, however, is the artist's sense of play and creativity in the construction of space. In both works, volumes are suggested (the bunch of grapes, the convex layers of the spinning top) by shading that hearkens back to the cones and spheres of Léger's pre-1920 work. But for every element that exists as a volume, another seems to be merely a flat painted area—the white background form in Still Life undulates with light and shadow to the left of the red bar but is completely smooth to its right. The Bunch of Grapes and Still Life are, in fact, the perfect illustrations of Léger's stated intention to "place my objects in space and make them hold together while making them stand out from the canvas":

> It's an easy interplay of relationships and rhythms between the colors of the background and the foreground, conducting lines, distances and oppositions. The object is truly the "subject" of my easel painting. I selected an object and got rid of the table. I put the object in space, minus perspective, minus anything to hold it there. I then had to liberate color to an even greater extent.[3]

At the same time, the objects in these paintings seem to exist almost as fragments of a dream—coming forward and receding as enigmatic symbols. By juxtaposing the man-made with the organic and flatness with volume, and above all by making the viewer question the relationship between the thing represented and its representation, Léger in the late 1920s was able to invent a new kind of painting for himself—a personal compromise between the Cubism of his early years, the Purism of the early 1920s, and the emerging Surrealism that surrounded him in Paris between the world wars.

The Bunch of Grapes
1928

Oil on canvas
80.6 x 129.5 cm (31¾ x 51 in.)

Still Life
1929

Oil on canvas
91.4 x 65.4 cm (36 x 25¾ in.)

Pablo Picasso

Spanish (worked in France), 1881–1973

THE STORY OF Picasso's meeting with the young Marie-Thérèse Walter has become a legend. Various authors and witnesses place the event in either 1925—when Marie-Thérèse was fifteen years old—or two years later, in 1927. Whether the encounter actually took place on the sidewalk in front of the Galeries Lafayette department store or outside the nearby Gare Saint-Lazare, it seems that Picasso was so struck by the young woman's appearance that he stopped her on the street. How must she have felt when this strange man, nearly thirty years her senior, said to her that he and she would "do great things together"?[1]

By 1928, Marie-Thérèse was involved in a secret romance with Picasso, who ten years earlier had married Olga Khoklova, a dancer from the Ballets Russes, with whom he had a young son, Paulo. The lithograph called simply *Face* (fig. 28) is among Picasso's first portraits of Marie-Thérèse. Picasso focuses on the face of his young lover—with its full cheeks, rounded jawline, and straight, Roman nose—so that it fills the plate of the print. It "takes on a new dimension," as Robert Rosenblum has observed,

> when one realizes that this startling proximity and cropping produce unexpected effects appropriate to the artist's personal circumstances—an erotic intimacy gleaned from a lover's close-up gaze and touch, and a mood of concealment that permits us to glimpse, but perhaps not quite recognize, only a fragment of the face of a newcomer still playing a clandestine role.[2]

It was the particular quality of Marie-Thérèse's profile, as well as her straight, blonde, bobbed hair, that makes her identifiable as the model in many of Picasso's works of the period 1928–39. Among these is the *Head of a Woman*, painted in 1934 at Boisgeloup, a seventeenth-century manor house near Gisors, in Normandy, that Picasso had purchased a few years earlier, and where he was to retreat with Marie-Thérèse. He used the stables of the house as a studio in which he created the extraordinary series of sculptures of her head over the coming years.

Unlike *Face*, with its clear suggestion of volumes in black and white, *Head of a Woman* is a jigsaw puzzle of intersecting lines and resulting shapes, variously (and antinaturalistically) colored in hues of blue, lilac, red, white, and yellow, with elements of green at either side suggesting the shape of the model's coiffure. Comparison with *Face* allows us to recognize the outline of Marie-Thérèse's head at right. The lithograph, by casting the left side of the model's face in shadow, subtly transforms a three-quarters view into a profile image, prefiguring a strategy that Picasso would use again and again in his portraits of the next decade. In *Head of a Woman*, the view is a combination of both perspectives. Here, however, instead of fading into shadow, the left side of the face breaks into light, with a sunburst shape joining the patches of yellow and lilac—the colors that had become Picasso's shorthand code for Marie-Thérèse, with yellow connoting her blonde hair and lilac her cool, pale skin.[3]

The portrait (if such it can be called) is quite different in mood from the calm and lyrical images of Marie-Thérèse sleeping or reading that announced her presence as Picasso's muse in 1932, at the artist's first retrospective exhibition. *Head of a Woman* is painted quickly, surely, and economically—

Fig. 28. Pablo Picasso, *Face*, 1928, Museum of Fine Arts, Boston.

but, above all, energetically. The basic shape of the head was laid in and the various planes of color established, then outlines of contrasting colors were added, generally over the shapes they contain. Next, a striped background was put in place—reminiscent of the striped treatment of Marie-Thérèse's body in Picasso's famous *Girl before a Mirror* of 1932, but also suggestive of light coming into a room through slatted blinds or shutters. Finally, as if trying to contain the energy of these colors and shapes, the artist surrounded them with a band of black.

Head of a Woman,
Portrait of Marie-Thérèse Walter
1934

Oil on canvas
55.5 x 38.5 cm (22 x 15¼ in.)

Joan Miró

Spanish, 1893–1983

JOAN MIRÓ, BORN ON the island of Palma de Mallorca, was the son of a goldsmith. He identified himself as a Catalan, and as a result his early training took place in Barcelona, where he would return periodically throughout his life. His move to Paris in 1920 marked the beginning of his engagement with the international avant-garde. Adopted by the Surrealists in the mid-1920s—though he never joined the group officially—he became one of the more influential members of the Paris art world in the period between the two world wars.

In the 1920s and early 1930s, in parallel with the art of Picasso and the Swiss painter Paul Klee (whose work the painter encountered in about 1924), Miró explored a curvilinear biomorphism, placing organic and geometric forms across a barely defined ground vaguely suggestive of deep space. The shapes might, as in *Composition* of 1934, represent human beings, but they could equally suggest animals, celestial bodies, or inanimate objects.

Composition is one of a number of mixed-media drawings or paintings that Miró created in 1934. That year saw the artist experiment with several different paper supports—among them "velvet paper," with a flocked surface that he worked over with pastel, and sandpaper, which provided a gritty, stony surface on which to inscribe runic figures that remind the viewer of ancient cave paintings. (Miró pronounced in 1929 that "painting has been in decline since the cavemen.")[1]

One set of these works was executed in white gouache on black paper. Often, as in *Composition*, these works show men and women together. Here, a large-headed man seen in profile at right embraces a woman at center whose tiny head faces the viewer, while one of her legs seems to wrap around her partner. At the left, another figure is present, an amorphous inverted teardrop shape upon which Miró has pasted a cut-out piece of blue paper. Drawing on the paper in black medium, he places eyes and brows at the top, shows hair sprouting from the "head," defines what looks to be a thumbnail or toenail at the bottom of the blue shape, and gives the figure an orifice in between—a mouth, it must be, though it is unmistakably vaginal. Would it be wrong to read the set of this figure's brow, and that of the central woman, as angry—the brow narrowing and deepening into a furrowed shape, the dotted eyes keenly focused?

Miró's technique stresses the erotic interpretation of his image. As the contour lines of his figures overlap, they create zones that the figures "share," which the artist often heightens by changing the zone's value—here, by moving from white to black to white again. In his oil paintings these zones often change hue, but in this gouache-and-paper work he has introduced only one color—a patch of blue that singles out the figure at left, perhaps an intruder. The dramatic role in *Composition* has been given, ironically, to the paper itself. Miró makes the body of the central woman fuse with the black background and activate it: it flows into her and out of her.

This play between ground and figure is also tied to the color of the ground—the rich black, like ink or a chalkboard, against which Miró works. As the critic Clement Greenberg wrote, "Miró had early discovered black as a *color*, and had begun using it…with an effect no other painter of our time except Matisse has approached. Black becomes his touchstone, as white for Picasso. It is the vehemence and the opacity of black and the precision with which it defines a plane that he tries to equal in his other deep colors."[2]

Composition
1934

Gouache and paper collage on black paper
laid on board
65 x 49 cm (25½ x 19¼ in.)

Yves Tanguy

French, 1900–1955

YVES TANGUY WAS BORN in Paris in 1900, the youngest child of a sailor who had become an administrator; both his parents were of Breton origin. The legend of Tanguy as a Celtic Breton was to provide a background for the interpretation of his Surrealist land- or seascapes of the 1920s and 1930s. Although he spent most of his life in Paris, visits to Brittany—in particular to Locronan, his mother's birthplace—must have familiarized him with the ancient dolmens and menhirs of the Druids, as well as with the remarkable rock formations that characterize the Breton coastline. After a time as a merchant seaman, Tanguy entered the army and served a tour of duty in Tunisia, where he would observe the deserts and the geology of North Africa.

His chance discovery in 1923 of Giorgio de Chirico's canvas *The Child's Brain* led him to try his hand at painting— he had already entered into the bohemian life of Montparnasse with his army friend, the poet Jacques Prévert. By 1925, Tanguy was one of the figures at the heart of the Paris Surrealist group, and in 1927 the short-lived Galerie Surréaliste gave him a solo exhibition. By that point, he had already arrived at a pictorial formula that he was to develop for the next three decades.

The untitled painting shown here is a beautiful example of Tanguy's mature style. Against a diaphanous background of gray and blue, the artist places a number of objects that come from his imagination. They resemble bones or rocks—with what might be the specter of a ship's mast at right—but they do not conform closely to any known object of the viewer's experience. There is movement in the painting. A wind or a current of water seems to flow through the "horizon" of the composition, and in the foreground a spout of air or water casts up a few pebble-like shapes.

Although the background had to be laid in before the objects could be placed, Tanguy was adamant that his imagery flowed from his imagination without planning:

> The painting takes form under my eyes, revealing its surprises bit by bit as it develops. That's what gives me the feeling of total freedom, and because of this I am incapable of making a plan or doing a preliminary sketch.[1]

Suppressing, as he said, "the line that divides water and sky," Tanguy here creates a landscape, or perhaps a seascape, that is meant above all to intrigue and perplex the viewer. The painter avoids the deliberate references his contemporary Salvador Dalí liked to make to everyday objects or people transformed by dreams. Instead, Tanguy transports his viewers into an imaginary world almost entirely alien to their experience. Still, the painter's shapes have dimension, and they cast shadows as if struck by the light of an underwater sun. They seem to "hold" things, to touch each other, to group together almost socially.

Works such as this painting nearly defy the historian's ability to describe them or to attempt to analyze the ways in which they affect us. The Surrealist poet Paul Eluard came closer to evoking the painter's atmosphere in his 1932 poem "Yves Tanguy," in which he wrote:

> I take nothing from these nets of flesh and tremors
> From the ends of the earth to the twilights of today
> Nothing can withstand my desolate images.
>
> Silence in the guise of wings has frozen plains
> Which the slightest desire cracks open
> Night turning around lays them bare
> And casts them back to the horizon.[2]

Oil on canvas
55 x 46 cm (21¾ x 18 in.)

René Magritte
Belgian, 1898–1967

Portrait of Mme. A. Thirifays
(The Heart Unveiled)
1936

Oil on canvas
80 x 64 cm (31½ x 25¼ in.)

RENÉ MAGRITTE STUDIED at the Academy of Fine Arts in Brussels during the First World War; his paintings from this period, representational in character, reveal the influence of Impressionism and, to some extent, Fauvism, though after the war he adopted a style that blended aspects of Cubism and Futurism. His discovery in 1922 of Giorgio de Chirico's works led him toward his personal brand of Surrealism, in which ordinary objects are depicted in extraordinary surroundings. Magritte strove to depersonalize his technique, deliberately adopting a dispassionate handling of his media in an attempt to conceal all traces of the painter's brushwork. By the late 1920s, the artist was recognized as one of the leading painters of the Surrealist movement. His works were sought after, and he was under contract to sell his canvases to the Brussels gallery Le Centaure.[1]

Magritte's fame grew beyond Belgium and France in the 1930s. He was included in a major international exhibition of Surrealism in London in 1936 but declined an invitation to join a friend and patron there to see the exhibition and meet with other artists. "I would have to leave the Cordière and Thirifays portraits unfinished," he wrote, "in spite of my urgent wish to complete them so as to begin thinking about the pictures due this year to the people to whom I am under contract."[2]

The "Thirifays portrait" that Magritte referred to is *The Heart Unveiled*, which depicts Tita Thirifays, a friend of the Surrealist poet Paul Eluard and the wife of André Thirifays, a founder of the Brussels Cinémathèque.[3] Tita Thirifays is shown against an arched opening of gray stone and a wooden floor that looks out on to a beach, beneath a bright blue sky. Just behind her, the sky congeals into a three-dimensional "shadow" of the standing

woman. Inexplicably, a boulder is also present: she rests her hand on it as she might have rested it on the back of a chair.

The portrait almost certainly derives from a photograph of Tita, if Magritte followed his usual practice here. "First he asked for photographs of his future models and worked from them, only later arranging a few sittings," wrote Claude Spaak, the husband of a woman who was another of Magritte's sitters in 1936; "only after that did he think about the background."[4]

Magritte's portraits went against the grain of his Surrealist method, inasmuch as the artist was obliged to recognize the particular qualities of the individual person rather than the generic qualities of an anonymous object. But to the fullest extent possible, he treated his sitters as things rather than people. In the year that he painted Tita Thirifays, he later wrote, he was able to see how objects behaved in his imagination and in his painting.

> In the course of my investigations, I became convinced that this element to be discovered, this one thing among all those attached somehow to each object, was invariably something I already knew, but that this knowledge was as if lost in the depths of my mind. As these investigations could give only one correct answer for each object, they were like the pursuit of a solution to a problem with three data: the object, the thing connected with it in the shadows of my consciousness, and the light into which this thing had to emerge.

The image of shadows from Magritte's unconsciousness emerging into light accords perfectly with the image of Tita Thirifays and her emerging "shadow," or double image, in *The Heart Unveiled*. "This is how we see the world," Magritte said. "We see it outside ourselves and yet we have only a representation of it within us—in the

same way, we sometimes situate in the past a thing which is happening in the present. So time and space are freed from the crude meaning which is the only one allowed to them in everyday experience."[5]

What of the painting's title? The portrait was first exhibited in 1936 in Brussels with only the enigmatic name *The Heart Unveiled*; later, Magritte amended the title to give precedence to the identity of the sitter. If we believe the artist's wife, Georgette Magritte, we should realize that the title did not determine the subject, but rather the opposite: "The titles always came after the picture [and] the title is not an explanation of the painting. It is a poetic element that is part of the picture. This proves that Magritte never began with an idea."[6] Magritte himself said that "titles are chosen in such a manner as to forestall situating my paintings within the framework of familiarity that, whenever it is threatened by anxiety, the mind automatically conjures up."[7]

This being said, the title of Magritte's 1944 still life, *The Tempest*, must surely reflect current events—the raging war that surrounded him in Belgium, France, and Germany. Magritte had initially fled Brussels on the eve of the German invasion but later returned to his home and lived out the war under German occupation. During the war, he produced works that seem to allude to the conflict, such as the image of peaceful doves emerging from stony leaves in *Natural Graces* of 1942 (fig. 29). (In 1927, Magritte had written to a friend, the poet and philosopher Paul Nougé: "I found a new potential inherent in things: the ability to gradually become something else, one object *merges* into another.")[8]

The previous year, Magritte had ironically adopted what was called his "Renoir manner," painting in bright colors and with feathery brushstrokes that mimicked

Impressionist technique. Though this style is present in *The Tempest*, Magritte's inscrutable approach to his subject is unchanged. A window opens onto the sea; a glass sits on the window ledge; a stem in the foreground sprouts a green hand, at right, and a leaf, at left. The leaf image had emerged in Magritte's art as early as 1930, in a painting from his *Key to Dreams* series, in which objects and nouns were linked in a painted grid. In one of these paintings, a leaf appeared above the apparently nonsensical designation "the table." (A more famous example of this approach to inscriptions can be found in Magritte's 1928 canvas *The Treachery of Images*, a picture of a pipe sporting the enigmatic caption "This is not a pipe.") Later, in his painting *The Giantess* from the mid-1930s, Magritte had engaged in a kind of pictorial synecdoche, making the leaf, a part, stand for the tree, the whole. There, in the artist's words, "the tree, as the subject of a problem, became a large leaf, the stem of which was a trunk directly planted in the ground."[9] Although Magritte rarely used conventional symbols in his paintings, it may be that the link between nature and man—gravely challenged by the war—is the meaning of the hand/leaf conjunction in *The Tempest*. After all, in another of Magritte's *Key to Dreams* paintings, a glass of water is painted above the inscription "the storm."[10]

Fig. 29. René Magritte, *Natural Graces*, 1942, Museum of Fine Arts, Boston.

Paul Delvaux

Belgian, 1897–1994

The Greeting (The Meeting)
1938

Oil on canvas
89 x 120.7 cm (35 x 47½ in.)

REJECTING THE CAREER in law chosen for him by his father, Paul Delvaux entered the Academy of Fine Arts in Brussels in 1916. At first he studied architecture, then decorative painting, and finally found his way to training as a painter pure and simple. Through the 1920s and into the 1930s, his work evolved from a late Impressionist style to one influenced by the Expressionism of such Belgian painters as James Ensor. In 1934, he discovered the early works of Giorgio de Chirico (see p. 110) in a Brussels exhibition: like his fellow Belgian René Magritte and like André Breton and Yves Tanguy in France, Delvaux was profoundly struck by de Chirico's "metaphysical" canvases, and quickly adopted a new and personal Surrealist manner.

Through his long career—he was working until about 1989—Delvaux painted canvas after canvas devoted to a series of dream cities occupied by graceful, often scantily draped women. *The Greeting* is a characteristic and celebrated example of his early Surrealist work. The setting of the meticulously executed painting is a paved square surrounded by brick-and-stone architecture, the façades modeled on French or Flemish prototypes of the sixteenth or seventeenth centuries. In the manner of Renaissance paintings of ideal cities, a broad street leads from the foreground toward the distance, where a dense forest lies beneath a mountain—evoking the landscapes in Tuscan Renaissance paintings. Two principal figures fill the foreground and are the subject of the meeting of the painting's title. At right is a woman, draped in classical style; she raises her hand in greeting to a man approaching from the left, who lifts his bowler hat to her. The disjunction between her antique costume and his modern clothing, between her semi-nudity and his bourgeois propriety, along with similar contrasts in the setting (with its references to the

Fig. 30. Paul Delvaux, *Daily Proposal (Woman with a Mirror)*, 1937, Museum of Fine Arts, Boston.

Renaissance and a modern tram at the end of the street), situate the painting in the world of dreams and imagination

A similar pair appears in another painting from the year before, *Daily Proposal* (fig. 30), where the man—generally identified in both works as Delvaux himself—and the woman seem to be estranged: she gazes at herself in a mirror, while he gestures towards her unnoticed. Who is the woman in these paintings? Is it Anne-Marie de Maertelaere, with whom Delvaux had had a relationship (opposed by his parents) and would marry much later in life; or Suzanne Purnal, whom he married in 1937? Breton said that Delvaux had "turned the whole universe into a single realm in which one woman, always the same woman, reigns over the great suburbs of the heart."[1] But Delvaux himself dismissed attempts to link

his paintings to the story of his life. When asked the source of inspiration for the women who peopled his paintings, he insisted that "they come from the very roots of the history of art. They just arrive. Do you see? They're naked because I can't dress them as if they belonged to some particular era of history. They're timeless,"[2]

Claude Spaak, who organized the first retrospective of Delvaux's art in Brussels and was the first owner of this painting (which later belonged to the Surrealist painter Kay Sage, the American wife of Yves Tanguy), once said: "If I had to sum up the art of Delvaux in two words, the best I could find would be mystery and melancholy. On how many streets, under how many arcades, in the shadow of how many statues…has the painter ventured?"[3]

Giorgio de Chirico

Italian, 1888–1978

GIORGIO DE CHIRICO, born to Italian parents living in Greece, was first trained at the Academy of Fine Arts in Munich, where he came to appreciate the strange and melancholy paintings of the German artist Arnold Böcklin. This appreciation for German culture extended as well to the metaphysical philosophy of Friedrich Nietzsche, whose writings he discovered when in his early twenties. De Chirico moved to Paris in 1912 and quickly became associated with the city's artistic vanguard, including Pablo Picasso, Constantin Brancusi, and the poet and critic Guillaume Apollinaire. Beginning around 1913, he embarked on a body of work that he called *pittura metafisica*—"metaphysical painting"—which became enormously influential when seen, over the next two decades, by the French and Belgian painters who would become known as Surrealists. The paintings were marked by a sense of strange loneliness; a sub-group of them showed an Italianate plaza leading toward a building in the distance, with a classical statue of a sleeping woman in the foreground.

This particular set of paintings, from the years 1913–14, came to be known as de Chirico's "Ariadne series," because the statue in the plaza was based on an antique sculpture of the so-called *Sleeping Ariadne* type; one example of these is located in the gardens at Versailles, which de Chirico visited around that time. As Michael R. Taylor has observed, "the figure of Ariadne, the abandoned princess of Greek mythology, haunted the work of Giorgio de Chirico like a phantom. A monument to loneliness and exile, she appears in every stage of the artist's career."[1]

Piazza d'Italia is one of many paintings that relate closely to the prewar Ariadne series. In the 1930s, more than fifteen years after his first "metaphysical" depictions of

the statue in the square, de Chirico began this new group of paintings, to each of which he gave the title *Piazza d'Italia*—as if they summed up, for him, not so much a particular place, but an imagined place reflecting the heart of Italy. The example shown here probably dates from 1954.

Like other works from this series, the painting is marked by an elevated perspective view of the plaza. Buildings, with arcades on the ground floor, recede toward a two-tiered tower, based on ancient Roman examples but also referencing such buildings in Renaissance depictions of cities originally used as lessons in linear perspective.[2] As in all the paintings in this group, sunlight comes into the painting from the depths of the pictorial space at right, casting the buildings at the right into deep shadow, highlighting the rounded form of the tower at the horizon and brightly striking the left-hand arcade.

The ways in which Italian—and specifically ancient Roman—architecture behaved under sunlight had become one of de Chirico's preoccupations forty years before, at the time of the Ariadne series. Then, he had written from Paris:

> there is nothing like the enigma of the arcade—created by the Romans, out of everything that can be Roman. A street; an arch. Sunshine has a special expression whenever it bathes a Roman wall in light; there's something more mysterious and plaintive in it than in French architecture…The Roman arcade is like one of the Fates; it has a voice that speaks, in riddles filled with strange Roman poetry, of shadows on old walls.[3]

De Chirico had found a solution to the problem in the Ariadne series and had returned to it in the years between the wars. But it must have continued to haunt him, for he would engage it, again and again, throughout the postwar period.

Piazza d'Italia
1954

Oil on canvas
39 x 48.6 cm (15½ x 19 in.)

Henry Moore

English, 1898–1986

Fig. 31. Henry Moore, *Madonna and Child*, 1943, Museum of Fine Arts, Boston.

A MINER'S SON, Henry Moore trained to become a teacher before entering the Leeds School of Art and, in 1921, the Royal College of Art, London. His ambition was to become a sculptor, unlike most of those around him, who had set their sights on the pictorial arts. Haunting the British Museum and reading as much as he could about the history of art, he was most intrigued by works outside the Western tradition—Egyptian sculpture, African and Oceanic carvings, or Meso-American stone figures by the Toltecs or the Mayans.

Moore's media are varied, from hand-carved stone and wood models to editions in bronze—either multiple versions of preparatory works or else unique, large-scale public commissions. His themes, on the other hand, are constant throughout his career. Mothers and children or family groups recur in his work from the 1930s until the end of his life, and the reclining figure, almost invariably female, is explored again and again.

Both of these themes relate closely to Moore's experience during the London Blitz, when he sought refuge with other Londoners in bomb shelters—often underground Tube stations. There he observed and drew (and surely drew again from memory later) the people that gathered together to wait out the alarm, huddling in family groups or recumbent, attempting to sleep.

At the height of the war, in 1943, Moore was commissioned to carve a modern Madonna and Child for Saint Matthew's Church in Northampton (a bronze cast of one of the studies for the Northampton group is in the MFA's collection: see fig.

31). Seated female figures, some holding children, had been a staple of his art in the previous decade; and although the life-size stone statue made further reference to the art of the past—to the Egyptian portrait groups he had long admired, for instance, or to the Madonnas of Michelangelo—it also was informed by his recent wartime experiences. From this important sculptural commission emerged a group of "family" sculptures, including the 1946 *Family Group*. Many drawings explored possible combinations of the figures—the man and woman standing or sitting, the children on their laps or standing beside them.[1] The solution achieved here—with both parents rigidly facing the viewer, a boy standing before his father, and what seems to be a daughter nursing at her mother's breast—is among the most iconic.

Human and animal, as well as art-historical, influences inform the bronze cast of a small-scale model for a monumental stone sculpture called *Reclining Figure: Bone Skirt*, which Moore completed near the end of his career, about 1978. The pose of the figure—supported on its elbows, with knees bent and raised—is one that Moore had admired early in his career in ancient American stone carvings of the god Chacmool, which had inspired a number of his stone and bronze compositions.[2] But comparison with other contemporaneous works by Moore suggests that the curving, organic shape of this woman's body was as much a reflection of his studies of the pelvic or collar bones of humans, or the antlers of animals, as of any ancient prototype.

Family Group
1946
Bronze with green patina
44.5 x 33.5 x 21.6 cm (17½ x 13 3/16 x 8½ in.)

Working Model for "Reclining Figure: Bone Skirt"
1977–79
Bronze with dark green patina
35.6 x 36.2 x 70 cm (14 x 14¼ x 27½ in.)

Marc Chagall

Russian (active in France), 1887–1985

MARC CHAGALL BECAME a symbol of the Russian émigré—particularly the Jewish émigré—in Paris between the world wars. His early paintings merged elements of Cubist fracturing of figures and forms with Expressionist color. He was in Paris before the First World War but found himself back in his native Vitebsk, in Belarus, when the war broke out and was unable to return to France until the early 1920s. After his second move to Paris, his paintings often showed a nostalgic re-creation of the folkloric traditions of his Belarussian homeland—characteristic barnyard animals, as well as human figures, real or fanciful, such as the famous "fiddler on the roof."

Tenderness is one of a group of paintings on paper that Chagall made in the 1960s on circus themes. He had explored such themes throughout his career, recalling in 1967 the itinerant performers—like the ones that Picasso (see p. 74) had depicted in his rose period—who came to his village. "These clowns, bareback riders, and acrobats have made themselves at home in my visions," he wrote. "Lured by their colors and make-up, I dream of painting new psychic distortions."[1]

Circus imagery is abundant in Chagall's late work. The artist's common reputation as an invariably optimistic reporter of the human comedy may distort more difficult readings of images such as *Tenderness*. Here, small figures appear at the top, bottom, and sides of the page—the familiar fiddler, two clowns, and an acrobat draw our attention to the couple on the circus horse at center. The clown and his nude companion on the back of the horse are physically close, but their heads pull away from each other—and hers is cast into deep blue shadow at left. True to Chagall's experience of "psychic distortions" in his own life—the loss of love, the tragedy of war, the difficulty of living in the modern world—their tenderness may not be without its moments of sorrow.

Tenderness
1960s

Watercolor, gouache, and pastel on
paper, laid down on paper
76.8 x 57.5 cm (30¼ x 22½ in.)

Joan Miró

Spanish, 1893–1983

The First Spark of Day III
1966

Oil and acrylic on canvas
145.8 x 114 cm (57½ x 45 in.)

BY THE 1950s AND EARLY 1960s, Miró was one of the "Old Masters" of modern European art. Like Picasso, he was internationally lionized in the years after the war, and the commissions he received for paintings and sculpture came from far and wide: his patrons included Harvard University, a hotel in Cincinnati, UNESCO in Paris, and his new dealer Aimé Maeght, for his private museum, the Fondation Maeght, in the southern French town of Saint-Paul de Vence. Miró's work was often exhibited at various galleries in Paris but was also seen regularly in other parts of Europe—for instance, at the 1954 Venice Biennale and at the first Documenta manifestation in Kassel, Germany, in 1955—as well as in the United States and Asia. Miró himself kept abreast of the newest developments in painting and the graphic arts, and is known to have attended the first Paris exhibition of Jackson Pollock's work in March 1952.[1]

Critics have often observed the interplay in Miró's work of the 1960s between his interbellum masterworks and the new gestural art, exemplified by Pollock's splattered and dripped canvases, that had emerged in America and spread to Europe with the rise of the powerful New York School. Miró was surely aware of the work of such artists as Pollock or Arshile Gorky. Even before the time of his 1959 retrospective at the Museum of Modern Art, Miró was in contact with their greatest apologist, Clement Greenberg, who in 1948 had written a monograph about him. In it, Greenberg expressed the hope "that one day the bland surfaces of [Miró's] canvases will become agitated and dense again and speak with a sonority surpassing that with which they spoke in the thirties."[2]

Despite such sentiments, the painter's work of the 1960s—including *The First Spark of Day III*—did not immediately answer Greenberg's call for "agitated and dense" surfaces. In 1961, Miró embarked on a series of huge canvases in two series—a group called *Blue I*, *II*, and *III*, and another given the group title *Mural Painting*. These were essentially vast monochromatic fields—about nine by twelve feet—animated by extremely discreet marks: delicate lines, bars of glowing color, and deep black spots, which read alternately as holes in space or as solid forms. (To American eyes, they immediately call up memories of the glowing color in paintings by Mark Rothko or the subtle rhythms of Barnett Newman.)

The First Spark of Day III, painted five years later, returns to the metaphor of the sky that Miró had evoked so powerfully in 1940 and 1941 in a series of gouache paintings on paper. To these he often gave celestial titles: *Morning Star*; *Woman in the Night*; *On the 13th, the Ladder Brushed the Firmament*; and *Awakening in the Early Morning*. Some of the paintings were grouped under the heading "Constellations," and their fame became greater in 1959 when they were published in facsimile—accompanied by poems by Miró's Surrealist comrade André Breton—and exhibited in Paris and New York.[3] Their surfaces were, in fact, agitated, covered with Miró-made star charts—black dots linked by lines, sinuously surrounding forms that were meant to suggest people or animals, all against a scumbled background of gray or blue, with sometimes a hint of red.

The night sky of the Constellations series has grown bright in *The First Spark of Day III*. The large canvas is ablaze with a ground of mottled yellow. Several reserves of white are subsequently filled with color or with splatters or daubs of black to create shapes that seem like stars seen through a telescope. In fact, deep black plays a strong role against the glowing yellow field: delicate lines trace across the canvas, as if they were the trails left by falling stars; four lines come together to make a spoke-like star shape at the upper left; and black circles (memories of the Constellations series, but reimagined by his *Blue* paintings) accent the composition.

The title that Miró gave the painting gives us a hint to its meaning for him. He called it, in French, *La première étincelle du jour*: not "the first light of day" —a more common phrase in English—but "the first *spark* of day." He had said, in 1959:

> For me, a picture needs to be like sparks. It has to dazzle you, like a woman's beauty or a poem can. It has to have a radiance— to be like these flints that shepherds in the Pyrenees use to light their pipes.

The First Spark of Day III is meant to dazzle us, to suggest a universe in which we can find new inspiration and pure joy. "In a painting, you should be able to discover new things every time you see it," Miró said. "But you can look at a painting for a whole week and never think of it again. It's also possible to look at a painting for a second and think of it for a lifetime." By the 1960s, Miró's art had become, as he hoped, something universal—for as he put it, painting "should give birth to a world."[4]

Notes

Pierre-Auguste Renoir
Woman in a Blouse of Chantilly Lace (p. 16)

1. Ambroise Vollard, *Renoir: An Intimate Record* (New York: Alfred A. Knopf, 1923), 112.

2. François Daulte, *Figures, 1860–1890*, vol. 1 of *Auguste Renoir: Catalogue raisonné de l'oeuvre peint* (Lausanne: Editions Durand-Ruel, 1971), cat. 46.

3. See Colin B. Bailey, et al., *Renoir's Portraits, Impressions of an Age* (New Haven, CT, and London: Yale University Press, 1997), cats. 11, 12.

4. Alexandra Murphy, personal communication to author, April 24, 2006.

Camille Pissarro
Portrait of Père Papeille, Pontoise; Portrait of Monsieur Louis Estruc (p. 18)

1. Joachim Pissarro, *Camille Pissarro* (New York: Harry N. Abrams, 1993), 283.

2. See Joachim Pissarro and Claire Durand-Ruel Snollaerts, *Pissarro, Critical Catalogue of Paintings* (Paris: Skira and Wildenstein Institute Publications, 2005), III:508.

3. Ibid., III:508.

4. See Pissarro and Snollaerts, *Pissarro*, II:342, no. 482. Joachim Pissarro, personal communication to author, May 2006.

5. For the 1884 oil portrait of Eugénie, see Pissarro and Snollaerts, *Pissarro*, III:508, no. 767.

Paul Cézanne
Trees in the Jas de Bouffan (p. 20)

1. See Henri Loyrette's entry in *Cézanne* (New York: Harry N. Abrams/Philadelphia Museum of Art, 1996), 139.

2. John Rewald, *The Paintings of Paul Cézanne: A Catalogue Raisonné* (New York: Harry N. Abrams, 1996), I:189.

3. See Theodore Reff, "Cézanne's Constructive Stroke," *The Art Quarterly* 25, no. 3 (Autumn 1962): 214–26.

4. See Denis Coutagne, "The Jas de Bouffan" in *Cézanne in Provence* (exh. cat.; Washington, DC: National Gallery of Art, in association with Yale University Press, 2006), 84; for the chronology of Cézanne's visits to Provence, see Isabelle Cahn, "A Provençal Chronology of Cézanne," ibid., 305–15.

Claude Monet
The Seine at Lavacourt (p. 23)

1. Daniel Wildenstein suggests that this painting might be the one sold to Charles Deudon in February 1878; see Daniel Wildenstein, *Monet:*

Catalogue Raisonné (Cologne: Taschen and Wildenstein Institute, 1996), II:190, no. 475. Because Monet did not move to Vétheuil until late summer 1878, however, it is unlikely that he painted this view in time to sell it to Deudon several months earlier.

2. The other potential sources for the Salon painting are ibid., II:210–12, nos. 538, 538a, 539, 540, and 541, all views of the same motif.

3. For the two Corot views of the bridge at Narni, see Michael Pantazzi, Vincent Pomarède, and Gary Tinterow, *Corot* (exh. cat.; New York: The Metropolitan Museum of Art, in association with Harry N. Abrams, 1996), cats. 26, 27.

4. Paul Hayes Tucker, *Claude Monet: Life and Art* (New Haven, CT, and London: Yale University Press, 1995), 106–7.

Claude Monet
The Manneporte Seen from Below (p. 24)

1. Daniel Wildenstein, *Monet: Catalogue Raisonné* (Cologne: Taschen and Wildenstein Institute, 1996), II:307, 309, no. 832.

2. Ibid., III:391–92, no. 1035.

3. Ibid., III:390, 392, no. 1036.

Claude Monet
Monte Carlo Seen from Roquebrune (p. 27)

1. See Joachim Pissarro, *Monet and the Mediterranean* (New York: Rizzoli, 1997), 39.

2. The paintings are Wildenstein, *Monet: Catalogue Raisonné* (Cologne: Taschen and Wildenstein Institute, 1996), II:332–35, nos. 889–890, 896–897, and 893–894. See also Pissarro, *Monet and the Mediterranean*, 107–12.

Eugène Boudin
Beach Scene near Trouville (p. 29)

1. In unpublished research, Juliet Wilson-Bareau has identified a number of Boudin's seaside scenes that were exhibited at the Salon in the 1860s. Among them are cat. nos. 303 (1865), 349 (1865?), 403 (1867), and 492 (1867?) in Robert Schmit, *Eugène Boudin, 1824–1898* (Paris: Schmit, 1973). Written communication to author, 2006.

2. Juliet Wilson-Bareau, written communication to author, June 2006.

3. Quoted in G. Jean-Aubry, *Eugène Boudin d'après des documents inédits: L'homme et l'oeuvre* (Paris: Editions Bernheim-Jeune, 1922), 181.

4. Quoted in George T. M. Shackelford and Fronia E. Wissman, *Impressions of Light: The French Landscape from Corot to Monet* (Boston: MFA Publications, 2002), 141.

5. Quoted in Jean-Aubry, *Eugène Boudin*, 185.

Pierre-Auguste Renoir
Bust of a Woman; Head of a Woman (p. 30)

1. Octave Mirbeau, "Notes on Art: Renoir," *La France*, December 8, 1884, quoted in Nicholas Wadley, ed., *Renoir, a Retrospective* (New York: Hugh Lauter Levin Associates, 1987), 165.

2. Renoir to Vollard, quoted in *Renoir* (exh. cat.; Boston: Museum of Fine Arts, 1985), 241.

3. John House, in ibid., 250.

Edgar Degas
Pagans and Degas's Father (p. 33)

1. Quoted in Jean Sutherland Boggs, *Portraits by Degas* (Berkeley: University of California Press, 1962), 22.

2. See the entry by Henri Loyrette on Degas's first double portrait of Pagans and Auguste De Gas in *Degas* (exh. cat.; Paris: Galeries Nationales du Grand Palais; Ottawa: National Gallery of Canada; New York: The Metropolitan Museum of Art, 1988–89), 169–71.

3. Quoted in Boggs, *Portraits*, 56.

4. This sketch appeared in the fourth sale of the contents of Degas's studio. See *Catalogue des tableaux, pastels et dessins par Edgar Degas et provenant de son atelier* (Paris: Galerie Georges Petit, 1919), no. 157.

Edgar Degas
Seated Dancer (p. 36)

1. Jill De Vonyar and Richard Kendall, *Degas and the Dance* (New York: Harry N. Abrams, 2002), 124, 128.

Mary Cassatt
Simone in a Plumed Hat (p. 38)

1. J.-K. Huysmans, from *L'art moderne*: "L'Exposition des Indépendants en 1881," quoted in Nancy Mowll Mathews, ed., *Cassatt: A Retrospective* (New York: Hugh Lauter Levin Associates, 1996), 132.

2. Nancy Mowll Mathews, *Mary Cassatt* (New York: Harry N. Abrams/Smithsonian Institution, 1987), 121.

3. Quoted in Peter C. Sutton, et al., *Prized Possessions: European Paintings from Private Collections of Friends of the Museum of Fine Arts, Boston* (exh. cat.; Boston: Museum of Fine Arts, 1991), 132.

4. Mathews, *Mary Cassatt*, 129.

5. See Sutton, *Prized Possessions*, 132.

Camille Pissarro
Gardener Standing by a Haystack, Overcast Sky, Eragny (also known as *Gray Weather, Morning with Figures, Eragny*) (p. 41)

1. Joachim Pissarro, *Camille Pissarro* (New York: Harry N. Abrams, 1993), 225.

Camille Pissarro

The Louvre, Winter Sunlight, Morning (p. 42)

1. For the most comprehensive study of Pissarro's series paintings, see Richard R. Brettell and Joachim Pissarro, *The Impressionist and the City: Pissarro's Series Paintings* (New Haven, CT: Yale University Press, 1992).

2. See ibid., 123–57, for a selection of images painted from this apartment.

Auguste Rodin

The Thinker; Eve; Kneeling Fauness; Bather (known as *The Zoubaloff Bather*); *The Prodigal Son; Fugit Amor; Triumphant Youth* (pp. 45–46)

1. Octave Mirbeau, quoted in John L. Tancock, *The Sculpture of Auguste Rodin: The Collection of the Rodin Museum, Philadelphia* (Philadelphia: Philadelphia Museum of Art, 1976), 96.

2. Antoinette Le Norman-Romain et al., *Rodin en 1900: L'Exposition de l'Alma* (exh. cat.; Paris: Réunion des Musées Nationaux/Musée du Luxembourg, 2001), 258.

3. Ibid., 260.

4. Tancock, *The Sculpture of Auguste Rodin*, 150.

5. Le Norman-Romain et al., *Rodin en 1900*, 264.

6. See Albert E. Elsen and Rosalyn Frankel Jamison, *Rodin's Art: The Rodin Collection of the Iris and B. Gerald Cantor Center for Visual Arts at Stanford University* (New York: Oxford University Press, 2003), 501n1.

7. Le Norman-Romain et al., *Rodin en 1900*, 126, 196.

8. Rilke and Alexandre quotes: ibid, 126, 196.

9. See Elsen and Jamison, *Rodin's Art*, 223–25.

Henri de Toulouse-Lautrec

Two Women Making Their Bed (p. 52)

1. Anne Roquebert, *Le Paris de Toulouse-Lautrec* (Paris: Hachette, 1992), 34.

2. See M. G. Dortu, *Toulouse-Lautrec et son oeuvre* (New York: Collectors Editions, 1971), nos. P.502 and P.505; P.557; P.552.

3. See ibid., nos. P.601; P.439; P.436 and 438.

4. Ibid., no. P.621.

5. See Richard Thomson in *Toulouse-Lautrec* (exh. cat.; Paris: Grand Palais, 1991), 442–43, 449.

Emile Bernard

Springtime (also known as *Madeleine in the Bois d'Amour*) (p. 54)

1. See MaryAnne Stevens in *Emile Bernard, 1868–1941: A Pioneer of Modern Art* (exh. cat.; Mannheim: Städtische Kunsthalle; Amsterdam: Van Gogh Museum; Zwolle: Waanders Publishers, 1990), 217.

2. See, for example, Corot's *Souvenir of Mortefontaine*, about 1864, Musée d'Orsay, Paris; or Cézanne's *Montagne Sainte-Victoire*, about 1887, Courtauld Institute, London.

3. Jean-Jacques Luthi, *Emile Bernard: Catalogue raisonné de l'oeuvre peint* (Paris: Editions Side, 1982), 42, no. 256. Luthi also cites *Printemps* as no. 364, 59.

4. See no. 80 in the *Inventaire des toiles vendues le 22 Mai 1901* in the Bernard-Fort Archives, Musée du Louvre, Paris. Bernard's description reads: "une femme cueille des fleurs, une autre en a la tête couronnée, paysage très fin d'arbres en fleurs et très frais en feuillure." The word *feuillure* generally refers to the decorative inner edge of a picture-frame; it is likely that the artist here meant to refer to the *feuilles*, or leaves, of the landscape.

Maurice Denis

The First Steps of Noële (p. 57)

1. Maurice Denis, 31 December 1939, in *Journal, Vol. III* (Paris: La Colombe, Editions du Vieux Colombier, 1959).

2. See Anne Gruson in *Maurice Denis, 1870–1943* (exh. cat.; Paris: Réunion des Musées Nationaux, 1994), 201.

3. Denis to Mme. Ernest Chausson, 10 October 1897, *Journal, Vol. I* (Paris: La Colombe, Editions du Vieux Colombier, 1957), 123.

Théodore van Rysselberghe

The Regatta (p. 58)

1. See Marina Ferretti-Bocquillon, et al., *Signac: 1863–1935* (exh. cat.; New Haven, CT: Yale University Press/The Metropolitan Museum of Art, 2001), 156.

2. See entry by Monique Nonne in *Méditerranée: De Courbet à Matisse* (exh. cat.; Paris: Réunion des Musées Nationaux, 2000), 224.

3. Ibid., 15.

Maximilien Luce

Camaret, The Breakwater; Eragny, The Banks of the Epte (p. 61)

1. The painting is in the Musée d'Orsay, Paris. For a chronology of Luce's life, see Jean Bouin-Luce and Denise Bazetoux, *Maximilien Luce, catalogue raisonné de l'oeuvre peint* (Paris: Editions JBL, 1986), I:23–30.

2. Jean-Pierre van Noppen (Université Libre de Bruxelles, Belgium), written communication to author, 2006.

3. See Bouin-Luce and Bazetoux, *Maximilen Luce*, II:25–31, 33–34, nos. 76–98, 109–11.

4. André Fontainas, October 1899, quoted in Peter C. Sutton et al., *Prized Possessions: European Paintings from Private Collections of Friends of the Museum of Fine Arts, Boston* (exh. cat.; Boston: Museum of Fine Arts, 1991), 173. See also Howard Lay in *Impressionism and Post-Impressionism: The Collector's Passion* (exh. cat.; Portland, ME: Portland Museum of Art, 1991), 45–46.

Henri Edmond Cross

Antibes, Afternoon (p. 65)

1. See *Henri Edmond Cross: 1856–1910* (exh. cat.; Douai: Musée de la Chartreuse, 1999), 15.

2. Cross to Signac, 1895, quoted in ibid., 47.

Paul Signac

Antibes, The Pink Cloud (p. 66)

1. For details of Seurat's chronology, see Marina Ferretti-Bocquillon et al., *Signac, 1863–1935* (exh. cat.; New Haven, CT: Yale University Press/The Metropolitan Museum of Art, 2001), 297–323.

2. See Françoise Cachin with Marina Ferretti-Bocquillon, *Signac: Catalogue raisonné de l'oeuvre peint* (Paris: Gallimard, 2000), 18.

3. Signac to Félix Fénéon, 5 December 1914, Signac Archives, Paris, quoted in Cachin, *Signac: Catalogue raisonné*, 305. The smaller canvas begun in November is *Esquisse du nuage rose, Antibes*, dated 1916 in ibid., 304, no. 508, but presumably under way in 1915.

4. Signac to Charles Angrand, 31 January 1915, quoted in Feretti-Bocquillon et al., *Signac*, 314.

5. See ibid., 253–54.

Henri Matisse

The Pont Saint-Michel (p. 68)

1. For elements of Matisse's biography in the years before and around 1900, see the chronology compiled by Judith Cousins in John Elderfield, *Henri Matisse: A Retrospective* (exh. cat.; New York: Museum of Modern Art, 1992), 81–87. See also Jack Flam, *Matisse: The Man and His Art, 1869–1918* (Ithaca, NY: Cornell University Press, 1986), and Hilary Spurling, *The Unknown Matisse: A Life of Henri Matisse. The Early Years, 1869–1908* (New York: Alfred A. Knopf, 1998).

Maurice de Vlaminck

Houses and Trees (p. 70)

1. See John Klein, "New Lessons from the School of Chatou: Derain and Vlaminck in the Paris Suburbs," in Judi Freeman et al., *The Fauve Landscape* (exh. cat.; New York: Abbeville Press/Los Angeles County Museum of Art, 1990), 123–51, especially 129.

2. See Maïthé Vallès-Bled, *Vlaminck, il pittore e la critica* (exh. cat.; Milan: Fabbri Editore, 1988), 334.

3. See Freeman et al., *The Fauve Landscape*, 87.

Raoul Dufy
Boats at Martigues (p. 72)

1. See Alvin Martin and Judi Freeman, "The Distant Cousins in Normandy: Braque, Dufy, and Friesz," in Judi Freeman et al., *The Fauve Landscape* (exh. cat.; New York: Abbeville Press/ Los Angeles County Museum of Art, 1990), 215–38.

2. Robert J. Boardingham, in Peter C. Sutton, et al., *Prized Possessions: European Paintings from Private Collections of Friends of the Museum of Fine Arts, Boston,* (exh. cat.; Boston: Museum of Fine Arts, 1991), 148–49.

Pablo Picasso
Head of a Jester (p. 74)

1. Guillaume Apollinaire, *La Plume*, May 15, 1905, in *Apollinaire on Art: Essays and Reviews, 1902–1918*, ed. Leroy C. Breunig (reprint; Boston: MFA Publications ["artWorks"], 2001), 15.

2. Roland Penrose, quoted in Werner Spies, *Sculpture by Picasso* (New York: Harry N. Abrams, 1971), 17. See Roland Penrose, *Picasso: His Life and Work* (New York: Harper and Brothers, 1958), 131.

3. Penrose, *Picasso*, 113.

4. See Harry Cooper, *Medardo Rosso: Second Impressions* (New Haven, CT: Yale University Press, in association with Harvard University Art Museums, 2003).

5. Sir Roland Penrose and John Golding, eds., *Picasso in Retrospect* (New York: Praeger, 1973), 127.

Georges Braque
The House (also known as *The House, La Roche-Guyon*) (p. 77)

1. See William Rubin, "Cézannism and the Beginnings of Cubism," in William Rubin, ed., *Cézanne: The Late Work* (exh. cat.; New York: Museum of Modern Art, 1977), 155.

2. Judith Cousins and Pierre Daix believe that Braque, who was in L'Estaque in Provence by the end of September 1907—before the opening of the Salon d'Automne on October 1—returned to Paris before the close of the exhibition on October 22, and saw the Cézanne exhibition at that time. See their chronology in William Rubin, *Picasso and Braque: Pioneering Cubism* (exh. cat.; New York: Museum of Modern Art, 1989), 346–47.

3. See Rubin in Rubin, *Cézanne: The Late Work*, 159.

4. Georges Braque, quoted in Rubin, *Picasso and Braque*, 353.

5. See ibid., 112.

6. Braun (written communication to author, 2006) points to three pairs in Nicole Worms de Romilly, *Catalogue de l'oeuvre de Georges Braque,* (Paris: Galerie Maeght, 1982), VII:69–70, 84–85, nos. 13 and 14, 16 and 17. The present canvas, no. 32, is paired with the Sydney canvas, no. 33.

7. Nicole Worms de Romilly published the painting as *House, La Roche-Guyon* and assigned it to the year 1909. See ibid., 84, 262, no. 32.

Fernand Léger
The Wounded Man (p. 78)

1. See Georges Bauquier, *Fernand Léger: Catalogue raisonné, 1903–1919* (Paris: Adrien Maeght, 1990), nos. 94–100.

2. Léger to Léonce Rosenberg, 1922, quoted in Christopher Green, *Léger and the Avant-Garde* (New Haven, CT: Yale University Press, 1976), 96.

3. For details of Léger's hospitalizations, see the chronology in Carolyn Lanchner, *Fernand Léger* (exh. cat.; New York: Museum of Modern Art, 1998), 265.

4. See Green, *Léger and the Avant-Garde*, 96–97. See also Dorothy Kosinski, ed., *Fernand Léger, 1911–1924: The Rhythm of Modern Life* (New York: Prestel, 1994), 68.

Jacques Lipchitz
Bather (p. 80)

1. See the chronology of Lipchitz's life and career compiled by Dolina Lemny in *Jacques Lipchitz: Collections du Centre Pompidou, Musée National d'Art Moderne et du Musée des Beaux-Arts de Nancy* (exh. cat.; Nancy: Musée des Beaux-Arts de Nancy, 2004), 166–91.

2. Christopher Green, "Lipchitz and Gris: The Cubisms of a Sculptor and a Painter," in Josef Helfensteina and Jordana Mendelson, eds., *Lipchitz and the Avant-Garde* (exh. cat.; Urbana-Champaign: Krannert Art Museum and Kinkead Pavilion, University of Illinois, 2001), 28. Green mentions that Paul Dermée was the first to refer to Lipchitz's work as "la sculpture pure."

3. Cf. Alan G. Wilkinson, *Lipchitz: A Life in Sculpture* (exh. cat.; Toronto: Art Gallery of Ontario, 1989), 72, where Picasso's *Harlequin* is compared to Lipchitz's 1915 *Detachable Figure: Dancer.*

4. Jacques Lipchitz in *Partisan Review* 12, 1945, quoted in *Jacques Lipchitz: Sculptures and Drawings, 1911–1970* (exh. cat.; Tel Aviv: Tel Aviv Museum, 1971), n.p.

5. See *Jacques Lipchitz*, 31, 196, no. 10.

6. For the stone and bronze variants of the plaster, see Alan G. Wilkinson, *The Sculpture of Jacques Lipchitz: A Catalogue Raisonné. Volume One: The Paris Years, 1910–1940* (London: Thames and Hudson, 1996), nos. 100–102. Lipchitz's working method is concisely explained in Derek Pullen, "A Note on Technique," in David Fraser Jenkins and Derek Pullen, *The Lipchitz Gift: Models for Sculpture* (exh. cat.; London: The Tate Gallery, 1986), 15–17.

Georges Braque
Pipe and Compote; Still Life with Pears, Lemons, and Almonds (p. 83)

1. See Douglas Cooper and Gary Tinterow, *The Essential Cubism: Braque, Picasso, and Their Friends, 1907–1920* (New York: George Braziller, 1984), 114.

2. Braque would, for instance, take inspiration from the first of his September 1912 collages, *Fruit Dish and Glass* (private collection, New York), in the conception of an early 1913 canvas, *Fruit Dish, Ace of Clubs*. See William Rubin, *Picasso and Braque: Pioneering Cubism* (exh. cat.; New York: Museum of Modern Art, 1989), 244, 277.

3. Georges Braque, "Thoughts and Reflections," quoted in Douglas Cooper, *Braque: The Great Years* (exh. cat.; Chicago: Art Institute of Chicago, 1972), 33–34.

4. See, for instance, *The Black Guéridon* and *Café-Bar*. Both are reproduced in Raymond Cogniat, *Georges Braque* (New York: Harry N. Abrams, 1976), 104–7.

5. It is worth noting that between 1900 and its entry to the French state collections in the 1960s the early Cézanne belonged to Gaston Bernheim de Villiers, a principal in the Galerie Bernheim-Jeune, where it was exhibited in a Cézanne retrospective in 1926. See *Cézanne* (exh. cat.; New York: Harry N. Abrams/Philadelphia Museum of Art, 1996), cat. 18.

Pierre Bonnard
Portrait of Mademoiselle Renée Monchaty (p. 86)

1. For details of Monchaty's life, see Sarah Whitfield, *Bonnard* (exh. cat.; London: Tate Publishing, 1998), 138. See also Nicholas Watkins, *Bonnard: Colour and Light* (London: Tate Publishing, 1998), 26–28.

2. See Timothy Hyman, *Bonnard* (London: Thames and Hudson, 1998), 112.

3. Sarah Whitfield, "Fragments of an Identical World," in Whitfield, *Bonnard*, 26–27n1.

4. Antoine Terrasse, quoted in ibid., 138.

Edouard Vuillard
The Two English Friends (also known as *Nude in an Interior*) (p. 88)

1. See MaryAnne Stevens in *Edouard Vuillard* (exh. cat.; New Haven, CT: Montreal Museum of Fine Arts and National Gallery of Art, Washington, DC, in association with Yale University Press, 2003), 326.

2. Guy Cogeval and Antoine Salomon, *Vuillard: The Inexhaustible Glance, Critical Catalogue of Paintings and Pastels* (Milan and Paris: Skira and the Wildenstein Institute, 2003), III:1365, no. XI-126.

Aristide Maillol
Nymph (p. 90)

1. Ronald Alley, *Tate Gallery Catalogues: The Foreign Paintings, Drawings, and Sculpture* (London: Tate Gallery, 1959), 131.

2. Bertrand Lorquin, *Aristide Maillol* (New York: Skira/Thames and Hudson, 1995), 112.

3. Pierre Camo, *Maillol, mon ami* (Lausanne: Editions du Grand-Chêne, 1950), 69.

4. See Alley, *Tate Gallery Catalogues*, 131.

Albert Marquet
The Passersby (p. 93)

1. See "Documentary Chronology," in Judi Freeman et al., *The Fauve Landscape* (exh. cat.; New York: Abbeville Press/Los Angeles County Museum of Art, 1990), 81.

2. Marcelle Marquet, *Marquet: Journeys* (Lausanne: International Art Book, 1969), 38.

Fernand Léger
The Bunch of Grapes; Still Life (p. 94)

1. Léger to Georges Charensol, 1924, quoted in Isabelle Monod-Fontaine, Claude Laugier, et al., *Fernand Léger* (exh. cat.; Paris: Centre Georges Pompidou, 1997), 146.

2. Léger, 1927, quoted in ibid., 156.

3. Léger, quoted in Michèle Richet, Claude Laugier, et al., *Fernand Léger* (exh. cat.; Paris: Galeries Nationales du Grand Palais, 1971), 91.

Pablo Picasso
Head of a Woman, Portrait of Marie-Thérèse Walter (p. 98)

1. For a summary of the various accounts of the meeting between Picasso and Walter, see Pierre Daix, *Dictionnaire Picasso* (Paris: Robert Laffont, 1995), 901–3. See also Robert Rosenblum, "Picasso's Blond Muse: The Reign of Marie-Thérèse Walter," in William Rubin, ed., *Picasso and Portraiture: Representation and Transformation* (exh. cat.; New York: Museum of Modern Art, 1996), 337–83.

2. Rosenblum, "Picasso's Blond Muse," 338.

3. See ibid., 342.

Joan Miró
Composition (p. 100)

1. Miró quoted in E. Tériade, "On expose: Joan Miró (Galerie Georges Bernheim, 109, Faubourg Saint-Honoré)," *L'Intransigeant* (May 7, 1928): 4; see also William Jeffett, "Cave Painting and the Assassination of Art: Joan Miró and Surrealism in Paris, 1921–1930," *Aura* 1, no. 1 (January 1993): 66–67. The author would like to thank Anne Umland and William Jeffett for their help.

2. Clement Greenberg, *Joan Miró* (New York: The Quadrangle Press, 1948), 31.

Yves Tanguy
Untitled (p. 102)

1. Tanguy, quoted in *Art Digest*, 1954. See Olivier Berggruen in *Yves Tanguy* (exh. cat.; Paris: Galerie Malingue, 2002), 10.

2. Extract from Paul Eluard, "Yves Tanguy" (1932, trans. Kay Sage Tanguy), quoted in *Yves Tanguy, un recueil de ses oeuvres/A Summary of His Works* (New York: Pierre Matisse, 1963), 13.

René Magritte
Portrait of Mme. A. Thirifays (The Heart Unveiled); The Tempest (pp. 105–6)

1. See Didier Ottinger, ed., *Magritte* (exh. cat.; Montreal: Montreal Museum of Fine Arts, 1996), 231.

2. Magritte to E. L. T. Mesens, June 23, 1936, quoted in David Sylvester and Sarah Whitfield, *René Magritte: Catalogue Raisonné* (London: Philip Wilson, in association with the Menil Foundation and Fonds Mercator, 1993), II:226.

3. See the 1996 interview with André Thirifays at http://www.cinergic.be/. Accessed July 2006.

4. Claude Spaak, 1972, quoted in Sylvester and Whitfield, *René Magritte*, II:227.

5. Both quotes: Magritte, quoted in David Sylvester, *Magritte* (exh. cat.; London: The Arts Council of Great Britain, 1969), 56.

6. "Listening to Georgette Magritte," in *René Magritte* (Chicago: Howard Greenfield/J. Philip O'Hara, 1972), 13.

7. Magritte, quoted in Patrick Waldberg, *René Magritte* (Brussels: A. de Rache, 1965), 169.

8. Magritte to Paul Nougé, November 1927, quoted in Giselle Ollinger-Zinque and Frederik Leen, eds., *Magritte, 1898–1967* (Ghent: Ludion, 1998), 23.

9. Sylvester and Whitfield, *Magritte*, II:194, no. 362.

10. See ibid., *La clef des songes (The Interpretation of Dreams)*, 1930, I:354, no. 332. The two elements are held in the hands of a model in Magritte's 1947 photograph *Queen Semiramis*. See *René Magritte* (exh. cat.; Tokyo: National Museum of Western Art, 1988), 178–79.

Paul Delvaux
The Greeting (The Meeting) (p. 109)

1. André Breton, *Surrealism and Painting*, trans. Simon Watson Taylor (1972; reprint, Boston: MFA Publications ["artWorks"], 2002), 80.

2. Paul Delvaux to Marie-France Saurat, in Roger Thérond, ed., *Encounters with Great Painters* (New York: Harry N. Abrams, 2001), 124.

3. Claude Spaak, *Paul Delvaux* (Antwerp: de Sikkel, 1948), 9.

Giorgio de Chirico
Piazza d'Italia (p. 110)

1. Michael R. Taylor, *Giorgio de Chirico and the Myth of Ariadne* (London: Merrell/Philadelphia Museum of Art, 2002), 15. Taylor offers a comprehensive analysis of the Ariadne series and its aftermath; the Versailles example of the *Ariadne*, as photographed by Eugène Atget, is reproduced on p. 80. See also James Thrall Soby, *Giorgio de Chirico* (New York: Museum of Modern Art, 1955), 52–56.

2. Taylor, *Giorgio de Chirico and the Myth of Ariadne*, 138.

3. Giorgio de Chirico, *Il meccanismo del pensiero: Critica, polemica, autobiografia, 1911–1943*, ed. Maurizio Fagiolo (Turin: Giulio Einaudi, 1985), 20.

Henry Moore
Family Group; Working Model for "Reclining Figure: Bone Skirt" (p. 112)

1. See, for instance, Susan Compton et al., *Henry Moore* (exh. cat.; London: Royal Academy of Arts, 1988), cats. 165, 166.

2. See Dörte Zbikowski, "Der Chacmool als Anregung für Moore's Reclining Figures," in Wilfried Seipel, ed., *Henry Moore, 1898–1986: Eine retrospektive zum 100. Geburtstag* (exh. cat.; Vienna: Kunsthistorisches Museum, 1998), 127–43.

Marc Chagall
Tenderness (p. 114)

1. Quoted in *Marc Chagall: Le Cirque* (exh. cat.; New York: Pierre Matisse Gallery, 1981), n.p.

Joan Miró
The First Spark of Day III (p. 117)

1. For this and other details of Miró's activities in the postwar period, see the chronology compiled by Anne Umland in Carolyn Lanchner, *Joan Miró* (exh. cat.; New York: Museum of Modern Art, 1993), 317–45.

2. Clement Greenberg, *Joan Miró* (New York: The Quadrangle Press, 1948), 44.

3. The facsimile was published by the Pierre Matisse Gallery, which exhibited it along with some of the originals in New York; a similar exhibition was held at the Galerie Berggruen, Paris. See the chronology in Lanchner, *Joan Miró*, 341.

4. "Joan Miró, Propos recueillis par Yvon Taillandier," 1959, quoted in *Joan Miró* (exh. cat.; Paris: Editions des Musées Nationaux, 1974), 34.

Documentation

Pierre-Auguste Renoir
French, 1841–1919
Woman in a Blouse of Chantilly Lace
Femme au corsage de Chantilly
1869
Oil on canvas
81.3 x 65.4 cm (32 x 25¾ in.)
Signed and dated lower left: Renoir 69
Photo by Melville McLean, 2003. Courtesy,
Portland Museum of Art, Maine.

PROVENANCE
Bernheim-Jeune et Cie., Paris; by descent to
Hugo Nathan, Frankfurt; Martha Nathan,
Geneva; Max Moos, Geneva; Scott M. Black
(acquired Christie's, New York, November 6,
2001, Lot 32: Impressionist and Modern Art
Including the Collection of René Gaffé).

SELECTED EXHIBITIONS
1913. Paris, Bernheim-Jeune et Cie., "Renoir,"
March 1913.
1956. Vevey, Musée Jenisch, "Renoir,"
July–September.
1959. Paris, Musée du Petit Palais, "De Géricault
à Matisse, chefs-d'oeuvres des collections suiss-
es," March–May.

SUGGESTED READINGS
Mirbeau, Octave. *Renoir*. Paris: Bernheim-Jeune,
1913, 33.
George, Waldemar, and René Huygue. "Genèse
d'une crise." In *L'amour de l'art*. Paris: Editions
Auguste Picard, 1932, 272.
Drucker, Michel, and Germain Bazin. *Renoir*.
Paris: P. Tisné, 1944, 182.
Chamson, André, and François Daulte. *Chefs-
d'oeuvre d'art français des collections suisses: De
Géricault à Matisse*. Paris: Art et Style, no. 50,
1959, xviii.
Daulte, François. *Auguste Renoir: Catalogue raison-
né de l'oeuvre peint*. Lausanne: Durand-Ruel,
1971, I:100–101, no. 46.

Camille Pissarro
French (born in the Danish West Indies),
1830–1903
Portrait of Père Papeille, Pontoise
Portrait de Père Papeille, Pontoise
about 1874
Pastel on paper mounted on board
54 x 44.5 cm (21¼ x 17½ in.)
Signed lower right: C. Pissarro
Photo by Meyersphoto.com. Courtesy, Portland
Museum of Art, Maine.

PROVENANCE
H. Cottereau, Paris; Galerie Urban, Paris; Mr.
and Mrs. Franklin N. Groves; Scott M. Black
(acquired Christie's, New York, November 15,
1988, Lot 111: Impressionist and Modern
Drawings and Watercolors).

SELECTED EXHIBITIONS
1992. Boston, Museum of Fine Arts, "Prized
Possessions: European Paintings from Private
Collections of Friends of the Museum of Fine
Arts," June 17–August 16.
1999. Portland Museum of Art, "Pursuing a
Passion: The Scott M. Black Collection," March
9–May 16.

SUGGESTED READINGS
Venturi, Lionello, and Ludovic Rodo Pissarro.
Camille Pissarro, son art—son oeuvre. Paris: P.
Rosenberg, 1939, I:290, no. 1523; II: pl. 293.
Pissarro, Joachim. *Camille Pissarro*. New York:
Harry N. Abrams, 1993, 283.

Portrait of Monsieur Louis Estruc
Portrait de Monsieur Louis Estruc
about 1876
Pastel on paper, laid on canvas
46.4 x 38.4 cm (18¼ x 15 in.)
Signed upper right: C. Pissarro
Photo by Benjamin Magro. Courtesy, Portland
Museum of Art, Maine.

PROVENANCE
Eugénie Estruc, Paris; Emile Leboeuf, Paris;
Scott M. Black (acquired Sotheby's, New York,
November 6, 2002, Lot 107: Impressionist and
Modern Art).

SUGGESTED READINGS
Venturi, Lionello, and Ludovic Rodo Pissarro.
Camille Pissarro, son art—son oeuvre. Paris: P.
Rosenberg, 1939, I:290, no. 1522; II: pl. 293.

Paul Cézanne
French, 1839–1906
Trees in the Jas de Bouffan
Arbres au Jas de Bouffan (also called *Bosquet au Jas de
Bouffan*)
about 1874
Oil on canvas
54.3 x 73.7 cm (21½ x 29 in.)
Photo by Melville D. McLean. Courtesy, Portland
Museum of Art, Maine.

PROVENANCE
Ambroise Vollard, Paris; Harry Graf Kessler,
Weimar; Bernheim-Jeune, Paris; Gustave Fayet,
Béziers and Paris; Mme. Friedlander-Fuld,
Berlin; Baronne Goldschmidt-Rothschild, Berlin
and Paris; Morris Guttman, New York; Mr. and

Mrs. John Loeb, New York; Knoedler Galleries,
New York; M. Lespagnol, Paris; Brame et
Lorenceau, Paris; Scott M. Black (acquired
Sotheby's, New York, November 8, 1995, Lot 25:
Impressionist and Modern Art).

SELECTED EXHIBITIONS
1939. Belgrade, Palais du Prince Paul, "La pein-
ture française au XIXème siècle."
1961. New York, The Metropolitan Museum of
Art, "Paintings from Private Collections"
(Summer Loan Exhibition).
1963. New York, The Metropolitan Museum of
Art, "Paintings from Private Collections"
(Summer Loan Exhibition).
1968. New York, The Metropolitan Museum of
Art, "New York Collects: Paintings, Watercolors
and Sculptures from Private Collections."
1974. Tokyo, National Museum of Western Art;
Kyoto, City Art Museum; Fukuoka, Cultural
Center, "Cézanne."
1975. New York, Wildenstein & Co., "Nature as
Scene: French Landscape Painting from Poussin
to Bonnard."
1993. Kunsthalle, Tübingen, "Cézanne
Gemälde."
1998. Portland Museum of Art, "Impressions of
the Riviera: Monet, Renoir, Matisse and their
Contemporaries," June 25–October 18.
1999. Portland Museum of Art, "Pursuing a
Passion: The Scott M. Black Collection," March
9–May 16.
2006. Washington, DC, National Gallery of Art,
"Cézanne in Provence," January 29–May 7.
2006. Portland Museum of Art, "Paris and the
Countryside: Modern Life in Late-19th-Century
France," June 23–October 15.

SUGGESTED READINGS
Rewald, John. *Cézanne, a Biography*. New York:
Harry N. Abrams, 1986.
Rewald, John, et al. *The Paintings of Paul Cézanne,
a Catalogue Raisonné*. New York: Harry N. Abrams,
1997, I:182–83, no. 267 (as *Bosquet au Jas de
Bouffan*); II:86.

Claude Monet
French, 1840–1926
The Seine at Lavacourt
La Seine à Lavacourt
1878
Oil on canvas
56 x 73.7 cm (22 x 29 in.)
Signed and dated lower right: 1878 Claude Monet
Photo by Meyersphoto.com. Courtesy, Portland
Museum of Art, Maine.

PROVENANCE

Possibly Charles Deudon, Paris (see p. 118, note 1); Charles Guasco, Paris (sold Galerie Georges Petit, June 11, 1900, Lot 53); Jules Strauss, Paris; Josef Stransky, New York; 1921, Bernheim-Jeune, Paris; 1921, H. J. Laroche, Paris; Jane Renouardt, Paris; Wildenstein & Co., London; by 1935, Charlesworth, Great Britain; by 1945, Sir Stephenson Kent, London; Lady Kent, London (sold Galerie Charpentier, Paris, March 18, 1959, Lot 9); private collection (sold Sotheby's, London, June 25, 1985, Lot 12); sale, Millon & Robert, March 25, 1994, Lot 42; sale, Millon & Robert, December 2, 1998, Lot 39; Wildenstein & Co.; private collection; Scott M. Black (acquired Sotheby's, New York, November 5, 2003, Lot 8: Impressionist and Modern Art).

SELECTED EXHIBITIONS

2006. Portland Museum of Art, "Paris and the Countryside: Modern Life in Late-19th-Century France," June 23–October 15.

SUGGESTED READINGS

Mauclair, Camille. *Claude Monet.* Paris: F. Rieder & Cie., 1924, pl. 22.
Malingue, Maurice. *Claude Monet.* Monaco: Les documents d'art, 1943, 87.
Gordon, Robert, and Andrew Forge. *Monet.* New York: Harry N. Abrams, 1983.
Kendall, Richard. *Monet by Himself: Paintings, Drawings, Pastels, Letters.* Trans. Bridget Strevens Romer. London: Macdonald Orbis, 1989.
Wildenstein, Daniel. *Monet, or, The Triumph of Impressionism: Catalogue Raisonné.* Rev. ed. 4 vols. Cologne: Taschen, 1996, II:190, no. 475.
Thomson, Richard, and Michael Clarke. *Monet: The Seine and the Sea.* Exh. cat. Edinburgh: National Galleries of Scotland, 2003.

Claude Monet

French, 1840–1926

The Manneporte Seen from Below
La Manneporte vue en aval
1883
Oil on canvas
73 x 92 cm (29 x 36¼ in.)
Stamped lower right: Claude Monet
Photo by Meyersphoto.com. Courtesy, Portland Museum of Art, Maine.

PROVENANCE

Michel Monet, Giverny; William Goetz, Beverly Hills; Sam Salz, New York; sale, Sotheby's, London, December 1, 1971, Lot 10; Marlborough Gallery, London; sale, Sotheby's, New York, May 21, 1981, Lot 521; Scott M. Black (acquired Christie's, New York, May 5, 1998, Lot 25: Impressionist and 19th-Century Art).

SELECTED EXHIBITIONS

1996. London, Marlborough Fine Art Ltd., "19th and 20th Century Masters," July–August.
1999. Portland Museum of Art, "Pursuing a Passion: The Scott M. Black Collection," March 9–May 16.
2006. Portland Museum of Art, "Paris and the Countryside: Modern Life in Late-19th-Century France," June 23–October 15.

SUGGESTED READINGS

Reutersward, Oscar. *Monet en konstnärshistorik.* Stockholm: A. Bonniers Förlag, 1948, 284.
Gordon, Robert, and Andrew Forge. *Monet.* New York: Abrams, 1983.
Kendall, Richard. *Monet by Himself: Paintings, Drawings, Pastels, Letters.* Trans. Bridget Strevens Romer. London: Macdonald Orbis, 1989.
Wildenstein, Daniel. *Monet, or, The Triumph of Impressionism.* Rev. ed. 4 vols. Cologne: Taschen, 1996, II:307, 309–10, no. 833.
Thomson, Richard, and Michael Clarke. *Monet: The Seine and the Sea.* Exh. cat. Edinburgh: National Galleries of Scotland, 2003.

Claude Monet

French, 1840–1926

Monte Carlo Seen from Roquebrune
Monte Carlo vu de Roquebrune
1884
Oil on canvas
66 x 81.3 cm (26 x 32 in.)
Signed lower center: Claude Monet
Photo by Benjamin Magro. Courtesy, Portland Museum of Art, Maine.

PROVENANCE

September 1891, purchased from the artist by Hammam for Knoedler, New York; Potter Palmer, Chicago; Wildenstein & Co.; Somlo, New York; sale, Sotheby's, London, April 5, 1978, Lot 9; sale, Christie's, New York, May 14, 1986; Scott M. Black (acquired Christie's, New York: May 14, 1986, Lot 15: Impressionist and Modern Paintings and Sculpture, Part 1).

SELECTED EXHIBITIONS

1992. Boston, Museum of Fine Arts, "Prized Possessions: European Paintings from Private Collections of Friends of the Museum of Fine Arts," June 17–August 16.
1997–98. Fort Worth, Kimbell Art Museum, "Monet and the Mediterranean," June 8–September 7; New York, Brooklyn Museum of Art, October 10, 1997–January 4, 1998.
1998. Portland Museum of Art, "Impressions of the Riviera: Monet, Renoir, Matisse and Their Contemporaries," June 25–October 18.
1999. Portland Museum of Art, "Pursuing a Passion: The Scott M. Black Collection," March 9–May 16.

2006. Portland Museum of Art, "Paris and the Countryside: Modern Life in Late-19th-Century France," June 23–October 15.

SUGGESTED READINGS

Hoschedé, Jean Pierre. *Claude Monet, ce mal connu; Intimité familiale d'un demi siècle à Giverny de 1883 à 1926.* Geneva: P. Cailler, 1960.
Kendall, Richard. *Monet by Himself: Paintings, Drawings, Pastels, Letters.* Trans. Bridget Strevens Romer. London: Macdonald Orbis, 1989.
Wildenstein, Daniel. *Monet, or, The Triumph of Impressionism: Catalogue Raisonné.* Rev. ed. 4 vols. Cologne: Taschen, 1996, II:333–34, no. 892.

Eugène Boudin

French, 1824–1898

Beach Scene near Trouville
Scène de plage aux environs de Trouville
1886
Oil on panel
16 x 35.2 cm (6¼ x 14 in.)
Signed lower left: E. Boudin; dated lower right: 1886
Photo by Meyersphoto.com. Courtesy, Portland Museum of Art, Maine.

PROVENANCE

Allard, Paris; William S. Paley, New York; by descent to private collection; Scott M. Black (acquired Christie's, New York, November 3, 2004, Lot 22: Impressionist and Modern Art).

SELECTED EXHIBITIONS

2006. Portland Museum of Art, "Paris and the Countryside: Modern Life in Late-19th-Century France," June 23–October 15.

SUGGESTED READINGS

Schmit, Robert. *Eugène Boudin, 1824–1898.* Paris: Schmit, 1973, II:326, no. 2169.

Pierre-Auguste Renoir

French, 1841–1919

Bust of a Woman
Buste de femme
about 1885
Pastel on paper
46 x 38 cm (18 x 15 in.)
Signed upper left: Renoir
Photo by Meyersphoto.com. Courtesy, Portland Museum of Art, Maine.

PROVENANCE

Georges Bernheim, Paris; Roulier Galleries, Chicago; Mr. and Mrs. Henry Regnory, Chicago; J.&S. Graphics, Inc., Chicago; August 14, 1974, William John Upjohn; Scott M. Black (acquired Christie's, New York; November 8, 2000, Lot 20: Impressionist and Modern Art).

SELECTED EXHIBITIONS
1933. Paris, Galerie Bernheim-Jeune, "Exposition des pastels français."

SUGGESTED READINGS
Bailey, Colin B., John B. Collins, Linda Nochlin, and Anne Distel. *Renoir's Portraits, Impressions of an Age.* New Haven, CT: Yale University Press, in association with the National Gallery of Canada, 1997.

Head of a Woman
Tête de femme
about 1887
Oil on canvas
31 x 25.5 cm (12¼ x 10 in.)
Signed upper left: Renoir
Courtesy, Portland Museum of Art, Maine.

PROVENANCE
Ambroise Vollard, Paris; Martin Fabiani, Paris; Leonard Benatov, Paris; Ernest Gutzwiller; Scott M. Black (acquired Sotheby's, London, June 24, 1996, Lot 15: Impressionist Art from the Gutzwiller Collection).

SELECTED EXHIBITIONS
1999. Portland Museum of Art, "Pursuing a Passion: The Scott M. Black Collection," March 9–May 16.

SUGGESTED READINGS
Vollard, Ambroise. *Tableaux, pastels et dessins de Pierre-Auguste Renoir.* Paris: A. Vollard, 1918, no. 47.
Daulte, François. *Auguste Renoir: Catalogue raisonné de l'oeuvre peint.* Lausanne: Durand-Ruel, 1971, I:332–33, no. 516.

Edgar Degas
French, 1834–1917

Pagans and Degas's Father
Pagans et le père de Degas
about 1895
Oil on canvas
81.3 x 83.8 cm (32 x 33 in.)

PROVENANCE
Henri Fèvre, Monte Carlo (sold 1925); Galerie Durand-Ruel, Paris; Sam Salz Inc., New York; 1957, Henry Ford II; Scott M. Black (acquired Sotheby's, New York: November 12, 1990, Lot 9: Impressionist and Modern Paintings, Drawings and Sculptures from the Estate of Henry Ford II).

SELECTED EXHIBITIONS
1926. Paris, Galerie Durand-Ruel, "Degas."
1932. New York, Durand-Ruel Gallery, "Degas."
1957. Detroit Institute of Arts.
1991. Portland Museum of Art, "Impressionism and Post-Impressionism: The Collector's Passion," July 30–October 14.

1992. Boston, Museum of Fine Arts, "Prized Possessions, European Paintings from Private Collections of Friends of the Museum of Fine Arts, Boston," June 17–August 16.
1996–97. London, National Gallery, "Degas: Beyond Impressionism," May 22–August 26, 1996; Art Institute of Chicago, September 28, 1996–January 5, 1997.
1999. Portland Museum of Art, "Pursuing a Passion: The Scott M. Black Collection," March 9–May 16.
2006. Portland Museum of Art, "Paris and the Countryside: Modern Life in Late-19th-Century France," June 23–October 15.

SUGGESTED READINGS
Lemoisne, Paul-André. *Degas et son oeuvre.* Paris: Arts et métiers graphiques, 1947, II:182–83, no. 345.
Boggs, Jean Sutherland. *Portraits by Degas.* Berkeley and Los Angeles: University of California Press, 1962, 56, 127, pl. 115.
Boggs, Jean Sutherland. "Degas at the Museum: Works in the Philadelphia Museum of Art and John G. Johnson Collection." *Philadelphia Museum of Art Bulletin* 81, no. 347 (Spring 1985).
Boggs, Jean Sutherland, et al. *Degas.* Exh. cat. New York: The Metropolitan Museum of Art, 1988, 534.
Loyrette, Henri. *Degas.* Paris: Fayard, 1991.

Edgar Degas
French, 1834–1917

Seated Dancer
Danseuse assise
1895–1900
Pastel on joined paper mounted on board
54 x 45 cm (21¼ x 17¾ in.)
Stamped lower left: Degas
Photo by Melville D. McLean. Courtesy, Portland Museum of Art, Maine.

PROVENANCE
The artist's studio (sold Galerie Georges Petit, May 6, 1918, Lot 257); René de Gas, Paris; Ambroise Vollard, Paris; Georges Bernheim, Paris; Scott M. Black (acquired Christie's, New York, May 12, 1993, Lot 6: Impressionist and Modern Paintings, Drawings and Sculpture).

SELECTED EXHIBITIONS
1932. Paris, Galerie Paul Rosenberg, "Dessins et pastels de Degas," December.
1953. Baltimore, Museum of Art.
1999. Portland Museum of Art, "Pursuing a Passion: The Scott M. Black Collection," March 9–May 16.
2006. Portland Museum of Art, "Paris and the Countryside: Modern Life in Late-19th-Century France," June 23–October 15.

SUGGESTED READINGS
Lemoisne, Paul-André. *Degas et son oeuvre.* Paris: Arts et métiers graphiques, 1947, III:672–73, no. 1158.
Kendall, Richard. *Degas by Himself, Drawings, Prints, Paintings, Writings.* London: MacDonald Orbis, 1987.
Boggs, Jean Sutherland, and Anne Maheux. *Degas Pastels.* New York: George Braziller, 1992.

Mary Cassatt
American (active in France), 1844–1926

Simone in a Plumed Hat
Simone coiffée d'un chapeau à plume
about 1903
Pastel over counterproof on paper
61 x 50 cm (24 x 19¾ in.)
Photo by Melville D. McLean. Courtesy, Portland Museum of Art, Maine.

PROVENANCE
Ambroise Vollard, Paris (from the artist); Arthur Tooth & Sons, London; May 1954, A. Chester Beatty, Jr.; Trustees of the Helen Gertrude Chester Beatty Will Trust; Scott M. Black (acquired Sotheby's, London, June 25, 1991, Lot 2: Impressionist, Modern and Contemporary Art).

SELECTED EXHIBITIONS
1966–67. Liverpool, Walker Art Gallery, "American Artists in Europe, 1800–1900."
1991. Portland Museum of Art, "Impressionism and Post-Impressionism: The Collector's Passion," July 30–October 14.
1992. Boston, Museum of Fine Arts, "Prized Possessions: European Paintings from Private Collections of Friends of the Museum of Fine Arts," June 17–August 16.
1999. Portland Museum of Art, "Pursuing a Passion: The Scott M. Black Collection," March 9– May 16.
2006. Portland Museum of Art, "Paris and the Countryside: Modern Life in Late-19th-Century France," June 23–October 15.

SUGGESTED READINGS
Segard, Achille. *Mary Cassatt, un peintre des enfants et des mères.* Paris: Société d'Editions Littéraires et Artistiques, Librairie Paul Ollendorf, 1913.
Breeskin, Adelyn D. *Mary Cassatt; A Catalogue Raisonné of the Oils, Pastels, Watercolors, and Drawings.* Washington, DC: Smithsonian Institution Press, 1970, 174, no. 446.
Mathews, Nancy Mowll. *Mary Cassatt.* New York: Harry N. Abrams, in association with The National Museum of American Art, Smithsonian Institution, 1987.
Mathews, Nancy Mowll. *Cassatt, a Retrospective.* Westport, CT: Hugh Lauter Levin Assciates, 1996.
Rosen, Marc, and Susan Pinsky. *Mary Cassatt, Prints and Drawings from the Artist's Studio.* Princeton, NJ: Princeton University Press, 2000.

Camille Pissarro
French (born in the Danish West Indies),
1830–1903

Gardener Standing by a Haystack, Overcast Sky, Eragny
(also known as *Gray Weather, Morning with Figures, Eragny*)
Jardinier devant une meule, temps gris, Eragny (also
known as *Temps gris, matin avec figures, Eragny*)
1899
Oil on canvas
60 x 73 cm (23½ x 28¾ in.)
Signed lower left: C. Pissarro, 99
Photo by Melville D. McLean. Courtesy, Portland
Museum of Art, Maine.

PROVENANCE
Robert E. Eisner, New York; sale, Sotheby's, New
York, May 9, 1989, Lot 28C; Wildenstein & Co.,
New York; Scott M. Black (acquired Christie's,
New York, May 12, 1999, Lot 20: Impressionist
and Nineteenth-Century Art).

SELECTED EXHIBITIONS
1965. New York, Wildenstein & Co., "Pissarro."
1991. Portland Museum of Art, "Impressionism
and Post-Impressionism: The Collector's
Passion," July 30–October 14.
1992. Boston, Museum of Fine Arts, "Prized
Possessions: European Paintings from Private
Collections of Friends of the Museum of Fine
Arts," June 17–August 16.
2006. Portland Museum of Art, "Paris and the
Countryside: Modern Life in Late-19th-Century
France," June 23–October 15.

SUGGESTED READINGS
Venturi, Lionello, and Ludovic Rodo Pissarro.
Camille Pissarro, son art—son oeuvre. Paris: P.
Rosenberg, 1939, I:231, no. 1080; II: pl. 216.
Pissarro, Joachim, and Claire Durand-Ruel
Snollaerts. *Pissarro: Critical Catalogue of Paintings.*
Trans. Mark Hutchinson and Michael Taylor.
Milan: Skira; Paris: Wildenstein Institute
Publications; New York: Rizzoli, 2005, III:793, no.
1278 (as *Gardener Standing by a Haystack, Overcast
Sky, Eragny*).

Camille Pissarro
French (born in the Danish West Indies),
1830–1903

The Louvre, Winter Sunlight, Morning
Le Louvre, soleil d'hiver, matin
1901
Oil on canvas
74 x 92 cm (29 x 36¼ in.)
Signed and dated lower left: C. Pissarro 1901
Photo by Meyersphoto.com.
Courtesy, Portland Museum of Art, Maine.

PROVENANCE
Julie Pissarro; 1921, Georges Manzana-Pissarro;
before 1930, Emile Laffon, Paris; A.&R. Ball,
New York; 1954, M. Knoedler & Co., New York;
1954, Pamela Woolworth; Mr. and Mrs. Norman
B. Woolworth, Monmouth, Maine (sold Parke-
Bernet Galleries, New York, October 31, 1962,
Lot 17); Carrie S. Beinecke (sold Christie's,
London, October 18, 1977, Lot 23); private col-
lection; Scott M. Black (acquired Sotheby's, New
York, November 2, 2005, Lot 56: Impressionist
and Modern Art).

SELECTED EXHIBITIONS
1930. Paris, Musée de l'Orangerie, "Exposition
centenaire de la naissance de l'artiste," no. 113
(titled *La Seine et le Louvre*).
2006 Portland Museum of Art, "Paris and the
Countryside: Modern Life in Late-19th-Century
France," June 23–October 15.

SUGGESTED READINGS
Venturi, Lionello, and Ludovic Rodo Pissarro.
Camille Pissarro, son art—son oeuvre. Paris: P.
Rosenberg, 1939, I:242, no. 1165; II: pl. 230.
Pissarro, Joachim, and Richard R. Brettell. *The
Impressionist and the City: Pissarro's Series Paintings.*
Ed. Mary Anne Stevens. Exh. cat. New Haven,
CT: Yale University Press, 1992.
Pissarro, Joachim. *Camille Pissarro.* New York:
Harry N. Abrams, 1993.
Pissarro, Joachim, and Claire Durand-Ruel
Snollaerts. *Pissarro. Critical Catalogue of Paintings.*
Trans. Mark Hutchinson and Michael Taylor.
Milan: Skira; Paris: Wildenstein Institute
Publications; New York: Rizzoli, 2005, III:861,
no. 1404.

Auguste Rodin
French, 1840–1917

The Thinker
Le penseur
Modeled about 1880–81; this version cast later
by Alexis Rudier
Bronze with dark brown and green patina
38 x 16.5 x 23.5 cm (15 x 6½ x 9¼ in.)
Signed: A. Rodin; inscribed: ALEXIS RUDIER.
FONDEUR. PARIS. 1ere Epreuve; raised signature
inside: A. Rodin

PROVENANCE
Anonymous sale, Parke-Bernet Galleries, Inc.,
October 29, 1970, Lot 8; Scott M. Black
(acquired Christie's, New York, November 16,
1988, Lot 256: Impressionist and Modern
Paintings and Sculpture).

SELECTED EXHIBITIONS
1991. Portland Museum of Art, "Impressionism
and Post-Impressionism: The Collector's
Passion," July 30–October 14.

1999. Portland Museum of Art, "Pursuing a
Passion: The Scott M. Black Collection," March
9–May 16.

Eve
Modeled about 1881; this version cast about
1920 by Alexis Rudier
Bronze
75 x 23 x 29.2 cm (29½ x 9 x 11½ in.)
Signed and inscribed: A. Rodin /Alexis Rudier
Fondeur, Paris; also signed with raised signature
on the underside

PROVENANCE
Fine Arts Associates, New York; 1957, private col-
lection; Scott M. Black (acquired Sotheby's, New
York, May 18, 1990, Lot 306A: Impressionist and
Modern Art).

SELECTED EXHIBITIONS
1991. Portland Museum of Art, "Impressionism
and Post-Impressionism: The Collector's
Passion," July 30–October 14.
1999. Portland Museum of Art, "Pursuing a
Passion: The Scott M. Black Collection," March
9–May 16.

Kneeling Fauness
Faunesse à genoux
Modeled about 1884; this version cast later by
Alexis Rudier
Bronze
52 x 20.3 x 28 cm (20½ x 8 x 11 in.)
Signed and stamped with foundry mark:
A. Rodin /Alexis Rudier Fondeur Paris

PROVENANCE
Sale, Sotheby's, Monaco, November 25, 1978,
Lot 74; Scott M. Black (acquired Sotheby's,
London, June 26, 1985, Lot 117: Impressionist
and Modern Paintings and Sculpture).

SELECTED EXHIBITIONS
1991. Portland Museum of Art, "Impressionism
and Post-Impressionism: The Collector's
Passion," July 30–October 14.
1999. Portland Museum of Art, "Pursuing a
Passion: The Scott M. Black Collection," March
9–May 16.

Bather (known as *The Zoubaloff Bather*)
Baigneuse (known as *Baigneuse Zoubaloff*)
Modeled in 1888; this version cast before 1952
by Alexis Rudier
Bronze with dark brown patina
35.6 x 16.8 x 21.6 cm (14 x 6⅝ x 8½ in.)
Signed and inscribed with foundry mark: A.
Rodin /Alexis Rudier Fondeur Paris
Photo by Benjamin Magro. Courtesy, Portland
Museum of Art, Maine.

PROVENANCE
Maurice Fenaille; by descent to Philippe Cochin de Billy (grandson of Maurice Fenaille); Scott M. Black (acquired Sotheby's, New York, November 14, 1985, Lot 218: Impressionist and Modern Paintings and Sculpture).

SELECTED EXHIBITIONS
1991. Portland Museum of Art, "Impressionism and Post-Impressionism: The Collector's Passion," July 30–October 14.
1999. Portland Museum of Art, "Pursuing a Passion: The Scott M. Black Collection," March 9–May 16.

The Prodigal Son
Le fils prodigue
Modeled about 1886; this version cast before 1952 by Alexis Rudier
Bronze with green and black patina
56 x 23 x 26 cm (22 x 9 x 10¼ in.)
Signed on top of base: A. Rodin; inscribed with foundry mark on back of base: Alexis Rudier. Fondeur. PARIS.

PROVENANCE
Rudier family, Paris; B. C. Holland Gallery, Chicago; 1965, Steven and Ursula Schwartz; Scott M. Black (acquired Christie's, New York, May 15, 1997, Lot 360: Impressionist and Modern Paintings, Drawings and Sculpture, Part 2).

SELECTED EXHIBITIONS
1999. Portland Museum of Art, "Pursuing a Passion: The Scott M. Black Collection," March 9–May 16.

Fugit Amor
Modeled before 1887; this version cast in 1964 by Georges Rudier
Bronze with dark brown and green patina
36.8 x 48.2 x 16.5 cm (14½ x 19 x 6½ in.)
Signed and inscribed: Georges Rudier. / Fondeur. Paris / © by Musée Rodin. 1964; raised signature inside

PROVENANCE
Scott M. Black (acquired Christie's, New York, November 13, 1985, Lot 259: Impressionist and Modern Paintings and Sculpture).

SELECTED EXHIBITIONS
1991. Portland Museum of Art, "Impressionism and Post-Impressionism: The Collector's Passion," July 30–October 14.
1999. Portland Museum of Art, "Pursuing a Passion: The Scott M. Black Collection," March 9–May 16.

Triumphant Youth
La jeunesse triomphante
Modeled about 1894; this version cast after 1898 by Thiébaut et Frères
Bronze with dark brown and green patina
50.2 x 30.5 x 30.5 cm (19¾ x 12 x 12 in.)
Signed and stamped: THIÉBAUT FRÈRES / FUMIERE / ET CIE. SUCR. / PARIS; numbered: 8eme Epreuve

PROVENANCE
Scott M. Black (acquired Christie's, New York, February 13, 1986, Lot 22: Impressionist and Modern Paintings, Drawings and Sculpture).

SELECTED EXHIBITIONS
1991. Portland Museum of Art, "Impressionism and Post-Impressionism: The Collector's Passion," July 30–October 14.
1999. Portland Museum of Art, "Pursuing a Passion: The Scott M. Black Collection," March 9–May 16.

SUGGESTED READINGS
Bénédicte, Léonce. *Catalogue sommaire des oeuvres d'Auguste Rodin et autres oeuvres d'art de la donation Rodin, exposées à l'Hôtel Biron, 77, rue de Varenne.* Paris: Imprimerie Beresniak, 1922.
Tancock, John L. *The Sculpture of Auguste Rodin.* Boston: David R. Godine, in association with the Philadelphia Museum of Art, 1976.
Elsen, Albert E., et al. *Rodin Rediscovered.* Washington, DC: National Gallery of Art, 1981.
Elsen, Albert E. *The Gates of Hell by Auguste Rodin.* Stanford, CA: Stanford University Press, 1985.
Butler, Ruth. *Rodin: The Shape of Genius.* New Haven, CT: Yale University Press, 1993.
Le Normand-Romain, Antoinette, and Hélène Marraud. *Rodin à Meudon, La Villa des Brillants.* Paris: Musée Rodin, 1996.
Le Normand-Romain, Antoinette, et al. *Rodin en 1900, l'Exposition de l'Alma.* Exh. cat. Paris: Musée du Luxembourg, Musée Rodin, and Réunion des Musées Nationaux, 2001.
Rodin, A Magnificent Obsession. London and Los Angeles: Merrell, in association with the Iris and B. Gerald Cantor Foundation; New York: Rizzoli, distributed through St. Martin's Press, 2001.

Henri de Toulouse-Lautrec
French, 1864–1901

Two Women Making Their Bed
Deux femmes faisant leur lit
1891
Oil on board
60 x 79.4 cm (23½ x 31¼ in.)
Signed lower left: HTLautrec / à Albert 91
Photo by Melville McLean. Courtesy, Portland Museum of Art, Maine.

PROVENANCE
Joseph (?) Albert, Paris; Petiet; private collection, Switzerland; sale, Enghien, France, November 23, 1986, Lot 59; Scott M. Black (acquired Christie's, New York, November 18, 1998, Lot 44: Impressionist and Nineteenth-Century Art).

SELECTED EXHIBITIONS
1914. Paris, Galerie Rosenberg.
1959. Paris, Musée Jacquemart-André, "Chefs-d'oeuvre de Toulouse-Lautrec," March 10–April 30.
1960. Paris, Musée National d'Art Moderne, "Les sources du XX siècle."
1961. London, Tate Gallery, "Toulouse-Lautrec."
1961–62. Munich, Haus der Kunst, "Toulouse Lautrec," October 17–December 17, 1961; Cologne, Wallraf-Richartz Museum, December 29, 1961–February 25, 1962.
1967–68. Stockholm, Nationalmuseum, "Toulouse Lautrec," December 26, 1967–March 3, 1968.
1968. Humlebaek, Denmark, Louisiana Museum, "Toulouse-Lautrec," March–April.
1969. Tokyo, National Museum of Western Art, "Toulouse-Lautrec," January–February.
1976. Albi, Musée Toulouse-Lautrec, "Toulouse-Lautrec."
1999. Portland Museum of Art, "Pursuing a Passion: The Scott M. Black Collection," March 9–May 16.
2006. Portland Museum of Art, "Paris and the Countryside: Modern Life in Late-19th-Century France," June 23–October 15.

SUGGESTED READINGS
Coquiot, Gustave. *H. de Toulouse-Lautrec.* Paris: A. Blaizot, 1913.
Joyant, Maurice. *Henri de Toulouse-Lautrec, 1864–1901, peintre.* Paris: H. Floury, 1926, 284.
Dortu, M. G. *Toulouse-Lautrec et son oeuvre.* New York: Collectors Editions, 1971. II:308–309, no. 503.
Denvir, Bernard. *Toulouse-Lautrec.* London: Thames and Hudson, 1991.
Frèches, Claire, José Frèches. *Toulouse-Lautrec: Les lumières de la nuit.* Paris: Gallimard and Réunion des Musées Nationaux, 1991.
Roquebert, Anne. *Le Paris de Toulouse-Lautrec.* Paris: Hachette and Réunion des Musées Nationaux, 1992.
Thomson, Richard, Claire Frèches-Thory, et al. *Toulouse-Lautrec.* Exh. cat. London: South Bank Centre, 1992.

Emile Bernard
French, 1868–1941

Springtime (also known as *Madeleine in the Bois d'Amour*)
Le printemps (also known as *Madeleine au Bois d'Amour*)
1892
Oil on cardboard
74 x 100.2 cm (29 x 39½ in.)
Signed lower right: E. Bernard 1892
© 2006 Artists Rights Society (ARS), New York/ADAGP, Paris.

PROVENANCE
Ambroise Vollard, Paris; William Mazer; Scott M. Black (acquired Christie's, New York, November 18, 1998, Lot 21: Impressionist and Nineteenth-Century Art).

SELECTED EXHIBITIONS
1999. Portland Museum of Art, "Pursuing a Passion: The Scott M. Black Collection," March 9–May 16.
2006. Portland Museum of Art, "Paris and the Countryside: Modern Life in Late-19th-Century France," June 23–October 15.

SUGGESTED READINGS
Luthi, Jean-Jacques. *Emile Bernard, catalogue raisonné de l'oeuvre peint.* Paris: Editions Side, 1982, 42, no. 256 (as *Madeleine au Bois d'Amour*, 1890, ill.); 59, no. 364 (as *Printemps*, not ill.).
Stevens, MaryAnne. *Emile Bernard, 1868–1941, a Pioneer of Modern Art.* Exh. cat. Mannheim: Städtische Kunsthalle; Amsterdam: Van Gogh Museum; Zwolle. Waanders Publishers, 1990.

Maurice Denis
French, 1870–1943

The First Steps of Noële
Les premiers pas de Noële
1897
Oil on board
47 x 62.2 cm (18⅛ x 24½ in.)
Signed and dated lower left: MAUD 97
© 2006 Artists Rights Society (ARS), New York/ADAGP, Paris.
Photo by Meyersphoto.com. Courtesy, Portland Museum of Art, Maine.

PROVENANCE
Estate of the artist; sale, Paris, Christian de Quay, November 17, 1994, Lot 335: Importants Tableaux Modernes; Scott M. Black (acquired Sotheby's, New York, May 2, 1996, Lot 158: Impressionist and Modern Art).

SELECTED EXHIBITIONS
1996. Boston, Museum of Fine Arts, "Gauguin and the School of Pont-Aven," June 26–September 15.
1999. Portland Museum of Art, "Pursuing a Passion: The Scott M. Black Collection," March 9–May 16.
2006. Portland Museum of Art, "Paris and the Countryside: Modern Life in Late-19th-Century France," June 23–October 15.

SUGGESTED READINGS
Frèches-Thory, Claire and Antoine Terrasse. *The Nabis, Bonnard, Vuillard, and Their Circle.* New York: Harry N. Abrams, 1991.
Bouillon, Jean-Paul. *Maurice Denis.* Geneva: Skira, 1993.
Frèches-Thory, Claire, and Ursula Perucchi-Petri. *Nabis, 1888–1900: Pierre Bonnard, Maurice Denis, Henri-Gabriel Ibels, Georges Lacombe, Aristide Maillol, Paul Elie Ranson, Jozsef Rippl-Ronai, Ker-Xavier Roussel, Paul Sérusier, Félix Vallotton, Jan Verkade, Edouard Vuillard.* Exh. cat. Munich: Prestel-Verlag; Paris: Réunion des Musées Nationaux, 1993.
Cogeval, Guy, et al. *Maurice Denis, 1870–1943.* Exh. cat. Ghent: Snoeck-Ducaju, 1994.

Théodore van Rysselberghe
Belgian, 1862–1926

The Regatta
La régate
1892
Oil on canvas
61 x 80.6 cm (24 x 31¾ in.)
Signed lower right: 18 TVR 92
Painted wooden border thought to have been added by Henry van de Velde

PROVENANCE
Saenger-Sèthe Collection; Mr. and Mrs. Hugo Perls, New York; sale, Sotheby's, New York, 1983, Lot 312; Herbert Black, Montreal; Scott M. Black (acquired Christie's, New York, November 10, 1987, Lot 25: Impressionist and Modern Paintings and Sculpture).

SELECTED EXHIBITIONS
1962. Ghent, Musée des Beaux-Arts, "Rétrospective Theo van Rysselberghe," July–September.
1991. Portland Museum of Art, "Impressionism and Post-Impressionism: The Collector's Passion," July 30–October 14.
1992. Boston, Museum of Fine Arts, "Prized Possessions, European Paintings from Private Collections of Friends of the Museum of Fine Arts," June 17–August 16.
1998. Portland Museum of Art, "Impressions of the Riviera: Monet, Renoir, Matisse and Their Contemporaries," June 25–October 18.

1999. Portland Museum of Art, "Pursuing a Passion: The Scott M. Black Collection," March 9–May 16.
2000–1. Paris, Galeries Nationales du Grand Palais, "Méditerranée, De Courbet à Matisse," September 2000–January 2001.
2002. Portland Museum of Art, "Neo-Impressionism: Artists on the Edge," June 27–October 20.
2006. Portland Museum of Art, "Paris and the Countryside: Modern Life in Late-19th-Century France," June 23–October 15.

SUGGESTED READINGS
Maret, François. *Theo van Rysselberghe.* Antwerp: De Sikkel, for the Ministère de l'instruction publique, 1948
Eeckhout, Paul. *Rétrospective Théo van Rysselberghe.* Exh. cat. Ghent: Museum voor Schone Kunsten: 1962.
Hoozee, Robert, et al. *Theo van Rysselberghe, néo-impressionniste.* Exh. cat. Ghent: Pandora, 1993.
Stevens, MaryAnne, and Robert Hoozee. *Impressionism to Symbolism: The Belgian Avant-Garde, 1880–1900.* Exh. cat. London: Royal Academy of Arts; Ghent: Ludion Press, 1994.
Feltkamp, Ronald. *Théo van Rysselberghe, 1862–1926, catalogue raisonné.* Brussels: Racine; Paris: Editions de l'Amateur, 2003, 58, 295, no. 1892-011.

Maximilien Luce
French, 1858–1941

Camaret, The Breakwater
Camaret, la digue
1895
Oil on canvas
64.8 x 92 cm (25½ x 36¼ in.)
Signed and dated lower left: Luce 95
© 2006 Artists Rights Society (ARS), New York/ADAGP, Paris.
Photo by Meyersphoto.com. Courtesy, Portland Museum of Art, Maine.

PROVENANCE
Sale, Hôtel Drouot, Paris, June 9, 1928, no. 66; Elsa Anna Maria Kröller-Muller; by descent to Mrs. Eileen Harper-Schaefer; Scott M. Black (acquired Sotheby's, New York, November 10, 1992, Lot 34: Impressionist and Modern Paintings, Drawings and Sculpture, Part 1).

SELECTED EXHIBITIONS
1999. Portland Museum of Art, "Pursuing a Passion: The Scott M. Black Collection," March 9–May 16.
2002. Portland Museum of Art, "Neo-Impressionism, Artists on the Edge."
2006. Portland Museum of Art, "Paris and the Countryside: Modern Life in Late-19th-Century France," June 23–October 15.

SUGGESTED READINGS

Bouin-Luce, Jean, and Denise Bazetoux.
Maximilien Luce, catalogue raisonné de l'oeuvre peint.
Paris: JBL, 1986, II:383, no. 1559.
Maximilien Luce, Epoque néo-impressionniste,
1887–1903. Exh. cat. Paris: Galerie H. Odermatt-
Ph. Cazeau, 1988.
Maximilien Luce, 1858–1941, The Evolution of a
Post-Impressionist. Exh. cat. New York: Wildenstein,
1997.

Eragny, The Banks of the Epte
Eragny, les bords de l'Epte
1899
Oil on canvas
81.3 x 116.2 cm (32 x 45¾ in.)
Signed and dated lower right: Luce 99
© 2006 Artists Rights Society (ARS), New
York/ADAGP, Paris.
Photo by Benjamin Magro. Courtesy, Portland
Museum of Art, Maine.

PROVENANCE

Arthur Tooth & Sons, London, 1961; private col-
lection; Scott M. Black (acquired Sotheby's,
London, June 28, 1989, Lot 106: Impressionist
and Modern Paintings and Sculpture, Part 2).

SELECTED EXHIBITIONS

1899. Paris, Galerie Durand-Ruel, "M. Luce."
1904. Paris, "XXieme Salon des Artistes
Independants."
1991. Portland Museum of Art, "Impressionism
and Post-Impressionism: The Collector's
Passion," July 30–October 14.
1992. Boston, Museum of Fine Arts, "Prized
Possessions, European Paintings from Private
Collections of Friends of the Museum of Fine
Arts," June 17–August 16.
1999. Portland Museum of Art, "Pursuing a
Passion: The Scott M. Black Collection," March
9–May 16.
2002. Portland Museum of Art, "Neo-
Impressionism, Artists on the Edge."
2006. Portland Museum of Art, "Paris and the
Countryside: Modern Life in Late-19th-Century
France," June 23–October 15.

SUGGESTED READINGS

Bouin-Luce, Jean, and Denise Bazetoux.
Maximilien Luce, catalogue raisonné de l'oeuvre peint.
Paris: Editions JBL, 1986, II:31, no. 98.
Maximilien Luce, époque néo-impressionniste,
1887–1903. Exh. cat. Paris: Galerie H. Odermatt-
Ph. Cazeau, 1988.
Maximilien Luce, 1858–1941, The Evolution of a
Post-Impressionist. Exh. cat. New York: Wildenstein,
1997.
Ferretti-Bocquillon, Marina, et al. *Le néo-*
impressionnisme: De Seurat à Paul Klee. Exh. cat.
Paris: Réunion des Musées Nationaux, 2005.

Henri Edmond Cross
French, 1856–1910

Antibes, Afternoon
Antibes, après-midi
1908
Oil on canvas
81 x 100 cm (32 x 39½ in.)
Signed lower left: Henri Edmond Cross 08
Photo by Meyersphoto.com. Courtesy, Portland
Museum of Art, Maine.

PROVENANCE

Galerie Bernheim-Jeune et Cie., Paris; Baron von
Bodenhausen, Munich; Fine Arts Associates, New
York; sale, Christie's, New York, November 15,
1988, Lot 23: Impressionist and Modern
Paintings and Sculpture; Scott M. Black
(acquired Sotheby's, New York, November 8,
1995, Lot 48: Impressionist and Modern Art).

SELECTED EXHIBITIONS

1910. Paris, Galerie Bernheim-Jeune et Cie.,
"Exposition Henri-Edmond Cross."
1951. New York, Fine Arts Associates, "Henri-
Edmond Cross."
1998. Portland Museum of Art, "Impressions of
the Riviera: Monet, Renoir, Matisse and Their
Contemporaries," June 25–October 18.
1999. Portland Museum of Art, "Pursuing a
Passion: The Scott M. Black Collection," March
9–May 16.
2002. Portland Museum of Art, "Neo-
Impressionism: Artists on the Edge," June 27–
October 20.

SUGGESTED READINGS

Cousturier, Lucie. *H. E. Cross.* Paris: G. Crès &
Cie., 1932.
Compin, Isabelle and Bernard Dorival. *H. E.*
Cross. Paris: Quatre Chemins-Editart, 1964, 307.
no. 206.
Baligand, Françoise, et al. *Henri Edmond Cross,*
1856–1910. Exh. cat. Paris: Somogy, 1998.
Bocquillon-Ferretti, Marina. *Le néo-*
impressionnisme: De Seurat à Paul Klee. Exh. cat.
Paris: Réunion des Musées Nationaux, 2005.

Paul Signac
(French, 1863–1935)

Antibes, The Pink Cloud
Antibes, le nuage rose
1916
Oil on Canvas
71 x 91.4 cm (28 x 36 in.)
Signed and dated lower left: P. Signac/1916

PROVENANCE

April 2, 1917, Galerie Bernheim-Jeune, Paris
(from the artist); Bernheim-Jeune collection
until 1963; Jean Dauberville, Paris; sale,
Sotheby's, New York, June 28, 1978; 1981,

Cavalieri Holding & Co. Inc.; sale, Christie's,
London, March 30, 1987, Lot 23: Impressionist
and Modern Paintings and Sculpture; private col-
lection, London; sale, Christie's, London, June
25, 1990, Lot 32: Impressionist and Modern
Paintings and Sculpture; Scott M. Black (acquired
Christie's, New York, May 12, 1992, Lot 122:
Impressionist and Modern Paintings, Drawings
and Sculpture, Part 1).

SELECTED EXHIBITIONS

1923. Paris, Galerie Bernheim-Jeune, "Paul
Signac, peintures, cartons de tableaux, dessins-
aquarelle," May.
1927. Berlin, Galerie Goldschmidt, "Paul Signac,"
February–March.
1927. Frankfurt, Galerie Goldschmidt, "Paul
Signac," March–May.
1951. Paris, Galerie Bernheim-Jeune, "Le Salon
du Demi-siècle," April–June.
1961. Paris, Galerie Bernheim-Jeune, "Paysages
de France de l'impressionnisme à nos jours,"
March–May.
1961–62. Paris, Galerie Bernheim-Jeune, "Au fil
de l'Eau," November 1961–January 1962.
1963–64. Paris, Musée du Louvre, "Signac,"
December 1963–February 1964.
1998. Portland Museum of Art, "Impressions of
the Riviera: Monet, Renoir, Matisse and Their
Contemporaries," June 25–October 18.
1999. Portland Museum of Art, "Pursuing a
Passion: The Scott M. Black Collection," March
9–May 16.
2001. New York, The Metropolitan Museum of
Art, "Signac, 1863–1935" October 9–December 30.

SUGGESTED READINGS

Cousturier, Lucie. *P. Signac.* Paris: G. Crès & Cie.,
1922.
Cachin, Francoise. *Paul Signac.* Paris:
Bibliothèque des Arts, 1971.
"Signac prend le large." *Beaux Arts Magazine,*
July–August 1992, no. 103:72–73.
Cachin, Francoise, and Marina Ferretti-
Bocquillon. *Signac: Catalogue raisonné de l'oeuvre*
peint. Paris: Gallimard, 2000, 305, no. 509.
Ferretti-Bocquillon, Marina, and Charles Cachin.
Paul Signac: A Collection of Watercolors and Drawings.
Exh. cat. New York: Harry N. Abrams, 2000.

Henri Matisse
French, 1869–1954

The Pont Saint-Michel
Le Pont Saint-Michel
1900
Oil on canvas
46.4 x 60 cm (18¼ x 22 in.)
Signed lower left: Henri Matisse
© 2006 Succession H. Matisse, Paris/Artists
Rights Society (ARS), New York.

PROVENANCE
By 1907, Michael and Sarah Stein, Paris; about 1919, Trygve Sagen, Norway; Consul Peter Krag, Oslo and Paris (to his wife, later); Mrs. Sigri Welhaven, Oslo; by gift to private collection, Scandinavia; Scott M. Black (acquired Christie's, London, June 24, 1991, Lot 14: Impressionist and Modern Paintings and Sculpture).

SELECTED EXHIBITIONS
1914. Berlin, Galerie Gurlitt, "Henri Matisse," July.
1960–61. Paris, Musée National d'Art Moderne, "Les sources du XXème siècle," November 1960–January 1961.
1970. Paris, Grand Palais, "Henri Matisse, exposition du centenaire," April–September.
1992. Boston, Museum of Fine Arts, "Prized Possessions, European Paintings from Private Collections of Friends of the Museum of Fine Arts," June 17–August 16.
1999. Portland Museum of Art, "Pursuing a Passion: The Scott M. Black Collection," March 9–May 16.
2006. Portland Museum of Art, "Paris and the Countryside: Modern Life in Late-19th-Century France," June 23–October 15.

SUGGESTED READINGS
Gowing, Lawrence. *Matisse*. New York: Oxford University Press, 1979, 27 (erroneously cited as pl. 16)
Flam, Jack. *Matisse, the Man and His Art, 1869–1918*. Ithaca, NY: Cornell University Press, 1986.
Spurling, Hilary. *The Unknown Matisse*. New York: Alfred A. Knopf, 1998.

Maurice de Vlaminck
French, 1876–1958

Houses and Trees
Maisons et arbres
1906
Oil on canvas
54.3 x 65.4 cm (21½ x 25¾ in.)
Signed lower left: Vlaminck
© 2006 Artists Rights Society (ARS), New York/ADAGP, Paris.

PROVENANCE
Colonel C. Michael Paul, New York; Josephine Bay Paul and C. Michael Paul Foundations; Scott Black (acquired Sotheby's, New York, November 3, 1993, Lot 25: Impressionist and Modern Paintings, Drawings and Sculpture, Part I).

SELECTED EXHIBITIONS
1959. Basel, Galerie Beyeler, "Les Fauves," as *Soleil d'hiver*.
1987. New York, The Metropolitan Museum of Art (on loan since 1982).
1990–91. Los Angeles County Museum of Art; New York, The Metropolitan Museum of Art;

London, Royal Academy of Arts, "The Fauve Landscape."
1999. Portland Museum of Art, "Pursuing a Passion: The Scott M. Black Collection," March 9–May 16.

SUGGESTED READINGS
Genevoix, Maurice. *Vlaminck: I. L'homme, II. L'oeuvre*. Paris: Flammarion, 1954, 38.
Herbert, James D. *Fauve Painting: The Making of Cultural Politics*. New Haven, CT; London; and Ottawa: Yale University Press, in association with the National Gallery of Canada, 1992.

Raoul Dufy
French, 1877–1953

Boats at Martigues
Barques à Martigues
1907
Oil on canvas
65 x 81.3 cm (25½ x 31¾ in.)
Signed lower left: Raoul Dufy
© 2006 Artists Rights Society (ARS), New York/ADAGP, Paris.

PROVENANCE
Germaine Dufy, Paris; Maurice Lafaille, Paris; 1986, Artemis Group, London; Arnold and Anne Gumowitz, New York; Scott M. Black (acquired Sotheby's, New York, November 6, 1991, Lot 17: Impressionist and Modern Paintings, Drawings and Sculpture, Part 1).

SELECTED EXHIBITIONS
1987. Saint-Tropez, Musée de l'Annonciade, "Les oeuvres Fauves de Raoul Dufy."
1990–91. Los Angeles County Museum of Art; New York, The Metropolitan Museum of Art; London, Royal Academy of Arts, "The Fauve Landscape."
1991. Portland Museum of Art, "Impressionism and Post-Impressionism: The Collector's Passion," July 30–October 14.
1992. Boston, Museum of Fine Arts, "Prized Possessions, European Paintings from Private Collections of Friends of the Museum of Fine Arts," June 17–August 16.
1998. Portland Museum of Art, "Impressions of the Riviera: Monet, Renoir, Matisse and Their Contemporaries," June 25–October 18.
1999. Portland Museum of Art, "Pursuing a Passion: The Scott M. Black Collection," March 9–May 16.

SUGGESTED READINGS
Lafaille, Maurice. *Raoul Dufy, catalogue raisonné de l'oeuvre peint*. Geneva: Editions Motte, 1972–1985 (not in catalogue; to be included in a forthcoming supplement).
"Dufy, le Fauve sage." *L'Express International*, September 18, 1987, no.1888.
Perez-Tibi, Dora. *Dufy*. Paris: Flammarion, 1989, 34, 323, no. 29.

Pablo Picasso
Spanish (worked in France), 1881–1973

Head of a Jester
Tête de fou
Modeled in 1905; this version cast later by Valsuani
Bronze
40.6 cm x 36.8 x 19 cm (16 x 14½ x 7½ in.)
© 2006 Estate of Pablo Picasso/Artists Rights Society (ARS), New York.

PROVENANCE
Ambroise Vollard, Paris; Harold and Ruth Uris; Scott M. Black (acquired Christie's, New York, November 13, 1996, Lot 18: Impressionist and Modern Paintings, Drawings and Sculpture, Part 1).

SELECTED EXHIBITIONS
1999. Portland Museum of Art, "Pursuing a Passion: The Scott M. Black Collection," March 9–May 16.

SUGGESTED READINGS
Kahnweiler, Daniel-Henri. *Les sculptures de Picasso*. Paris: Les Editions du Chêne, 1948, pl. 2 (another cast).
Penrose, Roland. *The Sculpture of Picasso*. Exh. cat. New York: Museum of Modern Art, 1967, 17, 26, 41, 52, 221 (another cast).
Spies, Werner. *Sculpture by Picasso, with a Catalogue of the Works*. Trans. J. Maxwell Brownjohn. New York: Harry N. Abrams, 1971, 17–18, no. 4 (another cast).
Richardson, John, with the collaboration of Marilyn McCully. *A Life of Picasso*. New York: Random House, 1991, I (1881–1906): 348 (another cast).
Rubin, William, et al. *Picasso and Portraiture: Representation and Transformation*. Exh. cat. New York: Museum of Modern Art, distributed by H. N. Abrams, 1996.
Spies, Werner, and Christine Piot. *Picasso sculpteur, catalogue raisonné des sculptures*. Paris: Centre Pompidou, 2000, 27, pl. 4 (another cast).

Georges Braque
French, 1882–1963

The House (also known as *The House, La Roche-Guyon*)
Maison (also known as *Maison, La Roche-Guyon*)
1908
Oil on canvas
46 x 38.6 cm (18⅛ x 15¾₆ in.)
© 2006 Artists Rights Society (ARS), New York/ADAGP, Paris.

PROVENANCE
Daniel-Henri Kahnweiler, Paris (probably sold Hôtel Drouot, Paris, "4ème vente Kahnweiler," May 7–8, 1923, Lot 113, under the title *Paysage*);

Dr. Gustave F. Reber, Lausanne; Kleeman Galleries, New York; Knoedler & Co., New York; private collection, New York; 1980, Marisa del Re Gallery, New York; 1982, Mario Ruspoli, New York; sale, Christie's, New York, May 17, 1983, Lot 47; Stanley J. Seeger; Scott M. Black (acquired Sotheby's, New York, May 8, 2001, Lot 26: The Eye of a Collector—Works from the Collection of Stanley J. Seeger).

SELECTED EXHIBITIONS
1908. Paris, Galerie Kahnweiler, "Braque."
1980. St. Paul de Vence, Fondation Maeght, "Georges Braque."
1980. Cologne, Kunsthalle, "Kubismus, Künstler, Themen, Werke, 1907–1920."
1983. Bari, Castello Svevo, "Georges Braque, opere 1900–1963."
2005–6. Boston, Museum of Fine Arts, "Facets of Cubism," December 2005–April 2006.

SUGGESTED READINGS
Isarlov, Georges. *Catalogue des oeuvres de Georges Braque.* Paris: 1932, 16, no 51.
Rosenblum, Robert. *Cubism and Twentieth-Century Art.* New York: Harry N. Abrams, 1960, 42, no. 19.
Worms de Romilly, Nicole, and Jean Laude. *Braque, Cubism, 1907–1914.* Paris: Maeght, 1982, VII:84, no. 32.

Fernand Léger
French, 1881–1955

The Wounded Man
Le blessé
1917
Oil on canvas
61.6 x 46.7 cm (24¼ x 18½ in.)
Signed lower right: FLEGER/17
© 2006 Artists Rights Society (ARS), New York/ADAGP, Paris.
Photo by Meyersphoto.com. Courtesy, Portland Museum of Art, Maine.

PROVENANCE
Galerie Simon, Paris; Pierre Matisse Gallery, New York; 1958, private collection; Scott M. Black (acquired Christie's, New York, November 11, 1997, Lot 150: Impressionist and Modern Paintings, Drawings and Sculpture, Part 1).

SELECTED EXHIBITIONS
1999. Portland Museum of Art, "Pursuing a Passion: The Scott M. Black Collection," March 9–May 16.
2005–6. Boston, Museum of Fine Arts, "Facets of Cubism," December 2005–April 2006.

SUGGESTED READINGS
Cooper, Douglas. "Les 3 Collines." *Edit,* 1949:70.
Zervos, Christian. "Fernand Léger." *Cahiers d'Art,* Huitième Année, 1933.
Green, Christopher. *Léger and the Avant-Garde.*

New Haven, CT: Yale University Press, 1976.
de Francia, Peter. *Fernand Léger.* New Haven, CT: Yale University Press, 1983.
Diehl, Gaston. *F. Léger.* New York: Crown Publishers, 1985.
Bauquier, Georges, et al. *Fernand Léger, catalogue raisonné, 1903–1919.* Paris: Adrien Maeght Editeur, 1990. I:186–87, no. 101.
Kosinski, Dorothy, ed. *Fernand Léger, 1911–1924, the Rhythm of Modern Life.* Munich: Prestel, 1994.
Carolyn Lanchner, et al. *Fernand Léger.* New York: The Museum of Modern Art, 1998.

Jacques Lipchitz
French (born in Lithuania), 1891–1973

Bather
Baigneuse
1919–20
Bronze with brown patina
71.8 x 28.3 cm (28¼ x 11 in.)

PROVENANCE
Pierre Lanique, Paris (from the artist); descendants of Pierre Lanique (sold Christie's, London, June 26, 1995, Lot 47); private collection; Scott M. Black (acquired Sotheby's, New York, May 6, 2003, Lot 27: Impressionist and Modern Art, Part 1).

SELECTED EXHIBITIONS
1993–94. Paris, Centre Georges Pompidou, "Pierre Chareau, un art intérieur."
2005–6. Boston, Museum of Fine Arts, "Facets of Cubism," December 2005–April 2006.

SUGGESTED READINGS
Hammacher, Abraham M. *Jacques Lipchitz, His Sculpture.* New York: H. N. Abrams, 1960, 25 (another cast).
Barbier, Nicole. *Lipchitz: Oeuvres de Jacques Lipchitz, 1891–1973.* Paris: Centre Georges Pompidou, Musée National d'Art Moderne, 1978, no. 10 (original plaster).
Fraser Jenkins, David, and Derek Pullen. *The Lipchitz Gift: Models for Sculpture.* Exh. cat. London: Tate Gallery Publications, 1986.
Wilkinson, Alan G. *Jacques Lipchitz, a Life in Sculpture.* Exh. cat. Toronto: Art Gallery of Ontario, 1989.
Wilkinson, Alan G. *The Sculpture of Jacques Lipchitz, a Catalogue Raisonné.* New York: Thames and Hudson, 1996, I:54, no. 101 (another cast).

Georges Braque
French, 1882–1963

Pipe and Compote
Pipe et compotier
1919
Oil and sand on canvas
35.5 x 64.8 cm (14 x 25½ in.)

© 2006 Artists Rights Society (ARS), New York/ADAGP, Paris.
Photo by Melville D. McLean. Courtesy, Portland Museum of Art, Maine.

PROVENANCE
Galerie l'Effort Moderne (Léonce Rosenberg), Paris; Marcel Sigismond, Paris; about 1965, private collection; Scott M. Black (acquired Christie's, New York, May 10, 1994, Lot 4: Important Impressionist and Modern Paintings from European Estates).

SELECTED EXHIBITIONS
1999. Portland Museum of Art, "Pursuing a Passion: The Scott M. Black Collection," March 9–May 16.
2005–6. Boston, Museum of Fine Arts, "Facets of Cubism," December 7, 2005–April 16, 2006.

SUGGESTED READINGS
Bissière, Roger. "Georges Braque." *Art d'Aujourd'hui,* 1920, no. 6: pl. 16.
Isarlov, Georges. *Catalogue des oeuvres de Georges Braque.* Paris: 1932, 88, no 258.
Worms de Romilly, Nicole, and Nicole S. Mangin. *Catalogue de l'oeuvre de Georges Braque.* Paris: Maeght Editeur, 1973, VI:59.
Fauchereau, Serge. *Braque.* New York: Rizzoli, 1987.

Still Life with Pears, Lemons, and Almonds
Nature morte aux poires, citrons, et amandes
1927
Oil on canvas
50.5 x 61 cm (20 x 24 in.)
Signed lower right: G Braque 27
© 2006 Artists Rights Society (ARS), New York/ADAGP, Paris.
Photo by Melville D. McLean. Courtesy, Portland Museum of Art, Maine.

PROVENANCE
Paul Rosenberg, New York; Perls Galleries, New York (no. 5651); Scott M. Black (acquired Sotheby's, New York, May 9, 1995, Lot 86: Impressionist and Modern Paintings, Drawings and Sculpture).

SELECTED EXHIBITIONS
1961. New York, Perls Galleries, "Trends of the Twenties, the School of Paris."
1964. New York, Perls Galleries, "G. Braque, an American Tribute: The Twenties."
1980. Saint-Paul-de-Vence, Fondation Maeght, "Georges Braque."
1999. Portland Museum of Art, "Pursuing a Passion: The Scott M. Black Collection," March 9–May 16.

SUGGESTED READINGS
Mangin, Nicole S., and Nicole Worms de Romilly. *Catalogue de l'oeuvre de Georges Braque, peintures, 1924–1927.* Paris: Maeght Editeur, 1959, V:96.

Cogniat, Raymond. *Georges Braque*. New York: Harry N. Abrams, 1980.
Zurcher, Bernard. *Georges Braque, Life and Work*. New York: Rizzoli, 1988.
Prat, Jean-Lous. *G. Braque*. Exh. cat. Martigny, Switzerland: Fondation Pierre Gianadda, 1992.

Pierre Bonnard
French, 1867–1947
Portrait of Mademoiselle Renée Monchaty
Portrait de Mademoiselle Renée Monchaty
about 1920
Oil on canvas
50.2 x 41.3 cm (19¾ x 16¼ in.)
Signed lower left: à Renée /Bonnard
© 2006 Artists Rights Society (ARS), New York/ADAGP, Paris.
Photo by Benjamin Magro. Courtesy, Portland Museum of Art, Maine.

PROVENANCE
French Art Gallery, London and New York; John Levy Gallery, New York; Arnold Kirkcby, Los Angeles; sale, Parke-Bernet Galleries, Inc., New York, November 19, 1958, Lot 27; Gordon Graves, Greenwich, CT; Guttmann Collection, New York; Hammer Galleries, New York; Sven Salen, Stockholm; Fabian Carlsonn, Göteborg; Scott M. Black (acquired Christie's, New York, November 12, 1985, Lot 64: Impressionist and Modern Paintings and Sculpture).

SELECTED EXHIBITIONS
1953. Rotterdam, Museum Boymans-van Beuningen, "Bonnard," May.
1953. London, O'Hana Gallery, "French Masters of the XIXth and XXth Centuries," June 10–July 31.
1999. Portland Museum of Art, "Pursuing a Passion: The Scott M. Black Collection," March 9–May 16.

SUGGESTED READINGS
Dauberville, Jean and Henry Dauberville. *Bonnard, catalogue raisonné de l'oeuvre peint*. Paris: Bernheim-Jeune, 1973, III:53, no. 1024.

Edouard Vuillard
French, 1868–1940
The Two English Friends (also known as *Nude in an Interior*)
Les deux anglaises (also known as *Nu dans un intérieur*)
1923
Oil on cardboard, laid down on paper
74.6 x 52 cm (29½ x 20½ in.)
Stamped lower right: E Vuillard
© 2006 Artists Rights Society (ARS), New York/ADAGP, Paris.
Photo by Bernard C. Meyers. Courtesy, Portland Museum of Art, Maine.

PROVENANCE
The artist's estate; 1945, Yves Doornic, Paris; anonymous sale, Hôtel Drouot, Paris, July 4, 1949, lot 17 (70 in catalogue raisonné); Dalzell Hatfield Galleries, Los Angeles; George N. Richard, New York; Scott M. Black (acquired Christie's, New York, November 14, 1989, Lot 28: Impressionist and Modern Paintings and Drawings).

SELECTED EXHIBITIONS
1991. Portland Museum of Art, "Impressionism and Post-Impressionism: The Collector's Passion," July 30–October 14.
1992. Boston, Museum of Fine Arts, "Prized Possessions, European Paintings from Private Collections of Friends of the Museum of Fine Arts," June 17–August 16.
1999. Portland Museum of Art, "Pursuing a Passion: The Scott M. Black Collection," March 9–May 16.

SUGGESTED READINGS
Dumas, Ann, and Guy Cogeval. *Vuillard*. Exh. cat. Paris: Flammarion, 1990.
Cogeval, Guy. *Vuillard: Master of the Intimate Interior*. London: Thames and Hudson, 2002.
Salomon, Antoine, and Guy Cogeval. *Vuillard: The Inexhaustible Glance: Critical Catalogue of Paintings and Pastels*. Milan: Skira; New York: Wildenstein Institute, distributed in North America by Rizzoli, 2003, II:1365, no. XI-126.
Cogeval, Guy, et al. *Edouard Vuillard*. Exh. cat. New Haven, CT: Yale University Press, in association with the Montreal Museum of Fine Arts and the National Gallery of Art, Washington, DC, 2003.

Aristide Maillol
French, 1861–1944
Nymph
Nymphe
1930
Bronze
155 x 40.6 x 24.1 cm (61 x 16 x 9½ in.)
Inscribed: AM, 6/6, Alexis Rudier Fondeur Paris
© 2006 Artists Rights Society (ARS), New York/ADAGP, Paris.
Photo by Meyersphoto.com. Courtesy, Portland Museum of Art, Maine.

PROVENANCE
The Keck Collection from La Lanterne, Bel Air, California; Scott M. Black (acquired Sotheby's, New York, November 6, 1991, Lot 30: Impressionist and Modern Paintings, Drawings and Sculpture).

SELECTED EXHIBITIONS
1999. Portland Museum of Art, "Pursuing a Passion: The Scott M. Black Collection," March 9–May 16.

SUGGESTED READINGS
Rewald, John. *Maillol*. London and New York: The Hyperion Press, 1939.
Camo, Pierre. *Maillol, mon ami*. Lausanne: Editions du Grand Chêne, Henri Kaeser, 1950.
The Tate Gallery, an Illustrated Companion to the National Collections of British and Modern Foreign Art. London: Tate Gallery Publications, 1979.

Albert Marquet
French, 1875–1947
The Passersby
Les passants
1933
Oil on canvas
46.2 x 55 cm (18¼ x 21½ in.)
Signed lower left: Marquet
© 2006 Artists Rights Society (ARS), New York/ADAGP, Paris.

PROVENANCE
Marcelle Marquet; private collection, Mme. Bernard, Paris; Galerie Malingue, Paris (on consignment from Mme. Bernard); Scott M. Black.

SELECTED EXHIBITIONS
1999. Portland Museum of Art, "Pursuing a Passion: The Scott M. Black Collection," March 9–May 16.

SUGGESTED READINGS
Marquet, Marcelle. *Marquet, Journeys*. Trans. Diana Imber. Lausanne: International Art Book, 1969.
Albert Marquet: 1875–1947. Exh. cat. Lausanne: Fondation de l'Hermitage, 1988.
Martinet, Jean-Claude, and Guy Wildenstein. *Marquet, l'Afrique du Nord: Catalogue de l'oeuvre peint*. Milan: Skira; Paris: Wildenstein Institute, 2001.

Fernand Léger
French, 1881–1955
The Bunch of Grapes
La grappe de raisin
1928
Oil on canvas
80.6 x 129.5 cm (31¾ x 51 in.)
Signed lower right: F.LEGER.28
© 2006 Artists Rights Society (ARS), New York/ADAGP, Paris.

PROVENANCE
Galerie Louise Leiris, Paris; Perls Galleries, New York (no. 7342); Scott M. Black (acquired Sotheby's, New York, May 9, 1995, Lot 87: Impressionist and Modern Paintings, Drawings and Sculpture).

SELECTED EXHIBITIONS
1956. Paris, Musée des Arts Décoratifs; Brussels, Palais des Beaux-Arts, "Fernand Léger 1881–1955."
1957. Basel, Kunsthalle, "Fernand Léger."

1957. Munich, Haus der Kunst, "Fernand Léger, 1881–1955."
1966. Bremen, Galerie Michael Hertz, "Fernand Léger."
1966. Marseille, Musée Cantini, "Fernand Léger."
1967. Tel Aviv Museum, "Fernand Léger."
1968. Vienna, Museum des 20. Jahrhunderts, "Fernand Léger: Oil Paintings."
1972. Paris, Grand Palais, "Fernand Léger."
1982. Buffalo, Albright-Knox Art Gallery; Montreal, Musée des Beaux-Arts; Dallas, Museum of Fine Arts, "Fernand Léger."
1982. Caracas, Museo de Arte Contemporaneo de Caracas, "Fernand Léger."
1999. Portland Museum of Art, "Pursuing a Passion: The Scott M. Black Collection," March 9–May 16.

SUGGESTED READINGS
Hoffman, Werner. *Fernand Léger.* Exh. cat. Vienna: Rosenbaum, 1968.
Richet, Michèle, and Claude Laugier. *Fernand Léger, Grand Palais, Octobre 1971–Janvier 1972.* Exh. cat. Paris: Réunion des Musées Nationaux, 1971.
Léger, Fernand. *Functions of Painting.* Ed. Edward F. Fry. Trans. Alexandra Anderson. New York: The Viking Press, 1973.
Green, Christopher. *Léger and the Avant-Garde.* New Haven, CT: Yale University Press, 1976.
Laugier, Claude, and Michèle Richet. *Léger, oeuvres de Fernand Léger (1881–1955).* Paris: Centre Georges Pompidou, Musée National d'Art Moderne, 1981.
Bauquier, Georges, et al. *Fernand Léger, catalogue raisonné, 1925–1928.* Paris: Adrien Maeght Editeur, 1993, III:330–31, no 595.
Carolyn Lanchner, et al. *Fernand Léger.* New York: The Museum of Modern Art, 1998.

Still Life
Nature morte
1929
Oil on canvas
91.4 x 65.4 cm (36 x 25¾ in.)
Signed lower right: F.LEGER.29
© 2006 Artists Rights Society (ARS), New York/ADAGP, Paris.

PROVENANCE
Mme. Simone Herman; Perls Galleries, New York; private collection; Scott M. Black (acquired Christie's, New York, May 5, 2004, Lot 297: Impressionist and Modern Art and Impressionist and Modern Works on Paper).

SELECTED EXHIBITIONS
1956. Bruxelles, Palais des Beaux-Arts, "Fernand Léger, 1881–1955," October–November.
1968. New York, Perls Galleries, "Fernand Léger: Oil Paintings," November–December.

1992. Boston, Museum of Fine Arts, "Prized Possessions, European Paintings from Private Collections of Friends of the Museum of Fine Arts," June 17–August 16.
1999. Portland Museum of Art, "Pursuing a Passion: The Scott M. Black Collection," March 9–May 16.

SUGGESTED READINGS
Zervos, Christian. "De l'importance de l'object dans la peinture d'aujourd'hui." *Cahiers d'Art,* Cinquième Année, 1930, 346.
Zervos, Christian. "Georges Braque." *Cahiers d'Art,* Huitième Année, 1933.
Léger, Fernand. *Functions of Painting.* Ed. Edward F. Fry. Trans. Alexandra Anderson. New York: The Viking Press, 1973.
Green, Christopher. *Léger and the Avant-Garde.* New Haven, CT: Yale University Press, 1976.
Bauquier, Georges, et al. *Fernand Léger, catalogue raisonné, 1929–1931.* Paris: Adrien Maeght Editeur, 1995, IV:60–61, no. 637.
Carolyn Lanchner, et al. *Fernand Léger.* New York: The Museum of Modern Art, 1998.

Pablo Picasso
Spanish (worked in France), 1881–1973

Head of a Woman, Portrait of Marie-Thérèse Walter
Tête de femme, portrait de Marie-Thérèse Walter
1934
Oil on canvas
55.5 x 38.5 cm (22 x 15¼ in.)
Dated upper right: Boisgeloup 17 juillet /XXXIV
© 2006 Estate of Pablo Picasso/Artists Rights Society (ARS), New York.

PROVENANCE
Estate of the artist; Jacqueline Picasso, Mougins; Galerie Louise Leiris, Paris; Saidenberg Gallery, New York; private collection, USA; Scott M. Black (acquired Sotheby's, London, November 30, 1993, Lot 64: Impressionist and Modern Paintings, Drawings and Sculpture).

SELECTED EXHIBITIONS
1999. Portland Museum of Art, "Pursuing a Passion: The Scott M. Black Collection," March 9–May 16.

SUGGESTED READINGS
Nochlin, Linda. "Picasso's Color: Schemes and Gambits." *Art in America,* December 1980.
Daix, Pierre. *Dictionnaire Picasso.* Paris: Robert Laffont, 1995.
Rubin, William, et al. *Picasso and Portraiture: Representation and Transformation.* Exh. cat. New York: The Museum of Modern Art, distributed by H. N. Abrams, 1996.

Joan Miró
Spanish, 1893–1983

Composition
1934
Gouache and paper collage on black paper laid on board
65 x 49 cm (25½ x 19¼ in.)
Signed, reverse: Miró
© 2006 Successió Miró/Artists Rights Society (ARS), New York/ADAGP, Paris.
Photo by Meyersphoto.com. Courtesy, Portland Museum of Art, Maine.

PROVENANCE
Pierre Matisse Gallery, New York (from the artist); by 1941, Collection Embiricos, Lausanne; Teshigahara Family Collection, Tokyo; Sogetsu Art Museum, Tokyo; private collection, USA; Scott M. Black (acquired Sotheby's, New York, November 5, 2003, Lot 50: Impressionist and Modern Art, Part 1).

SELECTED EXHIBITIONS
1935. New York, Pierre Matisse Gallery, "Paintings, Temperas, Pastels" (titled *Gouache on Black Paper*).

SUGGESTED READINGS
Rowell, Margit. *Miró.* New York: H. N. Abrams, 1970.
Stich, Sidra. *Joan Miró, The Development of a Sign Language.* Exh. cat. Saint Louis: Washington University Gallery of Art, 1980.
Baumann, Felix, et al. *Joan Miró.* Exh. cat. Zürich: Kunsthaus Zürich; Düsseldorf: Städtische Kunsthalle, 1986.
Miró: La collection du Centre Georges Pompidou, Musée National d'Art Moderne. Exh. cat. Paris: Centre Georges Pompidou, Réunion des Musées Nationaux, 1999.
Dupin, Jacques, and Ariane Lelong-Mainaud. *Joan Miró. Catalogue raisonné. Paintings.* 6 vols. Paris: Daniel Lelong, 1999–2004.
The Pierpont Morgan Library. *Pierre Matisse and His Artists.* Exh. cat. New York: The Pierpont Morgan Library, 2002, 165.

Yves Tanguy
French, 1900–1955

Untitled
1937
Oil on canvas
55 x 46 cm (21¾ x 18 in.)
Signed lower right: YVES TANGUY 37
© 2006 Estate of Yves Tanguy/Artists Rights Society (ARS), New York.

PROVENANCE
Probably 1937, private collection; private collection, Sweden; sale, Christie's, London, April 2, 1990, Lot 41; sale, Christie's, London, December 3, 1990, Lot 35; 1991, André-François Petit, Paris; Scott M. Black (acquired Sotheby's, London, December 4, 2000, Lot 7: Surrealism: Dreams and Imagery).

SUGGESTED READINGS

Soby, James Thrall. *Yves Tanguy*. Exh. cat. New York: The Museum of Modern Art, 1955.
Yves Tanguy. Un recueil de ses oeuvres / A Summary of His Works. New York: P. Matisse, 1963.
Angliviel de La Beaumelle, Agnès, and Florence Chauveau. *Yves Tanguy: Rétrospective, 1925–1955*. Exh. cat. Paris: Centre Georges Pompidou, Musée National d'Art Moderne, 1982.
Von Maur, Karin, et al. *Yves Tanguy and Surrealism*. Trans. John Brownjohn and John S. Southard. Ostfildern-Ruit: Hatje Cantz; New York: Art Publishers, 2001.

René Magritte

Belgian, 1898–1967

Portrait of Mme. A. Thirifays (The Heart Unveiled)
Portrait de Mme. A. Thirifays (Le coeur dévoilé)
1936
Oil on canvas
80 x 64 cm (31½ x 25¼ in.)
Signed upper right: Magritte
© 2006 C. Herscovici, Brussels / Artists Rights Society (ARS), New York.
Photo by Meyersphoto.com. Courtesy, Portland Museum of Art, Maine.

PROVENANCE

Mr. and Mrs. André Thirifays, Brussels; Brook Street Gallery, London; sale, Sotheby's, London, July 4, 1973, Lot 104; sale, Sotheby's, London, December 2, 1982, Lot 445; Scott M. Black (acquired Christie's, New York, May 12, 1993, Lot 36: Impressionist and Modern Paintings, Drawings and Sculpture).

SELECTED EXHIBITIONS

1938. Brussels, Palais de Beaux-Arts, "Les compagnons de l'art, exposition d'art belge contemporain," June–August.
1962. Knokke-le-Zoute, Belgium, Casino Communal, "L'oeuvre de René Magritte," July–August.
1972. Art Fair Bruges, summer.
1999. Portland Museum of Art, "Pursuing a Passion: The Scott M. Black Collection," March 9–May 16.

SUGGESTED READINGS

Sylvester, David. *Magritte*. Exh. cat. London: Arts Council of Great Britain, 1969.
Saucet, Jean, and René Passeron. *René Magritte*. Chicago: J. P. O'Hara, 1972.
Scutenaire, Louis, et al. *Retrospective Magritte*. Exh. cat. Paris: Centre National d'Art et de Culture Georges Pompidou, 1978.
Sylvester, David, and Sarah Whitfield. *René Magritte: Catalogue raisonné*. Antwerp: Fonds Mercator, in association with the Menil Foundation, 1992, II:226, no. 412.
Whitfield, Sarah. *Magritte*. Exh. cat. London: South Bank Centre, 1992.

The Tempest
La tempête
about 1944
Oil on canvas mounted on board
45 x 55 cm (18 x 21½ in.)
Signed lower right: Magritte
© 2006 C. Herscovici, Brussels / Artists Rights Society (ARS), New York.
Photo by Benjamin Magro. Courtesy, Portland Museum of Art, Maine.

PROVENANCE

1945, Mme. Lou Cosyn, Brussels; October 1945, purchased by Lockwood Thompson, Cleveland; sale, Christie's, New York, November 6, 1979; Scott M. Black (acquired Christie's, New York, November 16, 1988, Lot 372: Impressionist and Modern Paintings and Sculpture, Part 2).

SELECTED EXHIBITIONS

1960. Cleveland, Ohio, Intown Club, "Clevelanders Collect Art," January.
1970. Painsville, Lake Erie College Art and Cultural Center, "Exhibition for the Dedication of the Fine Arts Center," May.
1999. Portland Museum of Art, "Pursuing a Passion: The Scott M. Black Collection" March 9–May 16.

SUGGESTED READINGS

Sylvester, David. *Magritte*. Exh. cat. London: Arts Council of Great Britain, 1969.
Scutenaire, Louis, et al. *Retrospective Magritte*. Exh. cat. Paris: Centre National d'Art et de Culture Georges Pompidou, 1978.
Sylvester, David, and Sarah Whitfield. *René Magritte: Catalogue raisonné*. Antwerp: Fonds Mercator, in association with the Menil Foundation, 1992, II:350, no. 576.
Ollinger-Zinque, Gisèle, and Frederik Leen. *Magritte, 1898–1967*. Exh. cat. Ghent: Ludion Press; New York: Harry N. Abrams, 1998.

Paul Delvaux

Belgian, 1897–1994

The Greeting (The Meeting)
Le salut (La rencontre)
1938
Oil on canvas
89 x 120.7 cm (35 x 47½ in.)
Signed lower right: P. DELVAUX / 11-38
© 2006 Artists Rights Society (ARS), New York / SABAM, Brussels.

PROVENANCE

Claude Spaak, Paris; Kay Sage Tanguy, New York; June 12, 1963, The Museum of Modern Art, New York (bequest of Kay Sage Tanguy); Galerie Jan Krugier, Geneva, 1977; Scott M. Black (acquired Sotheby's, New York, May 13, 1992, Lot 84: Impressionist and Modern Paintings, Drawings and Sculpture).

SELECTED EXHIBITIONS

1946. New York, Julien Levy Gallery, "Recent Paintings from Belgium by Paul Delvaux."
1964. Boston, Museum of Fine Arts, "Surrealism."
1966. New York, The Museum of Modern Art, "Recent Acquisitions: Kay Sage Tanguy Bequest."
1971. Caracas, Museo de Bellas Artes (and traveling), "L'art du surrealisme."
1972–73. Auckland, City Art Gallery; Sydney, Art Gallery of South Wales; Melbourne, National Gallery of Victoria; Adelaide, Art Gallery of South Australia, "Surrealism."
1973. New York, The Museum of Modern Art, "Surrealist Illusion from the Museum Collection."
1974. New York, The New York Cultural Center; Houston, The Museum of Fine Arts, "Painters of the Mind's Eye. Belgian Symbolists and Surrealists."
1999. Portland Museum of Art, "Pursuing a Passion: The Scott M. Black Collection" March 9–May 16.

SUGGESTED READINGS

Spaak, Claude. *Paul Delvaux*. Antwerp: De Sikkel, 1948.
de Bock, Paul Aloïse. *Paul Delvaux. L'homme, le peintre, psychologie d'un art*. Brussels: Laconti, 1967.
Paquet, Marcel. *Paul Delvaux et l'essence de la peinture*. Paris: Editions de la Différence, 1982.
Rombaut, Marc. *Paul Delvaux*. New York: Rizzoli, 1990.
Scott, David H. T. *Paul Delvaux: Surrealizing the Nude*. London: Reaktion Books; Seattle: University of Washington Press, 1992.

Giorgio de Chirico

Italian, 1888–1978

Piazza d'Italia
1954
Oil on canvas
39 x 48.6 cm (15½ x 19 in.)
Signed lower left: G. de Chirico
© 2006 Artists Rights Society (ARS), New York / SIAE, Rome.
Photo by Meyersphoto.com. Courtesy, Portland Museum of Art, Maine.

PROVENANCE

Galleria Codebo, Turin; Galleria d'Arte Moderna, Turin; London Arts Gallery; private collection, Pennsylvania; Scott M. Black (acquired Christie's, New York, November 12, 1992, Lot 226: Impressionist and Modern Paintings, Drawings and Sculpture).

SELECTED EXHIBITIONS

1999. Portland Museum of Art, "Pursuing a Passion: The Scott M. Black Collection," March 9–May 16.
2002–3. Philadelphia Museum of Art, "Giorgio de Chirico and the Myth of Ariadne," November 3, 2002–January 5, 2003.

SUGGESTED READINGS
Fagiolo Dell'Arco, Maurizio, et al. *De Chirico.*
New York: The Museum of Modern Art, 1982.
Sakraischik, Claudio Bruni. *Catalogo generale
Giorgio de Chirico.* Milan: Edizioni Electa Spa,
1987. (This version not included in catalogue; the
authenticity of this painting has been confirmed
by Sakraischik.)
Taylor, Michael R., et al. *Giorgio de Chirico and the
Myth of Ariadne.* Exh. cat. London: Merrell/
Philadelphia Museum of Art, 2002, 155, pl. 43.

Henry Moore
English, 1898–1986
Family Group
1946
Bronze with green patina
44.5 x 33.5 x 21.6 cm (17½ x 13⅜ x 8½ in.)
Conceived and cast in 1946 in an edition of seven
or seven plus one
Signed on back of base: Moore
Reproduced by permission of the Henry Moore
Foundation.

PROVENANCE
Paul Heim, Paris; private collection; Scott M.
Black (acquired Christie's, New York, April 30,
1996, Lot 51: Impressionist and Modern
Paintings, Drawings and Sculpture, Part 1).

SELECTED EXHIBITIONS
1995–96. Paris, Musée d'Art Moderne, "Passions
privées," December 1995–March 1996.
1999. Portland Museum of Art, "Pursuing a
Passion: The Scott M. Black Collection," March
9–May 16.

SUGGESTED READINGS
Bowness, Alan. *Henry Moore: Sculpture and
Drawings.* London: Lund Humphries, 1965.
Gelburd, Gail, et al. *Mother and Child: The Art of
Henry Moore.* Exh. cat. Hempstead, NY: Hofstra
Museum, Hofstra University, 1987, cat. 30 (anoth-
er cast).
Sylvester, David, ed. *Henry Moore, Complete
Sculpture.* London: Lund, Humphries, 1988, I:15,
no. 241 (another cast).
Hedgecoe, John. *A Monumental Vision, the Sculpture
of Henry Moore.* New York: Stewart, Tabori &
Chang, 1998.
McCaughey, Patrick. *Henry Moore and the Heroic, a
Centenary Tribute.* Exh. cat. New Haven, CT: Yale
Center for British Art, 1999, cat. 6 (another cast).

Working Model for "Reclining Figure: Bone Skirt"
1977–79
Bronze with dark green patina
35.6 x 36.2 x 70 cm (14 x 14 ¼ x 27½ in.)
Signed and numbered on top of base: Moore 9/9
Reproduced by permission of the Henry Moore
Foundation.

PROVENANCE
John Kluge; Scott M. Black (acquired Christie's,
New York, May 8, 1991, Lot 51: Impressionist and
Modern Paintings, Drawings and Sculpture, Part 1).

SELECTED EXHIBITIONS
1999. Portland Museum of Art, "Pursuing a
Passion: The Scott M. Black Collection," March
9–May 16.

SUGGESTED READINGS
Russell, John. *Henry Moore.* London: Allen Lane,
The Penguin Press, 1968.
Henry Moore, The Reclining Figure. Exh. cat. Ohio:
Columbus Museum of Art, 1984.
Bowness, Alan, ed. *Henry Moore, Complete Sculpture.*
London: Lund Humphries, 1988, no. 723, pls.
124, 125 (another cast).
Monferini, Augusta, and Henry Moore. *Henry
Moore, gli ultimi 10 anni.* Exh. cat. Milan: Skira,
1995, cat. 17 (another cast).
Hedgecoe, John. *A Monumental Vision, the Sculpture
of Henry Moore.* New York: Stewart, Tabori &
Chang, 1998.

Marc Chagall
Russian (active in France), 1887–1985
Tenderness
La tendresse
1960s
Watercolor, gouache, and pastel on paper, laid
down on paper
76.8 x 57.5 cm (30¼ x 22½ in.)
Signed lower right: Marc Chagall
© 2006 Artists Rights Society (ARS), New
York/ADAGP, Paris.
Courtesy, Portland Museum of Art, Maine.

PROVENANCE
Galerie Maeght, Paris; Scott M. Black (acquired
Christie's, New York, May 16, 1990, Lot 225:
Impressionist and Modern Drawings and
Watercolors).

SELECTED EXHIBITIONS
1971. Tokyo, Fuji TV Gallery, "Magician of Love—
Marc Chagall," 1971.
1981. Gunma, Prefectural Museum, "Chagall,
Love and Life."
1999. Portland Museum of Art, "Pursuing a
Passion: The Scott M. Black Collection," March
9–May 16.

SUGGESTED READINGS
*Marc Chagall, le cirque: Estampes, livre illustré, mono-
types, dessins.* Exh. cat. Geneva: Galerie Gérald
Cramer, 1972.
Sorlier, Charles. *Chagall by Chagall.* Trans. John
Shepley. New York: H. N. Abrams, 1979.
Southgate, Patsy, trans. *Marc Chagall, Le Cirque,
Paintings, 1969–1980.* New York: Pierre Matisse
Gallery, 1981.
Compton, Susan. *Chagall.* Exh. cat. London:
Royal Academy of Arts/Weidenfeld and
Nicolson, 1985.
Clair, Jean, and Pierre Théberge. *The Great
Parade: Portrait of the Artist as Clown.* Exh. cat. New
Haven, CT; London; and Ottawa: Yale University
Press and The National Gallery of Canada, 2004.

Joan Miró
Spanish, 1893–1983
The First Spark of Day III
La première etincelle du jour III
1966
Oil and acrylic on canvas
145.8 x 114 cm (57½ x 45 in.)
Signed lower left: Miró
© 2006 Successió Miró/Artists Rights Society
(ARS), New York/ADAGP, Paris.
Photo by Meyersphoto.com. Courtesy, Portland
Museum of Art, Maine.

PROVENANCE
Galerie Maeght, Paris; Stephen Hahn; Carimati
Collection; sale, Christie's, London, July 3, 1979,
Lot 91; private collection; Scott M. Black
(acquired Sotheby's, New York, May 3, 2005, Lot
46: Impressionist and Modern Art).

SELECTED EXHIBITIONS
1968. Saint-Paul-de-Vence, Fondation Maeght,
"Miró."
1968–69. Barcelona, Antic Hospital de la Santa
Creu, "Miró."
1971. Bordeaux, Galerie des Beaux-Arts,"Le sur-
réalisme."
1972. New York, Acquavella Galleries, "Joan
Miró."
1980. Washington, DC, Hirshhorn Museum and
Sculpture Garden; Washington, DC, Smithsonian
Institution; Buffalo, NY, Albright-Knox Art
Gallery, "Miró."

SUGGESTED READINGS
Dupin, Jacques. *Miró.* Trans. Norbert Guterman.
Exh. cat. New York: H. N. Abrams, 1961.
Miró, Joan. *Yo trabajo como un hortelano.*
Introduction by Yvon Taillandier. Barcelona:
Editorial G. Gili, 1964.
Tapié, M. *Joan Miró.* Milan: Fratelli Fabbri, 1970,
no. 102.
Joan Miró, a Retrospective. New York: Solomon R.
Guggenheim Museum; New Haven, CT: Yale
University Press, 1987.
Dupin, Jacques, and Ariane Lelong-Mainaud.
Joan Miró. Catalogue raisonné. Paintings.
1959–1968. Paris: Daniel Lelong and Successió
Miró, 2002, IV:183, no. 1236.

Figure Illustrations

Fig. 1
Camille Pissarro
French (born in the Danish West Indies),
1830–1903
Sunlight on the Road, Pontoise, 1874
Oil on canvas
52.4 x 81.6 cm (20⅝ x 32⅛ in.)
Museum of Fine Arts, Boston, Juliana Cheney
Edwards Collection 25.114

Fig. 2
Paul Cézanne
French, 1839–1906
Trees in the Jas de Bouffan, Springtime, 1878–80
Watercolor and gouache over pencil on paper
25.1 x 29.8 cm (9⅞ x 11¾ in.)
Private Collection, courtesy Galerie Cazeau-
Béraudière, Paris

Fig. 3
Claude Monet
French, 1840–1926
The Seine at Lavacourt, 1880
Oil on canvas
98.4 x 149.2 cm (38¾ x 58¾ in.)
Dallas Museum of Art, Munger Fund 1938.4.M

Fig. 4
Claude Monet
French, 1840–1926
Cap Martin, near Menton, 1884
Oil on canvas
67.2 x 81.6 cm (26½ x 32⅛ in.)
Museum of Fine Arts, Boston, Juliana Cheney
Edwards Collection 25.128

Fig. 5
Eugène Boudin
French, 1824–1898
Fashionable Figures on the Beach, 1865
Oil on panel
35.5 x 57.5 cm (14 x 22⅝ in.)
Museum of Fine Arts, Boston, Gift of Mr. and
Mrs. John J. Wilson 1974.565

Fig. 6
Pierre-Auguste Renoir
French, 1841–1919
Boating Couple, about 1881
Pastel on paper
45.1 x 58.4 cm (17¾ x 23 in.)
Museum of Fine Arts, Boston, Given in memory
of Governor Alvan T. Fuller by the Fuller
Foundation 61.393

Fig. 7
Edgar Degas
French, 1834–1917
Sketch for "Pagans and Degas's Father," 1882
Pastel and charcoal on paper
47.9 x 61.1 cm (18⅞ x 24⅟₁₆ in.)
Philadelphia Museum of Art: The Mr. and Mrs.
Carroll S. Tyson, Jr., Collection, 1963
1963-116-7

Fig. 8
Edgar Degas
French, 1834–1917
*Degas's Father Listening to Lorenzo Pagans Playing
the Guitar*, about 1872
Oil on canvas
81.6 x 65.1 cm (32⅛ x 25⅝ in.)
Museum of Fine Arts, Boston, Bequest of John
T. Spaulding 48.533

Fig. 9
Edgar Degas
French, 1834–1917
Dancers Resting, 1881–85
Pastel on paper mounted on cardboard
49.8 x 58.4 cm (19⅝ x 23 in.)
Museum of Fine Arts, Boston, Juliana Cheney
Edwards Collection 39.669

Fig. 10
Mary Cassatt
American, 1844–1926
Ellen Mary in a White Coat, about 1896
Oil on canvas
81.28 x 60.32 cm (32 x 23¾ in.)
Museum of Fine Arts, Boston, Anonymous
Fractional Gift in honor of Ellen Mary Cassatt
1982.630

Fig. 11
Camille Pissarro
French (born in the Danish West Indies),
1830–1903
View from the Artist's Window, Eragny, 1885
Oil on canvas
54.5 x 65.1 cm (21⅞₁₆ x 25⅝ in.)
Museum of Fine Arts, Boston, Juliana Cheney
Edwards Collection 25.115

Fig. 12
Auguste Rodin
French, 1840–1917
The Gates of Hell, 1880–1917
Bronze
635 x 400 x 85 cm (250 x 157½ x 33½ in.)
Musée Rodin, Paris S. 1304
Photograph by Jean de Calan

Fig. 13
Henri de Toulouse-Lautrec
French, 1864–1901
Woman in Bed, Profile, 1896
Color lithograph
Sheet: 40.1 x 52.2 cm (15¹³⁄₁₆ x 20 ⁹⁄₁₆ in.)
Museum of Fine Arts, Boston, Lee M. Friedman
Fund 68.556

Fig. 14
Paul Gauguin
French, 1848–1903
Landscape with Two Breton Women, 1889
Oil on canvas
72.4 x 91.4 cm (28½ x 36 in.)
Museum of Fine Arts, Boston, Gift of Harry and
Mildred Remis and Robert and Ruth Remis
1976.42

Fig. 15
Maurice Denis
French, 1870–1943
Mother and Child with an Apple, 1897
Oil on canvas
69 x 51 cm (27⅛ x 20⅛ in.)
Courtesy Galerie Malingue, Paris
© 2006 Artists Rights Society (ARS), New
York/ADAGP, Paris.

Fig. 16
Paul Signac
French, 1863–1935
Port of Saint-Cast, 1890
Oil on canvas
66.0 x 82.5 cm (26 x 32½ in.)
Museum of Fine Arts, Boston, Gift of William A.
Coolidge 1991.584

Fig. 17
Claude Monet
French, 1840–1926
Antibes Seen from the Plateau Notre-Dame, 1888
Oil on canvas
65.7 x 81.3 cm (25⅞ x 32 in.)
Museum of Fine Arts, Boston, Juliana Cheney
Edwards Collection 39.672

Fig. 18
Paul Signac
French, 1863–1935
Antibes in Stormy Weather—The Pink Cloud, about
1915
Watercolor and pencil on paper
25.4 x 19 cm (10 x 7½ in.)
Arkansas Arts Center Foundation Collection: Gift
of James T. Dyke 1999.065.044

Fig. 19
Vincent van Gogh
Dutch (worked in France), 1853–1890
Houses at Auvers, 1890
Oil on canvas
75.6 x 61.9 cm (29¾ x 24⅜ in.)
Museum of Fine Arts, Boston, Bequest of John T.
Spaulding 48.549

Fig. 20
Georges Braque
French, 1882–1963
Fishing Boats, 1909
Oil on canvas
92.1 x 73.3 cm (36¼ x 28⅞ in.)
The Museum of Fine Arts, Houston; Gift of
Audrey Jones Black 74.135
© 2006 Artists Rights Society (ARS), New
York/ADAGP, Paris.

Fig. 21
Pablo Picasso
Spanish (worked in France), 1881–1973
Head of a Woman, 1909
Bronze
41.3 x 24.8 x 26.7 cm (16¼ x 9¾ x 10½ in.)
Museum of Fine Arts, Boston, Gift of D. Gilbert
Lehrman 1976.821

Fig. 22
Georges Braque
French, 1882–1963
Landscape with Houses, 1908–9
Oil on canvas
65.5 x 54 cm (25⅝ x 21¼ in.)
Collection: Art Gallery of New South Wales,
Sydney, Purchased 1980 2.1980
© 2006 Artists Rights Society (ARS), New
York/ADAGP, Paris.

Fig. 23
Pablo Picasso
Spanish (worked in France), 1881–1973
Harlequin, late 1915
Oil on canvas
183.5 x 105.1 cm (72¼ x 41⅜ in.)
The Museum of Modern Art, New York, Acquired
through the Lillie P. Bliss Bequest 76.1950
Digital image © The Museum of Modern Art/
Licensed by SCALA/Art Resource, NY.

Fig. 24
Paul Cézanne
French, 1839–1906
Still Life with Green Pot and Pewter Jug, about 1869
Oil on canvas
64 x 81 cm (25 x 32 in.)
Musee d'Orsay, Paris RF1964-37
Photo credit: Hervé Lewandowski/Réunion des
Musées Nationaux/Art Resource, NY.

Fig. 25
Edouard Vuillard
French, 1868–1940
Madame Vuillard Lighting the Stove, 1924
Oil on paper mounted on canvas
63.5 x 74.3 cm (25 x 29¼ in.)
Flint Institute of Arts, Michigan, Gift of the
Whiting Foundation through Mr. and Mrs.
Donald E. Johnson 1971.12
© 2006 Artists Rights Society (ARS), New
York/ADAGP, Paris.

Fig. 26
Aristide Maillol
French, 1861–1944
Torso of Summer, about 1910–11
Bronze
142.2 x 45.7 x 33 cm (56 x 18 x 13 in.)
Museum of Fine Arts, Boston, Gift of Mr. and
Mrs. John J. Wilson 1986.1022
© 2006 Artists Rights Society (ARS), New
York/ADAGP, Paris.

Fig. 27
Albert Marquet
French, 1875–1947
Posters at Trouville, 1906
Oil on canvas
65.1 x 81.3 cm (25⅝ x 32 in.)
National Gallery of Art, Washington, DC,
Collection of Mr. and Mrs. John Hay Whitney
1998.74.1
© 2006 Artists Rights Society (ARS), New
York/ADAGP, Paris.
Image © 2006 Board of Trustees, National
Gallery of Art, Washington.

Fig. 28
Pablo Picasso
Spanish (worked in France), 1881–1973
Face, 1928
Lithograph published in André Level, *Picasso*
(Paris: Editions G. Crès et Cie., 1928)
Image: 20.6 x 14.2 cm (8⅛ x 5⁵⁄₁₆ in.)
Museum of Fine Arts, Boston, Gift of Mrs.
George R. Rowland, Sr. 1981.126
© 2006 Estate of Pablo Picasso/Artists Rights
Society (ARS), New York.

Fig. 29
René Magritte
Belgian, 1898–1967
Natural Graces, 1942
Gouache over graphite on paper
41.6 x 59.4 cm (16⅜ x 23⅜ in.)
Museum of Fine Arts, Boston, Melvin Blake and
Frank Purnell Collection 2003.16
© 2006 C. Herscovici, Brussels/Artists Rights
Society (ARS), New York.

Fig. 30
Paul Delvaux
Belgian, 1897–1994
Daily Proposal (Woman with a Mirror), 1937
Oil on canvas
105.4 x 130.2 cm (41½ x 51¼ in.)
Museum of Fine Arts, Boston, Melvin Blake and
Frank Purnell Collection 2003.32
© 2006 Artists Rights Society (ARS), New
York/SABAM, Brussels.

Fig. 31
Henry Moore
English, 1898–1986
Madonna and Child, 1943
Bronze
H. 13.8 cm (H. 5⁷⁄₁₆ in.)
Museum of Fine Arts, Boston, Gift of Mr. and
Mrs. Herbert J. Richman 1981.345
Reproduced by permission of the Henry Moore
Foundation.

BRITAIN
1 Londinium (London)
2 Wandsworth
3 Aylesford
4 Gussage All Saints
5 Hengistbury Head
6 Bulbury Camp
7 Maiden Castle
8 Durnovaria (Dorchester)
9 St. Michael's Mount
10 Carn Euny
11 Bosigran Castle
12 Chysauster
13 Trevelgue Head
14 Lesser Garth
15 Tal-y-llyn
16 Dinorben
17 Trer' Ceiri
18 Lochar Moss
19 Muthill (Pitkelonney)
20 Stanwick
21 Witham
22 Snettisham
23 Desborough
24 Ipswich
25 Camulodunum (Colchester)
26 Welwyn
27 Verulamium (St Albans)

IRELAND
1 Tara
2 Clonmacnoise
3 'Paps'
4 Staigue F.
5 Dingle
6 Blasket Islands
7 Craggaunowen
8 Turoe
9 Somerset
10 Attymon
11 Cruachan
12 Keshcarrigan
13 Ballyshannon
14 Broighter
15 Lisnacrogher
16 Clogher
17 Loughnashade
18 Emain Macha
19 Cornalaragh
20 Cuainlge
21 Lough Crew

FRANCE
1 Basse-Yutz
2 Somme-Bionne
3 Pogny
4 Paillard
5 Camp d'Artus
6 Plouégat-Moysan
7 Ste Anne-en-Trégastel
8 Kernevez
9 Lampaul-Ploudalmézeau
10 Ouessant
11 Kerguilly-en-Dinéault
12 Castel-Meur
 Pointe du Raz
13 Kélouer-Plouhinec
14 Lann-Tinnikei
 Tronoan
 Kervadel-en-Plobannalec
15 Penmarc'h
16 Kernavest
17 Rocher au Bono

THE
CELTS OF
THE
WEST

TEXT BY VENCESLAS KRUTA
PHOTOGRAPHS BY WERNER FORMAN

TRANSLATED BY ALAN SHERIDAN

ORBIS·LONDON

Half-title page: The ear of wheat on the gold coin symbolizes the close link between gold and wheat for the Celts of the Iron Age, when wheat was widely exported and bartered for gold.

Title page: Bronze mirror discovered at Desborough, Northamptonshire. Note the fold-over symmetry of the design, giving no single point of focus.

This page: Detail from the bronze shield fitting pictured on page 82.

TO PAUL-MARIE DUVAL

Graphic design by Bedřich Forman

Printed in Yugoslavia
ISBN 0-85613-658-1

CONTENTS

Probably as early as the second millennium BC, Celtic-speaking peoples from central Europe set off into the setting sun towards the oceanic islands, on the westernmost edge of the world as they knew it. The furthest point of the lands settled by the Celts was the Blasket Islands, off the Dingle Peninsula, Co. Kerry. For the Celts, there was nothing beyond but an endless stretch of water into which the sun sank; there lay the Blissful Isles of the Other World, the paradise of the chosen few. A distant echo of this lingers on in Avalon, the isle of mediaeval legend where King Arthur awaited the day when he would return to liberate the downtrodden Britons.

INTRODUCTION

The Celts of the western seaboard – Bretons, Scots, Welsh and Irish – are today the only ones to perpetuate the languages of the ancient Celtic peoples that imposed themselves, sometimes by force, for many centuries, throughout practically all of the territories extending from the Atlantic to the Carpathians and from the plains of the north to the northern shores of the Mediterranean. It is thanks to the western Celts that an original Celtic literature has been preserved for us. The works of generations of anonymous poets, these narratives were already certainly several centuries old when they came to be written down, at the dawn of the Middle Ages, by Irish monks. The last possessors of an oral tradition which in the other countries of Celtic origin has dissolved into the luxuriant world of folktale, the Celts of the British Isles also kept alive a figurative art that occupies just as important a place as their epic and mythological narratives in the cultural treasury which has been bequeathed to us by the peoples of ancient Europe.

Compared with the heritage of the great urban civilizations of the Mediterranean, the Celtic heritage may seem at first sight somewhat marginal, fashioned by an essentially rural society, whose life could not but be uncouth and crude, and its culture, lacking all refinement, basically intuitive or imitative. The roots of this disparaging judgement go back to antiquity, to Greek and Latin authors whose information compensates for the absence of a historical tradition recorded by the Celts themselves. The picture they create clearly derives from a vision based on the systematic opposition of the Graeco-Roman world to the unordered world of the barbarians, among whom the Celts long featured as the principal protagonists in Europe.

In fact, an attentive and unprejudiced examination of the information contained in these texts allows us to sketch a much more subtle picture and often yields parallels between the two civilizations where one might at first be tempted to see only contrasts.

Bronze disc dating from the first or second centuries AD, found in Monasterevin, Kildare. This is the only known complete example in Ireland, and its function has not yet been satisfactorily explained. One hypothesis is that it was used to decorate chariots, suspended in pairs, one on each side of the chariot.

These problems of assessment were not very different when, only recently, we began to study material remains — traces of destroyed or abandoned dwellings, places of burial or of worship, objects. These remains provide the best source of information at our disposal and also the only one we can expect to be regularly added to in the future. The abundance of Greek and Roman monumental stone architecture and the absence of comparable remains from the Celtic world led to an emphasis on an opposition that has finally proved to be more apparent than real, and which was generally the consequence of an inability to approach the study of the material in any way other than in terms of a system of values which gave the classical model pride of place; indeed, the degree of development of an ancient civilization was measured solely by the distance that still remained to be covered before the classical ideal was attained.

The significant progress recently made in Celtic archaeology is due to the fact that artefacts are discovered in the ground almost daily, and the methods of analysis are constantly being refined. Equally important is the co-operation, which is becoming increasingly effective and valuable, of the so-called auxiliary disciplines – anthropology, palaeozoology, palaeobotany, palaeometallurgy, etc. This interdisciplinary co-operation has made possible a notable increase in our knowledge, and, by throwing new light on the indirect evidence provided by the authors of antiquity, has undermined traditional points of view.

An increasingly important role is being played by a particular category of archaeological remains, the texts, unfortunately short and few in number, that were inscribed by the ancient Celts in their own language. These texts provide fundamental material for the study of the oldest Celtic languages and furnish irrefutable proof of the early geographic extension of the Celtic-speaking people.

The picture of the world of the ancient Celts that is gradually taking shape is still extremely fragmentary. It is, however, much richer and less schematic than the traditional image, which portrays the principal, if not the sole merit of the Celtic populations as having been their rapid assimilation of the benefits of the civilization that Rome imposed on them. It is now becoming increasingly clear that the Celts' loss of independence did not lead to an immediate, radical upheaval; not only did the pre-

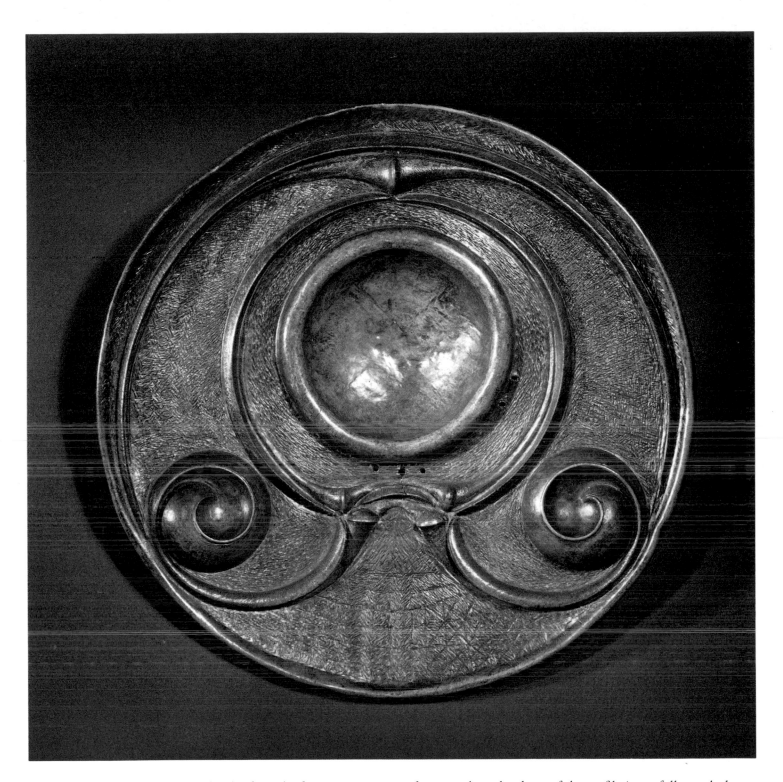

Celtic art blossomed in the British Isles from the first century onwards, when similar forms of expression were dying out on the Continent. Artists of the period demonstrate a mastery of the interplay of curves and show how well they knew how to use compasses. This hammered-bronze disc found in Ireland and dating probably from the end of the first century AD illustrates the plastic quality of this work and its subtly allusive character. The main design is made up of eccentric circles which, although regular in shape, are of varying thickness and profile. This type of curve, where the shape of the profile is carefully worked out, particularly where it thickens out at the end like a hunting horn, is a typical feature of the insular style. The apparently strict symmetry is relieved by some subsidiary detail; in the present case it lies in the treatment of the background, particularly between the two spirals. In spite of its basically abstract character it suggests the face of a monster, to a greater or lesser extent, according to the strength and angle of the light in which it is viewed.

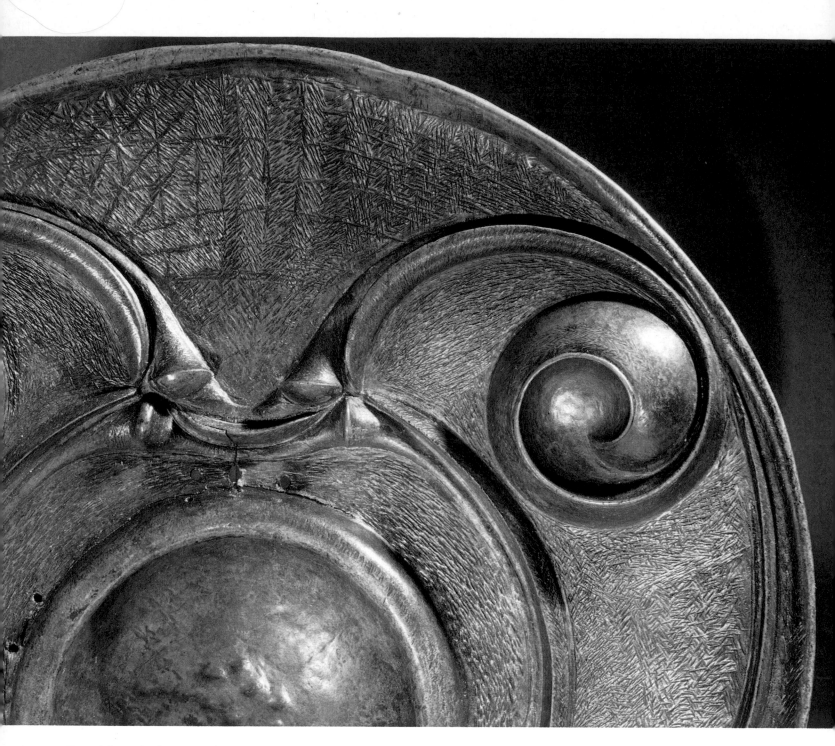

Detail from the hammered-bronze disc pictured on the previous page

Roman socio-economic system continue to function without undergoing readily appreciable changes, but many of the fundamental aspects of the civilization of the Roman provinces of the West – sanctuaries, urban centres, territorial and other networks – owe their development to elements that were implanted long before the conquest. The adjectives 'Gallo-Roman' or 'Romano-British' express perfectly the dual legacy of these provincial cultures and the fundamental role played in their formation by the Celtic background.

The Celts are beginning to emerge from the anonymous mass of the non-literate peoples who lived in Europe during the late sixth century BC. Separated at that time by almost two thousand years from the Indo-European trunk, their linguistic family already had a long history and comprised several distinct groups occupying vast territories in central and western Europe.

At the centre were the populations living between the Alps and the

southern edge of the great plains of northern Europe: this was the birthplace, in the fifth century BC, of the La Tène civilization (named after an archaeological site at one end of the Lake of Neuchâtel, Switzerland, where objects characteristic of the period were found under water from the middle of the nineteenth century). Since then, the La Tène civilization has been attributed to the historical Celts, that is to say, to those who were responsible for the invasion of Italy at the beginning of the fourth century BC, and who, in the following century, penetrated into the Balkans, and settled as far afield as Asia Minor.

The analysis of the so-called Lepontic inscriptions – dating from the late sixth century BC and written in characters deriving from the Etruscan alphabet – shows, however, that Celtic groups (the first Celts to use writing to record their language) were already well integrated into northern Italy, in present-day Lombardy and perhaps even further south, while their transalpine cousins settled in the Po plain and moved south as far as Rome.

A third group of Celtic-speaking populations was already living at this time in the western part of the Iberian peninsula. They had probably arrived there long before and seem to have retained only sporadic contacts with inland Europe.

Thus it is clear that the Celticization of Europe began well before the entry of the Celts into history and the birth of the La Tène civilization in the fifth century BC. The gradual spread of this civilization from its initial territory, traditionally regarded as the surest and most obvious symptom of Celtic expansion, would seem to represent, therefore, only the final stage of the migratory movements of the central group alone.

These historical invasions were not aimed solely at territories in which the Celts had not yet settled, but also at regions that had been Celticized at an earlier date, but which did not belong to the cultural area of the newcomers. Such a situation occurred in northern Italy. It was probably also the case in Brittany and the British Isles, for their Celticization could not have been due solely to the populations that brought with them the La Tène civilization. Indeed, the appearance and diffusion of its characteristic manifestations is very uneven in these regions, and can be linked only to the arrival of small groups which settled in relatively limited areas. Only the existence of a totally Celticized background from at least the First Iron Age (from the eighth century BC or earlier) can explain the deep-rooted implantation of the language and the remarkable vigour of the traditions to be observed at the time when the Roman armies occupied Gaul and landed for the first time in Britain. If Caesar is to be believed, Britain was even at this time one of the great spiritual and intellectual centres of the Celtic world: it was there that the Druidic doctrine was born, then transmitted to the Continent, and it was to Britain that those who wished to study the doctrine in depth went for instruction.

The ancient Celts of the outer fringes do not, therefore, represent a peripheral group, a world that is merely the distant echo of Continental Celtic culture. They form an ancient entity that was endowed from the beginning with its own distinct personality, due principally, no doubt, to the inheritance of a substratum that had already succeeded in developing into an original and remarkably advanced civilization on the western seaboard of Europe. The anachronistic and fanciful picture built up in the nineteenth century, whereby Druids and megaliths were linked together, although based on a misconception, thus involuntarily symbolizes the fusion, which must have taken place, at some very remote date, of the Celtic-speaking immigrants with the descendants of the original civilizations of the neolithic period and Bronze Age.

The characteristic atmosphere and play of light in the temperate forests may well have been a factor in developing the quality of feeling so well conveyed by the art of the ancient Celts. The outer walls of Camp d'Artus near Huelgoat, Finistère, on the southern slopes of the Arée hills, are today covered with forest, but in the first century BC they defended a large oppidum (early town) of an Armorican people, the Osismi. The ramparts, made of earth, stones and wood, are now in poor condition but one can still see the twelve- to fourteen-foot drop. However, nothing remains of any of the buildings, made of non-durable materials — dwellings, workshops, religious edifices — which must have covered the seventy-five-acre site.

THE CELTS OF THE WESTERN SEABOARD ENTER HISTORY

Left: A large number of Iron Age promontory forts are to be found on the Cornish coast around Land's End. Pictured here is the view from the spectacular site of Bosigran Castle near Zennor.

Below: This model of a ship, probably dating from the first century BC or the beginning of the first century AD, was discovered by chance at the end of the last century at Broighter, Co, Derry (see illustration page 25).

In the early fourth century BC, at the same time that Alexander the Great was advancing towards the Indus and assembling within an immense empire all the regions of Europe, Africa and Asia which bordered the eastern Mediterranean and extended to the shores of the Black Sea and the Indian Ocean, a Greek from Marseilles named Pytheas embarked upon a long sea voyage beyond the Pillars of Hercules (Gibraltar), heading for the almost legendary countries of the north whence came amber and tin. In a work entitled *On the Ocean*, he left an account of the astonishing journey that took him to the coasts of the Baltic and probably even to Iceland (Thule). Unfortunately his account has been lost, but we know something of its broad outlines from a number of references to it by Greek and Latin authors, who, in fact, are often very critical and suspicious of an exploit that was never to be repeated throughout antiquity.

It required unfailing courage and a true explorer's spirit for Pytheas to risk his life on a strange ocean, then known only through the account of a Carthaginian named Himilcon. This had been translated into Greek and was therefore probably known to Pytheas; Himilcon had vividly described the many dangers lurking in those misty waters, littered with algae and peopled by sea monsters. About two hundred years before Pytheas, Himilcon had followed the Iberian coast northwards and, after sailing for four months, had arrived at the islands known as the Oestrymnides which are probably situated close to the southern coast of Armorica. (Armorica is the name for the north-western extremities of Gaul, comprising present-day Brittany and the western part of present-day Normandy; the word is derived from Celtic words *ar*, 'on', and *mor*, 'sea'.) The inhabitants of the Oestrymnides traded with the two great islands, Ierne and Albion, the present-day Ireland and Britain.

This information is confirmed by Pytheas, who recognized the peninsula of the *(Os)timioi* (Armorica), the Kabaion cape (Pointe du Raz or Penmarc'h) which forms its extreme tip, and the island of Ouximasa or

Uxisama (Ushant). After calculating the latitude of these places – he was not only an intrepid navigator, but also an expert astronomer and mathematician – Pytheas went on towards the great islands which he was the first to call Prettanikai (British). Turning the sea currents to his advantage, he circumnavigated Britain, probably sailing up the west coast – from Cape Belerion (the Lizard?) to the Orkas islands (Orkneys) – then down the east coast – from the same islands to a point beyond a promontory called Kantion (Kent), situated almost opposite the mouth of a great Continental river (the Rhine); here the coast suddenly changes direction and swings west towards the tin deposits of Cornwall, in the vicinity of Cape Belerion, which he had already identified on the first part of the voyage.

Pytheas's voyage and the unfortunately incomplete allusions to it that have survived are obviously of outstanding interest for the history of Greek geography and navigation. They also provide indirect, but perfectly convincing, evidence concerning the regularity and volume of the sea traffic developed by the peoples who inhabited the ocean seaboard. Pytheas would never have been able to carry out this part of the voyage without encountering major difficulties if he had not benefited from the knowledge of the currents, tides and winds possessed by the native sailors, as well as from relatively accurate information concerning the principal geographical landmarks whose vernacular names he was able to record.

At the time of Pytheas, this traffic probably consisted primarily of the flourishing trade in tin, which was transported by ships to the coast, then carried overland to the Mediterranean, notably to Marseilles, his native city. However, such traffic had existed long before this, from the time of the earliest Atlantic civilizations – those associated with the builders of the megalithic monuments of the neolithic period and early Bronze Age – as we know from those elements shared at that time by the islands and the different regions of the Atlantic coast, from Galicia to the Channel.

Though later pushed into second place by the spread from the Mediterranean of literate civilizations, Atlantic cultural communities of this sort formed, for several thousand years, not only an extension and culmination of various influences emanating from the heart of the Continent or its southern confines but also centres of undeniable vitality and originality. Their role, unknown to us for so long, is now becoming increasingly apparent, mainly thanks to the dates revealed by the radio-carbon method, which provide indisputable proof of the antiquity of the first agricultural civilizations on Europe's far-western fringe. They begin in the fifth millennium BC, and are apparently contemporary with their closest equivalents in inland Europe.

However, Pytheas's evidence also contains essential information concerning the settlement of these regions: indeed, the names of places and peoples that he collected in Armorica and in the islands are generally close to, if not identical with, the names used several centuries later by Celtic or completely Celticized populations, and linguists are almost unanimous in attributing them to this same family of languages. Thus the names of the two great islands, Ierne and Albion, recorded in the late sixth or early seventh century BC by Himilcon, correspond to the names of the same islands in Old Irish: Eriu and Albu. Again, the *(Os)timioi* of Armorica were no doubt the same people as the *Osismi* who occupied at the time of Julius Caesar's conquest of Gaul the present *département* of Finistère and the western part of the Côtes-du-Nord; indeed their name would appear to mean in Celtic 'the most distant', in other words, 'the people from the edge of the world', which expresses remarkably well their geographical situation.

Verica, king of the Atrebates, *one of the sons of Commios of Gallic War fame, succeeded his exiled brother, Tincommios, shortly before the death of Augustus. Verica was a contemporary of Tiberius (AD 14–37) and of his successor, Claudius. He sought aid from Rome and was thereby at the origin of the expedition of AD 43 which led to Britain being partly occupied and transformed into a Roman province.*

The obverse of this gold coin (the reverse is illustrated on page 81) bears the abbreviated name of the king and the picture of a vine leaf. The choice of this emblem must be linked with the popularity of imported wine in the lower Thames valley from the middle of the first century AD. The rich burial-places of the area (see illustrations pages 94 and 95) are notable for their amphorae, together with pieces from wine services. Fragments are also frequently found in living quarters, especially on coastal sites.

This leads one to believe that at the time of Pytheas's voyage and probably even as early as the voyage of Himilcon, Armorica and the British Isles were inhabited by Celtic or Celticized populations. The first Celtic-speaking groups must therefore have arrived in these areas long before, perhaps even by the time that the Celts broke away from the great Indo-European family, which seems to coincide with the beginnings of metallurgy, *i.e.*, at some point during the third millennium BC. Coming as they did from inland Europe, following the path of the sun, they had to be initiated into the secrets of maritime navigation, which had hitherto been totally unknown to them, for they had originally been shepherds and farmers. Their teachers in navigation were natives, who apparently spoke a pre-Indo–European language, with whom they interbred: by imposing their language upon the natives, they formed the foundations of a Celtic fringe so deep-rooted that it has succeeded in preserving the essential elements of its culture right up to the present time.

We must not overestimate the role of migrations in the process of Celticization so that we overlook the existence of a native substratum. Only the durability of this substratum, which was probably always numerically superior, can explain the continuity of settlement from the appearance of the first agricultural civilizations down to historical times. However, it would be just as unreasonable to ignore the fact that only the arrival of the Celtic-speaking populations in sufficient numbers could have made it possible for the Celtic languages to spread and take root in the insular environment.

It is unlikely that this occurred as the result of a single migration; evidence of Continental influences in the islands at the beginning of the Iron Age (eighth and seventh centuries BC), archaeological remains and even entirely explicit texts point to several successive waves of immigrants to Britain.

The earliest proof of the first influx of historical Celts may be the presence in the Thames valley, from London to Oxfordshire, of a relatively large series of objects which are clearly intrusive. These objects have perfectly convincing parallels in materials dating from the fifth century BC found in Champagne that are typical of the archaeological facies known as Marnian (after the River Marne). The most significant pieces are daggers with decorated bronze sheaths, discovered almost exclusively in the bed of the Thames, and brooches, some of which are almost identical with Marnian examples and may even have been manufactured in the same workshops.

Obviously, the fact that these objects were found in isolated sites and therefore cannot be directly linked with the dwellings or burial places of their owners means that they may not be proof of an immigration. They could be seen as imported luxury objects or booty brought back from military incursions on the Continent. This is a particularly tempting hypothesis, since the sacrifice of some of the spoils of a vanquished enemy is often presented as an explanation for the deposits of Celtic weapons found in rivers.

However, the fact that these objects are apparently early examples of forms that were later to characterize the facies of the Iron Age in Britain implies a degree of indigenousness that is difficult to reconcile with the idea that they derive from the formal, fortuitous imitation of objects of foreign provenance. One can plausibly suggest that there was an immigration of groups, not necessarily very large, but including metal-workers as well as warriors, who were completely and no doubt rapidly integrated into the local environment.

Cunobelinus (AD 10–40) was the second member of the powerful dynasty which ruled over the Catuvellauni *and the* Trinovantes, *north of the Thames, to have his name featured on coins. (The first was his father, Tasciovanus.) His gold coinage was probably struck at* Camulodunum (Colchester), *the main town of the* Trinovantes. *The reverse carries the king's name in full and, above it, the picture of two galloping horses over the outline of a wheel. This is clearly a transformation of the triumphal chariots of Roman coinage.*

The nature and origin of more recent migrations is succinctly but clearly described by Julius Caesar:

> The interior of Britain is peopled by inhabitants who, on the basis of oral tradition, declare themselves to be natives; on the coast live tribes who came from Belgium to pillage and wage war (almost all of them bear the names of their places of origin); when the fighting was over, these men remained in the country and became settlers.
>
> *Gallic War*, V, 12

In fact, at least two British peoples from the first century BC bore the same names as peoples living in northern Gaul: the *Atrebates*, who settled to the south of the Thames in what is now Hampshire and West Sussex, and the *Parisii* of east Yorkshire.

The close link between the first of these tribal groups and the Belgic people who gave the town of Arras and the Artois region their names is exemplified by the changing fortunes of their King Commios, who, after assisting Julius Caesar during his expeditions to Britain in 55 and 54 BC, changed sides to become one of the leaders of the Gallic coalition of the year 53, and took refuge in Britain, where he – and his sons – reigned over the local *Atrebates*.

The strengthening of the Continental influences among the insular *Belgae* at the time of the Gallic wars is obviously bound up with the influx of refugees whose historical background is well known to us. Similar situations must also have arisen earlier, but their repercussions on archaeological material are probably not always explicit and it is difficult, without the help of written documents, to distinguish between this type of migration and the results of influences deriving from different causes.

The settlement of the Belgic peoples in Gaul and Britain illustrates particularly well the problems raised by the study of ethnic movements based on archaeological evidence alone. Indeed, the fact that the *Belgae* arrived in Britain prior to Julius Caesar's expedition from the north of present-day France throws light on only one aspect of a vast phenomenon, which extends well beyond the narrow framework of relations between Gaul and Britain.

According to evidence found mainly in present-day Champagne, the formation of the Belgic peoples in Gaul must be bound up with the arrival, in the mid-third century BC, of fairly large but disparate groups, originally from Celtic territories along the Danube, between the Erzgebirge of Bohemia and the western part of the Carpathian basin. They belonged to a demographic network the density of which had become considerably lowered since the late fifth century. They founded new cemeteries which were characterized in particular by the frequency of quadrangular or circular enclosures around the graves and by the sporadic, but significant, practice of cremation in a milieu where inhumation had hitherto been the absolute rule. The newcomers brought with them objects with forms unknown in the region but widespread in the Danubian zone, as well as articles of dress such as the ankle-rings worn by well-to-do women, which were quite alien to local traditions. The newcomers retained some of their customs, abandoning others to conform to local practices and, one or two generations after their arrival, formed with the natives an apparently homogeneous group of populations. The peoples whom Julius Caesar found settled in Belgic Gaul sprang directly from the fusion, at that time relatively recent, of a conglomerate of Celtic groups, both native and foreign.

The sudden appearance in Britain of a fairly large series of objects more

Lostmarc'h Head, near Crozon, Finistère, was the site of an Iron Age settlement covering about two-and-a-half acres. It was protected by a double line of trenches and is a typical example of a fortified headland.

or less directly linked to third-century Danubian forms, which in Gaul indicate the arrival of new populations, might be the symptom of a similar phenomenon in Britain as well. The case of the *Parisii* of Yorkshire, a tribal group bearing the same name as the Gallic people who gave the capital of France its name, is particularly interesting in this respect.

The territory which the *Parisii* occupied in the century following the Roman conquest of the island, according to the second-century Alexandrine geographer Ptolemy, possesses the greatest density of Iron Age cemeteries in Britain that is currently known. Their most salient features – the presence of quadrangular enclosures around the graves and of great ditches in which a two-wheeled war-chariot was placed – clearly show a Continental influence, but other aspects – the sidelong crouching or even foetal position of many of the skeletons – have no equivalent in the funerary rites of the Continental Celts and must be regarded as stemming from strictly local traditions.

This duality of funerary practices seems to result from the mixture of native populations with Continental immigrants whose arrival must have coincided with the beginning of these necropolises. Now, the oldest objects so far discovered in these burial places are precisely those that possess the most obvious Continental affinities. Furthermore, those objects that can be most convincingly related to them are of Danubian ancestry or origin and date from the third century BC. The very same objects occur in Champagne, together with the beginnings of the new wave of quad-rangular enclosures which coincides with the formation of the Belgic peoples. It is probable, therefore, that the migratory wave that affected Yorkshire was the most northerly tip of population movements largely centred at that time on northern France. This might well explain why the people whom Ptolemy describes as having settled in that part of Britain have the same name as the Gallic *Parisii*, who almost certainly emerged from the ethnic upheavals of the third century BC. Let us note here a point which might be of more than coincidental interest: it is only in the territories of the *Parisii*, both in Britain and in Gaul, that one finds chariot burials dating from the third century BC.

Yorkshire probably does not constitute an isolated case, but the extreme limit of a migratory wave that had previously affected more southerly regions. The phenomenon appears here with particular clarity precisely because the territory of the *Parisii* lies on the periphery of that part of Britain in which the presence of Belgic populations has been confirmed. In the more southerly regions, especially those bordering the coast beyond the Thames estuary, which were occupied by the *Atrebates* and other Belgic peoples, the consequences of this hypothetical intrusion in the third century would seem to have been blurred. The transformations caused by the continuous influx of men, objects and ideas, and maintained by the flourishing commercial relations of these regions with the Continent, created a more complex culture.

It is in this part of Britain that we first find symptoms of the formation of tribal confederations associated with settlements of a crudely urban character, usually referred to by the Latin term *oppidum*. This process occurred apparently a little later in Britain than on the Continent, where the development of *oppida* and the socio-economic system that goes with them began to spread as early as the second century BC. The principal expansion of similar settlements in the southern part of Britain must be taken to have occurred in the following century, more particularly after the conquest of Gaul, for it is then that the first British coins began to be struck by the different tribal groups of that region alone.

On these coins is found the earliest writing produced by the island Celts.

Hengistbury Head in Dorset, at the southern end of Christchurch Bay, just west of the Isle of Wight, is protected from the land by a double rampart and was inhabited in ancient times (see illustration pages 108–109). Its excellent natural harbour probably made it one of the largest centres of trade between Britain and the Continent in the first century BC. Amongst other finds, fragments of Roman amphorae dating from well before the conquest, as well as coins of various Armorican peoples, were unearthed there during excavations early this century, proving that there had been direct contacts. Tin was probably one of the main products traded at Hengistbury. The Isle of Wight (Vectis) was traditionally associated with trade in this much sought-after raw material.

Some coins bear short inscriptions in Latin characters – names of persons, generally in abbreviated form – that perpetuate the memory of the members of the great local dynasties. Almost all of these are mentioned in written sources, as, to name a few, Commios and his sons, Tincommios and Verica, Tasciovanus, king of the powerful *Catuvellauni* of Essex, and his son Cunobelin, Shakespeare's Cymbeline.

It was these rich, powerful people living along the lower course of the Thames who confronted Julius Caesar during his two expeditions; and it was with their hard-won submission that the Roman conquest of the island, never to be completed, began, after the landing of Claudius's legions in the year AD 43. The province of Britain that was then created was at first limited to this southern part of the island, which was already endowed with the beginnings of an urban network.

However, setting up Roman authority, even in these regions where the degree of organization previously achieved facilitated the control of political and economic life, was no easy matter. Less than two decades after the creation of the province, in the year 61, hamfisted bureaucratic exactions were to provoke the uprising of the *Iceni* of Norfolk, at the very moment when the legate Suetonius Paulinus was trying to conquer the famous Druid sanctuary on the island of Mona (Anglesey). Led by Queen Boudicca (Boadicea), the rebels, joined by contingents of other peoples, attacked the colony of Camulodunum (Colchester) and the towns of Londinium (London) and Verulamium (St Albans), massacred the Roman garrisons and inflicted a bloody defeat on one legion, before they were finally defeated in their turn.

The Roman advance was resumed during the reign of Vespasian. It made especial headway after the year 77, under the legate Julius Agricola, whose son-in-law, the historian Tacitus, has left a detailed account of the operations. After a campaign against the *Ordovices* in northern Wales, Agricola organized the northern frontier of the province, which was to be thrust back a few decades later and to remain between the Clyde and the Firth of Forth. He even considered conquering Ireland, but gave up the idea; he did sail his fleet round Scotland and with his troops thrust northward into the interior where he inflicted a defeat on the Caledonian coalition on the slopes of the Mons Graupius (Grampian Hills).

The province of Britain had now reached its maximum extent: the greater part of the island was conquered, but the peoples living in the mountainous regions of Wales and in northern Scotland were to remain permanently outside the Empire.

The same went for Ireland, the only country that remained wholly Celtic and independent until the Middle Ages. Situated apparently outside the great migratory currents that reached the south of Britain in the Iron Age, the Emerald Isle no doubt owes its Celtic character to a very early immigration (dating from the Bronze or early Iron Age). There is no evidence at present available as to the date, origin and form of this migration, but it can nevertheless be said that the Gaelic-speaking settlers who peopled Ireland were not of the same origin as those who spread the Britonic dialects throughout the neighbouring island – which rules out the hypothesis of a late migration from Britain, as well as that of a migration after the sixth century BC directly from the Continent. Indeed, the indications of such direct contacts at this time are quite sporadic, while relations with the neighbouring island were apparently frequent and uninterrupted, thus confirming what Tacitus has to say on the matter:

> The nature of the soil, the climate, the ethnic characteristics and civilization are little different from those of Britain: our chief sources

A stone inscribed with ogham characters (Ogham Stone) which still stands near Colaiste Ide on the west of the Dingle peninsula, Co. Kerry. Ogham script takes its name from Ogma, a god associated with the magic power of the word; the Continental Celts called him Ogmios. This script lends itself well to carving on wooden beams and seems to have been used initially only for magical purposes. It is based on the Latin alphabet: the letters are made up of one or more lines arranged perpendicularly or obliquely along the axis formed by the corner of the stone. The script was probably first used in Ireland around the beginning of the fourth century AD and remained in use for several centuries. Inscriptions found on standing stones only comprise names, sometimes personal, sometimes alone, with a patronymic.

The first mariners to venture from the Mediterranean out on to the Ocean must have been amazed by its tides, as here on the Finistère coast, near Lostmarc'h Point on the Crozon Peninsula. Back in the fourth century BC, Pytheas of Marseilles, who had probably learned about the tides from the local Armoricans, realized that they had some relationship with the moon. In this he was far in advance of his contemporary, the scholar Timeus, who believed that the tides were caused by rivers flowing into the Ocean from the Celtic mountains.

23

of knowledge are the points of access and the ports thanks to traders and commercial relations.

Agricola, XXXIV

The resemblance noted by the historian between the appearance and the way of life of the populations of the two islands obviously concerned not the Britons of the province, but the still un-Romanized groups outside. Commercial contracts, perhaps implying the temporary presence of Roman merchants, are confirmed in Ireland particularly by discoveries of coins, exotic objects in a place where monetary circulation was not practised.

However, these contacts do not appear to have brought with them phenomena comparable with those to be observed prior to the Roman conquest in the southern part of Britain. The Ireland of the pre-Christian Iron Age offers no evidence of an evolution that might have led to urban-type formations like the *oppida*. The fortified residences of the many chiefs and local sovereigns are almost always modest in size and even the largest and most important of them never seem to have assumed the essential functions of an urban centre.

Writing, too, appeared only later, shortly before the arrival of St Patrick (432) and the introduction of Christianity into Ireland. This writing, called ogham, was an original creation: the letters of the Latin alphabet are rendered by means of groups of perpendicular and oblique lines arranged along an axis. Almost all the inscriptions of this type have been found on stones – we are not certain whether they were boundary marks or funerary stelae – and are confined to personal names.

Based on the domination of a tribal aristocracy whose expansion throughout rural areas is confirmed by the many small forts dotted across the country at the dawn of the Middle Ages, the society of pre-Christian Ireland was certainly closer to that of Celtic Europe under the Hallstatt dynasties of the early Iron Age than it was to the Gaul of the first century BC, with its primitive urban network of *oppida*, organized in federations of tribes united by common political and religious institutions.

Crossing the Irish Sea to what is now Brittany, we know unfortunately little about the degree of organization achieved by the great Armorican communities: the *Osismi*, already referred to by Pytheas; the *Coriosolites*, eastern neighbours of the *Osismi*, who had settled along the northern coast of the peninsula and gave their name to the small town of Corseul; the

This scabbard, with a broad-bladed iron dagger, is the most remarkable example of Armorican ornamental work of the fifth century BC so far discovered. It was excavated last century in a tumulus at Kernavest, in the Quiberon peninsula, Morbihan, which covered three stone coffins probably originally containing bodies buried in a crouching position. The engraved decoration of the bronze trimmings which covered most of the wooden sheath is similar in many ways to the decoration of Armorican pottery, which in turn is known to derive from metal originals. New patterns, which were first used in the fifth century BC with the emergence of Early Celtic art, are combined with simple geometric shapes in general use since the beginning of the Iron Age. This is seen in the rows of interlacing half-circles (on the plate decorating the mouth of the sheath) and the groups of 'palmettes' (on the small quadrangular appliqués in the centre). The shape of the dagger seems to be peculiar to Armorica; the decoration on its scabbard is similar to many other Celtic weapons of the same period, especially from the Champagne region.

The model of the ship, pictured also on page 15, discovered at Broighter, Co. Derry, on what had been a beach near the mouth of the River Roe in Lough Foyle. The choice of site, on the high water mark, and the presence of the gold boat, suggest that it might have been a votive offering to some sea god, perhaps Manannán mac Lir, king of the Ocean and of the Blissful Isles of the Other World. He was not solely an Irish god, for he is supposed to have given his name to the Isle of Man and also has a Welsh equivalent, Manawydan Fab Llyr.

The Broighter model represents a type of ship intended for the high seas, square-rigged with a horizontal yard and eight pairs of oars, and a rudder on the port side aft. It was a vessel probably similar to those of the Armorican Veneti. Naval historians put the average size of these ships at around a hundred feet long with a beam of somewhat less than thirty feet.

25

Redones, situated inland, around Rennes; and lastly, the *Veneti*, the powerful people who occupied the present *département* of Morbihan and whose name is preserved in that of the town of Vannes.

Himilcon had probably gone to this area in the early sixth century BC not so much to seek adventure as to look for sources of tin, and, as his account shows, maritime traffic with the British Isles was one of the principal activities of the coastal populations of Armorica. The important role played in this region by sea navigation is fully confirmed, nearly five hundred years later, by Julius Caesar's description of the *Veneti*:

> This people is by far the most powerful of all those along the coast: they possess the largest number of ships, a fleet that trades with Britain; they are superior to other peoples in their knowledge and experience of navigation; lastly, as the sea is violent and ceaselessly batters a coast possessed of only a few ports, which they control, almost all those who usually navigate these waters are tributary to them.
>
> *Gallic War*, III, 8

When, in 56 BC, it confronted the Roman ships, this *Venetan* fleet – augmented perhaps by ships belonging to its allies – may have amounted to over two hundred heavy ships, perfectly suited to ocean navigation.

Of course, *Venetan* mastery of the sea was not simply a matter of prestige, but involved effective control of one of the two great routes by which British tin was brought to the Continent and thence to the shores of the Mediterranean. Whatever the duration and extent of this monopoly, trade in this raw material – indispensable to civilizations in which bronze remained irreplaceable and very widely used – naturally had important repercussions on the local economy and involved more or less direct, but certainly regular, contacts with the Mediterranean world.

However, as so often happens in such cases, the archaeological evidence for such contacts, clear enough in the written documents, is neither copious nor particularly explicit. The discoveries of imported objects, hitherto sporadic, are probably a poor indication of the intensity of the phenomenon, but they do reveal, by their distribution in time, an unequivocal continuity. The oldest known Etruscan object found in Armorica may well go back to the late seventh century BC or to the beginning of the sixth century; it is a bronze vessel, similar to those found in the Rhone valley and its extensions; it was found among the offerings in the Tumulus du Rocher at Le Bono (Morbihan). Other noteworthy finds, Etruscan, Greek and even Celto-Italic (a Tronoan helmet) are spread over later centuries. One such, exceptional not only for its intrinsic value but also for the circumstances of its discovery, is a gold coin from the ancient city of Cyrene, struck between 322 and 315 BC; the coin was caught in the aerial roots of a piece of seaweed in the lower zone of the swamps, on the ancient littoral of the *Osismi*, near Lampaul-Ploudalmézeau (Finistère). The almost exact coincidence between the date of the minting of this coin and the supposed date of Pytheas's expedition is perhaps fortuitous, and there is nothing to justify a statement to the effect that it could have been lost by a Greek sailor.

The link with the tin trade is almost definite in the case of another find of coins which originated in the Celtic west and are not otherwise known to have circulated in Gaul: this treasure, made up of imitations of Marseilles silver drachmas, attributable to one of the peoples of the Transpadane (Insubres), which was discovered at Penzance, in Cornwall, near to the islet of St Michael's Mount, identified with the Ictis of the ancients, which was

This beautiful engraved pot, shaped like a bronze bucket, is believed to have been found last century in a tumulus at Kernevez, near Saint-Pol-de-Léon, Finistère. The decoration without any doubt derives from metal engraving of the fourth century BC typified by certain objects found in present-day Champagne and by the sumptuous wine jugs of Basse-Yutz (see illustration pages 52 and 53). The decoration of these luxury pieces shows the influence of Greco-Etruscan design after Celtic groups had settled south of the Po and the subsequent increase in contact between the two cultures. The decoration of the Saint-Pol-de Léon vase is in fact no more than an elegant version of the very common motif of the 'palmette' border: two double 'palmettes' surrounded and joined together by large oblique S's. The perfect application of this motif to the shape and size of the vase, and the quality of the workmanship, show an excellent grasp of the new style and of the technical problems involved. The person who designed and executed this piece was certainly not a mere artisan copying some foreign design of which he had little understanding, but a highly trained craftsman working almost directly from prototypes.

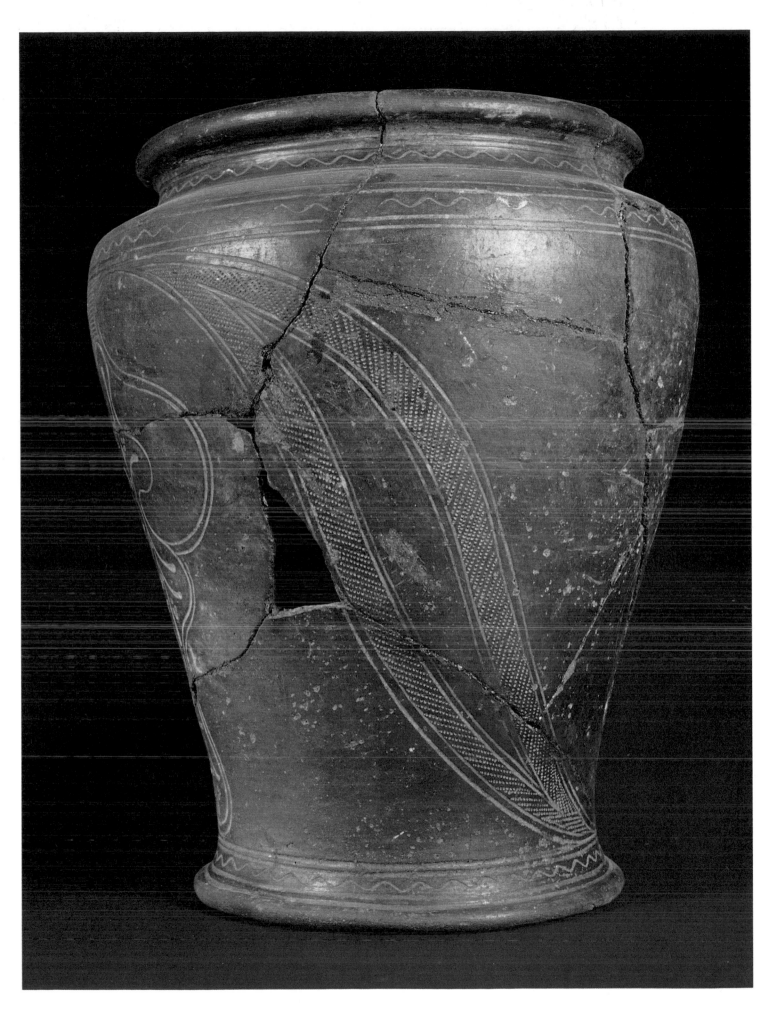

Above: A ceramic urn found in the funeral mound of Lann-Tinikei at Plomeur, Morbihan, on the south coast of Brittany. This type of pottery, decorated with juxtaposed stamped geometric shapes, is typical of the transition period from the Hallstatt to the La Tène period (fifth century BC). They were certainly based on metal originals. They were used as cremation urns, not only in tumulus burial places, but above all in flat grave cemeteries in which are often found standing stones carved into geometric shapes.

Left: This bronze bosset in high relief has features in common with typical ornaments of the third century BC found in the middle Danube area. It was discovered on the eastern fringe of Brittany. The sudden appearance, at a specific point of time, of unmistakably Danubian objects like this is probably linked with the arrival in Gaul of various Celtic groups from that area after the abrupt halt of their expansion towards the Balkans, just before the middle of the third century BC. This ebb of population towards the west seemingly played a major part in the emergence of the Belgic peoples. Its ripples were felt as far as the British Isles. The decoration of this beautifully made piece looks, at first sight, complicated: in fact, it is made up of three 'S' shapes whose ends spiral round globules in high relief. They suggest the form of the 'triskeles', i.e., a ternary scroll motif.

Above: These seven identical bronze bracelets were found, piled as illustrated, in one of the six tumuli built in the sixth century BC around the great megalithic burial-place of Rocher at Bono, Morbihan, when it was already several thousand years old. In one of these funeral mounds, which was surrounded by a low circular drystone wall, was found a bronze bowl made in Etruria towards the end of the seventh century BC or early in the following century. Underneath was a large bucket from a drinking service, also in bronze, used as a cremation urn.

Below: This engraved pot from Kélouer Plouhinec, Finistère, was also used as a cremation urn. It was discovered, protected by stones and filled with charred remains of bones, near an extensive settlement on the edge of a cliff. It is yet another example of the quality of Armorican ceramic work of the fourth century BC based on the decoration of metal vases. In this case, the main pattern is made up of a continuous series of S's skilfully intertwined and filled in with dotted marks.

the principal market and port of the export of tin to the Continent.

The indirect effects of the persistent relations between Armorica and the Mediterranean world probably explain the astonishing qualitative improvements in local ceramics – by far the largest and most significant category of archaeological material, found principally in cremation cemeteries or underground galleries whose function is still open to dispute, from the fifth century BC on.

Our appreciation of the Armorican ceramics of this period, which are largely inspired by metal models and remarkably close to certain productions of northern Italy, is even today distorted by the notion that they represent only a peripheral echo of what was being done in the great inland centres where the so-called La Tène (or Latenian) civilization, which is that of the historical Celts, was then taking shape. A comparison of the productions of the Armorican potters with those of their contemporaries in the Marnian zone or in central Europe would, on the contrary, suggest the autonomy of the Armorican facies. Armorica for several centuries successfully maintained a ceramic production of great originality and often of exceptional quality; what is more, its traditions left an indelible mark on the island milicu: its ornamental styles inspired the craftsmen of southern Britain, where vases imported from Armorica have been identified.

The picture, unfortunately still incomplete, of the Celtic west at the moment when it entered history is thus gradually detaching itself from the traditional stereotyped view of it as merely the extension, or frontier expression, of a culture which had originated with the historical Celts at the heart of Europe. The Atlantic world was apparently much more independent in its evolution than has generally been thought: open to various influences from far and near, but able to assimilate and transform them in a way quite as original as those of the great inland centres.

The Celts of the Atlantic coast were the last to keep an authentic culture alive; they were also among the first to give it the original form that, even today, retains its magical powers of fascination.

Below: A ceramic bowl with engraved decoration found in the Bellevue underground caves at Plouégat-Moysan, Finistère. These caves comprise five intercommunicating chambers reached down a vertical shaft. Such caves are common in Stone Age Armorica but their purpose is unknown; they might have been used as cellars, hiding places or sanctuaries. The decoration of this bowl still uses a type of ornamentation, relying on compasses, which was introduced into Armorica in the fifth century BC.

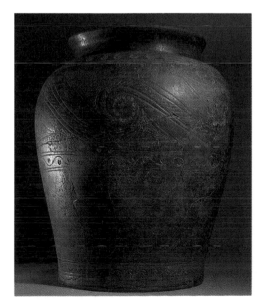

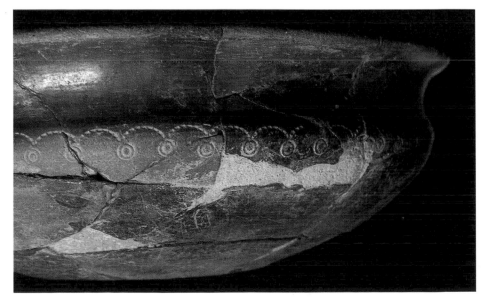

DAILY LIFE AND WORK

The economic base of the Celtic Iron Age world was a highly developed agriculture that was far more efficient and rational than is generally thought. Indeed, without good productivity providing sufficiently abundant surpluses, the emergence of a specialized body of craftsmen and the formation, in certain regions, of an embryonic urban network, would have been inconceivable.

However, the appearance of the first urban settlements, or *oppida*, did not to any great degree alter the long-established pattern of rural life, at least in Britain, as is shown by excavations on certain sites in the south of the country, which were occupied without notable interruption from the sixth century BC until long after the Roman conquest. These rural settlements, which in Britain were often surrounded by defensive walls, do not seem to have been inhabited by more than a few families, probably linked by blood ties, at the centre of a territory of some twenty to forty square miles, only part of which was cultivated, the remainder being left as woods or pasture.

The field boundaries, which can still be seen in parts of Britain to this day, were probably marked by hedges, which protected the fields from wind and from damage caused by animals, both wild and domestic. The landscape was probably not very different from that to be seen in the bocage regions of western France before the land regroupings of recent

Left: The countryside inhabited by the Celts in the Iron Age cannot have been very different from the experimental farm of Little Butser, Hampshire. Woods, fields and grazing land spread round the dwellings and provided most of the necessities of everyday life. Cereal production predominated as the varieties of wheat known in the Iron Age (see foreground of picture) gave very high yields. Thus the farm not only provided provisions all the year round but also a surplus which could be traded.

This page: The ear of wheat on this gold coin of King Cunobelinus (see illustration page 17) could just be the result of a progressive simplification and transformation of the laurel crown on the stater coin of Philip II of Macedonia, distant ancestor of many Celtic coins. However, the fact that wheat, apart from the vine (see illustration page 16), is the only plant to be seen on Celtic coins, confirms the prime importance of cereals in their economy. The inscription CA MV denotes the town of Camulodunum (Colchester) where Cunobelinus's gold coins were struck.

Above: This little bronze bovine head was found in an Iron Age fort at Dinorben, Denbighshire, in North Wales. It probably came from the handle joint of a wooden ceremonial bucket dating from the first century AD. It is a very good illustration of the characteristic expressiveness of Celtic animal figuration. Clearly this is not just an image of a useful and familiar animal, but the representation of a mythological or sacred beast. This type of fitting may also take the form of a boar – a much revered animal – or of a human head with divine attributes (see illustration page 100).

Right: The boar was by far the most widely depicted animal in Celtic art. It symbolized warlike strength and was used to decorate military insignia, shields and much coinage, and was sometimes directly associated with some important male divinity. The bell of the Celtic war trumpet, the carnyx, *was generally in the shape of a boar's head. It also appeared on the metal fittings of some wooden ceremonial buckets. On this illustration, two of the three bronze statuettes of boars found by chance in the last century at Hounslow, Middlesex. They were probably a votive offering dating from the first century BC.*

decades, and in certain parts of Britain and Ireland. These fields, rectangular in shape, were not large, usually between a quarter and a third of an acre, an area that could be easily ploughed by a swing-plough in a day.

The two pillars of Celtic agriculture in the Iron Age were cereal-growing and stock-rearing. As has been shown by experiments recently carried out at Little Butser (a farm which has been scientifically reconstituted on archaeological data near Petersfield, in Hampshire), the prehistoric varieties of cereal, known as long ago as the neolithic period and cultivated by the Celts – einkorn, spelt and emmer – were not only perfectly adapted to the soil and to the techniques used, but made it possible to obtain very high yields. Less demanding in nitrogen than modern hybrids, these cereals were quite capable, with the triennial use of natural fertilizers, of producing in these climates an average crop of almost a tonne per acre, that is, a yield three times higher than those regarded as exceptional in the Middle Ages and markedly higher than that produced in the same growing conditions by present-day varieties, whose protein content, and therefore nutritional value, is lower by half.

Other cereals were still cultivated: barley – then used to make beer (whose Gallic name, *cervoise*, survives in modern France) – as well as rye, oats, millet and buckwheat, which is particularly suitable to poor soil and cultivation on high ground. The flour was at first produced by crushing the grains by hand, and later, with the help of rotating mills; it was turned into bread, girdle cakes or porridge.

The grain was kept in barns insulated from the ground or in subterranean silos, which were particularly common in regions with a chalky subsoil. It has been proved experimentally that this method of storing gives excellent results: the grain can be kept, without any deterioration and retaining its full capacity for germination, for several years, on condition that the ditch is completely filled with grain that has been well separated from the straw, that it is hermetically sealed with a clay bung, protecting it from damp, and that it is opened only once for emptying. This method of storage was particularly suitable, therefore, for grain intended for use as seed, or for barter. It was much less suitable for supplies intended for everyday consumption. According to the Greek historian Diodorus, the Britons harvested the ears, then stored them without threshing in covered barns; each day they would pick out the ripest ears, which they then threshed and milled to prepare as food.

The legumes, because they could be kept in a dried state, formed another important contribution to the daily diet: peas, lentils, and above all the

Celtic bean, an undemanding, highly nourishing plant that can also be used as forage, were grown, probably already in alternation with cereals. There were also vegetables of European origin, with a long history of cultivation, which could be eaten fresh, but which could also be stored, under certain conditions: cabbages, carrots and turnips, as well as garlic and onions, which had been introduced into inland Europe from the Mediterranean basin as early as the third millennium BC.

Wild plants obviously made a substantial contribution to the diet of both man and beast. The forest, rich in berries and acorns, was a particularly important source of food. Fat han, or wild spinach, a plant rich in iron that grew very close to human dwellings, was probably consumed, like other wild plants, for its nutritional value as well as for its medicinal virtues. Apples and pears, which had been harvested since the neolithic period, were provided by trees that had probably already been improved by pruning and perhaps even by grafting. Flax and hemp were grown for their fibres, while the leaves of the woad were a source of blue dye and the madder root yielded a red dye that was still being used for textiles in the nineteenth century. Osiers, brambles and rushes provided, as today, the raw materials for basket making.

Apart from the absence of certain plants of American origin, in particular the potato, the vegetal environment of a Celtic farm in the Iron Age could not have been very different from that to be seen in the countryside of western France or of Britain until the development of single-crop farming and intensive agriculture. The same may be said of the tools used, the principal forms of which – hoes, shovels, rakes, sickles, scythes etc. – have not changed since the second half of the first millennium BC. Only the swing-plough has been replaced by the plough as we know it, but experiments have shown that the earlier tool, which is lighter but also more easily handled, and which from the fifth century BC was equipped with an iron share, was perfectly capable of preparing not only light soils, but also relatively heavy ones for sowing.

The traction power for ploughing was provided by cattle, whose milk, according to the geographer Strabo, was one of the main sources of nourishment. Cattle also provided over half the meat consumed, and played a crucial role in the life of the early Celtic peoples, as we know from the bloody wars fought over their ownership described in the Irish epics. Indeed, the importance of the Celtic gentry was calculated not so much in terms of the size of their property as by the number of head of cattle in their possession. The cattle of the Celtic Iron Age belonged to a small, short-horn variety (*Bos longifrons*), which has since disappeared, but whose

This pair of bronze fittings seems to have been intended for a wooden yoke. The animal heads they represent are turned outwards to serve as runners for the reins. The bovine creature with its short, strong horns is expressively rendered and adapted to the shape of the object it decorates as well as to its intended function: the widely spread hooves follow the curve of the wood, the tail is out of proportion and its curve exaggerated to form a ring, the rosette at its end prevents the leather strap from slipping out. They were found in the coastal fort of Bulbury, near Wareham, Dorset, and date probably from the first century BC.

In comparison with the boar the stag had only secondary importance in Celtic mythology, for it is relatively infrequently represented. This figure carved on a small bone surface is all the more exceptional coming from Ireland, where the general rule was to ban even the most approximate figurative representation. This specimen comes from a find of some five thousand bone pieces all of the same specific oblong shape: some four inches long and two or three centimetres wide at the middle, but narrowing towards the ends which are either rounded or pointed. They were found in an ancient megalithic burial ground in Lough Crew, Co. Meath. The other decorated bone pieces in the find, few in proportion, have compass designs (see illustrations page 91). The function of these unusual objects, dating it would seem, from the first century AD, remains obscure: it is unlikely that they are workshop rejects but more probably, bearing in mind the site, had some ritualistic or magical purpose.

distant descendants, still living in the islands, give us some idea of their characteristics.

The domestic pig, bred in the open air – strong, quick and even dangerous, if Strabo is to be believed – was also much smaller than present-day varieties, and smaller even than those introduced into Gaul after the Roman conquest. Its meat was particularly appreciated by the Celts, who ate it in preference to any other on their feast days; their salt pork was renowned, and was exported as far as Italy.

The sheep, too, belonged to a very different variety from those generally bred today, though they are still to be found on one island off the northwest coast of Scotland: the small, astonishingly agile horned ewes were noted above all for the excellent quality of their wool. Goats were probably reared principally for their milk; the farmyard already had hens, geese and ducks; the cat and the dog completed the familiar picture.

Celtic horses, of a size comparable with present-day ponies, were used in the islands mainly for drawing chariots, either for battle or for spectacle. They were still being used by the military élite at the time of the Roman conquest and remained in vogue in Ireland even longer, according to the epics. Recent excavations of a site in present-day Dorset have shown that the local inhabitants probably did not breed their own horses, but captured and trained adult wild animals.

Game does not seem to have played a very important part in the diet of the early Celts. Deer and wild-boar hunting was probably more of a pastime, an alternative to military exploits. This was surely not the case with fishing, especially on the coast of Brittany, where, as today, line and net fishing must have been practised, as too was the collection of shellfish, as evidenced by the abundant finds among culinary refuse of shells belonging to species that are still consumed today.

The immutable rhythm of the seasons determined the everyday activity of the Celtic peasants as it determined that of the generations which followed them. Indeed, the great festivals of the Celtic year have survived, sometimes in scarcely different form, to our day, and have equivalents in other early European agricultural civilizations. The beginning of the year was marked by the great feast of *Samain* (1 November), the end of the warm period of long days, which contrasts with the dark, cold winter when vegetation is dormant. The night of *Samain* was regarded as an interruption in the normal flow of time, an interval when the world of human beings could communicate directly for a time with the underworld of the supernatural inhabitants of the tumuli. The Irish feast of *Imbolc* (1 February) was probably the equivalent of the Roman *Lupercalia*, a feast that liberated fertility at the end of winter. The great feast of the beginning of summer – *Beltaine* – took place in May. It was close to the summer solstice and therefore had a solar character: great bonfires were lit in which animals and, according to Julius Caesar, even human victims were sacrificed. The bonfires on the feast of St John and May Day hark back to them. Lastly, after the harvest, on the first of August, came the feast of Lug (in Irish *Lugnasad*), the sovereign god, regarded as the inventor of skills

According to remains of bones found in Iron Age settlements, animals of the sheep family bred by the Celts in the British Isles were very similar to a species, the Soay, which has survived on the St Kilda Islands off the north-west of Scotland. These small animals look very like goats, are extremely agile and give excellent wool, but cannot be tended by dogs and can easily leap six-foot fences. Pictured here is one of these animals on the Little Butser experimental farm in Hampshire.

37

and crafts. It was marked by a military truce, which permitted a great gathering, the occasion for a fair, at which natural produce and man-made objects were bartered, and games, races, poetry recitals and musical performances also took place.

These great annual meetings, which attracted the population of an entire region, and at which most commercial transactions were carried out, must have played a very important role in the development of the specialized body of craftsmen that is one of the most remarkable aspects of Celtic civilization during the second Iron Age.

Celtic craftsmen excelled in metal-working – the crafts of the blacksmith, bronzesmith and goldsmith. The relatively large number of objects that have come down to us illustrate and justify all the praise heaped upon them by the writers of antiquity.

Iron, which was obtained from the low-grade ore very common in Europe, was distributed from the primary centres of production in the form of ingots, the oldest of which, weighing between eleven and thirteen pounds, were bi-pyramidal in shape. A store dating from the fifth century BC, discovered in Brittany near Saint-Connan, contained some fifty of these, weighing a total of about 650 pounds. This type of ingot was later replaced by long flat bars, forged at one end into a sort of rod not unlike the outline of a sword blade. About 1500 of these bars have been found in Britain where, according to Julius Caesar, iron ingots of a specific weight were used as currency alongside gold coins and copper.

The blacksmiths made out of this crude metal not only offensive weapons – swords and spears, which, thanks to their skill at assembling and welding irons with different properties, were often remarkable in quality – but also well designed and executed tools and other objects indispensable to various trades such as hoops for cooperage (the making of wooden receptacles), wheel-rims and other parts required by the cartwright. However, despite their skill, the island blacksmiths apparently never achieved the virtuosity of their Celtic counterparts on the Continent, who made in iron decorated weapons and elegant adornments of extraordinary delicacy, employing skills some of which have still not been rediscovered.

The production of armour for warriors – helmets and metal shield mountings and all the other decorated elements in their equipment, such as sword sheaths, mountings for chariots and harnesses, remained, as did the making of adornments, the prerogative of the master bronzesmith. The

This delicately curved bronze bit has a fine decoration derived from the 'palmette' motif, but which looks very much like a monstrous mask. It is one of a pair, originally part of a chariot harness, discovered in a peat bog near Attymon, Co. Galway. With them were two other pieces of the same harness, pendants of a special type found only in Ireland, the globular end of which, with its remarkably delicate 'triskeles', can be seen in the illustration below. They were probably executed towards the end of the first century AD.

Above, left: Detail of the upper end of a wrought-iron fire-dog in the shape of a stylized bovine animal with balled horns. This type of fire-dog is characteristic of an exceptionally rich group of cremation burial places, dating from the second half of the first century BC, situated in the lower Thames valley, settled by the Belgic peoples. The fire-dog in this picture was discovered early this century at Welwyn, Hertfordshire, in a large funeral chamber containing numerous ceramic and metal vases, as well as small bronze decorative fittings in the shape of human heads.

40

A 'Crannóg' (from the Irish 'crann', a tree) is a type of dwelling in use in Ireland from the Bronze Age until mediaeval times. It consists of buildings on a platform raised on stilts over water. Sometimes these artificial islands would be joined to the land by a bridge. Crannógs are found in low-lying areas devoid of stones and are similar in size and function, as fortified residences of noble families, to the 'raths' (circular forts) whose remains are found all over Ireland. This replica, based on data gathered from excavations of sites of this type, was at Graggaunowen, Co. Clare.

Interior and exterior of an exact replica of a large Iron Age house faithfully copied from archaeological finds at Little Butser experimental farm near Petersfield, Hampshire. It is circular in shape and based on the remains of a building excavated at Pimperne, Dorset, on an Iron Age site. The house is about forty feet in diameter and twenty-five feet high. Its frame is constructed from tree-trunks, some as long as thirty-five feet. The roof is thatched and the walls of mud and wattle.

fact that these craftsmen not only became skilled in the different ways of working bronze, but also possessed, apparently exclusively, the ability to design and execute, according to complex and strict rules, the subtle decorations that were to confer on the objects magical powers, obviously brought them a very special prestige: they were masters not only of their material, but also of the language of signs.

Working on a sheet of bronze by chasing – working on the reverse side in order to obtain a decoration in relief on the obverse – is an ornamental technique whose roots go very far back, both on the Continent and in Britain, where it became widespread at the end of the Bronze Age. Particularly suited to cases where the maintenance of the flexibility of the piece to be decorated excluded the possibility of obtaining relief through casting, this technique was to be used in the first century BC for mountings on wooden ceremonial buckets and on utensils that probably belonged to the drinking service used at banquets and which were included, with this function in mind, in certain burial places. The repetitive use of punches of various forms – generally geometrical – could also be carried out on the reverse, by the technique of chasing, and also by direct stamping on to the right side of a bronze sheet of some thickness. The few bronze objects decorated in this way known to us from the fifth century BC in the Celtic West – the Armorican dagger sheath found at Kernavest is the most remarkable item among them – give little idea of the vogue for this type of ornamentation, which is evidenced indirectly by the many examples of stamped pottery that were clearly inspired by metal prototypes.

Engraving on bronze is also a very old technique. However, the decoration carried out in this way in the fifth century BC by Celtic craftsmen is quite different from that of their predecessors – which was

43

Above: Bone spatulas discovered recently during excavations at the Gussage All Saints settlement in Dorset. These tools were used by the bronze-worker to shape the beeswax model of the piece to be cast. This was then covered in fire-clay and heated to melt out the wax. The resulting hollow was then filled with molten bronze and the object extracted by breaking the mould. The Celtic craftsmen had a complete mastery of this 'lost wax' method by which they produced very fine articles from the fifth century BC onwards.

Right: The fibula, a sort of brooch used to pin clothing, was a common feature of Celtic costume, both for men and women, throughout the Iron Age. The most costly examples are notable for the care taken over their decoration, no doubt with the intention of providing some magical protection to the wearer, often enhanced by the use of coloured material. Such was the case with this bronze specimen which originally had three studs, probably in enamel or glass paste. This piece of jewellery is one of the most beautiful surviving creations of the Iron Age Celts. The delicate modelling of the rounded decoration offers a subtle counterpoint, slightly out of phase, to the curve of the arc; the craftsman was able to exploit a totally functional shape solely by playing on the effect produced by the sinuous sequence of the object's basic curves. It was found last century at Clogher, Co. Tyrone, and probably dates from the second half of the first century BC.

basically geometrical and repetitive – in its variety, its skilful complexity and apparent freedom. These curvilinear compositions, engraved with an astonishing sureness of touch, were frequently achieved with the help of a compass. Indeed the direct use of this instrument for the preliminary tracing is to be observed on British mirrors, and is one of the most remarkable achievements of the art of the islands. The arrangement of very complicated combinations of circles, which provide the hidden underlying structure of such decoration, was probably prepared by preliminary drawings of the type to be found on an important collection of bone plates, discovered at Lough Crew in Ireland, on the site of a workshop that had been built on top of a megalithic burial place.

The technique known as *cire perdue* casting was generally used to give relief decoration to small objects: an exact model is fashioned in beeswax (on a core resistant to high temperatures, in the case of a hollow object), then covered completely with very fine fireproof clay, and heated in order to let the wax escape through openings previously made for this purpose. Molten bronze then replaces the wax in the mould thus obtained. Very delicate, complicated decoration can be reproduced by this method, its sole disadvantage being that the mould, having generally to be broken in order to extract the object, can only be used once.

This peculiarity explains one of the most interesting discoveries of the last decade, made during the systematic excavation of a small Iron Age dwelling at Gussage All Saints, on the ancient territory of the *Durotriges*, in southern Britain (Dorset). In a pit were found the rejects from the workshop of a first-century BC bronzesmith, which had been thrown there over a period of one or two years at most: of the thousands of fragments, weighing in all around four hundred pounds, about seven thousand belonged to moulds and six hundred to the crucibles in which the metal had been melted. The craftsman of Gussage All Saints occasionally made brooches, but he specialized mainly in the production of linch-pins, terrets and bits – in other words, objects intended to equip chariots similar to those used by the British against Caesar's troops. An examination of the fragments of moulds has revealed that the workshop must have produced, during the relatively short period when the waste was thrown into the pit, about fifty complete sets of chariot fittings, a quite surprising quantity even allowing for the probability that the chariots were not intended solely for the inhabitants of Gussage All Saints and its immediate surroundings. In fact this figure confirms indirectly Caesar's estimate of the forces lined up against him by Cassivelaunos, the powerful king of the *Catuvellauni*, who had settled to the north of the Thames, as four thousand chariots. This figure, often regarded as considerably inflated, now seems quite plausible in the light of the conclusions to be drawn from this exceptional discovery.

Bronze objects were frequently decorated by the application of coloured materials: first coral, of Mediterranean origin, which was valued and sought after probably mainly for the magical virtues attributed to it;

then a sort of enamel, obtained from coloured glass. The Celtic craftsmen gradually managed to achieve a direct fusion of this enamel and its metal supports in parts left hollow for this purpose. This is the technique of *champlevé*, which, in the century preceding the Roman conquest, underwent a quite remarkable development in Britain. Several colours – red, yellow and blue – could then be used to decorate harness parts (bits, ornamental plates), linch-pins for chariots, defensive weapons (helmets and shields), and, of course, ornaments.

The Celtic fondness for colour is also seen in the many-coloured materials that they used to make their clothes. According to Diodorus, 'they wear astonishing clothes, dyed tunics displaying every colour and trousers that they call breeches. On top they pin striped garments made of shaggy material in winter and smooth material in summer, divided into small squares of every shade and colour.' The quality of the woollen materials made in Gaul and Britain had a high reputation, and they were exported to Italy. Pliny the Elder praises the skill of the Gallic dyers, who reproduced with herbs all the shades of Phoenician purple, probably from a mixture of dyes obtained from woad and madder.

The skills of the wood-workers – carpenters, joiners, coopers and cartwrights – were the result of centuries of experience. Celtic vehicles, often of unusual design, and reasonable in weight despite their great sturdiness, were perfectly suited to travel on unpaved thoroughfares and to use in warfare, which requires good handling on uneven terrain. The cooper's craft was regarded by the ancients as a Celtic invention: it is illustrated above all by the invention of wooden buckets, assembled from staves according to principles that have remained the same to our own day.

Recent scientific attempts to reconstruct Celtic houses on the basis of traces of posts that have survived in the soil have clearly shown the error of the very widespread idea that the dwellings of the Iron Age were more or less shapeless huts, devoid of comfort. The great British houses, circular in plan, that have been restored at the experimental farm of Little Butser, had a diameter of between twenty and forty-five feet and could therefore achieve an overall area of almost 1500 square feet. Despite their imposing dimensions, these thatched buildings stand up perfectly well to the strongest winds and require only limited maintenance. They provide good protection against cold and damp, and the movement of smoke through the thatch prevents insects from settling in it.

Cooperage flourished in the British Isles, as is evidenced by the numerous receptacles that turn up in dwellings that once stood on the site of present-day peat bogs, in which organic materials are well preserved. These wooden vessels were sometimes decorated with engraved motifs, similar to those that adorn bronze or ceramic items.

The making of fine pottery was probably from early times the work of specialized craftsmen who made their living principally by selling their products. Analysis of the clay used, which makes it possible to study the diffusion of ceramics made in a given place, has shown that certain centres might supply an area of over sixty miles radius. Indeed, pottery made in Brittany has been discovered in southern Britain, which could only have been reached by sea. Vases were for a long time made by hand, the slow wheel being used only for the finishing. The introduction of the rapidly rotating potter's wheel accompanies in the Celtic west the spread of *oppida* and does not seem to have been used in Britain before the first century BC. Since the discoveries of potters' ovens have been sporadic and of a later date, it is probable that most ceramic products were baked in a furnace covered with turf, which made it possible to achieve a fairly regular temperature of between 500 and 700 degrees centigrade. The

Above: This little bronze fitting, some kind of lid, illustrates the skill of the craftsmen of the British Isles who used compasses to compose relief decorations whose dynamic equilibrium varied subtly according to the intensity and play of light. The decoration is based on two eccentric circles. On the one hand, it is made up of two features chased in well-defined relief – a hemispherical protuberance, off-centre in relation to the mount, on which the two extremities of a curvilinear motif, resembling a hunting horn, meet. On the other hand, it has two lower parts with engraved decoration – the inside of the large relief motif is occupied by double concentric circles filled with dots; on the outside is an area covered in small dots contained in a ring, repeating on the flat the hunting-horn shape. This beautiful piece comes from a deposit of metal objects discovered by chance at Somerset, Co. Galway, all dating from the first century AD.

Below: Finds from the workshop at Gussage All Saints, Dorset: from left to right, a triangular crucible used for melting bronze, a mould used to make the head – decorated with a 'triskeles' – of a linch-pin of a chariot, the broken mould for a horse's bit and, in front of it, the finished object and a terret (guiding ring), above which can be seen a fragment of a mould used for casting a decorated object of this type.

Left: This pot, decorated with large recessed horizontal S's, is very characteristic of ceramic work from the large fortified settlement of Maiden Castle in Dorset (see illustrations page 60) between the third century BC and the Roman conquest when the site was abandoned in favour of the town of Durnovaria – present-day Dorchester. Knowledge of the specific ceramic styles of a particular site or region allows us to identify zones of influence and direct commercial interchange, as well as sometimes revealing contacts over greater distances. This is the case, for example, with Armorican ceramics discovered on some sites on the south coast of England.

Below left: The Celts of the British Isles made increasing use of enamel and coloured glass inlays from the first century BC. Philostratus of Lemnos, a Greek author writing at the beginning of the third century AD, spoke of the skill of the 'barbarians of the Ocean' in the art of pouring colours (white, yellow, black and red) 'on incandescent copper where they fuse to become as hard as stone, retaining the figures which had been drawn there'. This heavy bronze bracelet, decorated with enamelled discs skilfully set in the ring-shaped extremities, is a good illustration of the fascination for colour which must have been particularly evident in fabrics which, unfortunately, are only known to us through the appreciations of writers of the period. It is one of a pair found by chance last century in the ground on a farm near Drummond Castle, Perthshire. This typically Scottish type of ornament (only one example, obviously imported, has been found in Ireland, on the west coast) probably dates from the end of the first century AD or the beginning of the following century. It shows the vigour of the survival of the traditions of Celtic art in parts of the British Isles beyond the frontiers of the Roman province.

widespread use of wooden vessels no doubt explains the absence of ceramic products in certain regions. This is particularly the case in Ireland.

Stone-working was apparently unusual and confined to specific uses and geographical areas, *e.g.* the granite stelae of Brittany, which, it is generally agreed, have definite religious significance, difficult though it remains to determine what that may be.

Building in stone developed to a great extent only in those regions that remained outside the Roman province – Wales, Scotland and Ireland. In particular, small fortresses have been found that were probably the residences of the Celtic aristocracy and its immediate entourage. This late phenomenon has no equivalent in other Celtic countries.

The information to be derived from written documents and from the ever increasing and ever more specific data provided by archaeology thus makes it possible to recreate a picture of the everyday life of the early Celts and of their environment that is at a considerable remove from certain widespread preconceptions: the picture that is emerging is one of a diversified and prosperous agriculture, of well-built and comfortable dwellings, of a highly skilled body of craftsmen, of trade by sea and land in full expansion; it is one of a colourful, rustic world, but one not lacking in refinements, a familiar picture in which it is not difficult to discern many of the roots of our own everyday life.

Stonework is rare, for wood was the material most favoured by the Celts. It was principally used for monuments which probably had a religious function. However, Brittany is particularly well endowed and several hundred stones attributable to the Iron Age have been identified there. They are usually quite well worked and often have vertical ridging or channelling. More elaborate decoration is exceptional. The decoration which one can just make out on one of the sides of the stone at Sainte-Anne-en-Trégastel, Côtes-du-Nord, which is about six feet high, is made up of interlaced S's. This motif is too widespread to permit exact dating, but the stone is generally considered to be relatively old, perhaps of the fifth or fourth century BC.

SOCIETY

Left: The ring fort at Staigue, Co. Kerry, over the north bank of the Kenmare estuary, is one of the best-preserved examples of a type of dwelling characteristic of Iron Age Ireland. It was probably built several hundred years before the Christian era as the seat of one of the many local dynasties which ruled the country at the time. Mighty drystone ramparts, thirteen feet thick and seventeen high, and a ditch protected an inner area about sixty-five feet in diameter, originally containing wooden buildings. Inside the ramparts are two small rooms and the top is reached by a staircase. Some of these forts have underground chambers used perhaps for the storage of dairy products or other perishable foodstuffs.

The period of a thousand or so years that elapsed between the first references by Greek authors to the Celts and the introduction of Christianity into Ireland in the early fifth century is far too long and full of event for Celtic society to have been able to maintain everywhere exactly the same structure and characteristics. The differences brought about by local peculiarities and developments have remained, unfortunately, very difficult to detect, for what information we possess on these fundamental aspects of the Celtic past lacks any even spread in time and in place. At present, we have, on the one hand, a sufficiently coherent and relatively complete picture of Gallic society immediately prior to the Roman conquest, based above all on information provided by Julius Caesar, and, on the other, a highly coloured picture of pre-Christian Irish society, drawn from a literature that is authentically Celtic. To these different viewpoints — in the first case, a society observed from outside, in the second, one described by individuals who were fully integrated into it — must be added not only geographical diversity and a probable chrono-

This page: The torque, a rigid type of necklace which owes its name to its often twisted shape, had a special significance for the Celts. It was worn as a sign of rank by certain noblemen and noblewomen and was also the attribute of the gods. This gold torque and a similar one made of twisted gold bands were discovered in a bog near Clonmacnoise, Co. Offaly. It is of a common Continental type with plug-shaped ends decorated with S's in low relief. The decoration of the part worn on the nape of the neck is derived from the Hercules' knot (nodus herculeus), a motif favoured by the clients of the Italiot goldsmiths of the fourth and third centuries BC because of its supposed magical qualities. The Clonmacnoise torque dates from the first half of the third century BC and is the oldest known object of the La Tène civilization so far found in Ireland.

The tubular gold torque from Broighter, Co. Derry, was probably a votive object and not meant to be worn. It was found by chance at the end of the last century on the banks of Lough Foyle with the model boat and five other gold objects (see illustrations pages 15 and 25). This remarkable piece is decorated in clear relief on a finely engraved background. The original pattern must have been drawn with compasses on the flat and transposed with great skill on to the curved and irregular surface of the gold. Although there are similarities with some British and Continental work, it is more likely that this is a totally original piece and probably the earliest known example of that specifically Irish style which was to flourish in the centuries before the arrival of Christianity. The pieces in the Broighter find are generally considered to date from the end of the first century BC.

logical gap of some centuries, but also the indisputable dissimilarity of contexts: by the beginning of the first century BC, Gaul was organized into 'cities' (*civitates*) and possessed an embryonic urban network made up of the *oppida*, while the Ireland of the epics was a country made up of small individual tribal units, a country without any sizeable concentrations of population, whose settlement took the form of a dispersion in a rural milieu, a state of affairs which, in Gaul, had considerably preceded the formation of the cities and the appearance of the *oppida*.

Since we are dealing with two different systems, it seems unlikely *a priori* that the social structures could have been the same. Of course, there were points in common, which reveal an undoubted kinship between the Gallic and Irish societies. However, there were also differences, sufficiently important and numerous to rule out any idea of constructing an overall theoretical model of early Celtic society out of a combination of the two pictures. Unfortunately, archaeology is not in a position to compensate, in this area, for the gaps in the written documents, since the material available does not always help us to tackle the problem of social structure: our knowledge of the society of pre-Christian Ireland would be more or less non-existent if we did not have other sources than the archaeological remains of the Iron Age discovered in that country.

Irish society is unquestionably the more archaic of the two forms known to us through written documents. Its basic unit is constituted by the family (*fine*, in Irish), which consists of several generations of the descendants and ancestors of a single individual. Taken in the broad sense – *derbfine*, that is to say, the five generations descending from a common great-grandfather – this family corresponds to the clan, and when several of these extended families have settled in a particular territory, they make up a tribe (*tuath*), ruled over by a king. There were some hundred and fifty kingdoms of this type in Ireland, under the authority, which was apparently often more formal than real, of regional sovereigns.

Strengthened by the fact that the land was the collective property of the clan, the importance of blood ties was not undermined in Ireland by the formation of urban centres whose cohesion was no longer based on the network of kinship links, but on economic and administrative requirements. This is one of the important features that distinguish the Ireland of the epics from the world of the *oppida*.

Women enjoyed rights which were apparently not very different from those of men. As in the case of men, the degree of women's independence was determined by their social rank: a noblewoman could own property, she had some say in the choice of a husband, she could separate from him, she could accompany him into battle, and even fight at his side, for certain women are known to have been the equals of the best warriors in the handling of arms. The hero *CúChulainn* was initiated into the secrets of the martial arts by women, witches who were particularly expert in this field. True, this example belongs to mythology and symbolism rather than to everyday reality, but it clearly shows that the Celts found no difficulty in conceiving of a situation in which the science and practice of war were not a male monopoly.

Most significant, a woman who belonged to the royal family could in certain cases accede to the monarchy, without having to give up part of her power to her husband. The existence of ruling queens, with husbands holding subordinate positions, was known not only in Ireland, but also in Britain, where two queens, Boudicca and Cartismandua, distinguished themselves at the head of the armies that opposed the Roman legions. On the Continent, several female burial sites, dating from the sixth to the fourth centuries BC, contained funerary offerings normally associated with

For many centuries, long before the arrival of Saint Patrick, Tara Hill, Co. Meath, was the most famous of all royal places. It was the scene of the triennial grand assemblies of the dignitaries of Ireland and place of residence of the High King who was considered to have spiritual authority over the whole country. All that can be seen today are traces of different-sized walls, singly or in groups, enclosing several megalithic monuments dating from before 2000 BC. The largest of these, the Hostages' Mound, can be seen in the background of this illustration. Tradition has it that on this burial mound stood the Fál stone. Pretenders to the Tara throne had to stand on it and undergo a test: if a cry came from the stone, this showed that the country's greatest guardian goddess was prepared to consummate the sacred union with the new king which was a fundamental guarantee of harmony between the people and their mother earth.

This pair of bronze jugs with inlaid red enamel and coral, found before the last war in a burial mound at Basse-Yutz, Moselle, is without doubt the most sumptuous Celtic drinking service so far discovered. Luxury pieces like this would be used at banquets organized by important figures and would accompany them to the Other World; they indicate the importance of such gatherings in the social life of the ancient Celts. It is almost certain that the rich ornamentation of

these exceptional pieces has a religious significance, but the actual meaning of the different elements and their inter-relationship remain hypothetical. The upper part of the handle represents a carnivorous animal with fierce fangs, perhaps a dog or a wolf, in hot pursuit of some small waterfowl on the spout – waterfowl were linked with sun worship in the Bronze Age. Two other crouching carnivores watch the bird, obviously ready to join the chase. The lower join of the handle is in the shape of a particular type of head, probably representing one of the great Celtic gods (see illustration page 102). These jugs show a strong Etrusco-Italic influence and were no doubt executed in the first half of the fourth century BC.

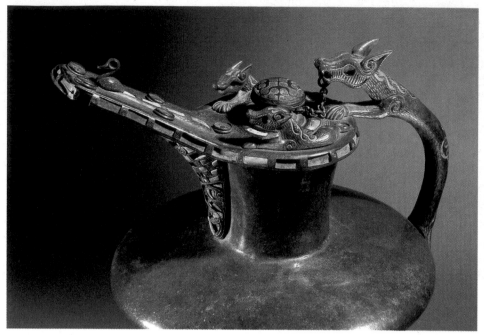

members of the regional dynasties, the 'princes' of the end of the first Iron Age and their successors, such as the service used for consuming wine at banquets, ceremonial or war chariots and ornaments made of precious metals.

The social hierarchies which developed within the tribe were clearly delineated. They were marked in the first instance by the ownership of livestock, since the land belonged to the clan as a whole and was inalienable. Freemen were those who owned livestock: they enjoyed a certain legal status, had the right to bear arms and therefore to take part in the general assembly of the tribe that elected the king, to demand his abdication in cases of grave dereliction of duty and to approve all important decisions.

This apparently democratic system, which made the assembly of all arms-bearing men the supreme legislative body, was in reality entirely controlled by the representatives of the noble fraction of the tribe, on whom a large part, probably the majority, of the community depended. The basis of this dependence was the granting of leases on livestock, according to certain well-defined types of contract that bound the client lessee to his lessor. In Ireland, the term used for the client was céile, meaning 'companion', the precise equivalent of the Gaulish term ambact, used on the Continent for those who found themselves in a similar situation.

The first type of contract involved high interest rates – the annual rent being equal to one-third of the livestock leased – and the obligation of homage and services in peace and war. At the beginning of the historical period, the lease was normally valid for three years, a period of time coinciding with the interval between certain great assemblies, that of Tara, for example, which might mean that the leases were renewed on such occasions, as also were the oaths of allegiance.

The second formula was economically less restrictive, for the interest rate was lower. However, in exchange for a special payment, it involved the abandonment by the client of his legal rights – determined by his 'honour-price', or 'composition-price', that is to say, his membership of a category defined by the amount of compensation received for damages caused by a third party – to the advantage of the lessor. The lessee, therefore, no longer enjoyed any status in law, except through his creditor; he was almost totally dependent and the contract could be terminated only

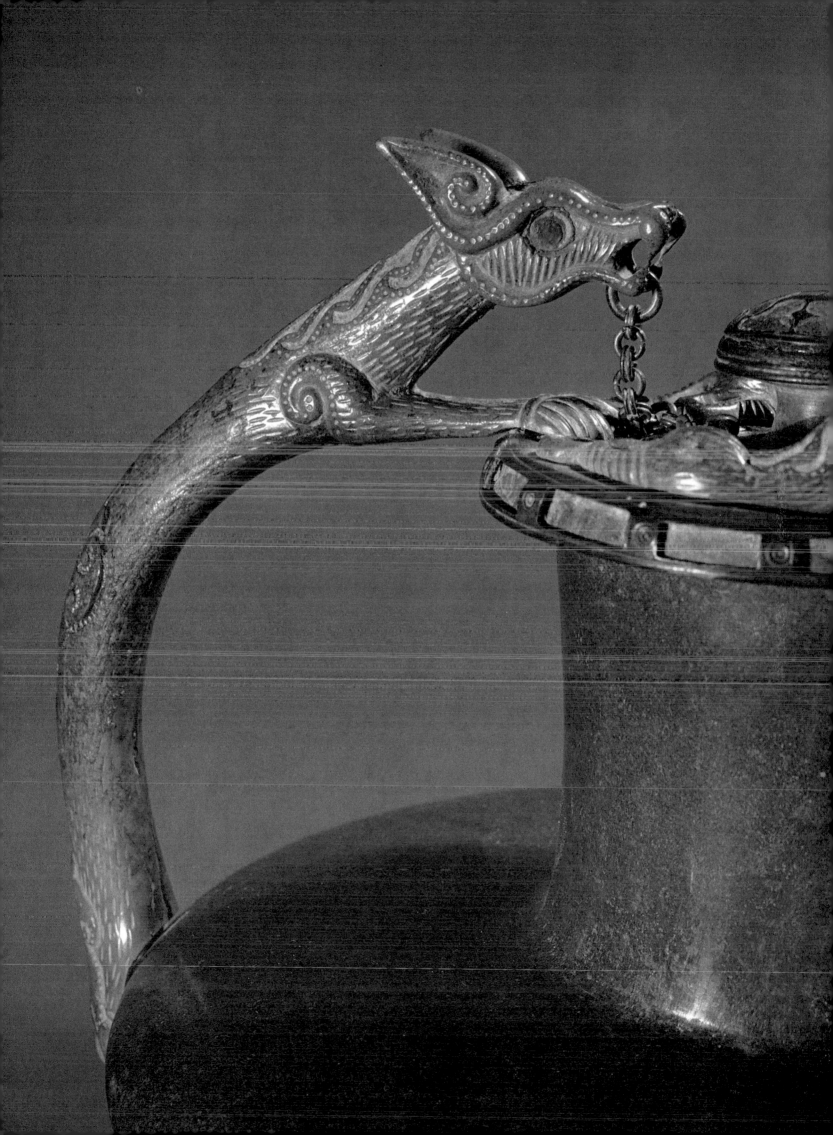

Above: The very well preserved bronze cup from Keshcarrigan, Co. Leitrim, probably dating from the first century AD, was found in a tributary of the Upper Shannon. It is well proportioned with a finely shaped lip and a handle in the shape of a stylized waterfowl, one of the most beautiful animal representations in Celtic art in the British Isles. The natural shape is transformed into a pattern of forms and curves with only the essential features remaining. Although bordering on the abstract, the figuration obtained in this way is extraordinarily expressive.

Opposite: All that remain today of the large wooden banqueting halls used by the Iron Age Celts are deep marks left by posts in the ground. The shape and size of the buildings can be deduced more or less accurately, but how they were decorated remains unknown. One can nevertheless imagine that there would have been woven hangings on the walls and the visible parts of the framework would have been richly carved. Perhaps the carving on beams and pillars looked something like the engraved decoration on this bronze sword scabbard, probably dating from the second century BC and found in a peat-bog at Lisnacrogher, Co. Antrim.

by his fulfilling conditions that were normally difficult if not impossible to meet.

One's membership in the nobility and one's place in its hierarchy were related to the number of clients one possessed of these two types. Thus the nobles were divided into categories each of which had an 'honour-price' proportionate to its importance. This notion was essential to early Celtic law, for it came into play not only in any question of compensation, but on the occasion of any juridical act. This 'honour-price' was the criterion that decided the value of any evidence, oath or security, and also an individual's ability to act as a plaintiff in a trial, it was impossible to bring an action against a person whose 'honour-price' was superior to one's own. It was therefore absolutely necessary to act through the mediation of a protector better placed than oneself in the hierarchical scale. So it was from the richest members of the community, those who owned enough livestock to have a large number of clients, that one would have to seek support, thus increasing their influence by that very fact and giving still further weight to their legal status.

Thus there grew up a strange, mutual dependence between the nobles and their clients, the status of the former being conditioned by the existence and number of the latter. These bonds were strengthened by a practice, peculiar to the Celts, known as 'fosterage', which consisted of sending one's children away to acquire a fuller education in a family of as high a social rank as possible. This was in fact a form of adoption that duplicated parental bonds and thus gave the child a second family. 'Fosterage' came to an end when the children reached marriageable age: fourteen for girls, seventeen for boys.

Naturally, the family that took in the child received from his parents compensation calculated in accordance with the social category to which the family belonged. This economic constraint must have had the inevitable consequence of a graded selection that faithfully reproduced the social pyramid: clients sent their children to their patrons, nobles to notably powerful, in particular royal, families, kings to sovereigns enjoying special prestige. Among the advantages of this system were the direct influence and control that could thus be exerted on the children, the usefulness of such family ties made with potential enemies or rivals (since the prohibiting of patricide and fratricide applied to the adoptive family without limitation in time) and the guarantee provided by having the children to hold as hostages, should the need arise.

The custom of 'fosterage' certainly contributed to the fragmentation, but also to the remarkable stability, of Irish society. Indeed, a multiplicity of links bound the various elements of the social structure: internal tensions and conflicts were inevitably dealt with either at the individual or the family level and resolved according to the rules of law belonging exclusively to the private sector. This mechanism functioned even in the quite frequent cases of armed confrontation between tribes, which were regarded as the expansion of essentially individual conflicts. In fact, battle was frequently reduced to single combat between champions of the two opposing parties.

The king was the key element of the social structure, the personalized expression of the tribe, the individual who was the guarantor of the harmony between the human community and its land, which was regarded as essentially divine. The ideal sovereign, as described in the written documents, was supposed to ensure a perfect climate, a temperature and rainfall favourable to vegetation, an abundance of livestock and good harvests, an absence of vermin and disease, peace and respect for law. His responsibilities were considerable, even if he did not seek to rival the

legendary Conn, described in the Irish epic, *Airne Fingen* (15) as

> . . . the best king of Ireland before the faith . . . [during whose reign] one worked the land only for a fortnight in the spring months and it yielded its grain three times a year. On the horns of the cows, cuckoos sang. There were a hundred bunches on every branch and a hundred nuts in every bunch, nine furrows for every ear of grain. The calves were milch cows before the normal age. The price of twelve bowls of honey and twelve bushels of wheat was one ounce of silver . . . Ireland was like paradise . . . with flowers full of honey . . .

'Handsome, agreeable and prosperous' are the adjectives applied to Conn in this same text and they express perfectly the essence of the rules of good government. Prosperity rewards two indispensable qualities: beauty (in other words, physical integrity and strength) to satisfy fully the sovereign's divine companion, the Earth, over which his rule extends, and amiability (that is to say, generosity) towards the members of the tribe who have chosen him to represent them. A physically diminished king, then, can represent a danger and he must be replaced or eliminated, but a king who keeps the riches that come to him only for himself is just as harmful to natural harmony, for one of the first functions of the sovereign is to redistribute some of the taxes and revenues that he receives by organizing banquets and entertainments and by making gifts to individuals who possess some particular merit – Druids, poets, warriors, craftsmen – and who contribute to his renown. Not to do so was a fault of such gravity that it could lead to his being deprived of his kingship. Thus Bres, sovereign of the mythical *Tuatha Dé Dànann*, was removed from the throne by his nobles because he

> . . . did not grease their knives and, although they visited him often, their breaths did not smell of beer. Nor did they see their poets, or their bards, or their satirists, or their harpists, or their musicians, or their hornplayers, or their tumblers, or their jesters entertaining them in the king's house. Nor did they attend contests between their athletes. They did not see their champions perform their feats before the king. . .

> *Cath Maige Turedh*, 36

The fall of Bres is also instructive concerning the role that might be played by poets in this kind of situation: it is a lampoon – a sort of ironic curse in verse declaimed before the interested party and as large an audience as possible – that appears to have instigated the fall of the unworthy sovereign.

Banquets were to the Celts an essential element of social life. Organized by the king or the richest nobles, they brought together the free members of both sexes of the different social categories and age groups on the occasion of the great festivals, especially *Samain* and *Lugnasad*, and probably also for important events in the lives of the notables – funerals, weddings and such. Indeed, participation in the festivities was compulsory, under pain of punishment. The hierarchical order was expressed in the placing of the guests in the hall, or outside in the case of the less privileged and the younger, and also by the choice of delicacies and drinks that were served to them. The 'hero's portion' went to the man who possessed the greatest courage and warlike qualities; the granting of this mark of favour could give rise not only to verbal contests, but also to mortal combat.

Right: The Celtic goddesses were probably descended from the mythology of the first farming people and personified the nurturing quality of the earth. They seem to have been as numerous as the tribal and regional kings with whom they entered into the symbolic union essential to the consecration of their sovereignty. The great goddess Danu *(Dana) or* Anu *was held in especially high esteem in Ireland for she was the mythical mother of the last generation of gods to rule over the country, the* Tuatha Dé Danann, *the 'Tribes of the goddess Dana.' Tradition still links her name to the two suggestively shaped hills overlooking a valley about thirty miles east of Killarny, Co. Kerry, now known as 'the Paps' and in Gaelic,* Dé Chich Anann, *'Anu's breasts'.*

Above: The great torque of Snettisham is made up of eight strands twisted together, each strand itself consisting of eight gold threads. The soldering at the ends holding them all together is concealed by hollow rings. Inside one of them was found a coin of the Atrebates struck just before Julius Caesar's expedition which gives a valuable clue to the date of manufacture.

56

Of course, such feasts provided opportunities to wear one's richest clothes and to bedeck oneself with one's finest jewellery, which displayed both the skill of the craftsmen who had made them and the wealth of those who had commissioned them. It was also a time when poets, musicians and historians could show the measure of their knowledge and talents. The prestige of the individual who organized the banquet increased in relation not only to the number and rank of the guests he succeeded in assembling, but also to the quality and variety of the entertainments offered. The men of art and knowledge – those who could recount the noble deeds of ancestors and legendary heroes, who could compose poems or songs of praise, or recite the genealogies of the noble guests – were particularly sought after and well remunerated, and they enjoyed the redoubtable privilege of being able to express their discontent or disagreement by using the unanswerable weapon of satire.

However, the royal banquet, especially when it took place on the occasion of one of the great festivals of the year, was not only what we should now call a Society event, it was also a ceremony, a sort of communion of the people round the sovereign, whose task it was, with the assistance and advice of the Druids, to see that nothing occurred that might make the tribe's Earth abandon her role as the nourishing, benevolent Mother. King Arthur's Round Table is a distant echo of this sacred aspect of the Celtic banquet.

Giraldus Cambrensis, an author of the late twelfth century, describes the inauguration of the king of an Ulster tribe that illustrates particularly well the sovereign's role in perpetuating the life forces: first he coupled symbolically in public with a white mare; the animal was then skinned, boiled, and eaten by the people and by the king, who had previously been immersed in the cooking broth. This ceremony, particularly bizarre when one remembers that it took place at a time when the country had already been Christian for over five hundred years, is quite obviously related to fertility rites. It explains the importance that was attributed to the physical integrity of the sovereign: if he were maimed or impotent, he would become unfit to assume his role and would endanger his people's food supply. The king had to be approved by his divine mate: the stone of *Fàl* at Tara was supposed to cry out approval of the new sovereign, in the name of the Land of Ireland.

From what we know of Gallic society of the first half of the first century BC, deriving mainly from written documents, the sacred aspect of kingship and its role as a symbolic link between the people and their territory had, to say the least, waned. At this time, Gaul was dominated by the oligarchy of the 'cities' – federations of tribes whose territory would correspond to the four great provinces in Ireland.

The system of government always had as its supreme organ the general assembly of freemen – those who had the right to bear arms – but this assembly does not appear to have been convened regularly; when it did meet it was usually for some exceptional circumstance such as a declaration of war. Power was held, in reality, at least in such 'cities' as that of the Eduens, by a much smaller assembly of notables, chosen presumably to represent the different tribes that made up the 'city'. Caesar referred to such assemblies by the appropriate term of 'senate'. This assembly of nobles elected annually a supreme magistrate, the *vergobret* ('he who carries out sentences'), who managed everyday affairs, but who had to submit all important decisions for the approval of the sentate or of the general assembly. His power was apparently limited to certain sectors, for the levying of taxes seems to have been farmed out to other notables and religious activity seems to have been the exclusive prerogative of the Druids.

Top and centre: The ringed ends of the torques in the bottom illustration are decorated in relief. The pattern would have been drawn with compasses on the flat and then transposed on to the curved and bulging surface of the necklace. A similar process is used for the decoration of engraved mirrors.

Bottom: These three solid-gold torques come from two different sites: in the foreground, two of the six double-stranded twisted torques found about fifteen years ago on a building site on the outskirts of Ipswich, Suffolk; in the background, the large torque found amongst other precious metal ornaments at Snettisham, Norfolk. This remarkable necklace weighs over two pounds and could only have belonged to a person of very high rank, or have been intended as a votive offering. It dates from the second half of the first century BC, like the Ipswich torques.

This unusual type of torque seems to be modelled on necklaces made of large pearls decorated with mouldings and is an effective compromise between a flexible and a rigid ornament. It was probably made in the first century AD by craftsmen working in the territory of the Brigantes, a powerful people living south of the river Tyne. The one in this picture was chanced upon in the middle of the last century, in bits inside a bronze cup, at Lochar Moss, Dumfriesshire. The relief decoration of the rigid part – a variation of the interlinked S's pattern – is drawn with compasses and made from a perforated bronze plate, fixed by a dozen rivets whose prominent heads form part of the composition.

What we have, then, is a dispersal of the former royal function into categories that were preferably temporary, with a view to avoiding any risk of a monopoly of power. The severe sanctions taken against those whose popularity or actions seemed to constitute a threat of personal domination over the city clearly show that it was just such a concern that had guided those who had worked out the system.

Pre-Christian Ireland and the Gaul of the *oppida* represent in fact two successive stages of Celtic society: the earlier is that of the Irish tribe, whose king symbolized unity and the link with an ancestral territory; later, the Gallic city expressed its unity through political and religious institutions common to the tribes that formed it. We do not know a great deal about those institutions, but we are beginning to understand more and more about the centralizing role played by the *oppidum*: this urban centre became the point of convergence of the activities of the city's territory, the centre that alone made its unity apparent. The name *Mediolanon* ('middle of the country'), borne by a number of *oppida*, is a remarkable expression of this new conception and explains why, at a time when the unity and security of the Roman Empire were already weakened, the names of the Gallic cities were given to their principal urban centres, the direct heirs of the great central *oppida* that had existed prior to the Roman conquest.

The introduction of the phenomenon of the *oppida* into Britain does not seem to have been accompanied by the establishment of a system comparable with the one which existed in certain Celtic cities, at least in Gaul. The existence of an embryonic urban network and the consolidation of tribal regroupings, on a scale comparable with that of the Gallic cities, did not exclude the preservation of kingship. This conception of kingship was nevertheless probably already closer to that of the Gallic magistrature than to that of archaic tribal kingship, which was to characterize Ireland and certain outlying regions of Britain for a long time to come.

The commanding fortress of Maiden Castle, Dorset, situated on the former territory of the Durotriges, was built in stages from the third century onwards on a neolithic site abandoned some three thousand years previously but still visible to this day. The imposing double line of enormous earth ramparts and ditches, with the counterscarp (outer slope) still visible on the outside, corresponds to the last of four Iron Age construction phases revealed by exploratory excavations on the site. The complexity of the defensive system around the forty-five-acre site is probably connected with the development of the sling as a military weapon from the second century BC. The fortress was taken by the Romans soon after the landing of Claudius's legions and was abandoned by its inhabitants about twenty years later in favour of the newly founded town of Durnovaria (Dorchester). The remains of a fourth-century AD sanctuary show that the site continued to play a religious role after that.

THE HEROIC IDEAL

The central boss of the Witham shield has a relief decoration designed on the principle of 'rotation symmetry' — it is made up of two identical parts which can be superimposed by rotating them through 180 degrees. The boss is decorated with a composite coral stud with two smaller and simpler ones next to it. The Celts attributed magical qualities to this red substance which they imported at vast expense from the Mediterranean, probably from the Bay of Naples, particularly in the fourth century BC and the beginning of the following century. The many similarities of the central stud, a combination of three oblong shapes, with continental examples constitutes one of the arguments for dating this fine object from the third century BC.

Our various sources of knowledge concerning the early Celts all agree as to their military abilities, their skill in quickly mobilizing large numbers of men, and the fundamental role played in society by the warrior element. The archaeological data, particularly regarding the high proportion of weapon-equipped burials, fully bear out this information.

In fact, every adult male was trained in the handling of weapons, owned his own panoply and could be mobilized if and when needed. The census carried out by the *Helvetii* prior to their attempted migration in 58 BC provides the figure of 92,000 men under arms for a population of 368,000 individuals. The fighting strength, therefore, represented one person out of four, an exceptionally high proportion, which, when one takes into account the number of women, children and old men, amounts to a total mobilization of able males. Thus a Celtic community was able to recruit from its own members at least twice as many fighting men as a classical Greek city of equal population. Such mobilizations were carried out, of course, only in exceptional circumstances, but it is all the more striking in that we are dealing with an already developed society, one in which, so some historians tend to suppose, part of the formerly free population had suffered a social decline and lost certain fundamental rights. The consequence of such a decline should have been the loss of the arms-bearing privilege, since this was proof of the free status that was the prerequisite of participation in the general assembly of the 'city', or community. It would now appear, however, that nothing of the kind took place, since despite the highly developed system of dependents (clients, *ambacts*) that then existed in the Gallic 'cities', dominated by an all-powerful oligarchy, the entire male population of arms-bearing age was able to take part in military activities.

The Irish epic, *Tain Bò Cùainlge*, describes a society completely dominated by the heroic ideal of the warrior aristocracy, a world remarkably close to that of the Homeric poems. Military glory, and the

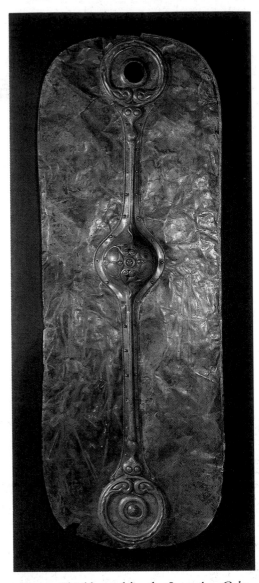

Above: Shields used by the Iron Age Celts were generally made of wood or leather, but occasionally metal pieces reinforced the centre or the edges. All-metal shields are rare, and have only been found in Britain. They were probably part of ceremonial armour or used as votive offerings. This bronze shield covering was found last century in the bed of the River Witham near Lincoln. It is in two parts: a number of bronze sheets covering both sides of the shield, and a decorated strip fixed down the middle, replacing an earlier piece shaped like a boar whose silhouette can just be made out from the difference in colour of the metal.

rewards to be reaped for the courage and pride that are the essential virtues of the Celtic warrior, appear to have been the sole preoccupations of the man who wished to follow in the footsteps of the heroes.

One day, when still a child in the Druidic school, CúChulainn heard that according to certain omens 'the young boy who takes up arms today will shine in battle and his fame will spread, but his life will be short'. He forthwith abandoned his games and went and asked the King to be allowed to take up arms immediately. Having obtained consent, he met the Druid Cathbar, the author of the dread omen, who fearfully described the sad fate in store for the child. CúChulainn's reply expresses perfectly the heroic ideal: 'Were I to be in the world for only one day and one night, it would matter not, as long as my fame and the tale of my deeds lived after me...'

Recounted during banquets and vigils, the glorious deeds of the ancestors, of tribal or legendary heroes, provided examples of conduct with which every Celt was imbued from earliest childhood, and from which he drew inspiration throughout his life. They inculcated an acute sense of honour and desire for high repute that required that certain rules be respected: a dishonest victory was regarded as more degrading than a defeat inflicted by a stronger adversary, and it was inconceivable that a hero should die in any other way than in combat.

The only thing that a Celtic warrior really feared was to see his reputation blemished or diminished: to be 'satirized' by a poet was the worst of dishonours, because it tarnished the image that one wished to create for posterity.

However, combat was not solely a matter of physical strength or skill in the handling of arms, and the rules to be respected did not concern only what would now be called fair play. The attitude of each warrior was conditioned by a series of prohibitions, independent of his will and sometimes contradictory. These taboos, known as *geasa*, had to be respected; if they were not, one had to brave all the dire consequences that would follow from one's refusal to do so. Weapons were themselves endowed with magical virtues, and the heroes of the epic made great use of the supernatural resources that they had learnt to master during their long apprenticeship.

After taking up arms and performing his first exploits as a warrior, CúChulainn went to the island of Britain, where, for three years, he perfected his military training by learning various 'feats', in themselves magical weapons of formidable effectiveness. Their secret was held by witches, who, at the same time, initiated the youth into sexual relations. Thus trained and equipped with the mysterious and fatal *gae bolga* ('javelin

Right: The disc-shaped extremities of the central strip of the Witham shield illustrate two aspects of Celtic art in the fourth and third centuries BC. Firstly, there is the adaptation of plant shapes borrowed from the Mediterranean into an allusive type of expressive art to produce transitional figurations, halfway between the vegetable and the animal, human or abstract kingdoms. Here, a 'palmette' pattern is modified to suggest the head of an animal with a prominent snout, globulous eyes and long pointed ears. The other characteristic is the engraved decoration which can hardly be seen from a normal distance and therefore cannot be taken in at the same time as the relief decoration. To see it properly, one has to come so close that an overall view becomes impossible. The most likely explanation for this is that signs were thought to have magical qualities: their presence on an object was probably more important than their being deciphered.

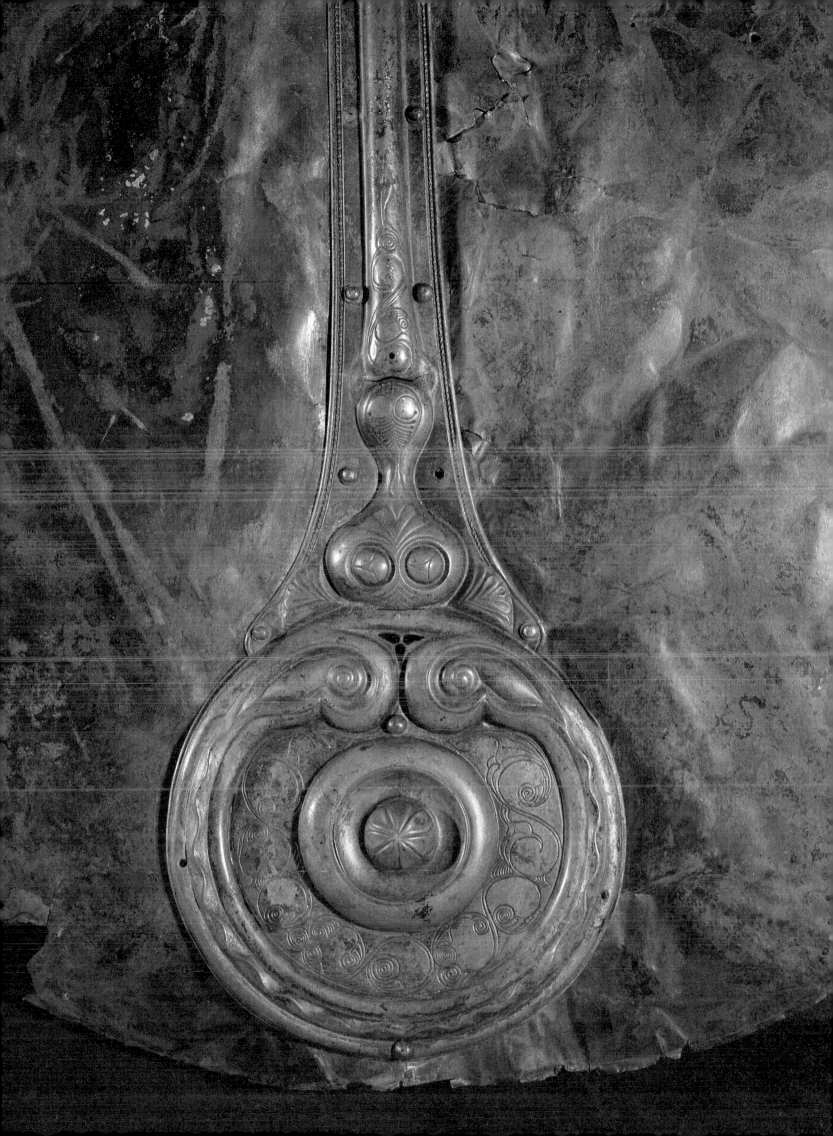

The fort of Dun Aonghus is poised 230 feet above the sea on a cliff top on the west coast of the Isle of Inishmore, Co. Galway. It is encircled by a triple line of thick drystone walls which, in the central part, still stand twenty feet high. This impressive fortification is preceded by forward defences made up of a wide band of hundreds of upright stones, like 'chevaux de frise', designed to slow up the advance of attackers when they were in sling-shot range. Legend has it that this fort was built by the fourth mythical race to have inhabited Ireland, the Fîr Bholg, *who are said to have taken refuge in the island after their defeat at the hands of the* Túatha Dé Danann. *The name of one of the* Fîr Bholg *chiefs, Aonghus, is perpetuated in the name of the fort. This remarkable fortification is one of the most impressive in Europe. Its date of construction is uncertain but experts generally believe it to have been built in the pre-Christian Iron Age.*

in the sack'), CúChulainn would have been invincible were it not for the *geasa*: those prohibitions, his transgression of them having become inevitable, were to drag him implacably to his end.

The hero's magical power was expressed in combat by a state of extreme excitement, a blind, murderous fury that could be turned against anyone. Thus, when CúChulainn, still a child, returned from his first expedition, which had been crowned with the massacre of three warriors whose heads he displayed on his chariot, King Conchobar feared the worst:

> . . . his hands are all red with blood; he is not sated with combat, and unless he is prevented, he will slay all the warriors of Emain [the capital of the kingdom of which CúChulainn was the champion]. In order to distract him, the king sent fifty naked women out to meet him, but . . . he hid his face . . . and did not see the nakedness of the women . . . In order to assuage his anger he was brought three vats of cool water. When he was put into the first, he made the water so hot that it broke the staves and the hoops of the vat, as one breaks a walnut shell. In the second vat, the water caused bubblings as large as a man's fist. In the third the heat was such as some men can bear and others cannot. Thus the young boy's anger was finally assuaged.
>
> *Táin Bò Cùainlge*

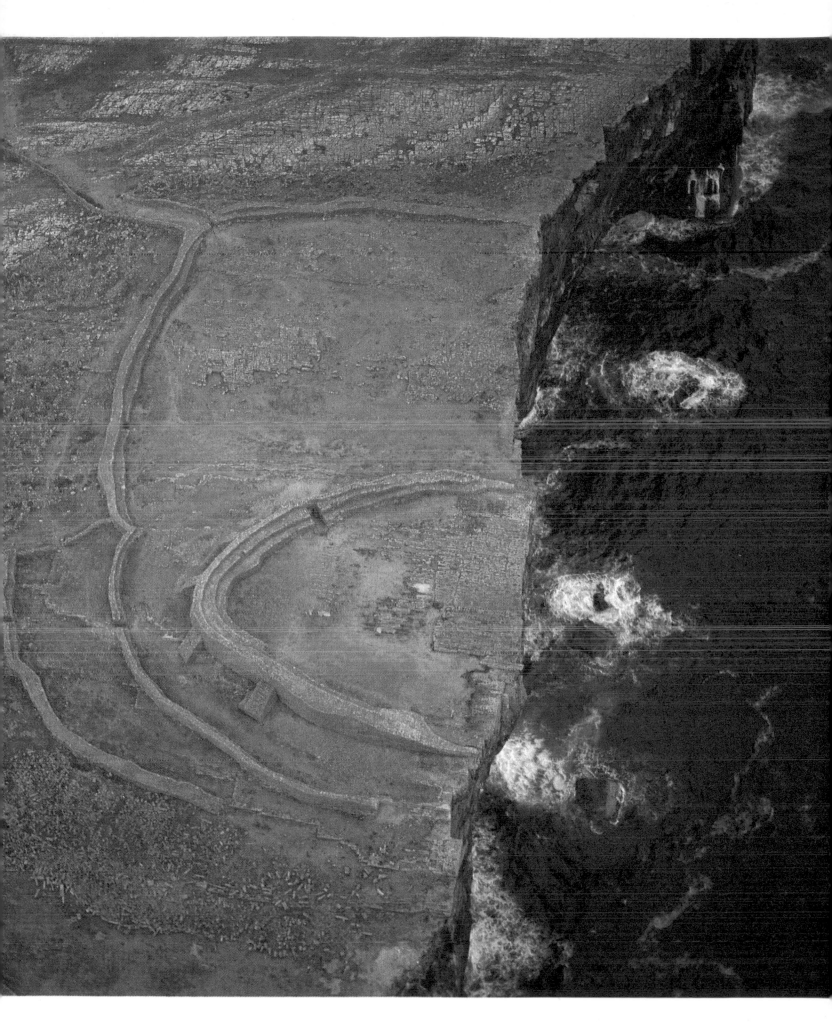

The most common weapon used by the Iron Age Celts was the spear. In Ireland a spear and a shield were given to young men when they became warriors. Celtic spearheads were sometimes prestige objects. They may have richly engraved or even relief decoration, and may be perforated or have an elegant undulating cutting edge. This example, found in the bed of the Thames in London, is the only known case where the iron head is embellished with bronze appliqué. The added pieces seem at first sight to form a regular pattern on the principle of fold-over symmetry, where the two parts can be superimposed by turning them over an axis, here the central moulding of the lance spearhead. But on closer examination the shapes and engraved decoration, of the two parts are not identical. Many works of the ancient Celts reveal this desire to create a dynamic disequilibrium in a basically static and symmetrical composition.

The state of trance that freed the magical charge possessed by the hero could be provoked by contortions. Thus CúChulainn as a child indulged in this kind of exercise before attacking the hundred and fifty sons of noble clients brought up by King Conchobar:

> . . . It seemed as if each of his hairs had been hammered into his head at the place where each hair had grown. It seemed as if each of his hairs threw off a fiery spark. He shut one of his eyes, and it became no bigger than the eye of a needle, he opened the other, and it became larger than a mead goblet. He opened his jaws so wide that his mouth reached his ears. He opened his lips so wide that one could see right down his throat. From the top of his head sprang the light that is the sign of heroes.
>
> *Táin Bó Cúainlge*

The distinctive mark of those who are chosen by destiny, the 'light of the hero', accompanied him to the very last. Mortally wounded, CúChulainn

> . . . reached the stone pillar that is in the plain and he put his belt around it so as not to be in a sitting or lying position and so that he would die standing. Men came and took up position round him, but dared not approach him: he seemed to them to be still alive . . . Then the grey of Macha [the one survivor of the two horses that drew his chariot] came up to CúChulainn to protect him as long as his soul was there, and the light of the hero continued to shine from his brow . . .
>
> *Oided Con Culainn*

It was only later that the hero's corpse could be decapitated and his head borne off as a trophy, according to Celtic practice, well attested on the Continent by the accounts of authors of antiquity and by much archaeological evidence.

Setting aside the exaggeration and the supernatural aspects proper to the fabulous world of the heroic epic, CúChulainn's life must reflect fairly faithfully that of a noble warrior of pre-Christian Ireland. Brought up first by his parents, the child was then sent – at the age of five in CúChulainn's case – to the royal court. There, in the company of other boys of noble birth, he learned various feats of skill and the handling of wooden weapons, and practised individual or team sports, among which the most popular was probably *báine*, a game not unlike hurley, in which the players, armed with curved bats, tried to place the ball in the opponent's goal. He would no doubt also have been given a smattering of literary education, but this kind of instruction was more the speciality of the Druidic schools, in which the intellectual élite of the country was brought up.

The future warriors were already subjected to the same rules as adults, and they set up their own relations of dependence. Thus, by way of welcome, CúChulainn was attacked by those who were to become his companions, because he had omitted in the first place to ask for their protection. Even though he made short shrift of his assailants, the young hero had nevertheless to ask for protection, since a magical prohibition was involved that would otherwise prevent his integration into the group. However, CúChulainn immediately turned on the boys, demanding that they place themselves in turn under his protection and patronage. He thus became the champion of the youth of Ulster before becoming that of the whole province.

The decisive moment was the taking up of arms, in CuChulainn's case at

This natural doorway of granite blocks was incorporated in the wall of the Camp d'Artus at Huelgoat, Finistère. Today it is overgrown with forest but in the first century BC it was the site of a large oppidum *inhabited by Armoricans of the Osismi tribe.*

an exceptionally early age, for he was only seven, whereas this usually took place at the end of the educative period envisaged by the system of 'fosterage', that is, at about the age of seventeen. The youth then received his panoply, the simplest version of which – *geissed* – consisted of a spear and a shield. This basic equipment could then be complemented with javelins and a sword. A great many texts mention that these offensive weapons were on occasion tipped with poison.

A warrior of a certain rank, more especially a hero, possessed a chariot driven by a charioteer, who was responsible for the upkeep of the vehicle and of the horses, but who did not take part directly in combat. Indeed the Irish word for hero – *eirr* – means literally 'chariot man'.

The military use of this light, two-wheeled vehicle, drawn by a pair of small horses harnessed by a yoke, was recorded among the Continental Celts from the fifth century BC. Its appearance in the offerings of certain burial places belonging to local chiefs or petty kings, from Champagne to southern Bohemia, is one of the signs that mark the beginning of the second Iron Age. The military use of these chariots by different groups of Continental Celts is still mentioned in texts of the third century BC, but they had already been completely replaced by cavalry by the time of the Gallic wars. The situation was not the same in the British Isles, where they were probably introduced in the third century BC and where they remained in use much longer than on the Continent. King Cassivelaunos

seems to have opposed Caesar with an army comprising no less than 4000 chariots and, almost a century and a half later, they were still being used by the Caledonian coalition, which, in the year 83, confronted Agricola's legions on the slopes of the Mons Graupius (Grampian Hills).

Caesar's description of the British chariot combat techniques at the time of his landing in 55 BC corroborates to a remarkable extent the descriptions of the Irish epic:

> First they drive along each side, throwing darts: the fear inspired by their horses and by the din of the wheels is usually enough to throw the ranks into disorder; then, having penetrated the cavalry units, they leap from their chariots and fight on foot. However, the charioteers gradually leave the mêlée and position their chariots in such a way that if the combatants are under pressure from superior numbers, they can easily rejoin them. They thus combine in combat the mobility of cavalry and the staunchness of infantry; their training and daily exercises enable them, when their horses are galloping down a very steep slope, to rein them in, slow them down very quickly and swing them round; they also run on to the shafts, stand firm on the yoke and, from there, leap into their chariots in a flash.
>
> *Gallic War*, IV, 33

This chased plaque in tinned copper is one of a pair of ornamental fittings, perhaps originally belonging to a shield. It was among a find of fragmentary metal objects discovered some twenty years ago at Tal-y-llyn, Gwynedd, in North Wales. Probably dating from the first century AD, the decoration of this piece is arranged around two heads placed symmetrically opposite one another and joined by their necks. Some experts believe that this is an allusion to the Celtic practice of keeping their enemies' heads as trophies. It is more likely that the so-called 'cut-off heads' motif represents some major Celtic divinity, most likely the great god associated with mistletoe and the 'palmette', symbol of the Tree of Life (see illustration page 102). The same may be the case with this Welsh ornamental fitting, since the motif surrounding the heads – known as a 'pelta' because its shape is similar to the Amazons' shield of that name – is in fact a Celtic version of the 'palmette'.

The cost of the equipment – vehicle and horses, in particular – and of the maintenance of a permanent driver, in addition to the requirements of intensive daily training, indicate clearly that the military élite mounted on chariots was recruited from the ranks of the nobility, which alone had the necessary time and means. This was a caste of beings whose ideal employment in time of peace must have been very close to that of the legendary King Conchobar, described in the epic *Táin Bó Cúainlge*, who was also famed for his fighting qualities:

> As soon as he had risen he began to settle the affairs of the province. He then divided the rest of the day into three parts: he spent the first watching the noble youths performing their feats of skill, playing games and hurling balls; the games of backgammon and 'chess' [in early times a game similar to draughts] occupied the second third; he spent the last third eating and drinking until everyone became drowsy, then the musicians lulled him to sleep.

The occasions for armed conflict between the different Celtic communities were numerous, but much time must have been spent raiding cattle, or protecting one's herd against raids. Indeed, the fundamental role played by livestock in the establishment of social hierarchy and the possibility of increasing this capital by means of the high interest earned by hiring stock out to clients, made it a coveted prey. The central episode of the epic of which CúChulainn is the principal hero, *Táin Bó Cúainlge*, 'The Capture of the Brown Bull of Cooley' (a region on the west coast, between Dundalk and Carlingford), describes just such a bloody war caused by the seizure of a magnificent brown bull. The instigator of the operation is Medb – Shakespeare's Queen Mab – sovereign of the province of Connaught, who wishes in this way to re-establish a balance between her possessions and those of her husband Ailill, the happy owner of a white bull of which she has no equivalent.

What seems to have begun as a quarrel between husband and wife, a mere problem of personal prestige, soon escalated into a general conflict between the provinces of Ulster and Connaught, involving the most

renowned representatives of the warrior élite. Despite appearances to the contrary, it would be pointless to seek in this narrative some historical nucleus, to see it as a record, distorted and magnified in its legendary guise, of one of the many wars between the Irish kingdoms. There are many indications to suggest that it is essentially a mythological account, adapted to a particular historical and geographical context by the introduction of characters known by tradition and by the systematic establishment of links between events and the topography of the region.

The possibility that we are dealing with a more or less free local adaptation of a narrative whose original conception might be much older and alien to the Irish environment should lead us to be wary of the chronological conclusions that we might be tempted to draw from the apparently archaic character of the warrior function in the epic cycle centred on the 'Capture of the Brown Bull of Cooley'. Indeed, the concept embodied in CúChulainn, of the tribal champion entrusted with the task of accepting challenges on behalf of his people and keeping a watchful eye on the defence of the territory's frontiers, appears to have fallen into disuse by the time of the composition of the most recent part of the Irish epic, called the Leinster cycle after the kingdom of the south-east whose supremacy it celebrates.

This is the cycle made famous by James Macpherson's pastiche, attributed to Ossian, the Oisín of the Irish texts. In the Leinster cycle, the warrior ideal is embodied by the *Fiana*, individuals of apparently noble extraction who devote their lives to hunting and fighting, but are no longer integrated into the traditional framework of the tribe. Organized into a sort of military confraternity led by Finn, Oisín's father, they live on the fringes of society: with no fixed ties, they wander round Ireland, hiring out their temporary services to the sovereigns.

The *Fiana* respect a code of warrior morality which is not very different from that guiding the behaviour of tribal champions like CúChulainn. However, for the *Fiana* war has become an end in itself, a vocation that involves a definitive break with the bonds that bind an individual to a particular territory. Finn and his companions express the ideal of a military class that believes it is able, through its professional competence and whatever favourable circumstances may offer outlets to mercenary groups, to free itself from the constraints that are otherwise imposed within the tribe by the system of dependence. As is almost certainly the case with the Ulster cycle, the version recorded by the texts of this part of the epic is probably the result of the transformation of an essentially mythological narrative whose antiquity and origin are still very difficult to determine. The fact that in this version the warrior function is clearly dissociated from tribal organization leads one to link this variant of the warrior ideal to a society that, no longer being able to integrate all those men who regard the military profession as the only one appropriate to their status as freemen of noble descent, cast them out. Such a situation is theoretically later than that described in the Ulster cycle (of which the *Táin Bó Cúainlge* is a part), but the two views of the warrior function are not incompatible, and may have coexisted all the more easily in that the marginalization of elements of a potentially destabilizing nature provided a temporary solution to the crisis threatening the tribal system.

Indeed, the search for correspondences between the world portrayed in the epic and the information provided by a study of artefacts indicates that the situations described in the epic do not necessarily belong, at least in their origin, to a specifically Irish context. The objects found in Ireland that have been attributed to the pre-Christian Iron Age are relatively few in number – under a thousand to date – and in almost every case without

The fortified promontory of Trevelgue Head on the north coast of Cornwall has been completely cut off from the land by the combined action of man and the sea. Access to the bridge which must formerly have crossed this impassable barrier was protected by five lines of fortifications and a number of ditches. The landward side of this artificial island was protected by other fortifications. The construction of such complex defensive systems must have been connected with the appearance of new weapons – notably the sling – against which the old defences were no longer effective.

meaningful context. They include a fairly high proportion of weapons and items of military equipment: over two hundred bits and harness parts, often found in pairs and thus confirming the use of the chariot, about twenty swords, usually short-bladed (the longest blade being less than twenty inches in length), a few decorated scabbards, a small number of spearheads and, lastly, a small leather-covered wooden shield which was remarkably well preserved in a peat bog. The intrinsic interest of these objects is obvious and their generally excellent quality clearly indicates the privileged situation of those for whom they were made.

However, there are three major obstacles to a useful comparison of texts and materials. First, it is probable that the samples found are not representative. Thus, for instance, the spear, which according to the texts was the most commonly used weapon, is represented by only a few isolated heads, whereas there is a much greater, quite disproportionate, number of butts. Secondly, it is impossible to add to the typological and stylistic analysis of these objects the valuable information obtained through the study of dwellings and graves. Thirdly, the chronological framework in which these objects must be viewed is too broad, extending, as it does, over a period of over five hundred years, from the third, second or first century BC to the early fifth century AD.

The situation is not much more encouraging in England, despite the much larger number of weapons and items of military equipment belonging to the Iron Age, a better knowledge of dwellings and an appreciable quantity of funerary items from this period. Unfortunately, their uneven scatter, both chronological and geographical, is such as to make it impossible to draw from them any conclusions of general validity.

The principal regional group of burial places from the second Iron Age in Britain is that found in east Yorkshire mentioned earlier, which has been recently named the 'Arras culture', after a site that is particularly well known, since it was explored as early as 1815. These burial places are probably attributable to the *Parisii*, who were located in this region by the geographer Ptolemy. Distributed over about thirty sites, the 350 or so burial places that seem to date from between the third century BC and the first century AD are generally fairly poor in grave goods, a large proportion containing only skeletons. It is unlikely that this funerary scarcity accurately reflects the real poverty of the populations using the cemeteries. It is rather the consequence of burial customs that limited both the quantity and quality of the objects buried. The composition of the grave goods doubtless reflects only partially the former social status or way of life of those buried there.

To this we can add the apparently temporary character of certain practices. Thus the four burial places containing weapons, swords with shields, occasionally a spear, that are known at this time, are all more or less contemporary and belong to the recent phase of the cemeteries. Furthermore, there are a dozen burial places in which a war-chariot, sometimes dismantled, has been placed. They all appear to be older than the previous ones and might even belong to the initial phase. In none of them are weapons to be found.

Therefore, good quality weapons and the war-chariot – according to the oldest texts and the Irish epic, two elements peculiar to the warrior élite of the islands – are dissociated in the Yorkshire burial sites: either one or the other was chosen successively as an emblematic deposit. The descriptions of battles between the Britons and the Roman army, and the activity of the workshop at Gussage All Saints, mentioned earlier, give incontrovertible evidence of the use of the war-chariot by the island nobility much after the last necropolises of the second Iron Age in this region went out of use. The

Above and opposite: As with other objects found in river beds in Britain, this very fine bronze shield, decorated with studs in red glass paste, is probably either a ceremonial or a votive piece. It was found last century in the bed of the Thames at Battersea in London and dates from the end of the first century BC or the following century. Contrasting with the static regular character of the relief decoration, already influenced perhaps by Roman art, is the twisting movement suggested by the studs and the allusiveness of the different parts, which evoke monstrous faces, changing with the angle of view.

individuals buried there along with their warrior's panoply must then, of necessity, have been among those who had the necessary means to maintain a war-chariot. Furthermore, it would certainly be unreasonable to assume that the absence of weapons in grave assemblages of the early period of the 'Arras culture', reflects a real absence of warriors in society. It is apparently a question of varying burial practices: the presence of the chariot must not be taken to have a very different meaning from the later placement of weapons in the tombs. Indeed the allusive, temporary and incomplete character of the information provided by grave goods becomes obvious when one extends this field of observation to the whole of the British Isles.

The disparity between the information provided by historians – which there is no reason to doubt – and the evidence yielded by the burial places is therefore flagrant: taken by themselves, the few examples of funerary furniture certainly do not allow us to reconstruct the situation described in the texts. Paradoxically, it is thanks to an exceptional discovery made on a dwelling site, up to now unique in the whole of the Celtic world, that we can archaeologically confirm the data recorded by Caesar: if we did not know the workshop of Gussage All Saints, the huge number of chariots that he attributes to Cassivelaunos's army would seem highly exaggerated.

Of all the weapons, offensive or defensive, dating from the second Iron Age in Britain, only a very small proportion has been found in burial places, and the proportion of finds in dwellings is not much higher. Most of the discovered weapons and all those of exceptional quality – the most remarkable being highly decorated helmets and shields – have no clear context and, indeed, have very often been found in water – a river, a lake, a peat bog. This phenomenon, which has also been widely observed on the Continent, is explained by the Celtic custom of sacrificing in this way part of the spoils of the enemy after its victory. It is doubtless for this reason that so many of these submerged objects are weapons and military equipment, and that the context in which they were found is far removed from their origin.

The most important of these votive deposits was discovered during World War II in a peat bog on Anglesey (the island of Mona of the ancients), at Llyn Cerrig Bach. Over a hundred and forty metal objects, including some that had been deliberately damaged before being thrown into the water, were found, together with a large quantity of bones of animals (cattle, sheep, pigs, horses and dogs). Most of the find consisted of weapons, harness parts (mainly bits), fittings belonging to several war-chariots, but it also included a few tools, pieces of bronze cauldrons, two

iron shackles used for chaining groups of prisoners by the neck, and a fragment of a large war trumpet, belonging to a type known in Ireland.

The whole of the deposit certainly dates from before the conquest of the island by the Romans in the year 60. The various objects all appear to date from more or less the same time, that is, from the first century BC or from the early part of the next century. In these circumstances, it remains difficult to determine to what degree the find represents a single offering or a series of successive deposits.

The offensive weapons found there consist of a lot of eleven long swords (the blade of the longest is two feet, eight inches long, without a point, and therefore used exclusively for slashing) and seven spearheads, one of which is of exceptional size (two feet, six inches long). The blade of one of the swords, made, like the others, of excellent quality steel, bears a stamp, the only one so far known in Britain. This peculiarity might suggest that the weapon was made on the Continent, where the use of stamps of this kind was very widespread in the second and first centuries BC.

Obviously, the artefacts found on the islands fully confirm the importance of the military aspect of Celtic society, but they do not allow us to establish the general lines of its development and to specify the nature of its links with the organization of society.

The situation is quite different on the Continent, where the mass of available information is easier to organize, and enables us to discern several successive stages, in which the variations in the nature of the weapons, in the techniques of combat implied by their use, and in their distribution according to social groups permit several interesting comparisons with the data recorded in various parts of the Irish epic.

The cemeteries of the fifth century BC, the oldest that can be attributed to the historical Celts with any certainty, suggest a society in which military equipment was very widespread. Not all adult males were buried with weapons, but the proportion of armed men – on average nearly a sixth of the total population – was very high. The military equipment

From an inland position some twelve miles south of Anglesey, on an exposed mountain top nearly 1600 feet high, the fortress of Tre'r Ceiri, Gwynedd, dominates the Welsh coast. In spite of the difficult weather conditions, a permanent settlement of several hundred people lived there over many centuries. This is shown by the stone sub-foundations of numerous buildings which are visible inside the drystone ramparts, still well preserved up to a height of twelve feet. Excavations indicate that it was inhabited, seemingly without interruption, until the end of the Roman occupation in the fourth century AD.

The Celtic war chariot depicted on the reverse side of this Roman denarius is being driven by a single warrior. He is naked, according to the custom of the time noted by classical writers, and armed with a spear and a shield. In the background can be seen a carnyx, the Celtic war trumpet with a bell in the shape of a boar's head. The image on the coin, struck at Narbonne, capital of the newly created Provincia, in 118 BC, presumably depicts the recent victory of the Roman armies over the Gauls under the command of Bituit.

This enamelled bronze terret was discovered some twenty years ago, with other metal objects, at Lesser Garth, Glamorganshire, near the South Wales coast on the former territory of the Silures. Terrets, characteristic fittings on Celtic chariots, were attached to the wooden yoke, generally in pairs. The Lesser Garth specimen is made up of three hemispherical pieces individually cast before being fixed together. The decoration uses the 'champlevé' technique whereby the enamel is melted directly on to the object into specially formed hollows. As is almost always the case with British decoration of the first century AD, the subtle succession of curves is based on compass lines.

consisted mainly of spears or javelins, often three or four per tomb. These long-distance weapons were sometimes found with weapons used in close combat: short stabbing-swords, single-edged cutlasses, long swords for thrusting or slashing. The tombs in which such weapons were found amount to about one-fifth of the total of armed men recognized in the cemeteries. It is in these tombs that the exceptional offerings have been found: two-wheeled war-chariots, of which this is the first appearance, or various prestige objects, especially those showing Eastern decorative motifs, which had by then been adopted by the Celts. These objects include in particular belt-hooks with open-work design, the themes of which – lotus flower, palmette, Tree of Life, Master of the Beasts – belong unquestionably to the religious domain and were to remain from then on associated with Celtic weapons: they were to appear in the next century on sword scabbards and, a thousand years later, mediaeval Welsh texts such as the *Mabinogion* collection still referred, when describing the hero's weapons, to magical swords decorated with golden 'dragons', which are simply the distant descendants of the monsters that guarded the Tree of Life.

The weapons of the Continental Celtic warriors of the fifth century BC were best suited to the type of warfare that began with the throwing of spears, and was followed by close combat, man-to-man fights that apparently only involved the élite. This was a combat in scattered formation, the basic unit probably consisting of small groups, each led by a warrior equipped for close combat. The chariots, the preserve of certain members of the élite, were a mode of transport particularly effective in actions involving harassment and pursuit. This technique of fighting, based on individual action, is in no way comparable with that which had long been predominant in the Mediterranean world, which used compact formations of heavy infantry, the hoplites.

This stage in the evolution of the military is undoubtedly the one which most closely corresponds to what is described in the cycle of the Irish epic of which CúChulainn is the principal hero. It was in this milieu, dominated by a tribal aristocracy that kept most military operations for itself, that this part of the epic must have been conceived and the conception of the military function that it expresses certainly did not survive on the Continent beyond the fifth century BC.

In the early fourth century BC a clearly perceptible change occurred, when Celtic groups penetrated into Italy south of the Po and settled there. The burial places of the warriors in which chariots are found are rare; groups of javelins give way to a single spear. The use of the sword, of a standardized size (the blade being two feet long), clearly became widespread, and the deposit of the shield, together with its metal pieces, more and more frequent. The main differences having thus been eliminated, the military equipment of the Celts was from this time uniform – a panoply comprising sword, spear and probably a helmet, although the last is rarely to be found in the grave goods – and the rank of the warriors is expressed principally in the quality of their equipment; the chariot was still used by the élite, but its inclusion in the tombs was now only sporadic. This uniformity probably corresponds to a new technique of combat, involving the use of more compact, more coherent formations. It is likely that the remarkable expansion of mercenary service among the Celts at this time had a great deal to do with this development.

The military expansion of the Celts reached the Balkan regions in the early third century BC, and led to the settling of the Galatians in Asia Minor. Its motive force was constituted at this time by highly mobile armed groups, which seem to have existed on the fringe of the tribal system, like the Irish *Fiana*. Made up at first of heterogeneous elements, they built up outside the already existing structures new ethnic entities based on an ideal model that was no longer that of the tribe, but that of a militarily organized confederation.

These marginal military confraternities that then travelled across Europe were unquestionably to become animated by an ideal of the warrior function very close to that embodied in the heroes of the Leinster cycle. This does not mean, of course, that the tribal epic was no longer appreciated and was doomed to oblivion. It had simply become necessary to complement it with accounts that better expressed the new conceptions. Thus the epic of which the Leinster cycle is probably a distant echo could be the literary counterpart of the revival and remarkable expansion in the plastic arts to be found principally at that time on weapons; the coincidence between what has been called the 'Sword Style' and the decisive role played by those who had commissioned these works is certainly not fortuitous.

The final stage of the evolution of the military phenomenon, as we are able to discern it from the materials found on the Continent, corresponds to the appearance and development of the *oppida*. Military organization and techniques of combat then underwent important modifications. One of the most obvious is the replacement of war-chariots by a cavalry that was equipped and trained to charge in formation. Bound up with the process of the establishment of the 'cities', the implications of these changes are numerous and far reaching, but they do not seem to have affected the British Isles except very marginally, and only in the areas where the system of the *oppida* was beginning to be developed. It is hardly surprising, therefore, if the ideas that undoubtedly accompanied these transformations appear to have left no echo in the Irish epic.

The illustration of a horse-rider brandishing a carnyx, *or war trumpet, features on the reverse of a gold coin of the powerful Catuvellauni. The obverse of this coin bears the name of Tasciovanus, father of Cunobelinus, who succeeded him around the year 10 BC. The inscription 'SEGO' on the reverse probably refers to the unidentified location of the mint.*

Left: Underground chambers made from large blocks of stone and known by the Cornish word 'fougou' are found on many Iron Age sites in Cornwall. As with similar phenomena in Brittany and Ireland, their function is unknown. They could be hiding places or storage chambers for perishable food or sanctuaries. Situated some six miles from Land's End, the Carn Euny 'fougou' near Sancreed is surely the most beautiful surviving monument of this type. It has two galleries, a circular chamber and a narrow tunnel which was perhaps a secret passage.

Below: The horseman on this British coin of the first half of the first century AD is equipped in typical Celtic style for the end of the Iron Age, allowing him to charge in formation: the saddled horse has a full range of trappings; the warrior is protected by a large oblong shield and a helmet and is armed with a spear and, although it is not shown here, no doubt also a long sword. This image features on the reverse of a gold coin of Verica, king of the Atrebates. His name figures on the obverse, associated with a vine leaf (see illustration page 16).

81

ART

There can be no doubt that the art of the ancient Celts provides the most authentic evidence that has survived of their mental outlook and their spiritual world. In contrast to works of literature, in which changes, sometimes considerable, and usually difficult to detect, may have altered not only form but also content, the creations of metalworkers have remained exactly as they were conceived. The lines and volumes, which have not faded or become blurred with the passage of time, are those that were envisaged or modelled some two thousand years ago.

Without this art, it would be difficult today to have much idea of the existence of a specifically Celtic mentality, shared for almost five hundred years by the peoples who inhabited the major part of Europe, from the Atlantic to the Carpathians. Despite their vitality and their military strength, the Celts never constituted a great empire, a political force comparable with those that dominated the East and the Mediterranean. They did, however, achieve a spiritual unity that has survived in the original plastic language that they evolved.

Because Celtic art was nourished on borrowings and influences that originated in the world of the Greek and Etruscan cities and because it used everyday objects, usually small in size, as its base, it was long regarded as a marginal emanation of classical art, a minor manifestation, essentially ornamental in character. Given such views, the different form that the Celts gave to Mediterranean motifs could be seen as no more than the result of lack of skill and understanding, a sign of the barbarism of its creators, of their inability to conceive a form of figurative expression comparable with those of the arts of classical antiquity.

However, the recent evolution of European art and the change in attitude towards forms of art other than those of Graeco-Roman classicism have enabled us to understand that what at first sight seems like an inadequacy, a shortcoming, was in fact a sign of authenticity and independence. The idea that early Celtic art represents a particularly

important and original landmark in European art is gradually becoming accepted. If, notwithstanding, this art still remains largely misunderstood, that is because it is difficult to come to grips with. In order to appreciate it fully, one must not only free oneself from traditional criteria, but also accustom the eye to subtle and often strange compositions, which can only be properly apprehended when one looks at the object close up, making use of the play of light as one moves to observe it from different angles. The way the objects are presented in museums does not usually make this kind of examination possible, and it is largely thanks to the technique of photographic enlargement that the plastic qualities of the masterpieces of Celtic art have been brought to light and revealed to the public at large.

The innovations that helped in the fifth century BC to free Celtic art from repetitive geometricism seem at first to have made relatively little impact on the Celts of the Atlantic seaboard. Themes of oriental origin – the Tree of Life surrounded by birds and monsters, the Master of the Beasts, the palmette, the lotus flower – which brought, via Italy, a

The skilful use of the compass is a characteristic innovation which occurred in the first phase of what can be considered specifically Celtic art throughout the area covered by the La Tène civilization. The instrument was used either directly on the object to be decorated or to make often very complex working drawings, which would be carried out afterwards by other methods. This circular harness plaque in bronze openwork, which was discovered last century in a chariot grave at Somme-Bionne, Marne, is one of the finest surviving Celtic works of the fifth century BC with compass decoration. The compass is used in such a way as to produce meaningful shapes rather than just an abstract mixture of curves and counter-curves: here they are mainly lotus flowers, somewhat distorted but still perfectly recognizable. Through a love of the ambiguous peculiar to Celtic art, these recognizable shapes can be perceived both in the solid parts and in the cut-away parts through which the colours of the support could originally be seen.

fundamental contribution to the formation of the new vocabulary, do not appear to have been so widespread in the west as in the more easterly regions. However, as mentioned earlier, scabbards of short swords of Marnian origin or inspiration, dating from the mid-fifth century BC and carrying decoration engraved with compasses have been found in the bed of the Thames. This decoration consists of quite simple motifs and no object from this period has yet been found in Britain which is comparable in its complexity with the astonishing *phalerae*, or decorative harness plaques, of Champagne or the Rhineland. The fact that the compass was used, however, is very important, for the systematic use of this instrument, whether to engrave decoration directly, or to sketch out compositions that were later to be executed in relief, was from that time on to be a peculiar feature of the art of the island Celts.

The propensity of Celtic artists to play with lines and volumes to the detriment of natural forms, their liking for equivocal shapes and their obvious desire to provide the possibility of multiple and even sometimes contradictory readings, find in the compass a particularly suitable aid. It is just as difficult to distinguish the background motif on the British mirrors of the first century BC as on the open-work *phalerae* of the Marne, drawn with a compass four centuries earlier: brilliant surfaces and matt surfaces, full forms and empty forms, provide the complementary elements for alternative readings between which one's choice can only be subjective and ephemeral, depending on the lighting and the orientation of the object, the mood and imagination of the observer.

The first important creations of Celtic art already show, therefore, the existence of original attitudes and techniques that clearly distinguish it from the art of classical antiquity. The fact that such works of art continued to be created and to be refined for close on to five hundred years, by artists living a great distance from one another but working in the same spirit, reveals the deep-rooted nature of their art. Theirs is a plastic language which appears to be perfectly adapted to a certain outlook, and it is interesting to remember in this context the Greek Diodorus's description of the spoken language of the Celts: '. . . brief, enigmatic, often hyperbolic, with frequent recourse to implied meanings . . .'

Although it is possible to discern already in the Celtic art of the fifth century BC all the fundamental elements of the vocabulary and syntax of this plastic language, it does not seem as yet to be fully formed, universally adopted and understood. From the early fourth century, following the establishment of direct, permanent contact between the Celts and the Greek and Etruscan civilizations of northern and central Italy, a second wave of borrowings from the Mediterranean world came to enrich Celtic art.

Celtic craftsmen now began to assimilate part of the Greek ornamental repertoire which until then had had little notable influence. Thus a new stylistic current was formed – known by specialists as the Waldalgesheim, or continuous vegetal style – which is largely made up of vegetal motifs, the most important being the foliated scroll, on account of its dynamic nature.

The use of these new motifs led to the simple juxtaposition of the elements of composition being replaced by continuous linking, and to the appearance of dynamic principles of assembling elements: symmetry by rotation (around a single point) increasingly replaces fold-over symmetry (following an axis); subtle balances are created by imposing contradictory movements on the principal and secondary motifs or by alternating static and dynamic motifs. These innovations considerably enriched Celtic art and finally freed it from its initial constraints.

Bronze mirrors with richly engraved backs are surely among the most impressive achievements of British Celtic art at its height. The decoration of these remarkable pieces is made by contrasting shiny surfaces with areas covered with short lines in a chequerboard pattern (the so-called 'basketry' pattern), reflecting light in the same way as a precious fabric. Decorations of this type are generally very complex and invariably drawn with a compass. They are made up of circles and various triangles with curved sides and arranged so as to create ambiguity between the decoration and the background and keep the eye in constant motion. This excellently preserved mirror which was discovered at the beginning of this century at Desborough, Northamptonshire, is the best example of a group found mainly on the western side of Britain and characterized by a strict respect for fold-over symmetry (see also illustration on title page).

The Celtic artists' fondness for contorted and equivocal shapes must have been influenced by the atmosphere of the temperate forests where the plant forms, changing according to the light and the season, would have been a constant source of inspiration. The Aber Valley natural park, situated east of Bangor, opposite Anglesey in North Wales, contains mainly oak forest which cannot be very different from that of the Iron Age.

88

This bronze trumpet bell with its rich chased decoration belongs to a large horn-shaped instrument, quite different from the carnyx. This fine piece was found nearly two centuries ago, together with three other trumpets of the same type which have since been lost, in the former lake of Loughnashade, which had been converted into a peat-bog. The site lies at the foot of the Emain Macha fort, now known as Navan Fort, an important place in the epic of the Ulster cycle and residence of the legendary king Conchobar. In spite of many points of similarity between the decoration of this Irish piece and Continental Celtic art of the third century BC, the general design, which strictly follows the fold-over symmetry principle, and other similarities to British works of the period preceding the Roman conquest (end of the first century BC and first half of the first century AD) indicate a later date.

The new style, developed in the Celto-Italic workshops, probably owes its rapid spread into the transalpine territories to the continual movement, above all military, brought about by the presence of the Celts south of the Po – raids on Greek or Etruscan towns, the movement of mercenaries, etc. The sumptuous ceremonial helmets from Amfreville and Pont d'Agris, spectacular evidence of this spreading influence, were discovered in regions that, according to our present knowledge, were beyond the western limits of the area of diffusion of the works characteristic of the initial period. There must have been expansion westwards, as is confirmed by the fragmentary helmet found on the southern coast of Brittany, at Tronoan, which is less elaborate than those mentioned above, but also of Celto-Italic origin.

It was probably this current, bound up with the prestige acquisitions of the warrior aristocracy and with the movement of groups of adventurers, that was responsible for the introduction of the foliated scroll and other innovations into the art of Britain: indeed, a particularly characteristic combination of scrolls, found on only a few objects, including the Amfreville helmet, is also to be found on a work whose British origin seems indisputable, the sword scabbard found at Standlake, in Oxfordshire, a region in which there are indications of Continental influence as early as the fifth century BC.

The analysis of many more recent creations of British art fully confirms the importance, for the later development of the local art, of the Celto-Italic influence. But not all the innovations that it brought with it were necessarily introduced directly into Britain: some may have arrived later, after having been assimilated by certain Continental centres.

One may consider this possibility among others in the case of the technique by which tiny secondary motifs, almost invisible except on very close examination, are inserted in the composition. The decoration thus

conceived requires two successive readings: the first, the normal one, to obtain an overall view, the second, detail by detail, to decipher the small-scale motifs. This curious duplication is already to be found on certain Celto-Italic objects, in particular the Amfreville helmet: the background is decorated at certain points with scarcely perceptible combinations of foliated scrolls, similar to those that make up the most remarkable element of the principal decoration.

One can find it on various works that belong to an obviously fully developed British art, probably dating from a period at least two centuries after the penetration of the Celto-Italic influence. Thus on shield mountings found in the River Witham and in the bed of the Thames near Wandsworth, the principal decoration, rendered in well-defined relief, is complemented by engraved motifs executed on a markedly smaller scale. The stylistic parallels that can be drawn between these fine works and certain manifestations of the art of the Danubian Celts at its height, in the third century BC, suggest that it was probably by this agency, and consequent upon the arrivals of populations of the same origin that took place at that time in various parts of western Europe, that this principle of composition was introduced into Britain. We should not, therefore, lose sight of the fact that, although it is true that the island milieu represents a

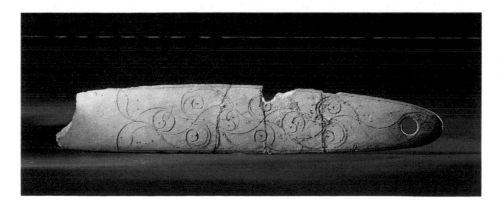

The Lough Crew, Co. Meath, bone flakes provide remarkable and diverse evidence about the compass techniques used in the first century AD, during the time when this type of decoration was at its height in art in Britain and Ireland (see illustration on page 35 for the context of this find). Chosen from about a hundred decorated flakes and fragments, these examples illustrate three types of composition: an entirely regular collection of circles and segments arranged on the principle of fold-over symmetry; a simple motif made up of three circles and two semi-circles set around a central point (rotation symmetry); and a very elaborate chain of curves which looks like two cleverly interlaced foliated scrolls.

sort of dead-end, in which influences from various parts of the Continent, arriving at various times, accumulated and fused, these influences did not always follow the most direct route from their places of origin.

Seen from another angle, the case of these double-scale compositions brings us to the delicate problem of how the Celts saw the function and meaning of plastic art. Indeed, if we try to determine the intentions behind this curious technique, which consists of enriching the composition with well-defined elements which normally pass unseen, it would seem clear that what we are dealing with is neither a concern with ornament for its own sake, nor the search for psychological effect, two possibilities one is at first tempted to propose to explain the decoration on such objects as shield mountings. In neither case could the results be regarded as successful, and it is difficult to see why Celtic artists would have gone on scrupulously repeating the same error for generations, especially on objects of military use – helmets, sword scabbards, chariot and shield mountings.

A better explanation can be found if one accepts from the outset that the Celtic artists thought that the various motifs they used possessed magical virtues and consequently conceived each composition as a combination of signs destined to give protection or to produce a particular effect. According to such a hypothesis, multiplying the signs was equivalent to increasing and diversifying power: rendering some of those signs almost invisiblewithout distorting their nature made it possible to benefit from an occult reserve whose effect could be all the more decisive in that it was unexpected. It is easy to see how such a secret weapon would be prized by a warrior. Obviously, the only ones possessing such an advantage were warriors who had managed to obtain the co-operation of those craftsmen most expert in the manipulation and assembling of signs: for the Celtic client of two thousand years ago, the functional (*i.e.* magical) qualities and the aesthetic qualities, the only ones that we are capable of appreciating today, were no doubt completely indistinguishable.

The potential magical charge of the motifs not only explains their astonishingly widespread use and their remarkable permanence, but must also have been of crucial importance in determining the selection of motifs borrowed from the Mediterranean repertoire. This is clear in certain cases at least, especially that of the themes of distant Eastern origin, assimilated from the fifth century BC onwards, whose various manifestations remained to the end fundamental elements of the Celtic repertoire. It is less apparent in the case of the Greek ornamental motifs introduced in the following century, with the exception of the 'Hercules' knot', whose success with the clients of the Campanian and Tarentine goldsmiths was due precisely to the magical virtues attributed to it. Adopted and adapted, then, by the Celts, this knot was to remain restricted to ornaments – torques, bracelets, buckles – and to enjoy a widespread but relatively short-lived vogue compared with such motifs as the foliated scroll and palmette: with the exception of a few late derivations, strictly confined to northern Italy and linked to a particular type of ornament, the popularity of the 'Hercules' knot', does not seem to have survived among the Celts beyond the mid-third century BC.

This is an important observation for the history of the art of the British Isles, for this motif occurs on a golden torque discovered in Ireland, in a bog near Clonmacnoise. Situated like other ornaments of this type on the back of the object, perhaps in order to give protection from evils that the eye is unable to ward off, this knot is a version still very close to the Italiot models, whose filigree decorations it fairly faithfully imitates. Its presence fully confirms, therefore, the conclusions provided by typological analysis of the Irish torque, which suggests that it is an imported work, or one

On this mirror from Aston, Hertfordshire, the disproportion between the smooth and finely striated parts, the latter meant to form the background to the decoration, causes one's overall perception to be inverted: the shiny parts, decorated as usual with circles and wavy-edged triangles, appear to form the background from which another motif stands out, when the mirror is placed handle upwards, looking like a monstrous creature whose globulous eyes, with wide rings round them, are closely set above a sort of snout.

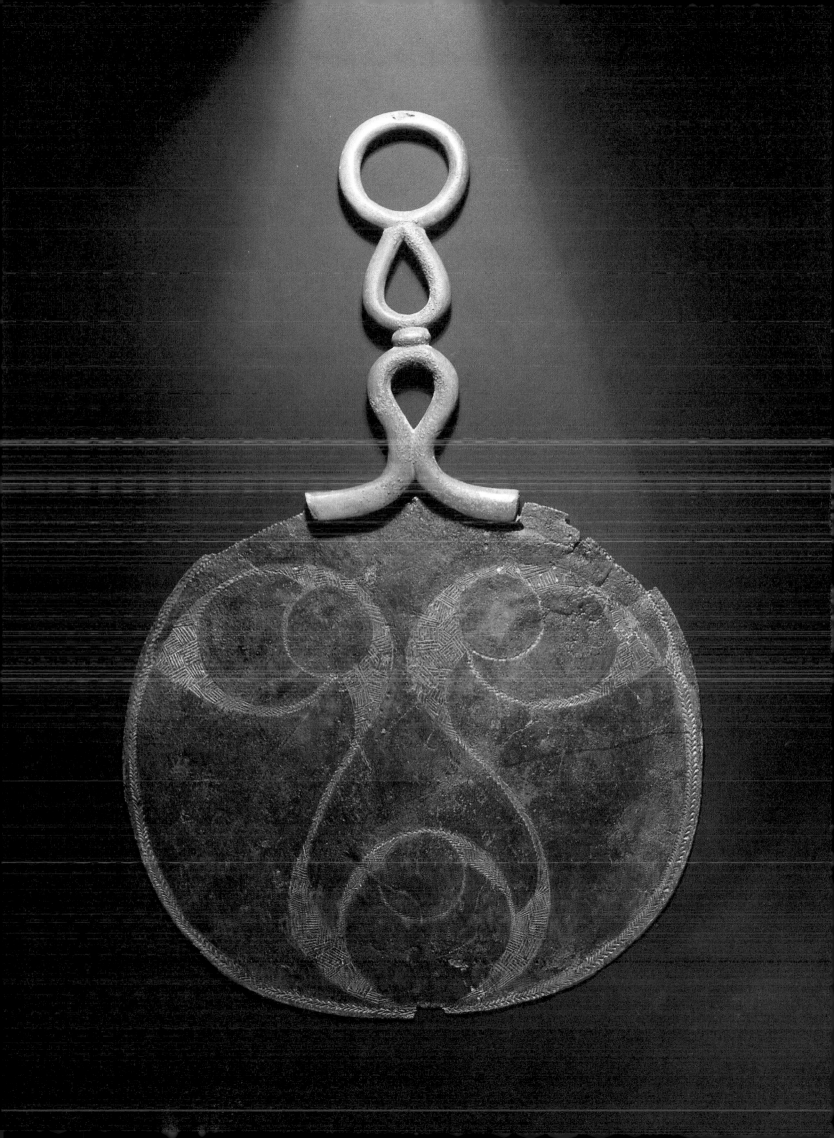

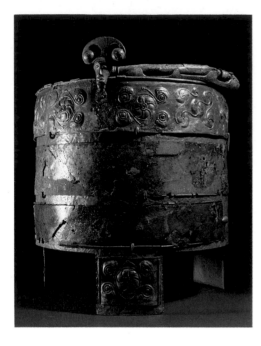

This wooden bucket with metal fittings was found in a first century BC cremation grave at Aylesford, Kent. It is one of about forty utensils of this type found over a wide area, from the south-east of England to the Pyrenees and stretching as far as the Carpathians. This type of receptacle of about three to five litres' capacity may have been part of a set of banqueting utensils used for diluting the resin-thickened wine with water. This liquor was drunk at the feasts which were important events in the social life of the Celts. This would explain the care taken in the manufacture and decoration of the object.

directly inspired by Continental production, of the late fourth or early third centuries BC.

The Clonmacnoise torque remains an isolated case in Ireland where it represents by far the oldest manifestation of Celtic art known to us. However, it constitutes unequivocal evidence of the presence of elements of Continental art in the island prior to the mid-third century BC. The extent of the phenomenon and its possible role in the formation of a local art are difficult to assess, for the comparisons that can be drawn between the Continental art of the third century and certain later Irish works are just as likely to be the result of influences from the neighbouring island as of local assimilation of the innovation of which the Clonmacnoise torque gives evidence.

Thus the motifs in well-marked relief – a Celtic form of a combination of palmettes and foliated scrolls – that decorate the bell of the great bronze trumpet of Loughnashade may have points of comparison both with third-century Continental art and with British art of the following centuries.

Despite the difficulties currently encountered by specialists in their efforts to establish a reliable framework for the evolution of the art of the islands, especially in view of the very small number of pieces found in a context that makes it possible to date them, we may nevertheless take it as a definite fact that the blossoming of this art was conditioned and nourished by an influx of Continental elements in the third century BC.

The works that indicate the maturity of art in the British Isles – the shield mountings of the Witham and the Thames mentioned above, the chamfrain of Torrs and others – probably do not date from before the second century BC, but they reveal a number of convincing parallels with Continental productions of the previous century. There is no possibility of confusion between the products of the islands and those of Celtic artists from the west or from the Danubian region, but the specific features which they have in common concern form rather than subject-matter, and execution rather than design.

In both cases, one notices the same fascination with the linking of flowing lines, curving this way and that, which had evolved from the transformations of the foliated scroll and other vegetal motifs; one sees the same attraction exerted by the interplay of subtle and equivocal allusions on the frontier between abstraction and figuration. A few touches transform a palmette into the suggestion of a face or mask – though whether it is closer to the animal or to the human it is impossible to say; or part of a scroll becomes the outline of some fabulous bird; or the composition becomes the emblematic microcosm of a magic forest, peopled with good or evil monsters, ephemeral, indefinable shadows, strange creatures created as much by the mood of the observer as by the imagination of the creator.

The terms 'Cheshire Style' (an allusion to the cat in *Alice's Adventures in Wonderland*) and 'plastic metamorphosis' (less original, but more accurate, because less restrictive) have been coined to refer to this type of representation specific to early Celtic art. Plastic metamorphosis means that the artist has chosen the precise moment at which, in the transition from one form – vegetal, human, animal, abstract – to another, the balance is not yet disrupted and none of these forms is allowed to predominate. Unlike certain representations of metamorphosis in classical art, there is nothing here to suggest the direction of the transformation and its irreversible character. For Celtic artists, each form contains the embryos of other forms and the prevalence of one form over the others can never be more than temporary and incomplete.

Is this the expression of some sort of vitalism? An operation of a magical character? The allusive illustration of mythological metamorphoses? We shall probably never know, but this plastic invention, which is of remarkable originality, shows clearly the interest felt by the Celts in the change from one form to another, thus confirming and enriching what we know from written documents, in which metempsychosis emerges as an essential element in Druidic doctrine. To a greater extent than any other, perhaps, this aspect of early Celtic art at its height reflects a view of the universe in which, by perpetual movement, the boundaries between the natural and the supernatural become blurred, in which the marvellous is regarded as a fundamental and omnipresent element of everyday reality. The Celtic artist does not describe the world around him, he reproduces it in his own way, on the basis of an inner projection that shatters appearances.

The remarkable balance achieved in the second century BC by British art and, one or two centuries later, by Irish art (the disc of the River Bann, 'the Petrie crown' and other objects), was to be disrupted in Britain in the course of the next century. What one is faced with, then, is a sort of bipolarization of plastic expression. On the one hand, there is the blossoming of the tendency to favour the interplay of lines and abstract

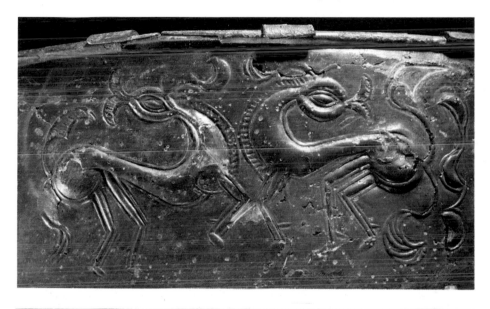

Details from the bucket pictured on facing page.
The sheet-bronze band with chased decoration fixed below the lip of the bucket is decorated successively with pairs of highly stylized horses, perhaps monsters for they seem to have two tails and a sort of plume instead of ears, rosettes containing six-armed swastikas, which make them look as if they are spinning, (each of these motifs is surrounded by four birds' heads wound round concentric circles), and finally, a chain of S's above four circles arranged in a square round a larger circle. The S's are placed so that their tails cut the circles in half to form the Chinese 'yin yang' shape. There can be no doubt that this whole decoration is based on religious symbolism, confirming the ceremonial purpose of the receptacle (see also illustration page 100).

This chased bronze fitting no doubt originally came from a war chariot. It was found at Stanwick, in North Yorkshire, site of the largest fortifications in the north of England, a system of defensive works around a 700-acre area. This was probably the headquarters of the anti-Roman Brigantes, ruled over in the last quarter of the first century AD by Venutius, enemy of Queen Cartismandua, who headed the faction of this people allied to the Romans. In its apparent simplicity, the Stanwick horse's head is one of the best Celtic animal works. Without losing their essential character, the natural forms are simplified into a motif which must have had a special symbolic meaning: the lower parts of the pair of facing S's make up the nostrils while the upper ones are replaced by the animal's eyes.

Below: The art of Celtic coins still remains largely unexplored and is often dismissed as merely stylistic and imitative of Greek models. But a systematic study of coin images and their comparison with other examples of Celtic plastic art of the Iron Age show quite clearly that the transformation of the original models does not derive from incompetence or fantasy on the part of the engravers but is the result of their deliberate adaptation to widely accepted and specifically Celtic concepts.

volumes brought about by the systematic use of the compass, particularly in the case of mirror decoration and most costume accessories. On the other hand, there is the proliferation of figurative elements, human or animal: statuettes, mountings on wooden receptacles and other objects assumed the forms of wild boars, horses, and bovines, almost always perfectly identifiable, despite a high degree of stylization.

This evolution doubtless corresponds to a more general phenomenon, for the same tendencies are also to be found in the final phase of Continental art. This at least is what one might conclude from an examination of the images on Gallic coins, for in Gaul, from the first half of the first century BC, representations appear which are fully in line with Graeco-Roman conventions, both in spirit and in formal execution. Such a weakening of the capacity for transformation and integration of external influences cannot be solely explained by the new strength of Mediterranean influences following the creation of the *Provincia*. It is probably the reflection of an internal crisis within Celtic society triggered off by the rise of the *oppida*, the Roman conquest merely bringing the crisis to a speedy conclusion.

The situation was different in Britain, where the development of *oppida* took place less evenly and less rapidly than on the Continent. For over a

Right: The obverse of the coin pictured above. The reason why the 'S' motif on the right of this coin is clearly linked with the face is not a desire for decorative effect: it is meant to represent an attribute, reinforced by repetition, to enable identification of the personage, certainly one of the major Celtic gods. This low-alloy coin was made by the Coriosolites *of Armorica just before the Roman conquest in the first half of the first century BC.*

One technique frequently used by Celtic coin engravers to transform the original model was to shrink part of the image. On this gold coin, what started as Apollo's laurelled hair ended up as a more important feature than the god's actual face. This coin can be dated from the end of the second century BC. It belongs to the Ambiani, a people from the north of Gaul whose name lives on in the name of the town of Amiens. It is the first coin of the Belgic people to be attested by finds in both the south-east of England and northern Gaul.

century, art was to remain the privileged expression of an essentially rural milieu, little influenced by Roman fashion and strongly attached to its own traditions. Even after the partial conquest of Britain, local craftsmen were to perpetuate at least the formal aspects of the island's art, thus giving Romano–British artistic production a specific character that has no equivalent in the other Celtic countries integrated within the Roman Empire.

In Ireland, which was affected neither by a development of urban centres nor by Roman conquest, the art preceding the introduction of Christianity represents both the brilliant epilogue to early Celtic art and the prologue to a Christian art that was to preserve and integrate the essential features of its heritage. It is through Irish art that Western mediaeval art was to rediscover the fruits of over a thousand years of original experimentation carried out by the Celts in the field of plastic expression – successive endeavours inspired by a desire to use the image as an emblematic intermediary, as a means of communication as effective as speech in the difficult relations between man and the sacred forces that govern the universe.

The Celts were very fond of colour and from the fifth century BC onwards used coral to decorate their finery and ceremonial arms. From the following century they made increasing use of red enamel or glass paste, and only in the third century BC did they develop the 'champlevé' technique. For a long time red was the only colour used in enamel work. Other colours, yellow and blue, only made their appearance in the first century BC. This fretted bronze plaque is a splendid example of Celtic enamel art at its height. It has keepers on the reverse side for fixing on a strap and seems to have belonged to a horse's harness. It was found at Paillard, Oise, on a Gallo-Roman site that was probably made in Britain where several other of these beautiful objects have been found. The rigorous axial symmetry of the compass composition, based on circles and triangles, and the use of red and yellow 'champlevé' enamel indicate that this high-quality work belongs to the richest period of British Celtic art, from the end of the first century BC to the middle of the following century.

THE GODS

Much decorative work by Celtic craftsmen seems to have had a religious significance, especially certain drinking utensils, like wine jugs and wooden buckets with richly worked metal fittings. A good example is the Aylesford bucket (see illustrations pages 94 and 95). Its bronze band is decorated with a sequence of obviously religious symbols and the handle attachments are made up of heads surmounted by a simplified 'palmette' pattern. They no doubt represent the great Celtic god associated with the Tree of Life, the symbol here reduced to a notional 'palmette' pattern, and to mistletoe. Interestingly, scientific analysis shows that the wooden staves of buckets of this kind are made of yew, which, according to Irish texts, was a sacred tree.

The spiritual unity that finds such lucid expression in the art of the ancient Celts was probably founded on a basically common conception of the nature of the gods, of the ordering of the universe, and of the destiny of man.

By compiling and comparing information from the various sources now at our disposal we are able to get a relatively accurate idea of at least some of the elements which made up this spiritual tradition. References by Greek and Latin authors, works of art and other archaeological remains that may be related to religious activities, inscriptions and images on stone, coins, etc. from the Roman period, mythological poems written down by Irish monks in the early Middle Ages — all of these fully confirm the antiquity, extent and deep-rootedness of a specifically Celtic religion. However, these sources do not allow us to reconstruct a complete, coherent picture or to estimate its development in time and determine what influence may have been exercised locally, in the many regions in which the Celts settled, by the indigenous religions of populations that in many cases, notably in western Europe, were probably not even of Indo-European descent.

To the superimposition or juxtaposition of different systems proper to polytheistic religions may have been added, as was the case in the Mediterranean world, the formation and spread of sects that held beliefs more or less marginal to the doctrines and practices common to the population as a whole. This may also have been the case with those confraternities of warriors that appear to have played such a crucial role among the Celts in the fourth and third centuries BC, whose deeds are recorded in the *Fiana* of the Leinster cycle: the abandonment of any attachment to territory and of all productive activity in favour of a warrior ideal directed towards the quest for a 'good death', the heroic death in combat which brings the deserving man closer to the gods, must have been based on the exalting of a particular aspect of the general doctrine.

Thus, like most other ancient religions, the Celtic religion did not form a monolithic, perfectly coherent body of doctrine, but rather an aggregate of beliefs, varying in time and place, within the framework of a flexible system centred round a small number of great pan-Celtic gods who were the protagonists standing out from the common mythological substratum, a composite pantheon combining a multitude of tribal gods, pre-Celtic local deities or cults peculiar to particular social groups.

The Irish myth cycle clearly shows that hierarchy in this divine world was seen as the result of fierce struggles between the successive generations of gods who had dominated the universe, from the primordial chaos to the appearance of an established order, an order maintained by the supremacy of the great Celtic gods and by the annihilation or submission of the others. Relationships that prefigure those between clients and patron, nobles and sovereign, king and tutelary divinity, were thought to exist between the different deities venerated by the Celtic or Celticized populations. However, this hierarchy was not a definitive one, for the victory of one human group over another could only be the consequence of the superior power of its gods and therefore necessarily implied the existence of a relation of dependence between the respective divinities parallel to that established between victor and vanquished.

If a passage by Diodorus of Sicily (first century BC), inspired by a lost work by Hecataeus concerning the Hyperboreans, is to be believed, the earliest mention of the gods of the regions populated by the Celts goes back to the sixth century BC. According to this text, there was, in the north of the Atlantic Ocean, opposite the country of the Celts, an island as large as Sicily, with a soil so fertile and a climate so temperate as to give two harvests a year. Peculiar to the island was a cult dedicated to Apollo, to whom a magnificent sacred enclosure and a temple, circular in plan and decorated with numerous offerings, had been erected; an entire city had been consecrated to this same god whom Greeks, Athenians and Delians alike travelled to honour; precious votive gifts with inscriptions in Greek letters survive as evidence of these visits.

Diodorus himself regards this story as legendary and there is certainly a strong element of the fabulous about it. However, without going so far as to take it unquestioningly as a description of the megalithic sanctuary of Stonehenge, the possibility that it is a somewhat distorted echo of travellers' accounts of Britain cannot be totally excluded. But if this should be the case, the Hyperborean Apollo would probably have been not a Celtic divinity, but the great sun god of the pre-Celtic populations. These populations are now thought to have maintained throughout the Iron Age the tradition of the circular sanctuaries, which were probably associated with that most valuable inheritance of the Atlantic civilizations, a calendar based on a thorough knowledge of the movement of the heavenly bodies, evidence for which is to be found in the great megalithic monuments. The fact that, when referring to the cult of Apollo on the island, the passage quoted by Diodorus refers to a nineteen-year cycle, based on astronomical observation – the equivalent of the 'Meton cycle' introduced in Athens during the fifth century BC in order to reconcile the lunar year and the solar year – suggests that we would be ill-advised to assume prematurely that this story has no basis in fact.

The earliest information available to us at present concerning the Celtic pantheon is in the form of figurative representations, unfortunately still unidentified, but whose divine character seems unquestionable, at least in certain cases. The most ancient of these figures go back to the fifth century BC and are closely related to themes of distant oriental origin which were typical of the art of those Celts who had settled north of the Alps.

The lower handle attachment of the sumptuous Basse-Yutz wine jugs (see illustrations pages 52–53) represents a bearded and moustached head with globulous coral eyes and adorned with a clearly recognizable 'palmette'. Heads of this type, crowned with emblematic representations of the Tree of Life, can be seen on many Celtic works from the Iron Age, especially wine jugs and coins. They probably represent one of the major Celtic gods, no doubt the one associated in the fifth century BC with the double mistletoe leaf.

Specially singled out and venerated trees played a crucial part in Celtic places of worship. The nemeton, or sanctuary, was originally simply an enclosed sacred wood. The oak tree was much revered, especially when it bore mistletoe which, growing parasitically in the air, always green, must have appeared to embody some mysterious aspect of the plant cycle and was therefore somehow directly linked with the great mysteries of life and death. One can well see from the majestic and imposing beauty of these oaks in the Aber national park in Wales (see illustration page 88) how such trees came to be specially chosen to incarnate the sacred.

The most significant, and also the most common, is a man's head, usually depicted with moustache and beard, and decked out with a strange head-gear that may be nothing more than the schematic, but perfectly identifiable, figuration of a pair of opposed mistletoe leaves. Indeed, this particular motif is often represented alone, with the mistletoe-berry taking the place of a human head. It is sometimes found in this form as the central element in the compositions of oriental inspiration adopted at this period by the Celts, in which the Tree of Life is surrounded by birds or monster-guardians. The existence of a direct relationship or even of an equivalence between these two kinds of representations containing the motif of the 'mistletoe leaf' is clearly confirmed by the handle of a wine pitcher of Celtic workmanship, found in a Rhineland tomb dating from the fourth century BC: the head, with moustache and beard, inscribed within the double leaf, is flanked by a pair of monsters with snake-like bodies and hooked beaks that usually accompany the symbol of the Tree of Life.

Mistletoe, an aerial, evergreen parasite found on trees which lose their leaves, was regarded as the attribute, perhaps even the vegetal incarnation or manifestation, of a great Celtic god. By analogy with mistletoe's

The head on the obverse of this gold coin of the Parisii of Gaul has the same attributes as the one on the Basse-Yutz handle attachments: hairstyle in the form of a pair of S's, which are normally found framing the 'palmette' pattern, and the face also surrounded by S's. These attributes are shown frontally here, no doubt so as to be readily recognizable, whereas the face itself is in profile as would have been the case with the original Greek model. It is interesting that this quarter stater of the first half of the first century BC was found not in Gaul but near Durham on the British territory of the Parisii.

behaviour in relation to the natural cycle of the seasons, this god was connected with the fundamental mysteries of life and death. Some five hundred years later, the Roman author, Pliny the Elder (first century AD) wrote:

> . . . the Druids – for such is the name they give to their magi – have nothing more sacred than the mistletoe and the tree that bears it, providing it is an oak. . . They consider everything that grows on those trees to be sent from Heaven and see in it a sign of the election of the tree by the god himself. Mistletoe of this species is very rarely found and when it is discovered it is picked with great religious pomp; this must be done on the sixth day of the moon, which for them marks the beginning of the months, years and centuries, which last for thirty years; this day is chosen because the moon is already strong without being at half-course. In their language they call this [mistletoe] 'that which cures all'. According to the rites, they prepare a sacrifice with religious festivities at the foot of the tree and bring two white bulls whose horns are tied for the first time. A priest, dressed in white, climbs into the tree, cuts the mistletoe with a golden sickle and places it on a white tunic. They then immolate the victims, praying to the god to make his gift propitious for those to whom he has granted it.

Natural History, XVI, 249–251

This ceremony, described with exceptional precision, has been seen as a mere magico-medical ritual. In fact, as is revealed in the quite explicit iconography of the fifth century BC, it was almost certainly a particularly important ritual pertaining to a cult associated with one of the greatest Celtic gods: it is hardly surprising that mistletoe was considered to have magical virtue, for, because it is perennial, it is to the tree what the soul is to the body. For this reason it was regarded as a direct emanation of the god in person.

No known inscription allows us at present to identify this god. However, archaeological documentation adds a few more touches to his anonymous portrait. First and foremost, a bronze statuette of a horse with a human head bedecked with the characteristic double leaf decorates a wine pitcher of the fifth century BC found in the Rhineland. This monstrous creature, unknown in ancient Europe outside the Celtic world, appears to be an animal avatar of the same great god. The human-headed horse is found again some centuries later on Gallic coins, especially in Armorica.

There is another important fact: the close link that seems to exist between this god and the Tree of Life enables us to recognize him in heads whose head-gear includes a suggestion of the palmette, or pair of facing 'S'-es, that is the most schematic version of the monster-guardians of the Tree. The heads possessing these distinctive signs seem to have appeared in the fourth century BC, at around the time the motif of the double mistletoe leaf began to disappear. They are frequently found on the obverse of coins struck, from the third century BC, by the Celtic or Celticized populations of the region between the Atlantic and the Carpathians. But apart from images on coins (which were anyway inspired by Greek prototypes), representative figures became rare from the fourth century BC. A single theme seems to have eluded this decline, namely, the pair of monster-guardians of the Tree of Life, with or without the palmette that symbolizes it. This motif – known as 'the dragons pair' – which is apparently an allusive, elliptical reference to the great god, is engraved on a large number

of sword scabbards of the fourth and third centuries BC. Nearly a thousand years later, a Welsh description of Arthur's sword, 'on which were engraved two golden serpents', which made it 'difficult for any person to gaze upon the sword', retains a distant echo of the magical power once associated with this symbol.

Finally, the importance of this god is fully confirmed by the nature of the objects which bear his image. These objects include carvings on stone such as stelae or statues, which were probably originally placed in sanctuaries (as is the case with the fragments of a statue of this type, recently found in a fortified centre in Bohemia), wine pitchers, and adnornments or pieces of equipment belonging to the leaders of the military élite. Through their connection with the institution of the banquet and the royal function, they reveal his regal character.

The survival over the centuries of iconographic themes that are directly related to this god, and their spread to almost the entire area occupied by the Continental Celts suggest that he was one of the great deities listed by Caesar, our principal source on the religion of the Gauls prior to the conquest. Everything seems to suggest that he may well have been the principal god, assimilated by Caesar to the Roman Mercury, because he was regarded as 'the inventor of all the arts, the guardian of roads and

Above and right: The characteristic motif of the pair of S's, here again framing the semi-circular heart of the 'palmette' pattern, can be seen in the hairstyle of the head on the obverse of this gold coin probably of the Aulerci Cenomani of the Le Mans region. The picture on the reverse, though derived from the original Greek image of a chariot at the gallop, depicts a purely Celtic invention: the human-headed horse Perhaps it represents the incarnation in monster form of the great god on the other side of this coin. It is interesting to note that the face of this mythological monster on a bronze statuette on a wine-jug lid of the fifth century BC found in Germany is surrounded by a double mistletoe leaf.

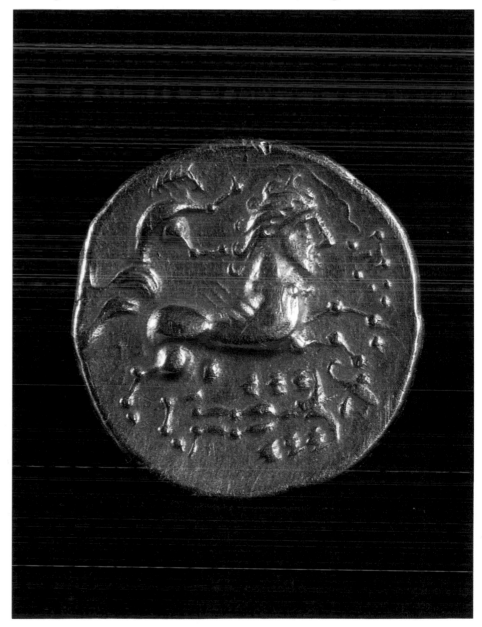

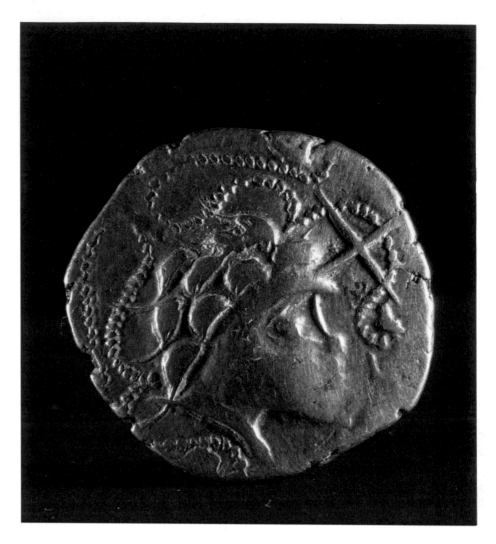

Two favourite images of the Armorican people – on the obverse, a head surrounded by S's and on the reverse, the human-headed horse – are combined on this coin of the first half of the first century BC attributable to the Namnetes people from whom the name of the town of Nantes derives. On this occasion there is a human figure with outspread arms under the horse.

travel, the great master of profit and commerce'. He is identified, very plausibly, with the god Lug, who left his name to several urban centres, including Lugdunum ('Lug's fortress', the present-day city of Lyons), the capital of the Three Gauls, where, from the year 12 BC, the festival of Augustus on 1 August replaced that of the god, the Gallic equivalent of the Irish Lugnasad: according to the traditional rules, the godlike Emperor of Victorious Rome thus took the place of the great Gallic god. But in spite of its plausibility, the connection between the 'god of the mistletoe leaves' and the god Lug cannot be anything more than one hypothesis among others, until some inscription is discovered which confirms or invalidates this hypothetical identification.

The god Lugh ('the Luminous One') of Irish mythology is better known: king of the last generation of gods, the Tuatha Dé Danann ('Tribe of the goddess Dana'), he bears the name of Samildánach ('Poly-technician'); his name is often followed by the qualifying phrase 'of the long arm', which confirms his solar nature; he also had a predilection for the javelin and sling. Like the bow and arrow of Apollo, these weapons are expressive of the sun's ability to strike from a great distance. A divine prototype of the royal function, Lugh, with his companion Eithne, the Land of Ireland, begot the hero CúChulainn, who was then brought into this world by the intermediary Deichtire, sister of King Conchobar.

One anecdote related by Diodorus of Sicily seems to suggest that the idea of representing gods as similar to men was still not very widespread among the Celts in the early third century BC, nor much appreciated by them. He tells of the condescending amusement of Brennos, the military

chief who had led an army to the gates of the temple at Delphi, on discovering that 'the Greeks believed that the gods had human form and erected [images of] them in wood and stone'. Indeed, the spread of effigies of deities seems to have been limited in the fifth century to those Celtic regions that were in most regular and frequent contact with the Mediterranean world. Such effigies were later conveyed to other regions mainly in the form of coins, which were themselves of Mediterranean origin.

The forms of art to which the Celts returned in the fourth century BC have sometimes been called aniconic (*i.e.* not portraying animal or human forms). This is incorrect. for what is at issue is not a rejection of the image, but a desire to conceal it by various means, so as to reserve its reading to the knowledgeable eye of the initiate. These artistic forms, while still figurative, are therefore elliptical, allusive, and esoteric, characteristic of the new vegetal style associated with the renewal of Celtic art. There is no reason to suppose that this trend represents a mere regression to archaic conceptions of the deity.

Indeed, it is possible that the powerful influences then being exerted on the Celts by the Greek cities of southern Italy introduced, in addition to the formal elements of the new style, ideas borrowed from Orphism and Pythagoreanism, the esoteric doctrines that were then enjoying a remarkable vogue. Orphism was a mystic religion which originated in Greece. It was developed particularly by the Greeks of Italy in the sixth century, and it stressed purification through reincarnation. Pythagoreanism, based on the teachings of the sixth-century Greek philosopher Pythagoras, also stressed reincarnation, and the significance of numbers and their relations. There are obvious and meaningful convergences that can be discerned between the preoccupations reflected in the Celtic art of this period and these doctrines – in particular an interest in the transition from one form to another and the importance accorded to the combination of geometric figures and volumes. While these artistic and philosophic convergences may have been fortuitous, it is also possible that they were a product of the influence of those religious and philosophical currents on certain members of the Celtic intellectual élite. If this were so, the stylistic diffusion of the Celto-Italic milieu would represent simply the material expression of a diffusion of ideas. Generally regarded as fanciful, the few passages by later authors affirming the existence of direct contacts between Pythagoras and the Druids may turn out to be not entirely without foundation.

The main source of our knowledge of the Celtic pantheon of the third and second centuries BC, unfortunately always anonymous, is to be found in images on coins, which provide a treasury of iconographical information that remains to be exploited, although there has been some interesting recent research. The listing of these images has proved to be a long-term undertaking, for there are well over ten thousand in all. We are now fairly certain that almost all these images belong to the religious domain, and that the primary reason modifications were made to the Mediterranean prototypes was a desire to adapt them to specifically Celtic concepts, which were perfectly defined in advance and known to those who used the coins: a few touches – usually the addition of the torque (necklace) and of characteristic attributes of the god – transform the head of Apollo on the obverse of Philip of Macedon's staters into one or another of the Celtic deities; the chariot on the reverse is replaced either by the monstrous horse with a human head, or a horse on which is perched either a bird of prey or a naked armed horsewoman, no doubt some warrior goddess who is the Continental equivalent of the Irish Morrigan, also known as Bodb, the 'Crow'.

This low-alloy coin, probably belonging to the Veneti *of Armorica and dating from the first half of the first century BC, shows the same juxtaposition of images as the preceding example: on the obverse, a head with the S's which originally framed the 'palmette' pattern, the heart of which still appears in the centre of the pair of S's. On the reverse, the human-headed horse, apparently guided by the small person waving a torque instead of the charioteer of the Greek original. The monster is leaping over a boar, emblem of warlike strength.*

The Iron Age Celts seem to have had a special respect for the funeral mounds and other monuments built by their distant ancestors. Some big megalithic tumuli in Ireland were considered to be the homes of the gods. The supernatural inhabitants of the Irish síd – the underground world of these mounds – entered into communication with the human world on the night of 31 October to 1 November which the Celts called Samain, end of the old year and start of the new. The beliefs surrounding this type of funeral monument explain why so many tumuli have been preserved on the sites of more recent habitation. For example, funeral mounds from the beginning of the Bronze Age (first half of the second millennium BC) were preserved inside the walls of the large harbour settlement of Hengistbury Head, Dorset, which was particulary active in the first century BC (see illustration page 20).

The information collected by Caesar in the mid-first century BC on the Gallic religion is still irreplaceable evidence, unique of its kind, and forms the basis of our knowledge in this area. He was the first to provide a list of the great gods and to define their functions. Unfortunately, he does not mention their Celtic names, but instead compares some of them to their counterparts in the Roman pantheon.

He also left the most complete and coherent description of the place and function of the Druids in the Celtic society of the time. The Druids were representatives of the intellectual élite who were at that time recruited from among the ranks of the nobility. They enjoyed special privileges, such as exemption from taxes and from armed service. However, before becoming Druids, they had to undergo a very long period of instruction – twenty years has been mentioned – an essential part of which consisted in the memorizing of sacred texts, there being a religious prohibition against their being written down. However, the Gallic Druids of Caesar's time were certainly able to write and 'for almost all other public and private purposes' used the alphabet borrowed from the Greeks. As representatives of the sacred function, the Druids regulated religious practices, presided over sacrifices, collected and interpreted omens. They alone 'knew the nature of the gods', which made them privileged intermediaries between the human world and the supernatural. As possessors of fundamental knowledge, they perpetuated a conception of man and the universe that was transmitted orally, in the form of an esoteric doctrine. We possess only a few very brief indications concerning its eschatological aspects. Thus, according to Caesar:

The essential point of the Druids' teaching is that souls do not die, but pass after death from one body into another; they hold that this brief is the best stimulant to courage, for thus men no longer fear death.
Gallic War VI, 14

These types of flat bronze spoon have so far almost only been found in the British Isles. The only two continental specimens come from the same grave at Pogny, Marne, in a small third-century BC burial place, excavated at the beginning of this century. British and Irish examples all seem to be more recent but have the same characteristics: they generally come in pairs with one of the spoons having two engraved lines crossing at right angles to each other, with a circle or circular hole at the intersection; the other spoon is generally smooth and may have a similar hole near the edge. These strange pieces seem to have been used for ritual libations. The engraved pattern inside some of them probably symbolizes the Celtic concept of the world order: the vertical and horizontal axes divide space into four parts whose unity is assured by the centre point, a hallowed place according to the sacred tradition. The examples in this picture all come from Ireland but the exact place and circumstances of their discovery is not known. The engraved decoration indicates that they date from the first century AD.

*The pyramid-shaped stone found at the end
of the last century at Kermaria en Pont-
L'Abbé, Finistère, quite near Penmarc'h
Point, is probably the best example of a
Celtic* omphalos *known to us. The shape
of this granite block and the way it is
decorated show clearly that it was intended
to mark the symbolic crossing point of the
two axes about which the universe
extended. The flat top of the stone has two
diagonal lines from corner to corner of the
pyramid so that each side panel corresponds
to one of the four quarters marked out by
these lines (see illustrations on following
page).*

This may be compared with two others, slightly more recent. The geographer Strabo (second half of the first century BC), says:

> The Druids declare – and others with them – that souls and the Universe are indestructible, but that one day fire and water will prevail against them.
>
> *Geography*, IV, 4, 4

A writer of the first century AD, Pomponius Mela, has this to say of the Druids' teachings:

> One of their doctrines has become widespread among the people, namely, that souls are immortal and that there is another life for the dead, which makes them more courageous in battle. It is for this reason, too, that they burn or bury with their dead all that is necessary to life; formerly they left to the other world the settlement of affairs and the payment of debts There were even some among them who threw themselves upon the funeral pyres of their close relatives as it they wished to go on living with them.
>
> *De Chorographia*, III, 2, 18

The two narrower faces of the stone pictured on the previous page. The decoration of each panel is different but always in four parts, framed top and bottom by meandering lines which encircle the whole stone. This motif is jagged in the upper part and curved in the lower part. One can only guess at the symbolic meaning of all this, but it seems obvious that it is linked to a concept of space divided into four equal but different parts, unified by a common centre. The Kermaria stone almost certainly dates from the fourth century BC.

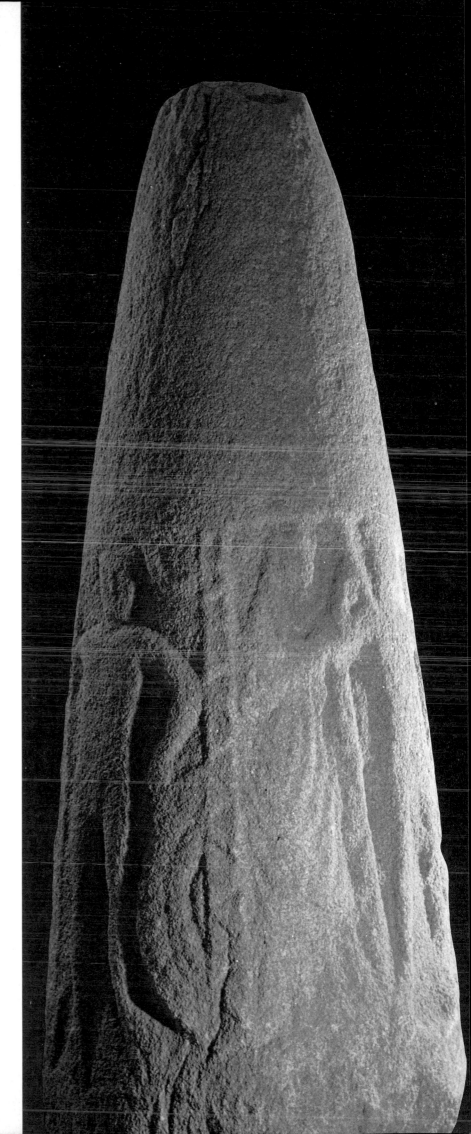

The standing stone of Kervadel at
Plobannalec, Finistère, also known as the
'Kernuz menhir', comes from a site only a
few miles from Kermaria. This seven foot-
high conical stone was probably already
several centuries old when it was given the
carved decoration, perhaps in the first
century AD, which makes it so interesting.
The lower part has four panels, separated
by wavy vertical lines, like those on the top
of the Turoe stone, and on the panels are
six figures and one animal. The figures are
probably of Gaulish gods assimilated with
Roman divinities of whom three can be
identified from their attributes: Hercules,
Mars and Mercury, with his staff,
accompanied by a much smaller figure,
either a minor god or a child. The presence
of Mercury, incorporating the great Celtic
god Lug, indicates that the figures on the
pillar probably represent the principal gods
in the Celtic pantheon. The way they are
set out on four panels may also indicate that
they were more or less directly linked with
the ancient Celtic division of space into four
parts as illustrated on the Kermaria and
Turoe stones.

A comparison of these three passages reveals that the posthumous life of the immortal soul was probably envisaged in two ways: it might be in another world, quite separate from the world of mortals, or it might be on earth, through the reincarnation of the soul, which is a new birth (metempsychosis). The first conception, whose antiquity is proved by the composition of the objects found in the graves of Celtic notables from the end of the first Iron Age, was certainly quite common, while the second may have been confined to a small group of initiates, as in the case of the comparable Greek doctrines of the Orphics and Pythagoreans.

According to other information provided by Caesar, the Gauls claimed to have sprung from a god whom he assimilates to the Roman Dispater, the shady counterpart of Jupiter. We do not know the Gallic name for this god, but we do know that of its Irish equivalent, Donn (the 'Dark One'), isolated from the other deities in the kingdom of the dead, at once beneficent and to be feared. It was probably on account of this belief that the Gauls measured time in terms of nights and not days. In fact, the Gallic calendar, known through an example engraved on bronze during the imperial period and found at Coligny (department of the Ain, in France), has turned out to be a calendar that was originally lunar, but later adapted to the solar year.

Its elaboration presupposes, then, a very long period of observation and recording of the movement of the heavenly bodies, as well as a good knowledge of mathematics. Indeed, the results obtained by the Druids in this fundamental discipline of their sacred science were highly praised by several Greek and Latin authors. A Greek writer of the third century even declares that the Druids could predict certain events by the calculus and arithmetic of the Pythagoreans, which had been taught to them by the Thracian, Zalmoxis, one of the philosopher's slaves, who was thought to have settled among the Celts after his master's death.

It is probable that the science of numbers, their relation to one another and their meaning, was also applied to the search for the sacred ordering of geographical space. Indeed, according to Pomponius Mela, the Druids 'claim to know the size of the earth and of the world'. It is probably to just such preoccupations that two fairly rare series of exceptional remains, which at first sight have no common denominator, may be related: carved stones, found mainly in Armorica and Ireland, but with direct antecedents going back in central Europe to the fifth century BC, and objects resembling very flat spoons, made of bronze, and in certain instances pierced with a central or asymmetrical hole. These 'spoons' generally come in pairs and have been found almost exclusively in Britain and Ireland.

One pair, however, apparently the oldest, was found in France, at Pogny (Marne), in a burial that formed part of a small necropolis dating from the third century BC which belonged to a group that had recently migrated to the region from the Danubian zone. The two spoons were found in a shallow bronze bowl, or patera, like those used in the classical world for offering libations to the gods. These objects had been placed on the right forearm of an adult male. He is probably the only Druid whose grave can be identified up to the present day, thanks to the particular nature of the grave offerings, which are clearly associated with a person who was responsible for sacrificial rituals.

It is important to note that, while one of the two spoons is smooth, the other bears on its inner face two engraved lines, the intersection of which is marked by a hole. In fact, therefore, the object is a miniature model of the ordering of the universe. The two axes of the cardinal points divide space into four parts and the hole corresponds to the *mundus* (a well that, in

Etruscan foundation rituals, represented the point of intersection of these cosmic axes and provided a means of communication, possible on certain ceremonial occasions, between the world of the living and the underworld) or to the Greek *omphalos* (the sacred stone above which the two lines of force that ordered terrestial and aerial space crossed).

There are sufficiently numerous and convincing examples to show that this type of division of a territory was conceived as the projection of a cosmic model: four parts regarded as equal, placed around an ideal centre a 'consecrated place' in which the unity of the parts is realized and in which contact between the sacred space, subterranean or aerial, and the human world is established. It is also clear that it represented for the Celts a strictly observed religious imperative. This can be observed at both extremities of the world inhabited by the ancient Celts. In the west, Ireland was divided into four fundamental provinces each of which provided a small piece of territory for the creation of a fifth, the province of the centre (Meath), in which the Druidic centre of Uisnech and Tara, the residence of the supreme kings of the island and the place of the great pan-Irish assemblies of the Lugnasad, was to be found. Similarly, in the east, the Galatians organized themselves into tetrarchies, whose meeting place was a central sanctuary called Drunemeton.

The skilfully structured conceptions of time and space that were worked out by the Druids and which are remarkably close to those that we know of the Mediterranean world, clearly show that the idea of a sort of wild anarchy that is so often attributed to the ancient Celts (in contrast with Greek or Roman order), is a misrepresentation resulting mainly from the relatively small amount of explicit information at our disposal and the difficulty encountered in its interpretation.

The presumed barbarity of the Celts, supposedly manifested by a bloodthirsty cruelty, is simply the facile explanation that has been offered since antiquity for the practice of human sacrifice, described in the texts, confirmed by archaeological discoveries, and abundantly commented upon by those who seek to pass critical judgment on the Celtic past, as well as by its defenders. If we are to discern the motivations underlying this custom, we must first understand that it was based on a conception of sacrifice as an essential religious act, vital to the maintenance of the universe. Julius Caesar is remarkably clear on this point; speaking of the prohibition of the making of sacrifices that might be used as punishment for disobeying the juridical decisions of the Druids, he remarks:

> For them, this punishment is the most serious one of all. Those on whom the prohibition is levied are regarded as impious criminals: people flee their sight, lest frequenting them bring great misfortunes upon them. Their demands in law are not accepted and no honour is accorded them.
>
> *Gallic War*, VI, 13

In the eyes of those profoundly religious people, no substitution was admissible in the performance of this fundamental act. The appropriate sacrifice had to be carried out, according to the rules, on pain of dire, inevitable consequences, liable to go to the point of disturbing the balances that were supposed to guarantee the good working of the universe.

This bronze head of a helmeted female deity was found at Kerguilly en Dinéault, Finistère, together with other parts of the same statue – the parts in sheet metal have corroded away. The hill-top site, formerly surrounded by a square enclosure, faces the 600-foot-high Menez-Hom dominating the Aulne estuary and which can be seen from a great distance, equally well from the Bay of Douarnenez as from the Roads of Brest. This first-century AD statuette is inspired by the Roman goddess Minerva but clearly differs from her by the swan on the crest of her helmet. It is therefore a case of a Roman version of a native goddess, most likely the great Celtic goddess known in Ireland as Brigit or Birgit.

The most desirable fate for an ancient Celt after leaving this world was to join those on the Blissful Isles in the Ocean, the paradise from which sadness, illness and death had been banished, where an endless feast gathered together warriors and their fair partners in peace and harmony, amongst trees heavy with sweet-smelling flowers and succulent fruits, to a background of enchanting music. This sunset is seen from the Finistère coast on Lostmarc'h Point near Crozon.

The area around the Pointe du Raz, Finistère, was densely populated in the Iron Age since at least six fortified headlands of the period have been identified there. The most impressive is on the Castel-Meur site, Cléden-Cap-Sizun, a rocky headland over 130 feet high. Its silhouette can be seen in the background of this picture (see illustration page 26).

EPILOGUE

The Roman conquest of Gaul and of a large part of the island of Britain did not lead to an immediate, radical overthrow of the life of the Celtic populations living in those regions. Indeed, the organization of the conquered territories into provinces, the economic and administrative control of which was exercised through an urban network, was greatly facilitated by the development of the *oppida* that characterized the final period of independence. The few new towns founded by the Romans were not intended to replace the ancient centres, and they were not the sign of a transformation of the earlier system. On the contrary, they were apparently the means of guaranteeing a military presence and of installing settlers devoted to Rome, without disturbing in too brutal a fashion the functioning of the traditional network.

The 'city', a federation of tribes bound together by common religious, political and administrative institutions, remained the basic entity of territorial organization in both Gaul and Britain. Far from being destroyed or undermined by Roman domination, it became even more firmly entrenched, developing and strengthening its links with the larger urban centres that were the direct heirs of the great *oppida*. The towns were now to become increasingly identified with the 'cities', and it is mainly thanks to those of them that were renamed after the 'cities' at the end of the Empire that the names of many of the peoples of Celtic Gaul have survived until our own time, over two thousand years later.

The presence of stone architecture is generally regarded as the feature that best distinguishes the cities of the Roman period from the early Celtic urban centres, which were built entirely of perishable materials. However, this opposition is far from being as straightforward as is usually thought. The building techniques used prior to the conquest, which made use principally of wood, mud and thatch, appear to have retained pride of place; the technique of masonry using stone and brick spread only gradually and was used mainly in the erection of public buildings. This was

This silver-gilt bronze fibula, originally found at Backworth, Northumberland, is a very good illustration of the meeting between the new ideas introduced into Britain by the Romans and the traditional Celtic culture which survived longer in this region, perhaps because the north of Britain remained independent. The shape of the fibula is directly derived from Roman models but the engraved decoration is in the pure Celtic tradition of the British Isles. On the buckle can be seen the 'triskeles' pattern chosen as much no doubt for its traditional symbolic meaning as for its decorative value.

still the case in most of the mediaeval cities of France and England, private houses generally using stone only for the lower parts – cellars and the load-bearing elements of the ground floor – the rest being carried out in stud-work and rough-cast.

Side by side with the buildings of Roman conception – temples, especially those dedicated to the imperial cult or to Roman deities, civil basilicas, thermae, theatres and amphitheatres – traditional architectural patterns continued to be used for buildings associated with specific functions. This was the case, for example, with the Celtic sanctuaries, where a closed *cella* of circular or quadrangular plan is surrounded by a gallery opening outwards by means of a peristyle, intended, according to the most widespread hypothesis, for ritual ambulation. Usually placed within an enclosure that clearly marked out the sacred space, this type of temple seems to have had particularly ancient wooden antecedents in Britain and was also very widespread before the conquest in the western part of the Continent between the Rhine and the Atlantic. The sanctuaries of the Roman period characterized by these temples were obviously devoted to native cults. They were generally to be found outside the urban centres, and excavations have shown that many of them bear traces of earlier constructions dating back to a time well before the end of independence.

It would seem, then, that a great many of the Celtic sanctuaries continued to be frequented without marked interruption after the conquest. Only those religious centres which harboured a real or potential political force contrary to Roman interests were dismantled, probably permanently; this happened to the Druidic sanctuary of Anglesey (Mona), which was destroyed in AD 61 by Paulinus's legions.

Unfortunately we do not know to what extent the destruction of certain sanctuaries was accompanied by the suppression of the deities worshipped there, or by discrimination against them. The very fragmentary nature of the information at our disposal concerning the pre-Roman Celtic religion makes it impossible for us to assess the importance and quality of the transformation that it underwent after the conquest. The impression given by the abundant documents on the religion of Roman Gaul and Britain is that it consisted of a vast and tangled native pantheon, upon which the Roman pantheon was partly superimposed. Apparently, however, this indigenous religion was pushed ever outwards from the urban centres into the countryside, as the official cults of the Empire and the more or less esoteric religions imported from the orient (the cults of Isis, Cybele, Mithra), which were particularly widespread among the military, to some degree supplanted it in the towns. This dislocation of the ancient Celtic religion, though most likely welcomed by the conquerors, was probably due not so much to the repression of Druidism as to the attraction that Graeco-Roman culture exerted upon the native élites. The educated sons of the nobility lost interest in the traditional teachings, and turned to the learning of Greek and Latin, which not only made possible their cultural integration, but also gave them access to administrative and political careers. As a result, ancestral beliefs were relegated to the countryside, where the myths which had always been the preserve of the scholars, jealously guarded and rigorously transmitted by the Druidic schools, were gradually dispersed to swell the inextricable mass of folk tales.

In these circumstances, the prohibition against writing down the sacred texts spelt death to the preservation of the oral literature of the Continental Celts: the only texts of a religious character written in a Celtic language that have come down to us are in fact either brief dedications or magical

invocations whose somewhat marginal nature is indicated by the very use of writing, and whose orthodoxy is probably debatable. However, there remains one important exception, namely, the Gallic calendar written down in the second century on bronze plaques, found at Coligny (Ain). Originally exhibited in a sanctuary and unquestionably intended for some religious use, this lunar calendar adapted to the solar year is not only eloquent and irrefutable evidence of the remarkable level of the astronomical and mathematical skill of the intellectual élites that had conceived and improved it over the centuries, but also the only authentic official written document to provide substantial information on a specifically Celtic aspect of religious life in Gaul.

The adhesion of the Gallic and British élites to Graeco-Roman culture certainly played an important role in the transformation of those provinces and their integration into the Empire. However, it was no doubt the traders and legionaries who contributed most to the spread of the use of Latin among the less affluent social classes. Indeed, this language of the educated, of the administration and the army, also became, with the advent of Christianity, the language of the only tolerated religion. Those Celtic dialects that had not yet disappeared now found themselves relegated to the status of rural patois. In the late fourth century, St Jerome refers to the existence of one of them in the region of Trier. The fact that he observes its kinship with the language of the Galatians of Asia Minor probably indicates that it was already an isolated relic. Armorica, the only part of the Continent where Celtic is still spoken, owes the resurgence of that language to the immigration of Britons, who left their country in the

Above: This penannular brooch in enamelled bronze, probably found in the bed of the river Shannon near Athlone, Co. Westmeagh, was made in the sixth or seventh century AD, that is, several hundred years before the introduction of Christianity to Ireland. The ornament owes its shape to Roman Britain but the flow of curves and counter-curves emerging from the red enamel background is totally in the spirit of Celtic work of nearly a thousand years before.

Right: This openwork bronze ornament, probably dating from the first century AD, found at Cornalagh, Co. Monaghen, belongs to a specifically Irish series of objects whose function remains unknown. It is further confirmation of the Celtic craftsman's fascination for effects achieved by compass-work. This piece from the final phase of pre-Christian Celtic art is remarkably similar to a set of openwork phalerae, or decorative harness plaques, of the early fourth century BC, characteristic of the first known attempts by the Celts to exploit the possibilities of the compass.

fifth century as a result of the pressure exerted by Saxon and Irish incursions.

The better resistance of the Celtic dialects of Britain, still in use at the end of the Empire, at least in the northern and south-western parts of the island, is probably due not only to the gap of a century that separates Britain's conquest from that of Gaul, but also to the fact that part of the Celtic-speaking population remained outside the frontier of the province.

However, the resurgence of the Celtic kingdoms, brought about by the collapse of the Empire and stimulated by resistance to invaders of Germanic origin – Angles and Saxons – was led by Britons imbued with Roman culture. After Vortigern and Ambrosius Aurelianus, the protagonist of that struggle of the Christian and Romanized Celts against the pagan barbarians was the historical model for the legendary King Arthur, a warrior chief from the south-west of the country. At first he inflicted a bloody defeat on his enemies, but was finally killed at the battle of Camlann, in about the year 539. It was around this personality that part of the literary patrimony of the British Celts now centred, thus constituting the nucleus of the *matière de Bretagne* ('matter of Britain' as it was called by mediaeval writers. Introduced into France and England by the courtly poets of the twelfth century, the Arthurian cycle was to enjoy a remarkable success, endowing European literature with an insular counterpart, of Celtic origin, to the *chansons de geste* of Charlemagne's peers.

Ireland, which remained independent, not only kept its language, but was able to preserve the tradition of literary teaching and to avoid the decline of the works transmitted orally. Thus, after the adoption of Christianity, which had the consequence of lifting the prohibition of the writing down of an oral literature which was essentially mythological in character, the Irish monks found at their disposal versions that were still relatively uncorrupt and coherent. They adjusted the narratives to some extent in order to attenuate their pagan aspects, to use the tradition for their own purposes, and, by a few erudite additions, to make them more like the classical literature they knew so well. Despite that, these texts remain unquestionably closer than any others to the oral literature of the ancient Celts. Whereas its other heir, Welsh literature, for the most part gives only a distant and fragmentary echo of the original themes, often so distorted that they can be distinguished only through sophisticated comparisons, Irish literature still reflects a relatively coherent and ordered system, a mythology whose antiquity and authenticity can scarcely be called into question. Its principal themes were probably common to all the ancient Celtic populations. Unfortunately, only a few hints given by the figurative art of the Continental Celts provide evidence in favour of this hypothesis. Even though it is quite probable that a pan-Celtic mythology existed in the Iron Age, we must no doubt abandon any claims to be able to reconstitute more than isolated aspects of it.

Ancient Celtic literature is not, however, merely a documentary corpus destined to satisfy the curiosity of scholars. The faith of its creators in the magical power of the word, their exuberance and poetic sense, their ability to blot out any boundary between reality and the world created by the imagination, give it qualities that guarantee it a place of honour in the heritage of mankind. In it one can recognize, as in the subtle metal-work fashioned by the Celts, the role of the dream and the taste for the supernatural through which we continue to participate in what was best in their legacy.

The care with which Christian symbols were integrated with monuments previously worshipped by the pagan Celts no doubt attests to the power of the beliefs still attaching to them. The Croas-Men monument at Lampaul-Ploudalmézeau, Finistère, is made up of an octagonal stele from the sixth or fifth century BC surmounted by a mediaeval cross.

BIBLIOGRAPHY

GENERAL:

Chadwick, N., *The Celts*, Pelican Books, 1970.

Cunliffe, B., *The Celtic World*, McGraw Hill, Maidenhead and Bodley Head, London, 1979.

Dillon, M. & Chadwick, N., *Celtic Realms*, Sphere Books, London, 1972. (Second edition)

Filip, J., *Celtic Civilisation and its Heritage*, Collet's-Academia, Wellingborough-Prague, 1977.

Kruta, V., Lessing, E., Szabó, M., *Les Celtes*, Hatier, Paris, 1978.

Laing, L., *Celtic Britain*, Paladin Books, London, 1981.

Powell, T.G.E., *The Celts*, Thames and Hudson, London, 1980.

Ross, A., *Everyday Life of the Pagan Celts*, Batsford, London, 1970.

HISTORICAL SOURCES:

Duval, P.-M., *La Gaule jusqu'au milieu du Ve siècle*, Les sources de l'histoire de France des origines à la fin du XVe siècle, vol. I, Picard, Paris, 1971.

Hawkes, C.F.C., *Pytheas: Europe and the Greek Explorers*, Eighth J.L. Myres Memorial Lecture, Oxford, 1978.

ART:

Brailsford, J., *Early Celtic Masterpieces from Britain in the British Museum*, British Museum Publications, London, 1975.

Duval, P.-M., *Les Celtes*, L'Univers des Formes, Gallimard, Paris, 1977.

Duval, P.-M. & Hawkes C.F.C. (eds), *Celtic Art in Ancient Europe – L'Art celtique en Europe protohistorique*, Seminar Press, London, 1976.

Duval, P.-M. & Kruta, V. (eds), *L'Art celtique de la période d'expansion: IVe et IIIe siècle avant notre ère*, Lib. Droz, Geneva–Paris, 1982.

Finlay, I., *Celtic Art. An Introduction*, Faber and Faber, London, 1973.

Fox, C., *Pattern and Purpose. A Survey of Early Celtic Art in Britain*, National Museum of Wales, Cardiff, 1958.

Jacobsthal, P., *Early Celtic Art*, Clarendon Press, Oxford, 1944 (repr. 1969).

McGregor, M., *Early Celtic Art in North Britain. A Study of decorative Metalwork from the third Century BC to the third Century AD*, University Press, Leicester, 1976.

Megaw, J.V.S., *Art of the European Iron Age. A Study of the Elusive Image*, Adams & Dart, Bath, 1970.
Treasures of Irish Art 1500 B.C.–1500 A.D., The Metropolitan Museum of Art & A. Knopf, New York, 1977.

LITERATURE:

Gantz, J. (trans.), *Early Irish Myths and Sagas*, Penguin, 1981.

Jackson, K. (trans.), *A Celtic Miscellany*, Penguin, 1971.

Jones, G. & T. (trans.), *The Mabinogion*, Dent-Dutton, London–New York, 1974.

Kinsella, T. (trans.), *The Tain*, Oxford University Press, 1970.

SOCIOLOGY:

Dillon, M., *Early Irish Society*, Mercier Press, Cork, 1954.

Jackson, K., *The Oldest Irish Tradition: A Window to the Iron Age*, The Rede Lecture 1964. Cambridge University Press, 1964.

McNiocaill, G., *Ireland before the Vikings*, The Gill History of Ireland 1, Gill and Macmillan, Dublin, 1972.

Rees, A. & B., *Celtic Heritage. Ancient Tradition in Ireland and Wales*, Thames and Hudson, London, 1961.

COINS:

Allen, D.F., *The Coins of the Ancient Celts*, Edinburgh University Press, 1980.

RELIGION:

Duval, P.-M., *Les Dieux de la Gaule*, Petite Bibliothèque Payot 298, Paris, 1976.

McCana, *Celtic Mythology*, Newnes Books, Feltham, 1983.

Piggott, S., *The Druids*, Pelican Books, 1974.

Ross, A., *Pagan Celtic Britain*, Cardinal ed., Sphere Books, London, 1974.

BRITTANY:

Giot, P.-R., Briard, J., Pape, L., *Protohistoire de la Bretagne*, Ouest-France, Rennes, 1979.

GREAT BRITAIN:

Alcock, L., *By South Cadbury is that Camelot . . .*, Thames and Hudson, London, 1972.

Cunliffe, B., *Iron Age Communities in Britain*, Routledge & Kegan Paul, London, 1974 (rev. edn. 1978).

Forde-Johnston, J., *Hillforts of the Iron Age in England and Wales. A Survey of the Surface Evidence*, Liverpool University Press, 1976.

Harding, D., *The Iron Age in Lowland Britain*, Routledge & Kegan Paul, London, 1974.

Reynolds, P.J., *Iron-Age Farm. The Butser Experiment*, Colonnade Books, British Museum Publications, London, 1979.

Stead, I.M., *The Arras Culture*, The Yorkshire Philosophical Society, York, 1979.

Wainwright, G.J., *Gussage All Saints. An Iron Age Settlement in Dorset*, Archaeological Reports 10, Department of the Environment, London, 1979.

IRELAND:

Herity, M. & Eogan, G., *Ireland in Prehistory*, Routledge & Kegan Paul, London, 1977.

Raftery, B., *La Tène in Ireland. Problems of Origin and Chronology*, Veröffentlichung des Vorgeschichtlichen Seminars, Marburg, Sonderband 2, Marburg, 1984.

INDEX

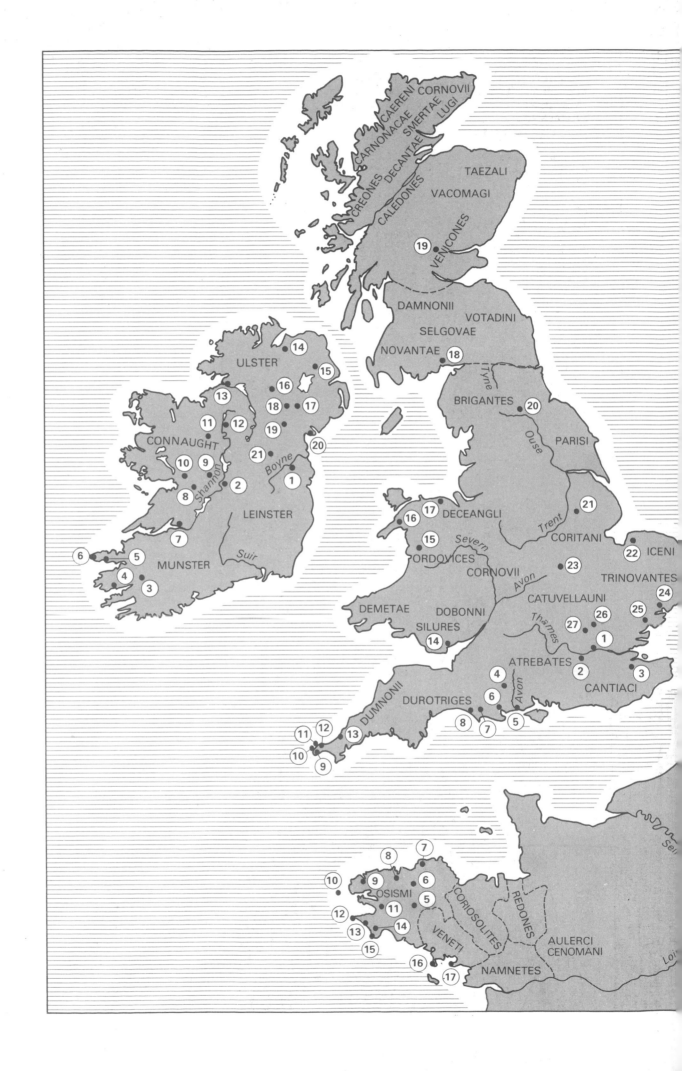